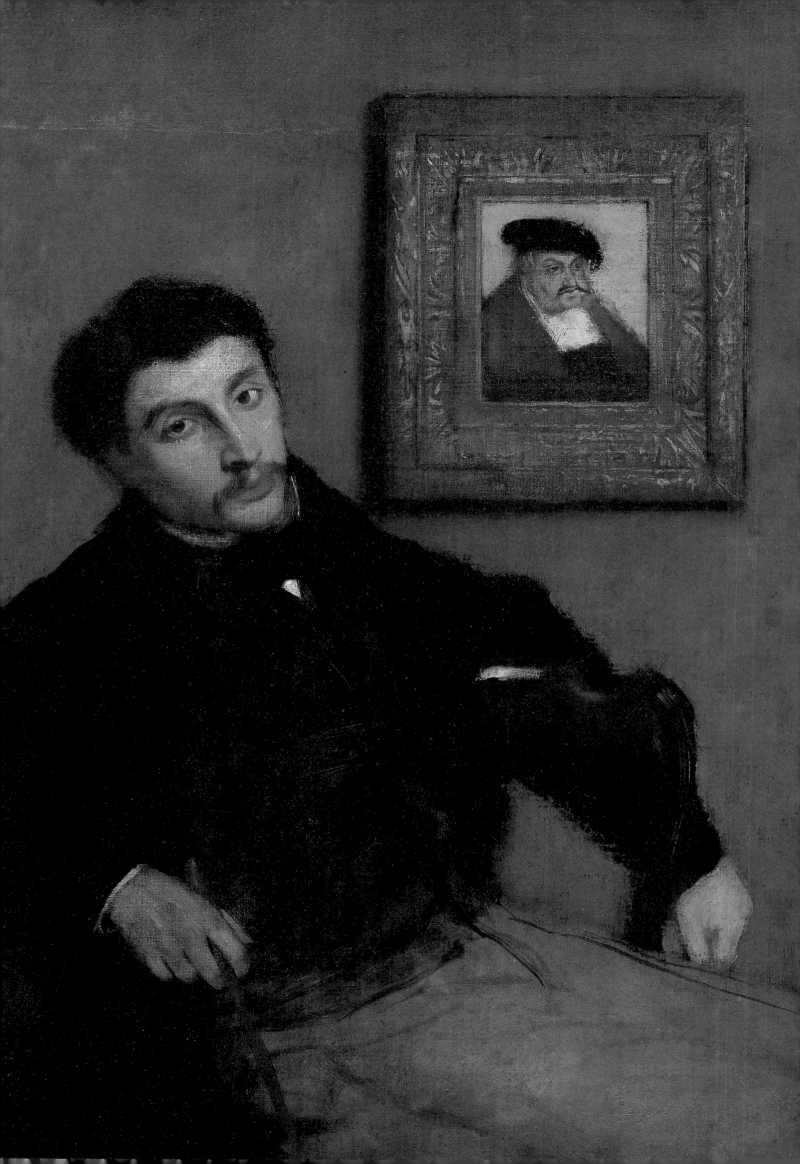

# FACES OF IMPRESSIONISM

## Portraits
## from American
## Collections

*Sona Johnston*
with the assistance of Susan Bollendorf

*Essay by John House*

The Baltimore Museum of Art
in association with Rizzoli International Publications

Published in conjunction with the exhibition
"Faces of Impressionism: Portraits from American Collections"
organized by Sona Johnston, Curator of Painting and Sculpture Before 1900,
The Baltimore Museum of Art, and circulated by the Museum.

The Baltimore Museum of Art
October 10, 1999–January 30, 2000

The Museum of Fine Arts, Houston
March 25–May 7, 2000

The Cleveland Museum of Art
May 28–July 30, 2000

This catalogue is made possible through the support of the
BMA's Procter & Gamble Cosmetics Foundation Publication Endowment Fund.

Front cover: Cat. no. 59. Pierre-Auguste Renoir. Detail, *Marie-Thérèse Durand-Ruel Sewing*.
1882. Sterling and Francine Clark Art Institute, Williamstown, Massachusetts (613)

Frontispiece: Cat. no. 25. Hilaire-Germain-Edgar Degas. Detail, *James-Jacques-Joseph Tissot*.
(c.1866–68). Lent by The Metropolitan Museum of Art: Rogers Fund, 1939 (1939.161)

Back cover: Cat. no. 1. Jean-Frédéric Bazille. *Self-Portrait*. (c. 1865). The Art Institute of Chicago:
Restricted gift of Mr. and Mrs. Frank H. Woods in memory of Mrs. Edward Harris Brewer
(1962.336)

First published in the United States of America in 1999 by
Rizzoli International Publications, Inc.
300 Park Avenue South
New York, NY 10010

Library of Congress Cataloging-in-Publication Data
Johnston, Sona
     Faces of impressionism: portraits from American collections /
  Sona Johnston with the assistance of Susan Bollendorf; essay by
  John House.
          p.    cm.
     Catalog of an exhibition held at the Baltimore Museum of Art.
     Includes bibliographical references and index.
     ISBN 0-8478-2210-9 (hc). —ISBN 0-912298-71-5 (pb)
     1. Portrait painting, French Exhibitions. 2. Portrait
  painting—19th century—France Exhibitions. 3. Impressionism (Art)—
  France Exhibitions. 4. Portrait painting—Collectors and
  collecting—United States Exhibitions. I. Bollendorf, Susan.
  II. House, John, 1945– . III. Baltimore Museum of Art.
  IV. Title.
  ND1316.5.J65    1999
  757'.0944'07475271—dc21                    99-23337
                                             CIP

Designed by Tsang Seymour Design

Printed in Italy

# CONTENTS

# PREFACE

In recent years, studies of French Impressionism have meticulously explored numerous aspects of this influential movement. Monographs have abundantly detailed the personal lives and public careers of this movement's innovative artists, who recorded the world around them in vibrant compositions. On occasion, a particular facet of their work has been the subject of an exhibition or book. Researches into their contribution to portrait painting have focused on Edgar Degas and, more recently, Auguste Renoir, both of whom were especially prolific in this genre.

Drawn from the remarkably rich holdings of American public and private collections, *Faces of Impressionism* is the first major exhibition to present an overview of portraiture realized by the Impressionist painters as a group. Works by two pivotal precursors of the movement, Gustave Courbet and Thomas Couture, are included, as are portraits by Henri Fantin-Latour and Frédéric Bazille, both of whom shared many of the goals of the more progressive artists of their time. The influential Édouard Manet also must be included, though he preferred to exhibit at the official Salons rather than with the Impressionists. A pupil of Couture and an artist much admired by the Impressionists for the vivid realism he brought to his paintings, Manet is represented by several works tracing the development of his innovative and varied approach to portraiture. Superb likenesses by Claude Monet, Renoir, Degas, Berthe Morisot, and the American expatriate Mary Cassatt demonstrate how these artists progressed from more traditional representations of subjects to the brilliant, light-filled canvases that mark their mature styles. Also included are works by Paul Cézanne and Paul Gauguin, both of whom participated in the Impressionists' exhibitions but eventually went beyond the boundaries of the movement to anticipate developments of the twentieth century.

For some, like Degas and Renoir, portraiture was a major vehicle of expression throughout their careers; others painted such images only occasionally. Virtually all of these artists, however, abandoned long-established conventions of traditional portrait painting, choosing instead to record their sitters in informal settings where they are often engaged in activities that define their identities. Familiarity with their subjects—often close acquaintances, colleagues, or relatives—produced especially insightful representations.

We thank the distinguished scholar John House, Professor of the History of Art and Deputy Director of the Courtauld Institute of Art, University of London, for his enlightening essay. Dr. House addresses the ways in which the Impressionists advanced beyond the traditions that held sway in the mid-nineteenth century to create a thoroughly "modern" concept of portrait painting. Implicit in his discussion is an exploration of the often indistinct boundaries between portraiture, figure, and genre painting.

We are deeply grateful to the organizer of this exhibition, Sona Johnston, who is Curator of Painting and Sculpture Before 1900 at the Museum. In her catalogue entries, she speaks to the ways portraiture shaped the careers of the Impressionist painters and examines the nature of the relationships between the artists and their sitters, often drawing upon contemporary texts. She has been ably assisted by Susan Bollendorf, Research Assistant, Department of Painting and Sculpture Before 1900, who contributed the entries on Gustave Caillebotte and directed procurement of the copious photographic materials for this publication.

We are pleased that *Faces of Impressionism* will travel to The Museum of Fine Arts, Houston, and The Cleveland Museum of Art. In those cities, as in Baltimore, we believe that this exhibition will delight all who experience it.

*Doreen Bolger*
Director
The Baltimore Museum of Art

# ACKNOWLEDGMENTS

Three years ago, when plans for this exhibition began to evolve, the thought of gathering together such a superb group of paintings seemed a remote possibility. The extraordinarily generous response to our requests for loans from both institutions and private individuals was overwhelming. To the directors and staffs of the lending museums and to the collectors Mrs. Noah L. Butkin, Dr. Herchel Smith, and Mr. and Mrs. Joseph Zicherman, we owe an enormous debt of gratitude.

Colleagues in every department of The Baltimore Museum of Art have contributed to the successful realization of this undertaking. I am especially grateful to Doreen Bolger, who graciously embraced the project upon her arrival as Director in 1998. I am indebted to Kathleen Basham, Associate Director, who dealt with the multitude of administrative issues generated by such a venture. Becca Seitz, Deputy Director for Communications, expertly negotiated matters related to the publication. Very much appreciated were the efforts of Deborah Tunney, Director of Public Programs, who, with her staff, planned the innovative educational programming for the exhibition. My sincere thanks also go to Melanie Harwood, Senior Registrar, whose department dealt with the often complex matters of insurance and shipping. The support of Nancy Press, Rights & Reproductions Manager, together with photographer José Sanchez, is also much appreciated. The formidable task of raising funds for an undertaking of this scope fell to Lisa Ketcham, Deputy Director for Development. As always, Karen Nielsen, Director of Exhibition Design & Installation, and her talented staff produced a handsome and elegant installation for the Baltimore venue of the exhibition. Special thanks for their ongoing efforts are due to Jacquie Meyer, Associate Registrar; David Penney, Exhibitions Coordinator; Laura Webb, formerly Rights & Reproductions Administrative Assistant; and Jay M. Fisher, Deputy Director for Curatorial Affairs. With her characteristic attention to detail, Audrey Frantz, Publications Manager, guided the preparation of the catalogue manuscript for publication with the support of Lisa Pupa, Publications Assistant.

The enthusiastic initial support offered by Arnold L. Lehman and Brenda Richardson, respectively former Director and Deputy Director for Art of the Baltimore Museum, is deeply appreciated, as were their diligent efforts in securing several major loans for the exhibition.

In the course of the project, numerous individuals generously responded to specific research inquiries, and for their valuable assistance I would like to express thanks to Kay Childs, Therese Dolan, Bruce Gimelson, Richard Love, Andrea Maltese, Nancy Mowll Mathews, Joachim Pissarro, Stephen Sensbach, and Barbara Stern Shapiro. The late Charles W. Mann, Jr. was an ongoing source of knowledge and enlightenment.

My sincere thanks go in particular to Joseph J. Rishel, Philadelphia Museum of Art, and to George T. M. Shackelford, Museum of Fine Arts, Boston, whose willingness to support critical loans from their institutions at the outset provided vital impetus to the undertaking. I would also like to extend my appreciation to Edgar Peters Bowron, Colin B. Bailey, and Eric M. Zafran for their interest and encouragement.

For the beautiful catalogue which accompanies this exhibition, we owe a debt of gratitude to Christopher Lyon, Senior Editor, and Laura Kleger, Editorial Assistant, at Rizzoli International Publications, Inc., and to designers Patrick Seymour and Claudia Yeo of Tsang Seymour Design, whose sensitive response to the material has produced a book of exceptional elegance. The task of securing the numerous comparative images for this publication was especially rigorous, and for their efforts I am grateful to Joseph Baillio, Richard Brettell, John Collins, Annette Fern, Galerie Daniel Malingue, Galerie Hopkins-Thomas-Custot, Kate Garmeson, Léonard Gianadda, Caroline Durand-Ruel Godfroy, Takako Nagasawa, Sophie Pietri, Lionel Pissarro, Cynthia Requardt, Sabine Rewald, Jayne Warman, Juliet Wilson-Bareau, and Marcel Wormser.

Finally, three individuals are worthy of special note. I am thankful to John House, whose engaging and informative essay addresses the concept of Impressionist portraiture with his characteristic erudition.

Susan Bollendorf, department Research Assistant, brought her keen mind, knowledge, and creativity to every phase of this undertaking. Her contributions are deeply appreciated. Lastly, I thank my husband and colleague William Johnston, who offered valuable suggestions, continual support, and relentless good humor throughout.

*Sona Johnston*
Curator of Painting and Sculpture
Before 1900
The Baltimore Museum of Art

# Lenders to the Exhibition

Albright-Knox Art Gallery, Buffalo, New York

The Art Institute of Chicago

The Baltimore Museum of Art

Brooklyn Museum of Art

Mrs. Noah L. Butkin

The Chrysler Museum of Art, Norfolk, Virginia

Sterling and Francine Clark Art Institute, Williamstown, Massachusetts

The Cleveland Museum of Art

Columbus Museum of Art, Ohio

Dallas Museum of Art

The Dayton Art Institute

The J. Paul Getty Museum, Los Angeles

Joslyn Art Museum, Omaha, Nebraska

Kimbell Art Museum, Fort Worth, Texas

Los Angeles County Museum of Art

The Metropolitan Museum of Art, New York

Milwaukee Art Museum

Museum of Fine Arts, Boston

The Museum of Fine Arts, Houston

Museum of Fine Arts, St. Petersburg, Florida

Museum of Fine Arts, Springfield, Massachusetts

National Gallery of Art, Washington, D.C.

National Portrait Gallery, Smithsonian Institution, Washington, D.C.

The Nelson-Atkins Museum of Art, Kansas City, Missouri

The Newark Museum

The Peabody Art Collection, Courtesy of the Maryland Commission on Artistic Property of the Maryland State Archives

The Henry and Rose Pearlman Foundation, Inc.

Philadelphia Museum of Art

The Phillips Collection, Washington, D.C.

The Saint Louis Art Museum

Seattle Art Museum

Smith College Museum of Art, Northampton, Massachusetts

Dr. Herchel Smith, Courtesy of the Williams College Museum of Art

The Toledo Museum of Art

Wadsworth Atheneum, Hartford, Connecticut

The Walters Art Gallery, Baltimore

Worcester Art Museum, Massachusetts

Yale University Art Gallery, New Haven, Connecticut

Mr. and Mrs. Joseph Zicherman, New York

Jane Voorhees Zimmerli Art Museum, Rutgers, The State University of New Jersey, New Brunswick

# Impressionism and the Modern Portrait

*John House*

At first sight, "Impressionist portraiture" may seem an unlikely combination of terms. Portraiture is essentially an art that defines and preserves personal identity, often with the purpose of propagating or commemorating the status and position of the sitter. Impressionism, by contrast, focuses on the transitory—visual effects caught in passing that elude precise identification.

The Impressionists' central concerns were gesture and movement, and the settings and attributes of their figures. Thus they defined the individuality of their subjects primarily in contingent, relative terms, and with respect to external circumstances. Relying on transitory phenomena to define sitters' personalities allowed them to create a distinctly modern sense of the individual.

The Impressionists' portraits virtually ignore what was seen in the nineteenth century as the primary purpose of portraiture: the teaching of history. The 1878 Exposition Universelle in Paris was accompanied by a major exhibition of French historical portraits; reviewing it, the critic and historian Paul Mantz lamented that France, unlike England, did not yet have a national portrait gallery. Such a gallery would include portraits of the most celebrated and influential figures in the nation's history, and would thus play a central role in enlightening schoolchildren and the uneducated about the great figures who were "the incarnation of the fatherland."[1] By contrast, most of the Impressionists' sitters were people of no special distinction—often friends or relatives of the artists themselves.

Yet the painters of the Impressionist generation made a major contribution to the art of portraiture. Presenting people of many different types and capturing them in the most diverse—and often unexpected—ways, they made a sustained attempt to express in pictorial terms the most characteristic aspects of the individual's experience in the modern world.

This essay begins by asking why portraits were made within the Impressionist circle and how they were exhibited. The core of the essay explores the types of "identities" that these portraits created for their subjects, focusing on the contrast between "public" and "private" ones, with particular consideration of the appropriate ways of treating male and female sitters. Central to this discussion are the means by which these identities were created, ranging from a focus on physiognomy and facial expression to rendering apparently casual gestures and seemingly incidental details of a sitter's environment. It concludes by examining the border between portraiture and genre painting, and attempting to define the Impressionists' contribution to portraiture in relation to differing notions of modernity.

## MAKING AND MARKETING PORTRAITS

The great diversity of scale, subject, and treatment in the paintings under consideration here immediately raises the question of definition. When viewed as images of individuals, all of them belong within a broad, inclusive definition of portraiture. Yet the pictures range from formal commissioned portraits, through various types of more private images of family and friends, to very informal studies. To make sense of the paintings, it is important to begin by defining the contexts in which they were made and the varied purposes they served.

The normal path to success for a portraitist in nineteenth-century Paris was twofold: through establishing a network of contacts and patrons, and through presenting portraits at public exhibitions, in the hope that they might attract clients. In a portrait thus shown, the style and the identity of the sitter both were significant. The treatment of the portrait could act as a marker, attracting the attention of patrons with compatible artistic tastes. The fact that an aristocratic patron, or a figure well known for other reasons, had commissioned a portrait from the artist carried much weight in a society whose values were dominated by self-advancement and questions of social and cultural identity.

On occasion, painters exhibited uncommissioned portraits, often of family members or friends; pictures such as these were a type of advertisement. A key example is the canvas that Charles [-Emile-Auguste] Carolus-Duran, a friend of both Édouard Manet and Claude Monet, exhibited at the 1869 Salon, a portrait of his wife now known as *La Dame au gant* (*The Woman with a Glove*) (fig. 1). This image of a quintessentially contemporary woman of fashion, apparently discarding her glove as she

*Opposite:* Detail, Cat. no. 29.

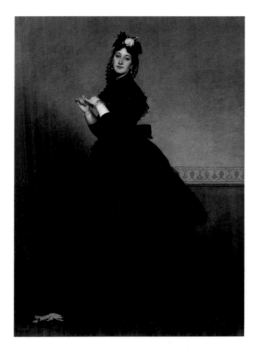

*Fig. 1. Charles [-Emile-Auguste] Carolus-Duran (1837–1917). La Dame au gant (The Woman with a Glove). 1869. Musée d'Orsay, Paris (RF 152)*

returns home, attracted the attention of the celebrated novelist Ernest Feydeau, who proceeded to commission a portrait of his own wife from Carolus-Duran. The subject of that canvas (*Portrait of Madame Ernest Feydeau*, 1870, Musée des Beaux-Arts de Lille), exhibited at the 1870 Salon, was viewed by critics as the epitome of the modern *parisienne*.

Of all the Impressionists, it was Pierre-Auguste Renoir, particularly in the late 1870s and early 1880s, who followed most closely the standard career path of the portrait painter.[2] His 1864 *Romaine Lacaux* (cat. no. 53) was a commission, treated within the conventions of formal portraiture of the period. At the 1865 Salon he exhibited a portrait of the father of his friend Alfred Sisley (Musée d'Orsay, Paris), also apparently commissioned.[3] Though the sitter would have been unknown to Salon viewers, this image of a genial elderly man was presumably exhibited to encourage further patronage.

Commissioned portraits also figured at the independent exhibitions organized by the Impressionist group. Renoir's two earliest portraits of members of the Charpentier family were shown in the Third Impressionist Exhibition in 1877,

with the indication that they belonged to the publisher Georges Charpentier. At the same show Paul Cézanne exhibited a commissioned portrait of Victor Chocquet, not the rather formal *Victor Chocquet in an Armchair* (1877; cat. no. 14) in this volume, but a portrait head.

The display of Renoir's celebrated *Portrait of Madame Georges Charpentier and Her Children* (fig. 2) at the Salon in 1879 established the credentials of both the painter and his sitter. Madame Marguerite Charpentier, hostess of a fashionable literary salon, was promoted as a supporter of "advanced" painting, while Renoir was revealed as the favored portraitist of the Charpentier circle. The portrait of the composer and musician Albert Cahen d'Anvers (cat. no. 58), painted in 1881, is a fine example of the commissions that Renoir received through his contacts with this circle.[4]

Also at the 1879 Salon, Renoir showed a work probably conceived as an advertisement, a full-length picture of Jeanne Samary, an actress at the Comédie-Française (State Hermitage Museum, Saint Petersburg). Since there is no evidence that this canvas was ever in Samary's possession, it seems likely that Renoir painted and exhibited it in order to extend his range of potential clients into theatrical circles, though it seems to have gained little attention.[5]

Renoir exhibited a number of his other commissioned portraits in these years, among them his *Studies of the Berard Children* (1881; cat. no. 57) and *Marie-Thérèse Durand-Ruel Sewing* (1882; cat. no. 59), both included in the one-artist show that the dealer Paul Durand-Ruel organized of Renoir's work in 1883. The format of the Berard picture, in particular, is quite informal, very far from the standard conventions of portraiture.

The Impressionists' portraits of their relatives and intimate friends were equally varied in treatment. Edgar Degas's *James-Jacques-Joseph Tissot* (c. 1866–68; cat. no. 25), depicting a fellow artist who was also a close friend, is as elaborately composed as any commissioned work, but many Impressionist portraits of those close to them were simply studies of heads or sketches of figures in everyday surroundings, made primarily because

the subjects happened to be available to pose at a particular moment. Although many of Cézanne's portraits of his wife are ambitiously conceived pictures, a canvas such as *Portrait of Madame Cézanne with Loosened Hair* (1890–92; cat. no. 17) should perhaps be viewed as one such informal study.

This very intimacy is central to the Impressionists' contribution to the art of portraiture. Focusing on sitters who were close to them, persons with whom they enjoyed an everyday familiarity, allowed them to develop a repertoire of forms and poses that evoke the immediacy of daily life, rather than the artificial conventions of "high art" portraiture. We shall now explore these forms, and analyze the types of identity that they construct for their sitters.

## CREATING IDENTITIES

Earlier portrait traditions often relied on a language that emphasized the status of sitters. By contrast, portraitists in the nineteenth century increasingly sought ways of expressing the inner essence, the character and personality, of their subjects. But how might that essence best be expressed? Some artists emphasized physiognomy—the physical makeup of the head and face—as the key to the personality within. Others focused on more transitory aspects of appearance such as facial expression and body language. Character might be expressed as well through a sitter's environment, the settings and attributes that suggest the activities, the habits and rhythms, of everyday life.

Academic art theory was rooted in the study of physiognomy and expression, and academic training insisted that nobility of character must be reflected by noble body forms. Renoir remembered the advice of Emile Signol, who had taught him at the École des Beaux-Arts: "Don't you realize that the big toe of Germanicus should be more majestic than the toe of your local coal-merchant?"[6] Signol's pronouncement was, of course, a straightforward expression of idealist theory, since no empirical evidence could be cited for the appearance of the toes of Germanicus, great-nephew of the Roman emperor Augustus. However, during the eighteenth century a growing body of theory argued that there was,

indeed, a correlation between physical appearance and moral character. This theory was elaborately codified in Johann Kaspar Lavater's *Essays on Physiognomy*, first published in German in 1775–78, and widely translated and reprinted in the late eighteenth and nineteenth centuries. For many in the nineteenth century, physiognomy came to offer the certainty of a science: the structure of the face and skull provided an adequate key to an individual's personality.[7]

However, Lavater's book also drew on another tradition, the study of facial expression, which arose from the belief that the imprint of lived experience, too, provided vital evidence about character. This strand of academic theory had been codified in the seventeenth century by the painter Charles Le Brun, who studied the facial movements that express each emotion.[8] In the academic training of painters in France, this led to a formulaic implementation of abstract rules rather than close study of actual facial expressions. From 1760 on, one of the standard competitions at the École des Beaux-Arts was the *tête d'expression*, for which the student was asked to paint a head displaying a specified emotion—terror or disdain, for instance.[9] This competition continued through the nineteenth century, though manuals like Lavater's encouraged an increasing number of artists to base their studies of expression on direct observation rather than academic formulae.

Both of these traditions continued to inform the practice of young artists and critics during the 1860s, but by that time it was widely recognized that these approaches needed to be developed and rethought if artists were to give a sense of the distinctive characteristics of modern experience. This need was clearly spelled out in a passage in the notebooks of Degas, probably written between 1868 and 1872: "Make the academic *tête d'expression* into a study of modern feeling; it's Lavater, but Lavater made more relative, in a sense—sometimes with signs of accessories."[10] Elsewhere in the same notebook, Degas emphasized that the expression of the face and of the body in a figure painting should be carefully coordinated, and that figures should be depicted in "familiar and typical poses."[11]

*Fig. 2. Pierre-Auguste Renoir (1841–1919).* Portrait of Madame Georges Charpentier (Marguerite Lemonnier) and Her Children, Georgette and Paul. *1878. The Metropolitan Museum of Art: Wolfe Fund, 1907. Catharine Lorillard Wolfe Collection (07.122)*

Art critics in Degas's circle debated how physiognomy and expression might be extended in various directions. In 1866 Edmond and Jules de Goncourt insisted that the portraitist should pay close attention to the model's hands, since it was there that "the individuality of each person's organism appears most clearly."[12] In the following year, Degas's friend Louis-Edmond Duranty pursued these arguments further in his essay "On Physiognomy." Insisting that a person's profession and circumstances have an important effect on their physiognomy, Duranty seems at times to be endorsing physiognomy's claims to be a science and the key to human feelings. However, he is skeptical of the view that hands are a marker of character, and throughout the essay he reveals misgivings about the whole subject. He admits the possibility of aberrant individuals whose appearances defy classification, and he speaks of the impotence of the police in the face of such individuals, since the police operate by stereotypes. He ends his essay by impatiently declaring that the perceptive viewer can understand more than any system can teach: "The best advice to give to those who want to recognize a man or men, is to show much spirit and shrewdness in unraveling their complexities, since words are lying, action is hypocritical and physiognomy is deceitful."[13]

Duranty produced a more extended proposal for a modern form of portraiture in his 1876 essay "The New Painting," apparently formulated in collaboration with Degas. In his search to express "the special note of the modern individual," Duranty insists that all parts of the body may express "the temperament, age, and social status" of the sitter, and he expands on the suggestion Degas had made in his notebook that "accessories" might play a significant part in characterizing subjects. For Duranty, people could not be separated from their surroundings; the details of a sitter's milieu provide vital evidence of his or her work or leisure activities: "The language of an empty apartment should be so clear-cut that one can deduce from it the character and habits of the person who lives in it."[14]

Duranty moves on from this discussion

to raise another issue that became central in the development of modern portraiture: the position of the viewer. He emphasizes the unexpected viewpoints, such as from above or below, from which modern life may be observed, and the ways in which figures may appear in fragmented form, as if cut off by the objects that surround them. Duranty's focus here is on characteristic scenes of modern urban life, rather than pictures of individuals, but his discussion highlights the importance of the viewpoint of the artist (and implicitly that of the viewer of the painting) in creating a distinctively modern image.[15]

The notion of individuality is central to the art of portraiture and at first sight may seem like a prerequisite for a portrait. However, portraiture before the nineteenth century had been preoccupied with the sitter's status, defined either by birth or achievement. The standard means of expressing this was by linking a portrait to some type or model, an exemplar by reference to which the portrait would gain its meanings. The particulars of an individual's appearance might certainly play a part, but only within the broader framework of that individual's position in society.[16]

The challenge in the nineteenth century was to find a means of conveying the novel types of individuality represented by successful members of the entrepreneurial middle classes, who were emerging—at least from the outset of Louis-Philippe's "bourgeois monarchy" in 1830—as the dominant force in French political, commercial, and cultural life. The critic Jules Castagnary, writing in 1857, discussed the possibilities of portraiture in terms of a sliding scale of degrees of individuality. At the bottom of this scale are the peasants in the countryside, whom he considers part of the land in which they live and work. Portraiture, in Castagnary's view, is inappropriate for children, since their identities are still unformed, and women also are excluded from full individuality because their appearance is the result of vanity and cosmetics, rather than the expression of an inner self. The only true individual is the successful bourgeois male.[17]

Yet even when painting male sitters, artists faced the problem of individuality, since they needed both to highlight the sitter's uniqueness and to mark out his position in society. Somehow the individual needed to be seen as representing a type, without his individuality being compromised. In the nineteenth century, the paradigmatic image of the modern bourgeois man was Jean-Auguste-Dominique Ingres's *Portrait of Monsieur Louis-François Bertin* of 1832 (fig. 3), an image of the founder of the newspaper *Le Journal des débats*. Seated frontally against a neutral background, and gazing directly at the spectator, Bertin projects an unchanging, stable identity—as securely grounded as his root-like hands, planted on his knees. For the critic and theoretician Charles Blanc in the 1860s, this image of Bertin revealed him as the personification of his class. It expresses the sitter's individuality, Blanc opines, but "its truth is a typical truth";[18] that is, the individual epitomizes the type, and thus, in a sense, for all the vividness of the portrayal, the picture comes to stand for a generic idea as much as for a unique human subject.

Blanc contrasts this icon of stability with what he sees as dangerous tendencies "to exaggerate the exception and the accident, in order to express certain strange types, temperaments that have been engendered by the mixing of races, by the current of new ideas, and by the decisions of history."[19] In a sense, the project for modern portraiture was to find a way to express these new "temperaments," so characteristic of the age. Yet the same basic problem remained: to find ways by which these exceptional personalities might be "real," without compromising the sense of their individuality and uniqueness.

The Impressionists' portraits were a response to this challenge. Ingres's *Bertin* was essentially treated physiognomically, his physical appearance being presented as the passport to his essence. By contrast, as we have said, the Impressionists relied on transitory phenomena to define sitters' personalities, and this allowed them to create a distinctly modern sense of the individual. However, they also at times engaged the traditions of portraiture, creating identities for sitters through references (albeit sometimes ironic) to the rhetorical conventions of court and civic portraits of the past.

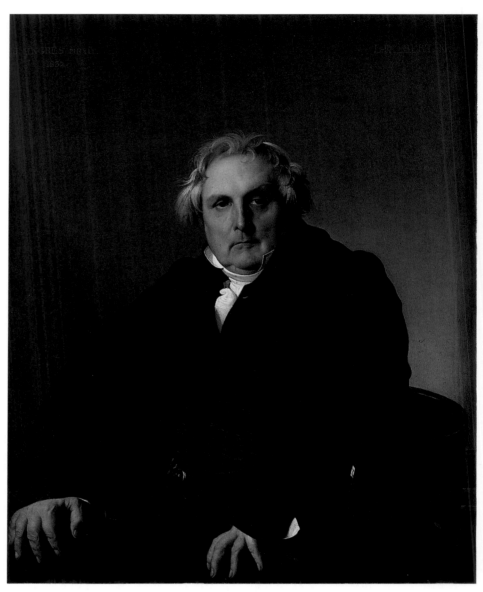

*Fig. 3. Jean-Auguste-Dominique Ingres (1780–1867). Portrait of Monsieur Louis-François Bertin. 1832. Musée du Louvre, Paris (RF 1071)*

The identities that Impressionist painters created for their sitters can be divided broadly into two categories, public and private. Much of the debate about the changing structures of society in the middle and late nineteenth century focused on the relationship between the public and the private spheres,[20] and paintings played a significant part in articulating this debate.

One crucial issue in the distinction between public and private was gender: for the most part, male figures were depicted in public contexts or in settings that evoked the idea of activity in the public sphere, while women were gener-

ally presented in private, domestic spaces. However, as we shall see, this distinction was by no means rigidly observed, and those paintings that transgress the accepted boundaries of gender shed light on shifting social patterns and identities.

Two types of male public identity emerge in Impressionist portraiture: the celebrated individual and the man-about-town, the *flâneur*. Manet's *Portrait of Clemenceau at the Tribune* (1879–80; cat. no. 40) is a rare example of the former, showing the radical republican politician about to speak at the tribunal—a known public figure poised to enact his public role. Far more characteristic are pictures

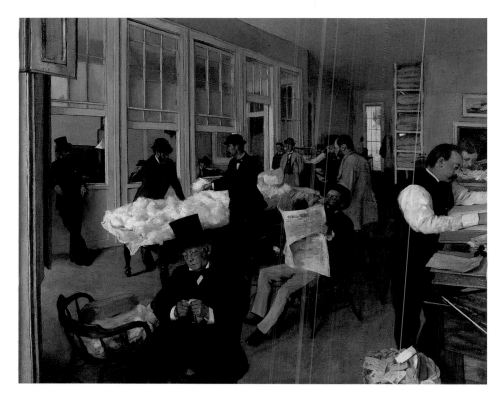

Fig. 4. *Hilaire-Germain-Edgar Degas (1834–1917)*. Portraits in an Office (New Orleans) [The Cotton Bureau]. *1873. Musée des Beaux-Arts de Pau*

such as Henri Fantin-Latour's *Édouard Manet* (1867; cat. no. 30) and *Portrait of Léon Maître* (1886; cat. no. 31). As with Ingres's *Bertin*, both Manet and Maître are portrayed against neutral backgrounds; but both are shown standing and carrying their canes, as if caught in passing as they participate in the shared public rituals of their class and social group. Body language and gesture count for as much as, or more than, physiognomy, as is testified by the caricatures of both pictures published when they were exhibited at the Salon.[21]

The proper space for the *flâneur* was the city street. In Charles Baudelaire's formulation, the *flâneur* was the archetypal male stroller, able to observe his surroundings with a passionate engagement; he retained his identity amid the crowd, while preserving his anonymity.[22] These ideas found visual form in Degas's *Portrait of Viscount Lepic and His Daughters (La Place de la Concorde)* of 1875 (State Hermitage Museum, Saint Petersburg): Degas's friend Lepic paces the sidewalk, apparently oblivious to the attention of the figure on the left and the viewer of the painting, implicitly

placed close to him and his children. Here no gazes meet and no focuses of attention coincide. Gustave Caillebotte's *Périssoires sur l'Yerres* (1877; cat. no. 3) offers an alternative setting for the *flâneur*, a river transformed into a boulevard by the exploratory gaze of the male oarsman.[23]

A further public sphere for portraiture, explored especially by Degas, was the workplace. In a sequence of pictures, explicitly titled "portraits" when they were first exhibited, he presented work environments as sites in which male identities are defined. In *Portraits in an Office (New Orleans)* of 1873, now generally known as *The Cotton Bureau* (fig. 4), the staff of his uncle's cotton market office go about their business, apparently unaware of each other, yet each is an integral part of the office's working processes. In *Portraits at the Stock Exchange* of 1878–79 (Musée d'Orsay, Paris), a group of wealthy brokers crowd together, though we do not know what they are studying with such focused attention.

In *The Cotton Bureau*, the setting is itemized in great detail; in *Portraits at the Stock Exchange*, it is more generalized,

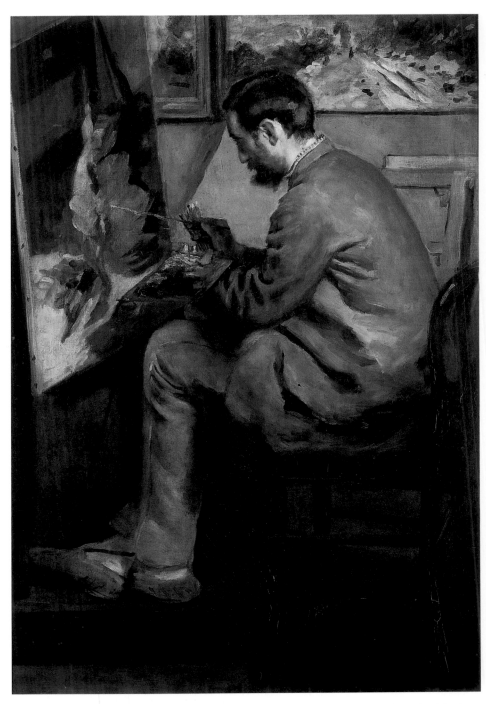

*Fig. 5. Pierre-Auguste Renoir (1841–1919). Portrait of Bazille at His Easel. 1867. Musée d'Orsay, Paris (RF 2448)*

but the picture's title leaves no room for uncertainty. This specificity contrasts with the more generic settings of many portraits in this period, which serve in a sense to personify the sitter. In Gustave Courbet's *Portrait of Clément Laurier* (1855; cat. no. 18), for instance, the sketchy landscape background behind the standing figure of the young republican attorney does not indicate a particular

place, but it may hint at the landscapes of the Berry region where Laurier had a home that Courbet visited.[24]

Self-portraits and portraits of artists in their studios complicate the distinction between public and private. Although a private space, the studio was the site of the painter's professional activity, a part of his public, professional identity, just as the cotton bureau was a part of Degas's

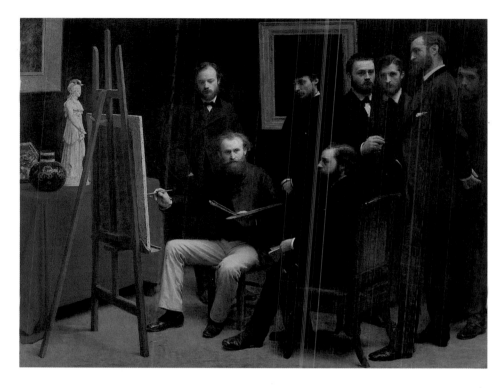

*Fig. 6. Ignace-Henri-Jean-Théodore Fantin-Latour (1836–1904).* Un Atelier aux Batignolles. *1870. Musée d'Orsay, Paris (RF 729)*

uncle's identity. The studio environment was treated in very different ways. In Degas's *James Tissot* (cat. no. 25), the painter is presented artfully, cane in hand, as if he has just returned from a stroll along the boulevard, while Renoir's *Portrait of Bazille at His Easel* of 1867 (fig. 5) shows Frédéric Bazille intent on his work in a quiet corner. Tissot is surrounded by paintings that are as much on display as he is (though, apart from the centrally placed portrait by Lucas Cranach, all of these pictures seem to be Degas's inventions, not actual works by Tissot[25]), while behind Bazille is a landscape sketch by Monet. Thus, whereas Tissot's space opens out to public gaze, Bazille's bears witness to the intimacy of the shared artistic enterprise of a group of young artist friends. A similar comparison can be made between two group portraits painted in 1870: Fantin-Latour's *Un Atelier aux Batignolles* (fig. 6), exhibited at the 1870 Salon, presents an elaborately composed ensemble of Manet, seated at his easel, surrounded by his supporters and followers. In Bazille's unexhibited *L'Atelier, Rue de la Condamine* (fig. 7), Bazille, Manet, and their friends are casually dispersed around

the studio in a spirit of camaraderie.

The privacy of the artist's workplace is underscored in Renoir's *Monet Working in His Garden at Argenteuil* (1873; cat. no. 55), where Monet is shown painting in an archetypal private space, the *hortus conclusus*, devoted to domesticity. This garden also appears in Manet's *The Monet Family in their Garden at Argenteuil* (1874; cat. no. 36). A more puzzling setting distinguishes Degas's unfinished *Portrait of a Man* (c. 1866; cat. no. 24). The figure is pictured in an interior, not surrounded by the attributes of artistic practice but seated between a pig's trotter and an uncooked leg of lamb. The only plausible interpretation of this canvas is that it represents the painter Robert Grahame, known for still lifes of meat.[26]

Self-portraiture also offered the painter many different ways of staging his personality. The Impressionist generation had the celebrated example of Courbet, who, especially in his earlier work, had represented himself in many guises. In a letter to his patron Alfred Bruyas in 1854, Courbet explained how his sequence of self-portraits, in their changing moods, formed a kind of autobiography, characterizing his

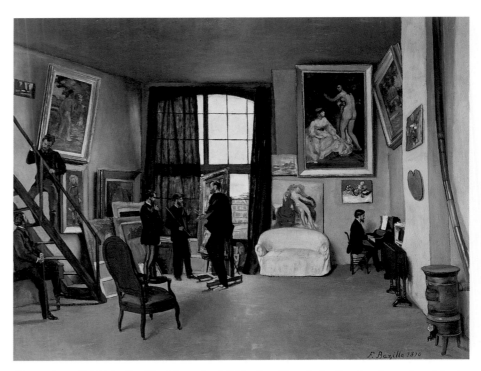

*Fig. 7. Jean-Frédéric Bazille (1841–1870). L'Atelier, Rue de la Condamine. 1870. Musée d'Orsay, Paris (RF 2449)*

developing relationship to society. This series would, he planned, culminate with the image of himself, "confident in his principles, a free man."[27] His vast canvas *The Studio of the Painter: A Real Allegory Summing Up Seven Years of My Artistic Life* (1854–55; Musée d'Orsay, Paris) was presumably the realization of this project.

Courbet reminds us that we should not view self-portraiture in terms of self-revelation; rather, as with portraits of anyone, the artist can stage his or her own identity in many ways. Bazille's *Self-Portrait* (c. 1865; cat. no. 1) presents the artist as a smart, fashionably dressed figure, despite the paint-laden palette he holds, whereas Cézanne's many self-portraits (for example, cat. no. 15) generally show the artist in humble work clothes. Cézanne's self-portraits show a great variety in mood and expression, but they cannot be interpreted as transparent reflections of the painter's mood at the time that he made them; rather, they suggest a studied exploration of a set of creative identities—in a sense a highly personalized sequence of *têtes d'expression*, defining the development of his artistic vision. If Courbet's self-portraits staged his life in terms of a sequence of assumed personae, Cézanne's mirror the ways in which

he visualized the progress of his own *sensations*, the sensory experiences of the world around him that became the starting point of his art.

Like the painter, the writer works in private to produce a public expression. Manet's *Portrait of Émile Zola* (fig. 8), exhibited at the 1868 Salon, focuses on the writer's surroundings and attributes,[28] at the expense, some felt, of the human essence of the sitter. Reviewing the Salon, the critic Théophile Thoré wrote of Manet's art:

*When he has placed on the canvas "the touch of colour" which a figure or an object makes on its natural surroundings, he gives up. Do not ask him for anything more, for the moment. But he will sort this out later, when he decides to give their relative value to the essential parts of human beings. His present vice is a sort of pantheism that places no higher value on a head than on a slipper . . . which paints everything almost uniformly—furniture, carpets, books, costumes, flesh, facial features.*[29]

Viewed in these terms, the Zola portrait is a prime example of characterization evoked through context.

However, a portrait that Manet painted at around the same date of another

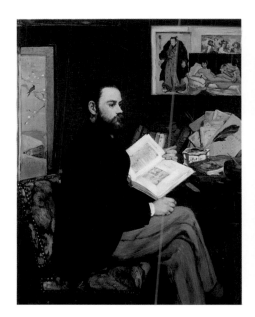

Fig. 8. Édouard Manet (1832–1883). Portrait of Émile Zola. 1868. Musée d'Orsay, Paris (RF 2205)

Fig. 9. Édouard Manet (1832–1883). Portrait of Théodore Duret. 1868. Musée du Petit-Palais, Paris

critic, his friend Théodore Duret (1868; fig. 9), expresses its meanings in very different ways. Here the primary meaning seems to be carried by the pose, a tribute, it has been persuasively argued, to Francisco Goya's *Portrait of Manuel Lapeña, Marquis of Bondad Real* of 1799 (Hispanic Society of America, New York), which Manet and Duret had probably seen together in Madrid in 1865.[30] However, the attributes, in the still life at bottom right of the picture, seem thematically unrelated to the primary image. Duret himself described the completion of the picture. When the figure appeared to be finished, Manet asked him to pose again and added, successively, the stool, the book beneath it, the tray and utensils on top of it, and finally the sharp yellow note of the lemon. Duret assumed that these additions were made simply to offset the dominant brown-gray tonality of the picture,[31] but Manet may have had more compelling reasons for the introduction of such apparently incongruous elements. A number of sources speak of his opposition to the narrative signs that enabled viewers to interpret standard genre paintings of the period. The illegibility of the details may thus be a deliberate provocation; comparably illegible elements appear in one of his major genre paintings from the same year, *Luncheon (Le*

*Déjeuner)*, shown at the 1869 Salon (Bayerische Staatsgemäldesammlungen, Munich).[32] The contrast between Manet's portraits of Zola and Duret reveals the freshness of conception that he brought to every project; as Manet insisted a few years later, "Each work should be a new creation of the mind."[33]

Despite its courtly rhetoric, the scale of the tiny Duret picture is quite unlike that of a conventional aristocratic portrait. In another canvas, the monumental but unfinished *Portrait of Carolus-Duran* of 1876 (Barber Institute of Fine Art, University of Birmingham), Manet ironically referred to the same traditions by presenting his friend—by now a highly successful and fashionable portraitist—in a particularly extravagant aristocratic pose. However, the wittiest play on these conventions was Monet's 1872 portrait of his son Jean on his mechanical horse (private collection), whose stance and placing so vividly recall equestrian child portraits such as those by Diego Velázquez, the prancing steed being replaced by a smart bourgeois toy.[34]

Parody of Old Master conventions acquired political immediacy in Cézanne's *Portrait of Achille Emperaire* (1870; fig. 10), in which Cézanne's dwarf friend is presented enthroned and at a monumental

scale, with his name boldly inscribed across the top, as in many court portraits of the sixteenth and seventeenth centuries. It has been persuasively argued that this canvas, rejected by the Salon jury in 1870, should be seen as a satirical reference to Napoleon III, both in its format and in the emphasis on the sitter's surname.[35]

The Emperaire portrait was intended for public display, but in a sequence of portraits of his Uncle Dominique, painted in 1866, Cézanne explored the possibilities of role-playing in a different way. His uncle is shown in various costumes and guises: as an advocate or attorney (Musée d'Orsay, Paris), an artisan (fig. 11), or a Dominican friar (private collection), as well as in everyday clothing. These portraits can be seen as an echo of academic *têtes d'expression*, translated into a drastically anti-academic technique; they can also be viewed in relation to the self-portraits by Rembrandt in which he presented himself in metaphorical or biblical guises. Aside from references to the past, these portraits of Uncle Dominique reveal a young artist experimenting with the expressive possibilities of portraiture when he had the opportunity to work intensively from a willing model.

So far, we have examined male portraits in terms of public settings and the public roles ascribed to the sitters. Portraits of women might also play a public role. Most frequently and obviously, this took place through the inclusion of portraits of women in public exhibitions such as the Salon, but women were also depicted as active participants in the public sphere.

When portraits were shown at the Salon, there was a loosely observed convention that the names of male sitters should be spelled out in the catalogue but women should remain anonymous or be identified by initials alone. When Renoir's *Portrait of Madame Charpentier and Her Children* was exhibited in 1879, Madame Charpentier was identified only by her initials, although most viewers would have been aware of her identity. In the Salon catalogues for 1869 and 1870, respectively, the titles of Carolus-Duran's *La Dame au gant (The Woman with a Glove)* (fig. 1) and *Portrait of Madame Ernest Feydeau* (Musée des Beaux-Arts de Lille) both appeared simply as *Portrait of Mme ***,* although, again, many viewers would at least have recognized Madame Feydeau. Sitters whom few if any viewers would have known were also presented anonymously: Berthe Morisot's *Mme. Morisot and Her Daughter, Mme. Pontillon (The Mother and Sister of the Artist)* (fig. 12) was exhibited simply as *Portraits of Mmes ***.*

That portrait and Renoir's of Madame Charpentier show the subjects in domestic settings. On occasion, women were presented in more public situations. The most vivid example is Renoir's *Portrait of Jeanne Samary*, mentioned earlier. Not only is Samary shown dressed for a semipublic appearance, at a fashionable ball, but also, unlike Madame Charpentier, her name and profession were given in full in the Salon catalogue: *Portrait of Mlle Jeanne Samary, Sociétaire of the Comédie-Française.*

Actresses and opera singers might also be portrayed in their performing roles, but these might be treated in very different ways. Manet's *Portrait of Émilie Ambre as Carmen* (c. 1879; cat. no. 39) shows the singer assuming a pose characteristic of the heroine of Bizet's opera, while Degas's unfinished *Portrait of Rose Caron* (c. 1885–90; cat. no. 28) presents the singer as if caught off-guard, making an impromptu gesture that is more awkward than graceful. Manet focused here, as in his portraits of male actors and singers, on the persona created by the performance, while Degas was fascinated by the disjunction between the performance and the lived experience of the person playing the role. Indeed, this had been the central theme of Degas's most ambitious theatrical subject, exhibited at the 1868 Salon with the teasing title *Portrait of Mlle E. F...; in Connection with the Ballet "La Source" (Portrait de Mlle E. F...; à propos du ballet de "La Source")* (Brooklyn Museum of Art). The work shows the dancer Eugénie Fiocre with other members of the cast and a horse, apparently resting during a dress rehearsal.[36]

More puzzling is Degas's *Portrait of Mary Cassatt* (c. 1884; cat. no. 27), in which Cassatt, seeming to be dressed for outdoors, holds three cards. According to one interpretation, Cassatt is being shown as a fortune-teller—a most inappropriate activity for a respectable woman.[37] It

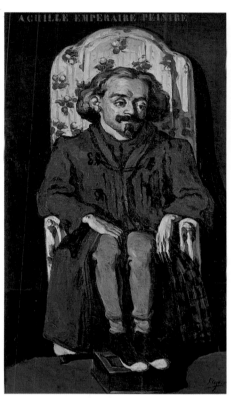

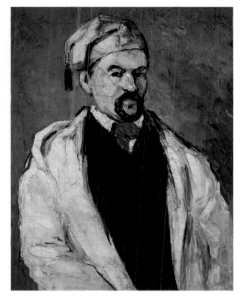

*Fig. 10. Paul Cézanne (1839–1906). Portrait of Achille Emperaire. 1870. Musée d'Orsay, Paris (1964–38)*

*Fig. 11. Paul Cézanne (1839–1906). Dominique Aubert, the Artist's Uncle. (c. 1866). The Metropolitan Museum of Art: Wolfe Fund, 1921; acquired from The Museum of Modern Art, Lillie P. Bliss Collection (53.140.1)*

seems more likely that she is holding small prints or photographs,[38] such as the photographic *cartes-de-visite* so freely exchanged in the later nineteenth century, though her oddly animated and informal pose and expression seem to suggest that this is something other than a conventional portrait. If Cassatt is being given a role here, it seems to have little to do with her professional calling as a painter.

A woman with no profession might be depicted in public or potentially public situations. In Manet's *Young Woman in a Round Hat (The Amazon)* (1879; cat. no. 38), the model, though posed indoors, is shown dressed for outdoors. Likewise, Carolus-Duran's spectacular Salon portraits presented the public face of the woman of fashion. His *Portrait of Madame Ernest Feydeau*, in particular, seemed to many critics to epitomize the modern woman, just as Ingres's *Bertin* had epitomized modern man a generation earlier. Marius Chaumelin noted that Carolus-Duran had not individualized the head enough, but he insisted that the overall appearance of the figure and her costume

were "frankly modern." For Manet's friend Théodore Duret, she was "a real type, a living woman, the woman of our time."[39] As with Bertin, the individual could be read as a type; but as a woman, perhaps, this could only take place with some sacrifice of her individuality.

Carolus-Duran's *La Dame au gant (The Woman with a Glove)* (fig. 1) has been recognized as reworking, in a more academic manner, the composition that the artist's friend Monet had exhibited at the 1866 Salon with the title *Camille* (fig. 13).[40] In *Camille*, the model seems to be moving rapidly past the viewer, her head momentarily turned as she adjusts her scarf. However, the titles of the two paintings reveal a key difference between them. Monet chose to identify his sitter by her Christian name, which places her beyond the pale of respectable portraiture; she is presented as either a model or a mistress. In later years Monet insisted: "I did not intend to make it precisely a portrait, but only a figure of a Parisian woman of that period."[41] Likewise, the canvas that Renoir exhibited as *Lise* at the 1868 Salon (Folkwang

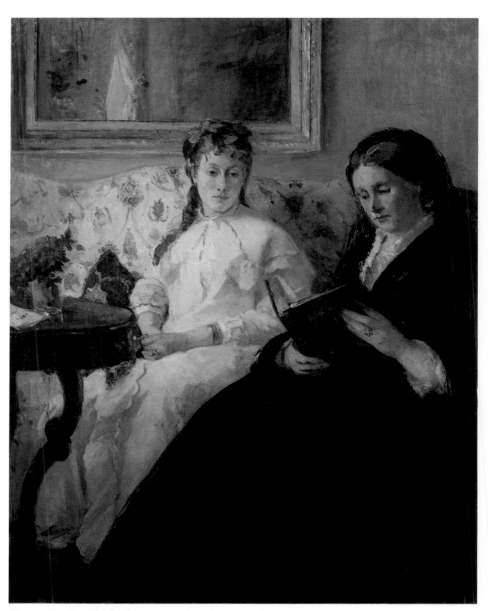

*Fig. 12. Berthe-Marie-Pauline Morisot (1841–1895).* Mme. Morisot and Her Daughter.
Mme. Pontillon [The Mother and Sister of the Artist]. *1869–70. National Gallery of Art,
Washington: Chester Dale Collection (1963.10.186)*

Museum, Essen) should be viewed as a
generic image of a modern young woman,
perhaps waiting for her lover in the woods,
rather than strictly as a portrait.[42]

As we have seen, images of women in
the domestic sphere might appear in the
very public spaces of the Salon. Madame
Charpentier must have chosen to have
Renoir portray her with her children in
her private drawing room to emphasize
her engagement with her domestic and
maternal roles, alongside her activities as
hostess of a literary and cultural salon.
Indeed, this is stressed by the informality

of the detail of her older child fidgeting as
she sits on the long-suffering family dog,
though the Japanese-style furniture and
décor and Madame Charpentier's slightly
abstracted air serve to remind us of her
position as a leader of fashion.

A more typically domestic image is
presented by pictures such as Morisot's
*Mme. Morisot and Her Daughter, Mme.
Pontillon (The Mother and Sister of the
Artist)* (fig. 12) and *Mme. Boursier and
Her Daughter* (1873; cat. no. 46), as well
as Caillebotte's *Woman Sitting on a
Red-Flowered Sofa* (1882; cat. no. 5). The

figures are shown in intimate environments, and standard domestic activities are evoked: reading, sewing, piano-playing. Likewise, women and children appear in many garden scenes (for example, cat. nos. 36 and 48), since the private garden was an integral part of the domestic sphere. Familial intimacy is suggested in a different way in Renoir's delightful *Studies of the Berard Children* (1881; cat. no. 57). The oldest boy, in school uniform, anchors the composition at bottom left, while delicate images of his younger sisters fill the rest of the canvas.

In their imagery, pictures such as these do nothing to question stock bourgeois gender roles. However, the treatment of some of them was in some ways problematic, in the way in which the figures are subordinated to their surroundings. In Caillebotte's interiors, for instance, the insistent details threaten to overwhelm the figure, recalling the "pantheism" that Thoré had criticized in Manet's *Portrait of Émile Zola*. This problem becomes more acute in garden scenes, in which the effects of light further divert attention from the sitter. In Monet's *Springtime* (c. 1872; cat. no. 43) and Morisot's *Reading (La Lecture)* (1873; cat. no. 45), for example, the figures are central but there is no special focus on them, and their coloring is modified by the play of light and shade.

In both of these cases, the sitters were family members, rather than potentially critical patrons; but when Renoir painted a number of commissioned portraits in garden settings in the early 1880s, the setting became a problem. One of these pictures was *Marie-Thérèse Durand-Ruel Sewing* (1882; cat. no. 59), part of a series of portraits of the children of his dealer, Paul Durand-Ruel. Despite his support for Renoir's art, Durand-Ruel was not very happy with these pictures, as Renoir reported to his friend Paul Berard. He jokingly added:

> I'm delighted by what is happening to me now. I'm going to return to the true path and I'm going to enter the studio of Bonnat [a leading academic portraitist; see fig. 19]. In a year or two I'll be able to earn 300000000000000 francs a year. Don't talk to me any more about portraits in sunlight. A nice dark background, that's the thing.[43]

At least Durand-Ruel accepted the commissioned paintings: in 1882 another patron, Léon Clapisson, rejected out of hand a portrait of his wife seated in a garden surrounded by roses (private collection), and Renoir was forced to execute another, far more sober, canvas of Madame Clapisson seated in an interior, wearing an evening gown and holding a fan (Art Institute of Chicago).[44]

Among the Impressionists' garden pictures, Monet's *Le Capeline rouge (The Red Cape, Camille Monet in the Snow)* (1870–75; cat. no. 44) is exceptional in two ways.[45] Monet's partner is in the garden but viewed through a window from within the house, and the season is winter. Thus the garden imagery, usually a sign of intimacy and security, instead creates a sense of unease and dislocation, as the woman's figure passes the window and she momentarily glances in. Whatever the experience that lay behind it, this was one of the few significant works from the early part of his career that Monet kept until his death, presumably because it held special significance for him.

On occasion, male figures appear within the domestic sphere, most frequently in images of married couples or family groups. Degas treated these subjects in ways that have been seen as questioning the familial harmony that such pictures habitually evoked. *Edmondo and Thérèse Morbilli* (c. 1865/67; cat. no. 23), depicting Degas's sister and brother-in-law, has been viewed as an expression of marital tension, while his monumental *The Bellelli Family* (c. 1858–67; fig. 14) has been discussed as the anatomy of a dysfunctional family.[46] However, we must ask whether these pictures should be understood simply in terms of the relationships between the individuals depicted. Both canvases can be viewed more broadly as representing the structural inequities of modern marriage in the 1850s and 1860s: the separate social spheres of husband and wife and the complex patterns of emotional, practical, and financial dependency within the family. Likewise, Degas's canvas of the two Bellelli children (1862–64; cat. no. 21) should not be viewed primarily in terms of the personal relationship between the two girls but rather in more general terms as a visualization of one of the dynamics of sisterhood.

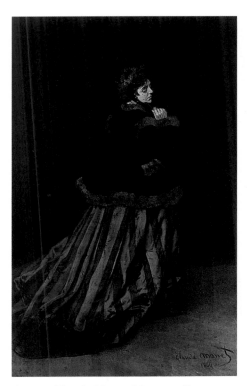

*Fig. 13. Claude Monet (1840–1926).
Camille. 1866. Kunstalle, Bremen*

In three paintings in the present exhibition, male figures are portrayed alone in domestic interiors. The subject of Cézanne's *Victor Chocquet in an Armchair* (1877; cat. no. 14) is depicted in front of paintings in his collection and thus is presented in a public guise, as an art collector. Renoir presents the composer Albert Cahen d'Anvers (1881; cat. no. 58) in a luxurious rococo domestic setting. Although this male figure has been viewed as contrasting with the lavish femininity of the décor around him,[47] the colors and textures of his hair, flesh, and clothing are carefully integrated into the overall scheme of the picture, serving in a sense to feminize and aestheticize the sitter. Caillebotte's *Portrait of a Man* (1880; cat. no. 4) is more ambiguous. Here the sitter is shown in an archetypally feminine situation: inside an apartment, half shielded from the outside world by a net curtain, and looking out toward the public space of a Paris boulevard.[48] The model for *Portrait of a Man* is unidentified, but recognizably the same man as in Caillebotte's *In a Café* (Musée des Beaux-Arts, Rouen), exhibited at the Fifth Impressionist Exhibition in 1880,

where the figure was interpreted as a typical habitué of Paris boulevard bars.[49] The two works perhaps should be seen not as portraits at all but rather as genre paintings, in which Caillebotte used the same model to personify two different aspects of urban experience.

So far, we have explored how the Impressionists' portraits presented their sitters and constructed identities for them. However, there was at the same time an increasing emphasis on the portrait as an expressive vehicle for the artist's own personality. Even an academic theoretician like Charles Blanc, after insisting on the need to capture the sitter's "soul," asserted that the greatest painters were those whose works were essentially the expression of their own imagination and genius.[50] The emergence of photography in the 1850s as the most immediate way of fixing a superficial likeness heightened the demands on "fine art" portraiture.[51] It intensified the pressure on the artist to penetrate surface appearances and reveal the sitter's essence; at the same time it was argued that the true portraitist—unlike the operator of a mechanical device such as a camera—should express something fundamental about himself in his portraiture.

Today we accept photography as an expressive medium in its own right and view photographers such as Nadar (Gaspard-Félix Tournachon) as among the most significant portraitists of the nineteenth century. However, in the nineteenth century the credentials of photography had not been established. Some argued that portrait photographers should be viewed as artists, but the dominant view among "fine art" theorists was that photography was merely mechanical, and that true art should define itself precisely through the ways it transcended mere mechanical reproduction.[52]

A statement by James Abbott McNeill Whistler about portraiture, published in 1878, sheds light on these demands:

> *Art should . . . stand alone, and appeal to the artistic sense of eye or ear, without confounding this with emotions entirely foreign to it . . . that is why I insist on calling my works "arrangements" and "harmonies."*
>
> *Take the portrait of my mother, exhibited at the Royal Academy as an*

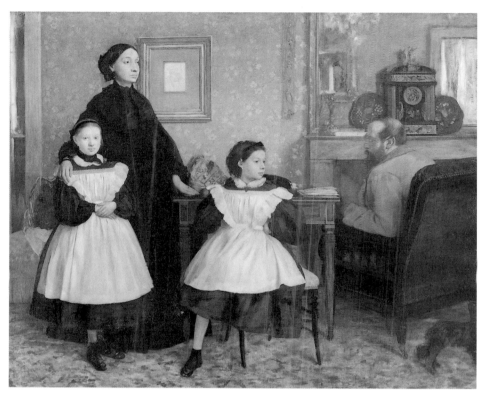

*Fig. 14. Hilaire-Germain-Edgar Degas (1834–1917). The Belleli Family. 1858–67.*
*Musée d'Orsay, Paris (RF 2210)*

*"Arrangement in Grey and Black"*
[Musée d'Orsay, Paris]. *Now that is
what it is. To me it is interesting as a
picture of my mother; but what can or
ought the public to care about the
identity of the portrait?*

*The imitator is a poor kind of crea-
ture. If the man who paints only the
tree, or the flower, or other surface he
sees before him were an artist, the king
of artists would be the photographer. It
is for the artist to do something beyond
this: in portrait painting to put on can-
vas something more than the face the
model wears for that one day; to paint
the man, in short, as well as his fea-
tures; in arrangement of colours to treat
a flower as his key, not as his model.*[53]

Photographic reproduction is certainly the
enemy here; but Whistler proposes two
very different alternatives to it. He argues
first that the identity of the sitter is of no
relevance to the public, who are invited
only to appreciate the skill and artistry of
the artist in making his "Arrangement";
but he then turns back to the far more
conventional formula, that the true artist
should go behind appearances and "paint
the man." He makes no attempt to recon-
cile the rival claims of artist and sitter.

In this context, Cézanne's later por-
traits pose particular problems of inter-
pretation. In "high modernist" art history
of this century, they are viewed primarily
as exercises in pictorial form, with little
concern for the issue of the sitter's identity.
The model for such interpretations was
the dealer Vollard's account of sitting for
Cézanne's *Portrait of Ambroise Vollard*
(Musée du Petit Palais, Paris) in 1899, in
which he compared Cézanne's approach
to portraiture to his fascination with the
immobile forms of still life.[54] Late in his
life, Vollard recorded that Cézanne told
him: "You should sit like an apple.
Whoever saw an apple fidgeting?"[55]

More recently, though, Cézanne's por-
traits, particularly those of his wife, have
come to be viewed as expressions of the
complexities of the relationship between
painter and sitter.[56] Here, as with
Cézanne's self-portraits, any interpretation
has to reconcile the values that he associ-
ated with his chosen subjects, on the
one hand, with the artist's constantly
reiterated determination to realize his

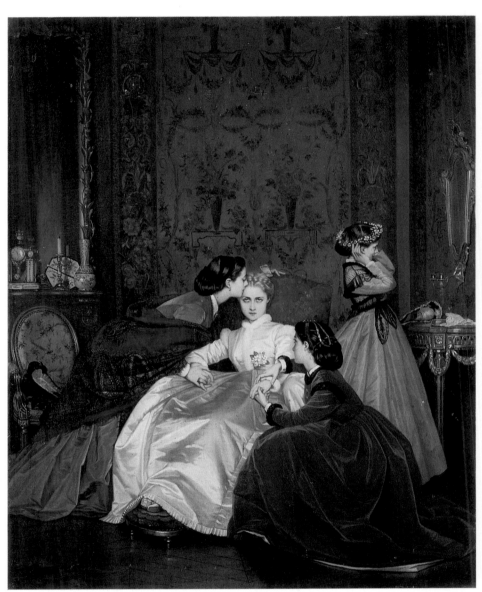

*Fig. 15. Auguste Toulmouche (1829–1890).* The Arranged Marriage (Le Mariage de raison). *1866. Private collection*

visual experiences—his *sensations*—in paint. His associations were both personal—as with the landscapes surrounding his birthplace, Aix-en-Provence, or with his wife and child—and artistic, since he systematically, throughout his career, re-explored the implications of the academic hierarchy of genres of subject matter in painting. Although in his late work he elevated still life far above its traditional lowly status, he retained a concern for the "higher" genres of figure-painting and for their historical and aesthetic associations.

Understood in these terms, his portraits may be seen both as aesthetic explorations, conceived in terms of the harmonies of colored forms on the canvas, and as

attempts to imbue these forms with human content. But again, as with Whistler, this human content has to be understood in two ways: as an attempt to penetrate the superficial appearance of his sitter and as the expression of the painter's unique sensibility. Cézanne's portraits leave both of these options tantalizingly open.[57]

## PORTRAITURE VERSUS GENRE PAINTING

In standard artistic theory of the nineteenth century, the distinction between portraiture and genre painting was unproblematic. Portraiture depicted individuals as individuals, while the figures in genre painting were typical, involved in

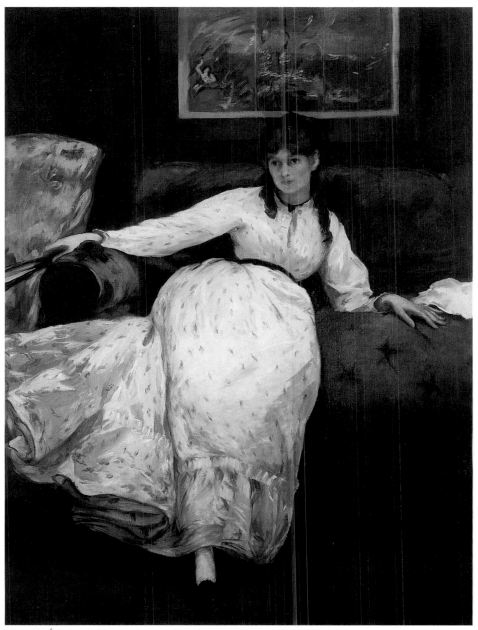

*Fig. 16. Édouard Manet (1832–1883). Repose (Le Repos), 1870. Museum of Art, Rhode Island School of Design: Bequest of the Estate of Mrs. Edith Stuyvesant Vanderbilt Gerry (59.027)*

generic activities and situations. This may be illustrated by the contrast between Morisot's *Mme. Morisot and Her Daughter, Mme. Pontillon (The Mother and Sister of the Artist)* (fig. 12) and a painting such as Auguste Toulmouche's *The Arranged Marriage (Le Mariage de raison)* (fig. 15), exhibited at the 1866 Salon. The specificity and careful characterization of faces and gestures in Morisot's canvas are quite unlike the generalization and stylization of Toulmouche's sleekly composed tableau. However, for a number of reasons such distinctions have become blurred in discussing Impressionist painting; in part, this is the result of the activities of subsequent art historians, but it also reflects the nature of the experiments that the painters themselves were making.

One focus for art-historical exploration has been the identification of the models who posed for the Impressionists' paintings. From this, we have learned much about their social and professional networks and contacts. However, there has been an accompanying tendency to

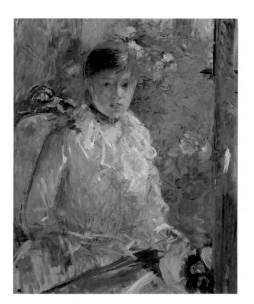

*Fig. 17. Berthe-Marie-Pauline Morisot (1841–1895). Summer (L'Été). (c. 1878). Musée Fabre, Montpellier, France: Cliché Frédéric Jaulmes (07.5.1)*

treat any picture whose models have been identified as a portrait, irrespective of the picture's original purpose and title. Manet's canvases representing Berthe Morisot are a prime case in point. While many of the smaller ones are clearly portrait studies (for example, cat. no. 35), the only two paintings including Morisot that he showed at the Salon were, through their titles, presented as genre paintings: *The Balcony* (Musée d'Orsay, Paris), shown in 1869, and *Repose (Le Repos)* (fig. 16), shown in 1873. Manet was probably referring to *Repose* when he wrote to Morisot's mother in 1871 asking for permission to exhibit the picture: "This painting is not at all in the character of a portrait, and in the catalogue I will call it a study (*étude*)."[58]

Likewise, a number of paintings in the present exhibition were originally shown as genre paintings. Morisot's *Reading (La Lecture)* (1873; cat. no. 45) was included in the first Impressionist group exhibition in 1874. Her *Woman with a Muff* (1880; cat. no. 47), through its title, would, together with its companion piece *Summer (L'Été)* (fig. 17), have been understood as a personification of the season when exhibited in 1880.[59] Cassatt's portrait of her sister Lydia Cassatt (1878–79; cat. no. 8) was exhibited in 1879 as *Woman*

*Reading.*[60] In nineteenth-century terms, a canvas such as Bazille's *Young Woman with Peonies* (1870; cat. no. 2) would unequivocally have been categorized as a genre painting. However, the evocative title *Melancholy* that a canvas by Degas now carries (late 1860s; cat. no. 26) is almost certainly not Degas's own; there are no traced examples of his use of such loaded titles, and the picture should rather be seen as one of his many studies of the characteristic informal and off-guard gestures of modern figures.[61]

The treatment of these paintings also contributes to their being viewed in terms of portraiture. For, in contrast to Toulmouche's stereotypes, the figures are treated in a distinctively particularized way and are evidently painted from actual individuals, and not reworked from stock facial types and gestures, even though few viewers of the paintings would have recognized their models. It was in response to this sense of particularity that a puzzled critic asked, when faced with Manet's *The Railway* (National Gallery of Art, Washington, D.C.) at the Salon of 1874: "Is Manet's *The Railway* a double portrait or a subject picture? . . . We lack the information to solve the problem; we are even more uncertain about the young girl, for this would be a portrait seen from the rear."[62]

It was in Manet's art that the borderlines between portraiture and genre were most systematically destabilized. For a short period around 1870, Degas treated his genre paintings in a comparable way, as in the canvas known as *Sulking* (c. 1870; Metropolitan Museum of Art, New York). However, in the early 1870s he began to make a clear distinction between his treatments of male and female figures in his multi-figure compositions. Females, such as his ballet dancers, are generally treated as types, whereas men, when they appear, are recognizable individuals enacting their professional roles, individualized as in *Portraits in an Office (New Orleans)* (fig. 4) or paintings of dance classes and theatre orchestras. In the ballet canvases, although Degas's compositions feature views from unexpected angles, and his figures are grouped in unconventional ways, the male figures are

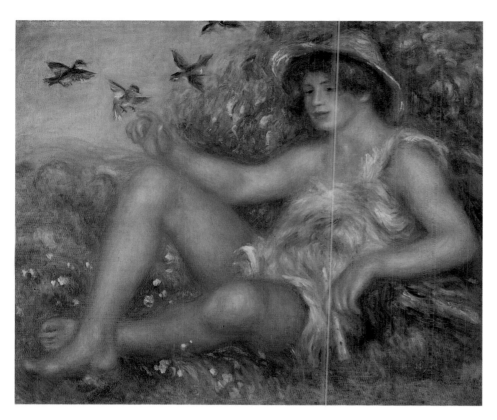

Fig. 18. Pierre-Auguste Renoir (1841–1919). The Young Shepherd in Repose. 1911. Museum of Art, Rhode Island School of Design: Museum Works of Art Reserve Fund (45.199)

never treated so that they lose their identity or surrender their authority over the anonymous female dancers.[63]

Renoir, like Manet, used recognizable models, generally from among his friends, for his more ambitious genre paintings, such as *A Ball at the Moulin de la Galette* of 1876 (Musée d'Orsay, Paris) and *The Luncheon of the Boating Party* of 1880–81 (Phillips Collection, Washington, D.C.). However, he did not emphasize the distinctive features of his models. A note on an early photograph of *The Luncheon of the Boating Party* indicates that the model for the male figure in the right foreground was Caillebotte "made to look much younger"; clearly he was prepared to modify his models' features so that they should blend into the mood of the overall tableau.[64] The conclusion to the story of Renoir's portraits of Madame Clapisson also indicates that Renoir drew a distinction between the treatments appropriate for portraiture and genre pictures. After its rejection by the Clapissons, the outdoor version, "with the model fixed so that it would not be too recognizable, was sold as a picture."[65]

With all of Renoir's genre paintings, the original viewers (apart from Renoir's friends) would not have been expected to identify the models; his use of different models for each figure in his multi-figure paintings in the 1870s and early 1880s, instead of resorting to stereotypes like Toulmouche. was a means of giving a sense of liveliness and immediacy to his vision of modern life. By contrast, in his later work. as he abandoned such explicitly contemporary subjects, he came increasingly to invent his own stereotypical figures as part of the idyllic scenarios he sought to create. A painting like the 1911 *The Young Shepherd in Repose* (fig. 18) is a spectacular but bizarre attempt to achieve a synthesis between portraiture and the generalized themes from classical mythology that so preoccupied him in his last years.

The boundaries between portraiture and genre painting may have become most blurred in the later work of Morisot and Cassatt. In the 1880s and 1890s they used a variety of models—both friends and servants—for their informal scenes of domestic life. However, it is significant that

31

these pictures portray women and children only; adult male figures never became part of the semi-anonymous private world celebrated by the two women artists among the Impressionists. On the rare occasions when a male figure appears, such as Morisot's husband Eugène Manet, the painter's brother, he is treated in a more distinctive, individualized manner.

Two rival notions of modernity were in play in France in the middle to late nineteenth century. One of them viewed the contemporary world in terms of science and progress. Science offered solutions to the physical and practical problems of the world, and man had it in his own hands to improve the human condition. The pseudoscience of physiognomy was an expression of this confidence in the power of knowledge to change the world in a positive way. It is in this context that we must view the type of portraiture that sought to penetrate the depths of human personality through unblinking observation of the sitter's physical appearance. Léon Bonnat's portraiture—mockingly acknowledged in Renoir's 1882 letter, quoted above—stands as a model of this approach, with its direct scrutiny of the model and its carefully impersonal handling, as seen in his 1883 portrait of William T. Walters, founder of the Walters Art Gallery in Baltimore (fig. 19).

Another view of modernity saw the contemporary world very differently. From this standpoint, the growth of the modern metropolis and the development of rapid transport such as the railway had led to a loss of certainties. Social and physical mobility meant that one no longer knew where one belonged; figures were glimpsed in passing and the experience of the crowd led to a further loss of identity.[66]

The figure of the detective epitomizes the first of these views. Searching for the smallest clues, able to anatomize and interpret the smallest sign, the detective used the tools of science to establish certainty amid apparent chaos. This is the model of the *flâneur* presented by the journalist and social commentator Victor Fournel in 1858: the man who, by close scrutiny, can identify everyone that he sees around him; Fournel even cites the authority of the physiognomists Franz Joseph Gall and Johann Kaspar Lavater as aids in his enterprise.[67] On this model, the viewer of the portrait is in a position of omniscience, presented with all the information that would enable the detective to reach his conclusions.

However, we have seen that Edmond Duranty, in his essay "On Physiognomy," raised doubts about the competence of the detective; and one of the earliest and most significant characterizations of modernity, Edgar Allan Poe's "The Man of the Crowd," ends by presenting as the archetypal figure of the modern city the man whose identity the observer can never unravel. Modernity, here, lies precisely in the viewer's inability to achieve any final resolution. Baudelaire's celebrated description of the *flâneur* vacillates between these two very different models.[68]

Where, in this context, should be located the Impressionists' experiments with portraiture? Certainly, in their commissioned portraits, they were trying to find ways of indicating a sitter's unique identity; as Renoir wryly put it, "it's a portrait, it's necessary for a mother to recognize her daughter."[69] However, their interest in their sitters' surroundings and their focus on the ephemeral gesture show that they were seeking ways of defining identity that did not depend on the pseudoscientific certainty of physiognomic theory. Beyond this, in some genre paintings, the painters (and perhaps especially Manet) pursued a type of illegibility far closer to Poe's "Man of the Crowd" than to the subjects studied by Fournel's confident social investigator.

In a sense, portraiture, with its demand for likeness, worked against this notion of the modern; but, especially in their more informal portraits and in images of their families and friends, the Impressionists came to define visual identity in a changeable, contingent way that can be seen as an expression of the uncertainties that commentators increasingly saw as defining characteristics of modernity.

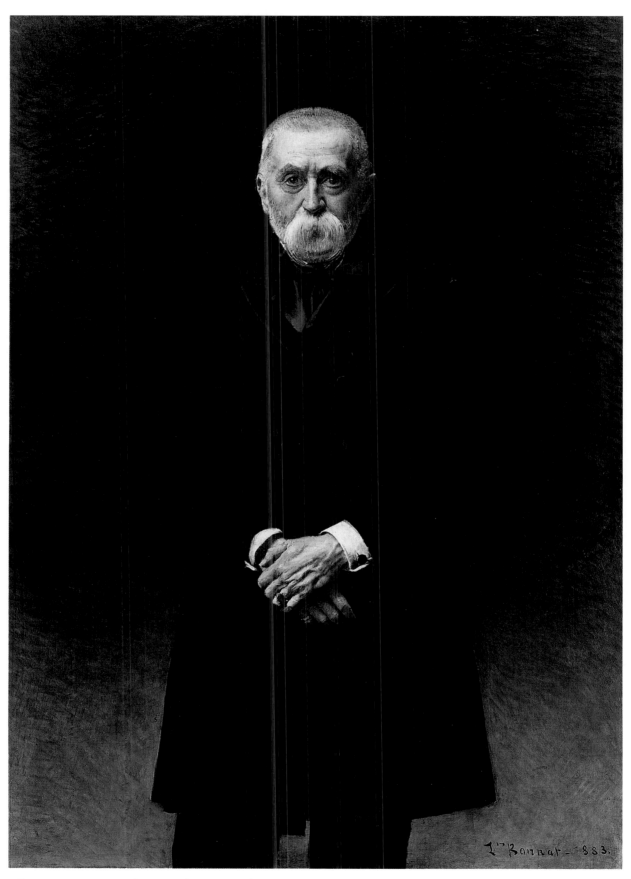

*Fig. 19. Léon Bonnat (1833–1922).* Portrait of William T. Walters. *1883. The Walters Art Gallery, Baltimore (37.758)*

# NOTES

1. Paul Mantz, "Les Portraits historiques au Trocadéro," *Gazette des Beaux-Arts*, second period, vol. 18 (1 December 1878), p. 882.

2. For a richly documented account of Renoir's portraiture, see Colin B. Bailey, with the assistance of John B. Collins, *Renoir's Portraits: Impressions of an Age*, exh. cat. (New Haven and London: Yale University Press in association with National Gallery of Canada, Ottawa, 1997).

3. Bailey, *Renoir's Portraits*, pp. 92–93.

4. See also Kathleen Adler, "Renoir's *Portrait of Albert Cahen d'Anvers*," *The J. Paul Getty Museum Journal* 23 (1995), pp. 31–40.

5. See Bailey, *Renoir's Portraits*, pp. 155–60.

6. Signol, as quoted by Renoir, in Ambroise Vollard, *La Vie et l'oeuvre de Pierre-Auguste Renoir* (1919), reprinted in Vollard, *En écoutant Cézanne, Degas, Renoir* (Paris: Bernard Grasset, 1938), p. 151.

7. For recent discussions of the impact of physiognomy on nineteenth-century art, see Elizabeth Anne McCauley, *A. A. E. Disdéri and the Carte de Visite Portrait Photograph* (New Haven and London: Yale University Press, 1985), pp. 167–72; Judith Wechsler, *A Human Comedy: Physiognomy and Caricature in 19th Century Paris* (London: Thames and Hudson, 1982); and Mary Cowling, *The Artist as Anthropologist: The Representation of Type and Character in Victorian Art* (Cambridge: Cambridge University Press, 1989).

8. See Jennifer Montagu, *The Expression of the Passions* (New Haven and London: Yale University Press, 1994).

9. See Philippe Grunchec, *Les Concours des Prix de Rome 1797–1863*, vol. 1 (Paris: École Nationale Supérieure des Beaux-Arts, 1986), pp. 26–27, 52–53.

10. Theodore Reff, *The Notebooks of Edgar Degas*, vol. 1 (Oxford: Clarendon Press, 1976), p. 117 (Notebook 23, p. 44).

11. Reff, *The Notebooks of Edgar Degas*, vol. 1, p. 118 (Notebook 23, pp. 46–47).

12. Edmond and Jules de Goncourt, *Idées et sensations* (Paris: E. Fasquelle, 1866), pp. 247–48.

13. Louis-Edmond Duranty, "Sur la physiognomie," *Revue libérale* (25 July 1867), pp. 499–523, quotation p. 523. Duranty's focus on the aberrant and illegible individual seems to be a reference to Edgar Allan Poe's celebrated story "The Man of the Crowd," which had recently been translated into French by Charles Baudelaire.

14. Louis-Edmond Duranty, "La Nouvelle Peinture" (1876), reprinted in Charles S. Moffett, ed., *The New Painting: Impressionism, 1874–1886*, exh. cat. (San Francisco: Fine Arts Museums of San Francisco, 1986), pp. 477–84 (quotations from pp. 481–82).

15. Duranty, "La Nouvelle Peinture," pp. 482–83.

16. For a searching and thought-provoking introduction to the history of portraiture, see Joanna Woodall, "Introduction: Facing the Subject," in Joanna Woodall, ed., *Portraiture: Facing the Subject* (Manchester and New York: Manchester University Press, 1997), pp. 1–25.

17. Jules Castagnary, *Salons (1857–1879)*, vol. 1 (Paris: Bibliothèque Charpentier, 1892), pp. 23, 33–42.

18. Charles Blanc, *Grammaire des arts du dessin* ([1867]; reprint, Paris: Henri Laurens, 1886), pp. 611–13.

19. Blanc, *Grammaire des art du dessin*, 1886 ed., p. 611.

20. On this, see Richard Sennett, *The Fall of Public Man* ([1977]; reprint, London: Faber and Faber, 1986), especially pp. 123–255, and T. J. Clark, *The Painting of Modern Life: Paris in the Art of Manet and His Followers* (New York: Alfred A. Knopf, 1985), pp. 23–78.

21. For Bertall's caricature of Fantin's *Manet*, see John Rewald, *The History of Impressionism*, 4th rev. ed. (New York: Museum of Modern Art, 1973), p. 138; for caricatures of Fantin's *Maître*, see Douglas Druick and Michel Hoog, *Fantin-Latour*, exh. cat. (Ottawa: National Gallery of Canada, National Museums of Canada, 1983), p. 333.

22. Charles Baudelaire, "Le Peintre de la vie moderne," *Le Figaro*, 26 and 29 November, 3 December 1863, reprinted in Baudelaire, *Écrits sur l'art*, vol. 2 (Paris: Le Livre de poche, 1971), pp. 139–49, especially pp. 144–46.

23. On the connotations of boating in this period, see John House, *Pierre-Auguste Renoir: La Promenade* (Los Angeles: J. Paul Getty Museum, 1997), pp. 35–49.

24. See also Sarah Faunce and Linda Nochlin, *Courbet Reconsidered*, exh. cat. (New York: Brooklyn Museum, 1988), pp. 131–32.

25. See also, most recently, Gary Tinterow and Henri Loyrette, *Origins of Impressionism*, exh. cat. (New York: Metropolitan Museum of Art, 1994; distributed by Harry N. Abrams), pp. 374–75.

26. See Tinterow and Loyrette, *Origins of Impressionism*, pp. 156, 168.

27. Courbet to Bruyas, 3 May 1854, in Petra ten-Doesschate Chu, ed., *Correspondance de Courbet* (Paris: Flammarion, 1996), pp. 113–14.

28. Although these attributes have been seen as belonging more to Manet himself than to Zola, the details in the picture mostly belong generically to the world of the writer (see Theodore Reff, "Manet's Portrait of Zola," *Burlington Magazine* 117, no. 862 (January 1975), pp. 35–44, and Tinterow and Loyrette, *Origins of Impressionism*, pp. 413–14).

29. Théophile Thoré, in *L'Indépendance belge*, 29 June 1868, reprinted in Thoré, *Salons de W. Bürger, 1861 à 1868*, vol. 2 (Paris: Librairie Internationale, 1870), pp. 531–32.

30. See George Mauner, *Manet: Peintre-philosophe* (University Park: Pennsylvania State University Press, 1975), pp. 103–8. However, Mauner's detailed iconographic reading of all the still-life elements in the picture in terms of Manet's friendship with Duret seems less persuasive (see also Françoise Cachin and Charles S. Moffett, in collaboration with Michel Melot, *Manet, 1832–1883*, exh. cat. [New York: Metropolitan Museum of Art, 1983; distributed by Harry N. Abrams], pp. 287–90).

31. Théodore Duret, *Histoire d'Edouard Manet* (Paris, 1926), as quoted in Cachin and Moffett, *Manet, 1832–1883*, p. 288.

32. For further discussion, see House, *Pierre-Auguste Renoir: La Promenade*, pp. 28–34.

33. Manet, as quoted in Stéphane Mallarmé, "The Impressionists and Édouard Manet," *Art Monthly Review* (September 1876), reprinted in Charles S. Moffett, *The New Painting*, p. 29.

34. See Paul Hayes Tucker, *Monet at Argenteuil* (New Haven and London: Yale University Press, 1982), pp. 131, 134–35.

35. See Nina Athanassoglou-Kallmyer, "An Artistic and Political Manifesto for Cézanne," *Art Bulletin* (September 1990), pp. 482–92.

36. On this, see Ann Dumas, *Degas's 'Mlle. Fiocre' in Context* (New York: Brooklyn Museum, 1988).

37. See, for example, Felix Baumann and Marianne Karabelnik, eds., *Degas Portraits*, exh. cat. (London: Merrell Holberton, 1994), pp. 270–71.

38. See, for example, Melissa McQuillan, *Impressionist Portraits* (London: Thames and Hudson, 1986), p. 172.

39. Marius Chaumelin, "Salon de 1870, VII," *La Presse*, 17 June 1870; Théodore Duret, "Salon de 1870"; reprinted in *Critique d'avant-garde* ([1885]; reprint, Paris: École Nationale Supérieure des Beaux-Arts, 1998), p. 40.

40. For Carolus-Duran's friendship with Monet, see the portrait by Carolus of Monet (Musée Marmottan, Paris), published without comment in Rewald, *History of Impressionism*, p. 150; on this, see John House, "Impressionism and History: The Rewald Legacy," *Art History* 9, no. 3 (September 1986), p. 370.

41. Letter from Monet to Gustav Pauli, Director of the Bremen Kunsthalle, 7 May 1906, at the date that the Kunsthalle bought the painting, in Daniel Wildenstein, *Claude Monet: Biographie et catalogue raisonné*, vol. 4 (Lausanne and Paris: Bibliothèque des Arts, 1985), p. 370.

42. *Lise* was interpreted in these terms by Renoir's friend Zacharie Astruc in his review of the Salon (Zacharie Astruc, "Salon de 1868 aux Champs-Élysées: Le Grand Style—II," *L'Étendard*, 27 June 1868).

43. Letter from Renoir to Berard, autumn 1882, Archives Durand-Ruel, Paris (extracts published Paris, Hôtel Drouot, Manuscript Sale Catalogue, 16 February 1979, lot 68).

44. See Bailey, *Renoir's Portraits*, pp. 80–81, 202–3, 316–17.

45. The dating of this canvas has been much debated; however, the breadth and boldness of the brushwork make it most likely to date from the winter that Monet and Camille spent at Étretat in 1868–69.

46. See, for example, Baumann and Karabelnik, *Degas Portraits*, pp. 182–85, 188–93; and Jean Sutherland Boggs et al., *Degas*, exh. cat. (New York: Metropolitan Museum of Art; Ottawa: National Gallery of Canada, 1988), pp. 77–83.

47. Adler, "Renoir's *Portrait of Albert Cahen d'Anvers*," pp. 37–38.

48. See also Anne Distel et al., *Gustave Caillebotte: Urban Impressionist*, exh. cat. (Paris: Réunion des Musées Nationaux; Chicago: Art Institute of Chicago; with Abbeville Press, 1995), pp. 206–7.

49. Distel, *Gustave Caillebotte*, pp. 208–9.

50. Blanc, *Grammaire des arts du dessin*, 1886 ed., pp. 614–15.

51. By far the most stimulating discussion of the relationships between "fine art" portraiture and photography is McCauley, *Disdéri*.

52. For a defense of portrait photography as an art, see Francis Wey, "Théorie du portrait," *La Lumière*, 27 April and 4 May 1851, reprinted in André Rouillé, *La Photographie en France: Textes & controverses, Une Anthologie, 1816–1871* (Paris: Macula, 1989), pp. 117–21; on this, and on Nadar, see Elizabeth Anne McCauley, *Industrial Madness: Commercial Photography in Paris, 1848–1871* (New Haven and London: Yale University Press, 1994), pp. 105–48, and especially p. 125. Charles Blanc voiced the standard view that portraiture became "art" precisely insofar as it went beyond photography (*Grammaire des arts du dessin*, 1886 ed., p. 611).

53. Whistler, "The Red Rag," *The World*, 22 May 1878, reprinted in Whistler, *The Gentle Art of Making Enemies* (London: William Heinemann, 1890), pp. 127–28.

54. Ambroise Vollard, "Paul Cézanne," 1914, reprinted in Vollard, *En écoutant Cézanne, Degas, Renoir*, 1938, pp. 61–62.

55. Cézanne, as quoted in Ambroise Vollard, *Recollections of a Picture Dealer* (London: Constable, 1936), p. 222.

56. Meyer Schapiro pioneered psychoanalytical readings of Cézanne; see especially his *Paul Cézanne* (New York: Harry N. Abrams, 1952), and his "The Apples of Cézanne," *Art News Annual* 34 (1968), reprinted in Schapiro, *Modern Art: 19th and 20th Centuries* (New York: George Braziller, 1978).

57. For recent discussion of the problems of interpretation that Cézanne's portraits of his wife pose, see the catalogue entries by Joseph J. Rishel in Françoise Cachin et al., *Cézanne*, exh. cat. (Philadelphia: Philadelphia Museum of Art; London: Tate Gallery, 1996), pp. 274–75, 293, 318–21, 346–47, and especially pp. 399–401.

58. Manet to Morisot, 1871, in Daniel Rosenfeld, ed., *European Painting and Sculpture, ca. 1770–1937 in the Museum of Art, Rhode Island School of Design* (Providence: Rhode Island School of Design, 1991), p. 117.

59. See also Charles F. Stuckey and William P. Scott, with the assistance of Suzanne G. Lindsay, *Berthe Morisot: Impressionist*, exh. cat. (South Hadley, Mass.: Mount Holyoke College Art Museum, in association with the National Gallery of Art, Washington, D.C.; New York: Hudson Hills Press, 1987), pp. 82–85.

60. For the latest and fullest evidence identifying the paintings included in the Impressionists' group exhibitions, see Ruth Berson, ed., *The New Painting: Impressionism, 1874–1886, Documentation* (San Francisco: Fine Arts Museums of San Francisco; Seattle: University of Washington Press, 1996).

61. It has been suggested that the picture may have been exhibited at the 1876 Impressionist Exhibition with the title *Portrait: Evening* (Berson, *The New Painting: Impressionism, 1874–1886, Documentation*, p. 49). Although it has repeatedly been stated that this picture was exhibited in the 1900 Exposition Universelle, it does not appear in the exhibition catalogue.

62. E. Duvergier de Hauranne, "Le Salon de 1874," *Revue des deux mondes*, 1 June 1874, p. 671.

63. See John House, "Degas' 'Tableaux de Genre,'" in Richard Kendall and Griselda Pollock, *Dealing with Degas: Representations of Women and the Politics of Vision* (London: Pandora Press, 1992), pp. 80–94.

64. The photograph is in the Archives Durand-Ruel, Paris; see John House and Anne Distel, *Renoir*, exh. cat. (London: Hayward Gallery, 1985), pp. 222–23.

65. Théodore Duret, *Renoir* (Paris: Bernheim-Jeune, 1924), pp. 70–71.

66. See Susanna Barrows, *Distorting Mirrors: Visions of the Crowd in Late Nineteenth-Century France* (New Haven and London: Yale University Press, 1981).

67. Victor Fournel, *Ce qu'on voit dans les rues de Paris* (1858), quoted in Robert L. Herbert, *Impressionism: Art, Leisure, and Parisian Society* (New Haven and London: Yale University Press, 1988), pp. 43–44. I am not convinced by Herbert's attempt to use the "detective" as the model for the Impressionists' visions of the modern city.

68. Baudelaire, "Le Peintre de la vie moderne" (see note 22); Poe's "The Man of the Crowd," first published in 1846, was known in Paris through Baudelaire's 1856 translation. For further discussion, see John House, "Curiosité," and Paul Smith, "'Le Peintre de la vie moderne' and 'La Peinture de la vie ancienne,'" both in Richard Hobbs, ed., *Impressions of French Modernity* (Manchester and New York: Manchester University Press, 1998), especially pp. 46–55, 78–85.

69. Renoir, as quoted in Jacques-Émile Blanche, "Renoir, Portraitiste," *L'Art vivant* (July 1933), p. 292.

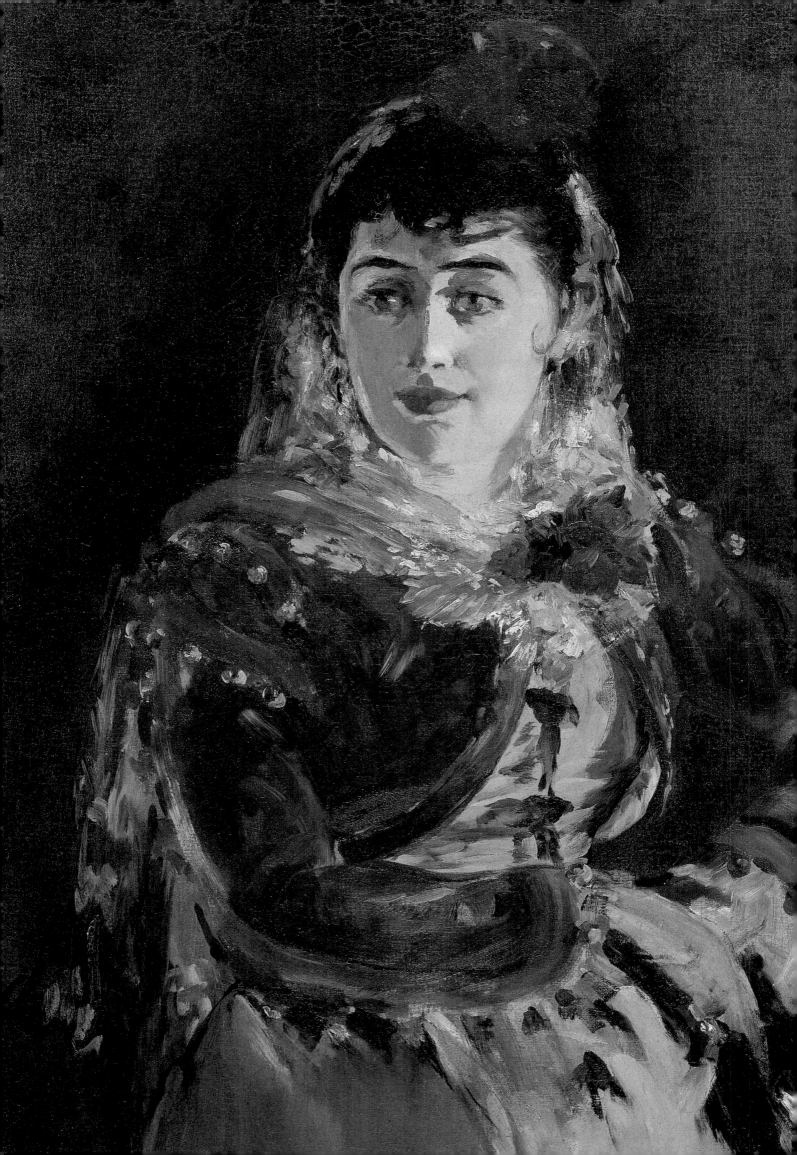

# On Portraits

*Paul Valéry*

In the variety of works which painting has to offer us, among all those which seek to attain poetry by representing combinations of visible objects, there is one particular case where painting itself finds its own range most severely restricted; and that is in the human likeness, the portrait.

Portraiture, in fact, is the branch of painting where subject is all-important. When the painter takes an individual likeness as his theme it must necessarily be his aim to make the portrait as like as possible, if with some embellishment. One can easily imagine portraits worthy, as paintings, to hang in a museum, and yet without any relationship with their subject.

The human face is the most individual of all things. It knows its owner's inmost thoughts, reflects all his peculiarities; from his earliest years, a child reads his mother's face, learns the meaning of every slightest look, the expression of the lines, and from babyhood he watches it, trying in some way to foretell, to read on it what is going to happen, what will be done. As a result, we are absolutely compelled, from childhood, to learn to read the human countenance—at least in what concerns the race to which we belong.

In a face there is always something of the past and something of expectation, always some more or less clear emotion; but if we reduce it to pure form, what we see is an absolute present, a present grown visible and in a way exempt from time. There is always a difference between what is and what might be—an aesthetic observation, if you remember what was meant by "Greek beauty" in the eighteenth century, that beauty established by the Greeks: their idea was to create a head expressing impassivity; in their statues they aimed at stable forms which break with the past and for which the future does not exist. Classic beauty meant a face without any history. We today have a more momentary, in a sense a more vibrant way of looking. I think the face as we see it presents, as it were, a series of possibilities. I do not mean those the painter has to choose from according to his theories, his personal tastes, his talent and gifts, but rather the ones inherent in the view he is to take of his model's face.

In a way there are two principal solutions open to him.

One painter will always turn his model into a still life. Before the living model he creates a still life on the canvas, because his mental attitude and his eye are the same as if he were painting a tree. In such a case he will create an inanimate object, without thought or speech.

But there are other painters whose aims and desires, far from accepting such restrictions, wish to give life to their creation. I will not choose among them. How is this second kind of painter who wishes, instead of a still life, to create the living from the living . . . how is he to set about portraying a person, who looks to him like an inanimate object?—for that is how we appear to other people. But this painter wants the illusion of giving life to life, he feels the need to rise to a more spiritual level than if he were merely molding a vase.

Now this achievement is not impossible, in view of the resources which painting has at its command. As a geometrical transformation, it admits a wide latitude in the choice of means; certain details, certain features of the model can be simplified or eliminated, or on the other hand certain features can be emphasized, exaggerated.

It is with this ability to range between the more and the less, as he works, that the painter can distinguish himself. In front of that human face, that eloquent, significant being, he can make his choice of emphasis; he can somehow find the key to it, the strategic viewpoint which will convince not only those who know and will recognize the model and see the resemblance, but also those who do not, and who will see the life in it.

A portrait is a portrait for so long as the sitter is alive, but once he and his generation have disappeared, the portrait becomes a picture.

*Paul Valéry; Degas, Manet, Morisot, trans. David Paul, Bollingen Series 45, vol. 12 (Princeton, New Jersey: Princeton University Press, 1989).*

*Paul Valéry (1871–1945), the French symbolist poet, essayist, and critic was intimately associated with the Impressionist circle. In 1892, shortly after his arrival in Paris from Sète, his birthplace in the south of France, he was introduced by Edgar Degas to his future wife, Jeannie Gobillard, a niece of Berthe Morisot. Within a brief period, the young writer came to know Monet and Renoir, joining lively gatherings at the homes of Morisot and the collector Henri Rouart. From 1902, Valéry and his wife lived in the Paris residence built in 1884 by Morisot and her husband, Eugène Manet, Édouard's younger brother. Valéry's writings include discourses on various contemporary painters and on selected artistic matters. This essay, based on a lecture, originally appeared in La Revue française, published July 15, 1928.*

*Opposite:* Detail, Cat. no. 39.

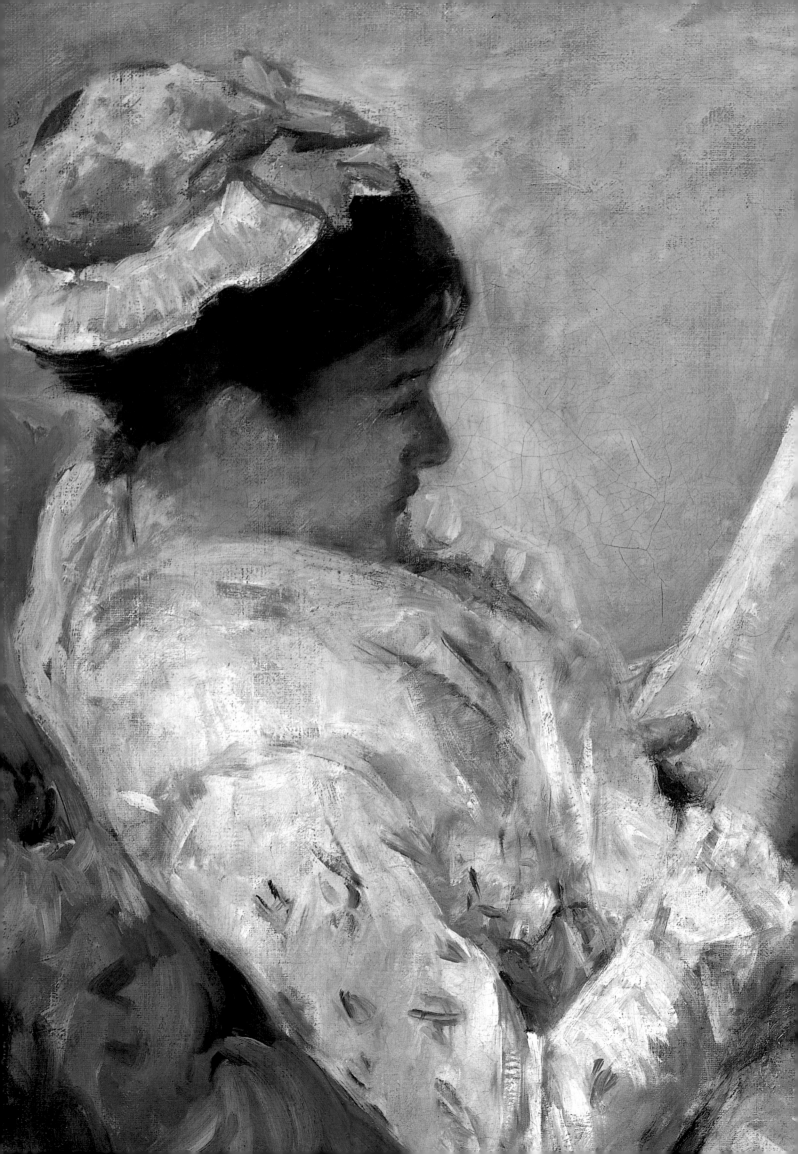

# CATALOGUE OF THE EXHIBITION

Works are arranged alphabetically by
artist and chronologically when there are
multiple works by the same artist.

Dates that appear on works are cited
without parentheses; dates ascribed on
either documentary or stylistic basis are
cited in parentheses.

Dimensions are cited in inches and
centimeters, height preceding width.

Provenances as given are from published
sources.

All comparative reproductions are oil on
canvas unless otherwise noted.

Owners' titles have been used in compar-
ative illustrations.

*Opposite:* Detail, Cat. no. 8.

CAT. NO. I
JEAN-FRÉDÉRIC BAZILLE
1841–1870

**Self-Portrait**
(c. 1865)

Oil on canvas
39 x 28 ¼ inches (99 x 71.8 cm)

The Art Institute of Chicago: Restricted gift of Mr. and Mrs. Frank H. Woods in memory of Mrs. Edward Harris Brewer (1962.336)

*Fig. 1a. Étienne Carjat (1828–1906). Photograph of Frédéric Bazille. (c. 1868). Private collection*

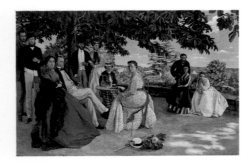

*Fig. 1b. Jean-Frédéric Bazille. Réunion de famille (The Family Gathering). 1867. Musée d'Orsay, Paris (RF 2749)*

From all accounts Frédéric Bazille was a generous and kind individual, a devoted son who corresponded regularly with his mother and father, and a charitable friend to his less advantaged colleagues. A native of Montpellier in the south of France, Bazille was the child of a prosperous wine-grower who had hoped that his son would pursue a calling in medicine. After studying the sciences in his native city, Bazille left for Paris in the autumn of 1862. Disinterested in a medical career, he entered the studio of the Swiss painter Charles Gleyre (1806–1874), where he met Pierre-Auguste Renoir, Alfred Sisley, and, most important, Claude Monet, to whom he became especially close. Correspondence between Monet and Bazille through the 1860s reveals Monet's incessant pleadings for financial assistance and Bazille's attempts to help his friend with funds from an allowance provided to him by his parents.[1] During the summer of 1865 at Chailly, near Fontainebleau, Bazille posed for a number of the male figures in Monet's ambitious composition *Le Déjeuner sur l'herbe*.[2] A tall, slender man, he is easily recognizable by his distinctive dark beard.

Self-portraiture presents a singular challenge to an artist who, as he confronts his image, must choose between the actual and the ideal, the truth and the fiction of his own character. Among Bazille's self-portraits, which include full-length representations in group pictures as well as individual bust-type portraits, this exam-

ple seems disarmingly candid. Thought to have been painted in 1865, the year in which he shared a Paris studio with Monet, or possibly a year or two later, it boldly establishes the young artist's identity as a painter, no longer distracted by medical studies. Grasping firmly his palette and brushes, he gazes out with marked concentration and intensity of purpose. It has been observed that Bazille represents himself as though in a mirror image, holding his palette in his right hand, leaving his left free for painting. In fact, he was evidently right-handed, as he appears in Renoir's *Portrait of Bazille at His Easel* (1867; House, fig. 5).[3]

Whether the particular demands of self-portraiture proved especially formidable for Bazille is not known. However, writing to his mother in the summer of 1867, while at work on a group portrait of his family in which he included his own likeness (fig. 1b), he commented, "I am now working on my portrait in the Méric [a family home outside Montpellier] painting and I am having a lot of trouble with it."[4] Indeed, he appears, somewhat awkwardly, at the extreme left, almost an afterthought within the complex arrangement of numerous seated and standing figures.

PROVENANCE
Marc Bazille, brother of the artist; André Bazille, his son, Montpellier, France; Mme. Rachou-Bazille, his daughter, Montpellier, France; Galerie Charpentier, Paris, sale 17 June 1960, no. 54; Wildenstein and Co., New York, until 1962.

NOTES
1. In a gesture of remarkable beneficence, Bazille would purchase Monet's ambitious *Women in the Garden* (1867; Musée d'Orsay, Paris) for 2,500 francs, making payments of 50 francs a month in an effort to aid Monet. See Didier Vatuone in Aleth Jourdan et al., *Frédéric Bazille: Prophet of Impressionism*, exh. cat. (Montpellier, France: Musée Fabre; New York: Brooklyn Museum, 1992), p. 162.
2. See Daniel Wildenstein, *Monet: Catalogue Raisonné*, vol. 2 (Cologne: Taschen/Wildenstein Institute, 1996), numbers W61, W62, W63/1, and W63/2.
3. See discussion in Michael Fried, *Manet's Modernism, or, The Face of Painting in the 1860s* (Chicago and London: University of Chicago Press, 1996), pp. 607–9, n. 31.
4. Bazille to his mother, summer 1867, letter no. 60, in J. Patrice Marandel and François Daulte, *Frédéric Bazille and Early Impressionism*, exh. cat. (Chicago: Art Institute of Chicago, 1978), p. 175.

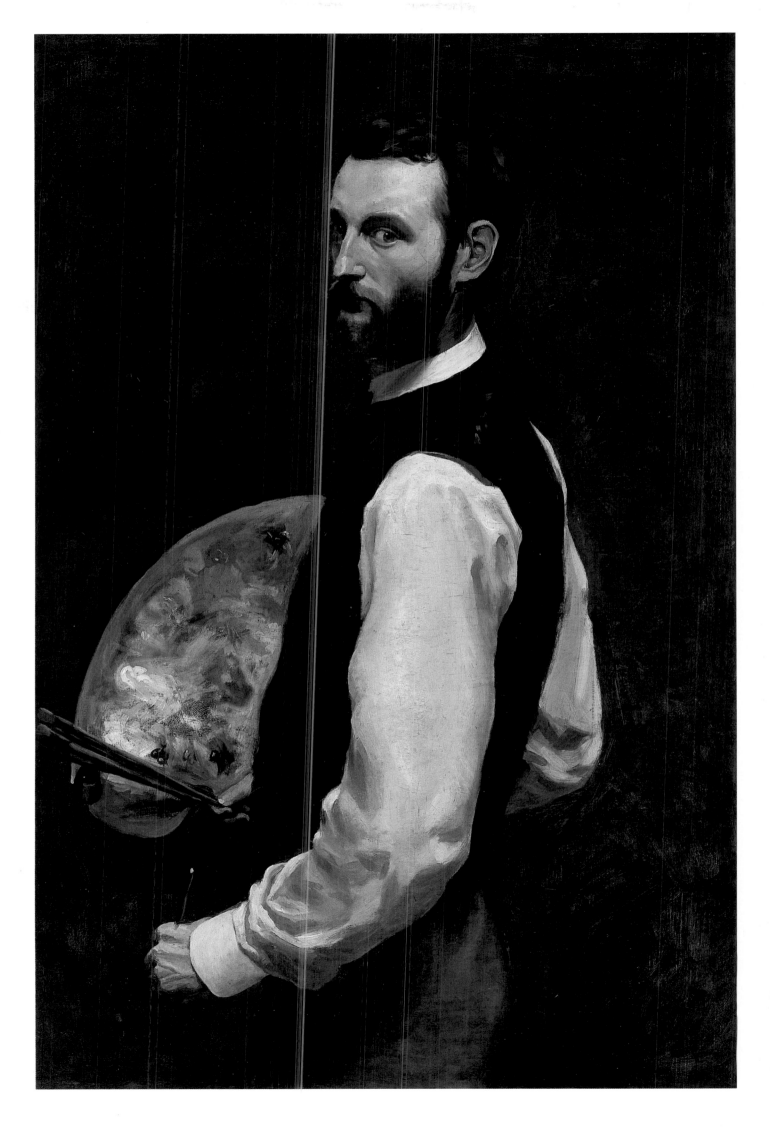

CAT. NO. 2

# JEAN-FRÉDÉRIC BAZILLE
1841–1870

## *Young Woman with Peonies*
1870

Oil on canvas
23 ¾ x 29 ¾ inches (60.3 x 75.6 cm)

National Gallery of Art, Washington:
Collection of Mr. and Mrs. Paul Mellon
(1983.1.6)

Fig. 2b. *Jean-Frédéric Bazille.* African
Woman with Peonies. *1870. Musée Fabre,
Montpellier, France (18-1-3)*

Fig. 2c. *Thomas Eakins (1844–1916).*
Negress. *1867–69. Fine Arts Museums of
San Francisco, Mildred Anna Williams
Collection, the California Palace of the
Legion of Honor (1966.41)*

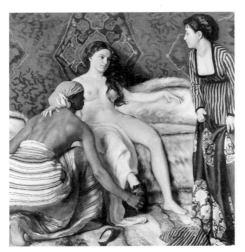

Fig. 2a. *Jean-Frédéric Bazille.* La Toilette.
*1869–70. Musée Fabre, Montpellier,
France: Cliché Frédéric Jaulmes (18-1-2)*

During the winter of 1869–70 Bazille was
occupied with several works that he hoped
to submit to the 1870 Salon, among them
an ambitious canvas titled *La Toilette*
(fig. 2a).[1] In a January 1870 letter to his
mother he conceded the composition was
proving "very difficult to do," continuing,
"There are three women, one of whom is
entirely nude, another nearly so."[2] The
semi-nude figure, a negress, kneels in front
of a young woman seated on a divan and
removes a shoe from the latter's extended
foot. The black model, shown from the
back, wears a boldly colored fabric
wrapped around her waist, and a scarf
covers her head. Most significantly, she
turns and reveals her distinctive profile.
Bazille also mentions the model in a letter
to his father: "I have just finished my day's
work, my negresse is leaving the studio and
I am getting ready to go and dine."[3]

Given the abundance of flowers in this
portrait of the same woman, it seems like-
ly that Bazille painted the work and a
related canvas, *African Woman with
Peonies* (fig. 2b), in the spring of 1870.
Here, the model balances on her lap a shal-
low basket overflowing with tulips, narcis-
sus, roses, and lilacs as she offers a bouquet
of peonies. A somewhat troubled expres-
sion marks her carefully drawn features
and seems in contrast to the joyous profu-
sion of flowers that all but envelops her.

The identity of the woman remains
unknown; however, she apparently posed
in various Paris ateliers throughout the

late 1860s. Her striking profile is again
recognized in a study by Thomas Eakins
painted while he was a pupil in Jean-Léon
Gérôme's studio in the late 1860s (fig. 2c).
Interestingly, both artists carefully
recorded her distinctive coral earring.

Frédéric Bazille's promising career
came to a tragic and abrupt end not more
than six months after *Young Woman with
Peonies* was completed. In August 1870 he
enlisted in the Third Regiment of the
Zouaves, following France's declaration
of war against Prussia. He was killed in
battle on 28 November, one week before
his twenty-ninth birthday. The painter
Alexandre-Eugène Castelnau (1827–1894)
noted Bazille's death with profound sad-
ness, writing in his journal at Montpellier:

> *Gaston Bazille arrived this morning
> with the body of his son Frédéric, killed
> in the battle of Beaune-la-Rolande. A
> tall handsome boy full of spirit . . . His
> father was looking for him for eight
> days.* [He was] *already dead and
> buried on the field of battle. . . . After a
> thousand difficulties and hardships, a
> thousand dangers, he obtained the
> melancholy satisfaction of rescuing
> from an unmarked grave the remains
> dear to him and to France.*[4]

## PROVENANCE
Given by the artist to Edmond Maître (d. 1898);
Gaston Maître; given to Marc Bazille, the artist's
brother, 1913; Frédéric Bazille, the artist's nephew,
Montpellier, France, until at least 1959; Wildenstein,
London, New York, and Paris; Paul Mellon,
Upperville, Virginia.

## NOTES
1. This composition, partially completed, is visible
on the wall in Bazille's *L'Atelier, Rue de la
Condamine* (1870; see House, fig. 7).

2. Bazille to his mother, 13–19 January 1870,
as quoted in Gary Tinterow and Henri Loyrette,
*Origins of Impressionism,* exh. cat. (New York:
Metropolitan Museum of Art; distributed by Harry
N. Abrams, 1994), p. 337.

3. Bazille to his father, 1870, in J. Patrice
Marandel and François Daulte, *Frédéric Bazille and
Early Impressionism,* exh. cat. (Chicago: Art Institute
of Chicago, 1978), p. 182.

4. Castelnau, journal entry, 14 December 1870,
as quoted in Didier Vatuone in Aleth Jourdan et al.,
*Frédéric Bazille: Prophet of Impressionism,* exh. cat.
(Montpellier, France: Musée Fabre; New York:
Brooklyn Museum, 1992), p. 166.

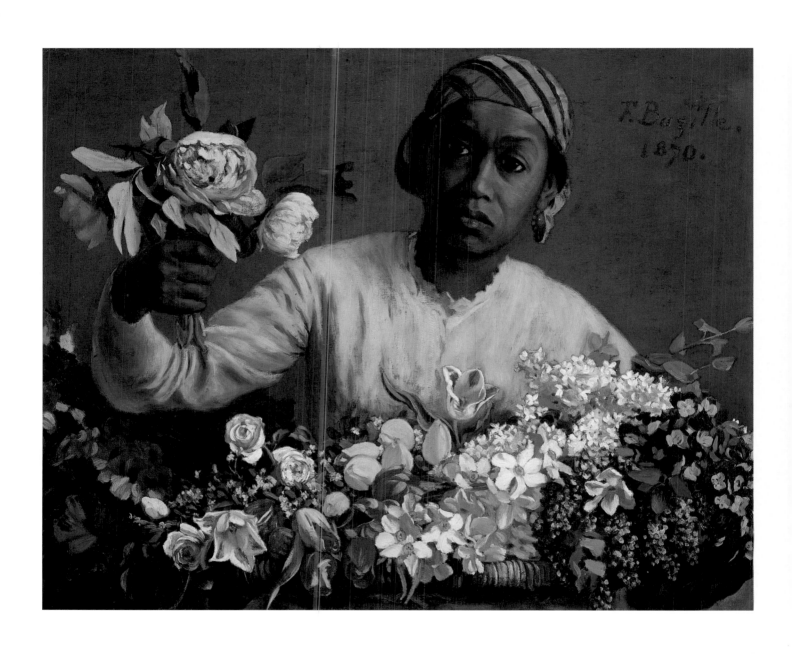

CAT. NO. 3
GUSTAVE CAILLEBOTTE
1848–1894

*Périssoires sur l'Yerres*
1877

Oil on canvas
40 ³/₄ x 61 ³/₈ inches (103.5 x 156 cm)

Milwaukee Art Museum: Gift of the
Milwaukee Journal Company, in Honor
of Miss Faye McBeath (M 1965.28)

*Fig. 3a. Gustave Caillebotte.* Partie de
bateau, *also known as* Canotier en
châpeau haut de forme. *1877–78. Private
collection*

*Fig. 3b. Gustave Caillebotte.*
Portrait of Eugène Lamy. *(c. 1889).*
*Collection Patrice Février, Paris*

Gustave Caillebotte was born in Paris in
1848, the son of Céleste Daufresne and
Martial Caillebotte, a textile entrepreneur
who accumulated his fortune by provid-
ing blankets and beds to the French mil-
itary. The Caillebotte family lived in
Paris, but in addition, Martial Caillebotte
senior in 1860 acquired an expansive
country estate in Seine-et-Oise along the
Yerres river, southeast of Paris.[1]

An accomplished painter, Caillebotte
was also an important collector of
Impressionist art and a great proponent of
Impressionism. Little is known about his
early years; he received a law degree in
1870 and served during the Franco-
Prussian War. In 1872 he attended the stu-
dio of the portraitist and academician Léon
Bonnat (1833–1922), and the following
year he entered the École des Beaux-Arts.
In 1875 the artist submitted his first paint-
ing to the Salon, *Floor Scrapers* (Musée
d'Orsay, Paris), and it was rejected. He was
invited by Henri Rouart and Auguste
Renoir to participate in the Second
Impressionist Exhibition in 1876, and he
not only exhibited eight paintings but also
purchased three pictures from Monet.[2]
Caillebotte began his significant patron-
age of his fellow Impressionists at this
exhibition.

Caillebotte's father died in 1874, leav-
ing Gustave, his mother, and brothers a
large inheritance. The artist continued
to live with his family in a luxurious
townhouse near the Place de l'Europe,
a recently modernized section of Paris.
In the typical manner of the newly
wealthy French bourgeoisie, Caillebotte's
family escaped the hubbub and pollution
of Paris in summers, passing their days at
Yerres, rowing and sailing.[3]

Caillebotte became an accomplished
sailor, and he devoted much of his life to
designing, building, and racing boats. His
large canvas *Périssoires sur l'Yerres* was
exhibited in 1879 in the Fourth Impres-
sionist Exhibition with more than thirty
additional works, primarily portraits and
rowing scenes. The painting describes the
tranquil, tree-lined Yerres river near his
family's country house. Three oarsmen
paddle flat-bottomed skiffs through
placid water loosely brushed in purples

and blues. These sportsmen wear typ-
ical rowing attire, including straw hats.
In contrast, Caillebotte's painting *Partie
de bateau* (1877–78; fig. 3a), also exhib-
ited at the 1879 Impressionist Exhibition,
uses dramatic perspective in depicting a
Parisian dandy or *flâneur* in a rowboat.
This weekend oarsman, still wearing his
vest, tie, and top hat, obviously has come
from Paris for the day to enjoy pleasure-
boating in the countryside.

Caillebotte's *Périssoires* provides an
instructive example of the fresh way in
which the Impressionists treated portrai-
ture. This group of artists believed that
a portrait should not simply serve as a
visual likeness but should also evoke a
sitter's character or personality. In the
case of *Périssoires*, Caillebotte gives the
central rower the distinctive features of
his good friend and fellow oarsman
Eugène Lamy (fig. 3b), the first owner of
the painting.[4] Caillebotte and Lamy were
members of a sailing club called Cercle
de la Voile de Paris, and the artist ably
characterizes his companion and their
friendship by depicting oarsmen engaged
in a favorite pastime.

PROVENANCE
Eugène Lamy, Paris; Drouot Sale, Paris, 2 March
1929; Gérard frères, Paris; Metthey, Paris, c. 1939;
Wildenstein.

NOTES
1. A thorough chronology of Caillebotte's life is
provided by Anne Distel in Anne Distel et al.,
*Gustave Caillebotte: Urban Impressionist*, exh. cat.
(Paris: Réunion des Musées Nationaux; Chicago: Art
Institute of Chicago; with Abbeville Press, 1995), pp.
311–18. See also Marie Berhaut, *Caillebotte:
Catalogue raisonné des peintures et pastels*, rev. and
exp. (Paris: Wildenstein Institute, 1994).

2. Ibid., and Berhaut, *Caillebotte*, p. 282.

3. For a discussion of how boating on the Seine in
the environs of Paris increasingly became associated
with the middle class as a leisure activity, see
Katherine Rothkopf, "From Argenteuil to Bougival:
Life and Leisure on the Seine, 1868–1882,"
in Eliza Rathbone et al., *Impressionists on the Seine:
A Celebration of Renoir's "Luncheon of the Boating
Party*," exh. cat. (Washington, D.C.: Phillips
Collection, 1996), pp. 57–85.

4. See Distel, *Gustave Caillebotte*, p. 78.

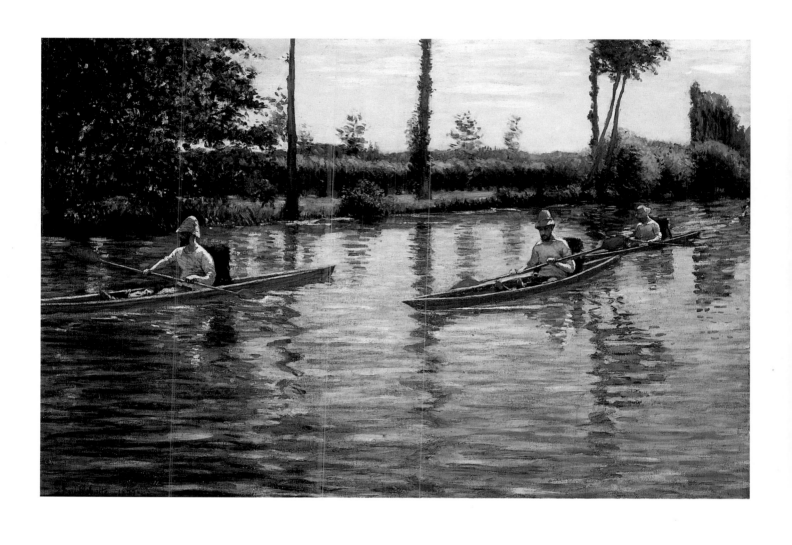

CAT. NO. 4
GUSTAVE CAILLEBOTTE
1848–1894

*Portrait of a Man*
1880

Oil on canvas
30 x 24 ½ inches (76.2 x 62.3 cm)

Mrs. Noah L. Butkin

*Fig. 4a. Gustave Caillebotte.* Vue prise à travers un balcon *(View through a Balcony Grille). 1880. Private collection*

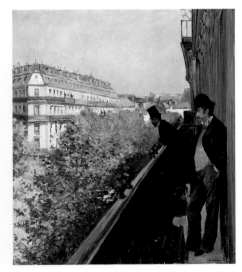

*Fig. 4b. Gustave Caillebotte.* Un Balcon, *also known as* Un balcon, boulevard Haussmann. *1880. Private collection, Paris*

After the death of his mother in 1878, Gustave and his brother Martial moved to an elegant apartment on the Boulevard Haussmann.[1] From this time until about 1885 Caillebotte painted a number of portraits in this familiar setting replete with soft gray walls, gilded moldings, red crushed velvet chairs, and wrought-iron balconies.

Portraiture was on the rise from the 1850s through the end of the century, as a rapidly expanding merchant and professional bourgeois class sought painted likenesses of themselves.[2] Although Caillebotte was independently wealthy and had no need for commissions, he painted many portraits, in the 1870s mostly of family members and in the 1880s of acquaintances. In his essay "The New Painting," the critic Louis-Edmond Duranty advocated that the best and most truthful portraits were those that included objects and surroundings suggesting a sitter's métier or character:

> *In actuality, a person never appears against neutral or vague backgrounds. Instead, surrounding him and behind him are the furniture, fireplaces, curtains, and wall that indicate his financial position, class, and profession. The individual will be at a piano, examining a sample of cotton in an office, or waiting in the wings for the moment to go onstage, or ironing on a makeshift table. He will be having lunch with his family or sitting in his armchair near his worktable, absorbed in thought.[3]*

Caillebotte's *Portrait of a Man* was painted in 1880, and although he did not exhibit it at an Impressionist Exhibition, it is similar to several portraits from the same year set in his apartment on the Boulevard Haussmann and shown at the Fifth Impressionist Exhibition of 1880. The unidentified subject is seated near a window in the artist's red velvet armchair. A simple white lace curtain frames the edge of the window, and an expanse of green treetops and the suggestion of buildings show through an ornate wrought-iron grille. This grille is featured in several paintings by the artist, and it is the subject of *Vue prise à travers un balcon (View through a Balcony Grille)* (fig. 4a), painted the same year. The exacting depiction of the apartment describes the interior world of

the Parisian bourgeois male, while the view through the ironwork speaks to a recently renovated Paris beyond.[4]

The identity of the sitter in *Portrait of a Man* remains a mystery; however, he apparently was a favorite model of Caillebotte, representing different Parisian male types.[5] In *Un Balcon* (1880; fig. 4b), he wears a fashionable derby and the clothing of a *flâneur* as he casually surveys the city from a perch on a balcony high above the Boulevard Haussmann. Similarly, in *Portrait of a Man* he epitomizes an affluent male bourgeois as he sits in thoughtful repose in the comfortable velvet armchair. This Parisian is not busy working or reading; rather, he enjoys a moment of contemplation as a warm light from the window illuminates his face.

In 1883 the critic Joris-Karl Huysmans (1848–1907) described many of Caillebotte's sitters when he observed in *L'Art moderne*: "Caillebotte is the painter of the bourgeoisie of business and finance at ease, able to provide well for their needs without being very rich, living near rue Lafayette or around the boulevard Haussmann."[6]

PROVENANCE
Family of the artist; Lorenceau, Paris.

NOTES
1. Anne Distel et al., *Gustave Caillebotte: Urban Impressionist*, exh. cat. (Paris: Réunion des Musées Nationaux; Chicago: Art Institute of Chicago; with Abbeville Press, 1995), p. 181.
2. Gary Tinterow and Henri Loyrette, *Origins of Impressionism*, exh. cat. (New York: Metropolitan Museum of Art; distributed by Harry N. Abrams, 1994), pp. 183–86. For an excellent discussion of portraiture during this time, see Henri Loyrette's essay "Portraits and Figures," herein pp. 183–230.
3. Duranty, "La Nouvelle Peinture" (1876), as quoted in Charles S. Moffett, ed., *The New Painting: Impressionism 1874–1886*, exh. cat. (San Francisco: Fine Arts Museums of San Francisco, 1986), p. 44.
4. For more on the significance of the balcony, see Kirk Varnedoe in *Gustave Caillebotte: A Retrospective Exhibition*, exh. cat. (Houston: Museum of Fine Arts, Houston, 1976), pp. 147–48.
5. See works such as *Dans un café* (1880; Musée des Beaux-Arts, Rouen).
6. Joris-Karl Huysmans, "L'exposition des indépendants en 1880," *L'Art moderne* (1883), as quoted in Moffett, *The New Painting*, p. 319.

CAT. NO. 5
GUSTAVE CAILLEBOTTE
1848–1894

*Woman Sitting on a Red-Flowered Sofa*
1882

Oil on canvas
31 7/8 x 25 5/8 inches (81 x 65.1 cm)

Seattle Art Museum, gift of Mr. and Mrs.
Prentice Bloedel (91.12)

Beginning with his participation in the Second Impressionist Exhibition in 1876, Gustave Caillebotte was a dedicated supporter of the movement, often arranging meetings among the artists and providing funds for the group's exhibitions. He also gave significant financial support to Claude Monet and Camille Pissarro, at times paying the rent for Monet's apartment in Paris, and "advancing" thousands of francs to both artists.[1] But the Impressionists were a fractious lot, and disagreements with Edgar Degas, in particular, led Caillebotte to forgo involvement in the Sixth Impressionist Exhibition in 1881.[2] He rejoined the group for the Seventh Impressionist Exhibition in 1882. This was Caillebotte's last show with the Impressionists.

*Woman Sitting on a Red-Flowered Sofa*, painted in 1882, presents an unidentified young female dressed in a conservative but elegant black dress embellished with a lace collar and cuffs and a corsage of pink flowers. A number of Impressionists painted fashionably attired women in interiors, either reading or relaxing; Édouard Manet's 1870 painting of Berthe Morisot, *Repose* (see House, fig. 16), is one example. Unlike these more decorative portraits, however, Caillebotte's painting seems stilted. Here, the subject sits somewhat stiffly on a richly upholstered sofa, her impassive gaze averted and her hands folded demurely in front of her. She appears confined within the flattened picture plane, with the heavy gilt frame behind her nearly touching her hair and her figure cropped just below her knees. The sitter's expression, or lack of one, is enigmatic. Like the woman reading in Caillebotte's *Intérieur, femme lisant* (1880; private collection, Paris), the subject in the present painting may be a friend of the artist. It is also possible that she is someone related to the Ambroselli family of Paris, who owned this work from 1882 until 1945. In describing Caillebotte's portraits, the critic Bertall (Charles-Albert d'Arnoux) wrote, "He has friends whom he likes and who like him: he seats them on strange sofas, in fantastic poses."[3]

By 1881 Caillebotte and his brother Martial had sold their estate along the Yerres river and purchased a house at Petit Gennevilliers, across the Seine from Argenteuil. The artist devoted increasing time to boating, gardening, and painting. He exhibited publicly just three more times, in 1886 and twice in 1888, but he continued to paint until his death in 1894 at the age of forty-five.

Caillebotte's legacy to Impressionism extended beyond painting to collecting. After the sudden death of his older brother, René, in 1876, he had written a will in which he bequeathed his collection of Impressionist art to France, stipulating that it go to the Luxembourg in Paris, which was then the national museum for works by living artists. In addition, he worded the gift document so that the government was prohibited from selecting only a few choice paintings from his collection. Caillebotte's younger brother, Martial, and the artist's good friend Auguste Renoir negotiated the terms of the bequest, and by 1897 thirty-eight paintings and pastels from the original Caillebotte collection of sixty-seven works were accepted by France and displayed in an annex of the Musée du Luxembourg.[4]

PROVENANCE
Ambroselli, Paris, 1882–c. 1945; Knoedler & Co., New York, c. 1954; Sotheby's Sale, London, 17 July 1957; Colonel Robert Adeane, London; Sotheby's Sale, London, 26 March 1958; Mr. and Mrs. Lester Avnet, New York; Parke-Bernet Sale, New York, 14 October 1965.

NOTES
1. See references to Monet's account books in Anne Distel et al., *Gustave Caillebotte: Urban Impressionist*, exh. cat. (Paris: Réunion des Musées Nationaux; Chicago: Art Institute of Chicago; with Abbeville Press, 1995), pp. 311-18.
2. For a detailed description of the Impressionist Exhibition of 1881, see Fronia E. Wissman, "The Sixth Exhibition of 1881: Realists among the Impressionists," in Charles S. Moffett, ed., *The New Painting: Impressionism, 1874–1886*, exh. cat. (San Francisco: Fine Arts Museums of San Francisco, 1986), pp. 337–69.
3. Bertall (Charles-Albert d'Arnoux), "Exposition des Indépendants, Ex-Impressionistes, Demain Intentionistes," *L'Artiste* (June 1879), as quoted in *Gustave Caillebotte: A Retrospective Exhibition*, exh. cat. (Houston: Museum of Fine Arts, Houston, 1976), p. 218.
4. For a transcript of Caillebotte's will, and an analysis of the problems with the bequest, see *Gustave Caillebotte: A Retrospective Exhibition*, pp. 197-204. For more discussion, see Anne Distel, *Impressionism: The First Collectors*, trans. Barbara Perroud-Benson (New York: Harry N. Abrams, 1990), pp. 245–63.

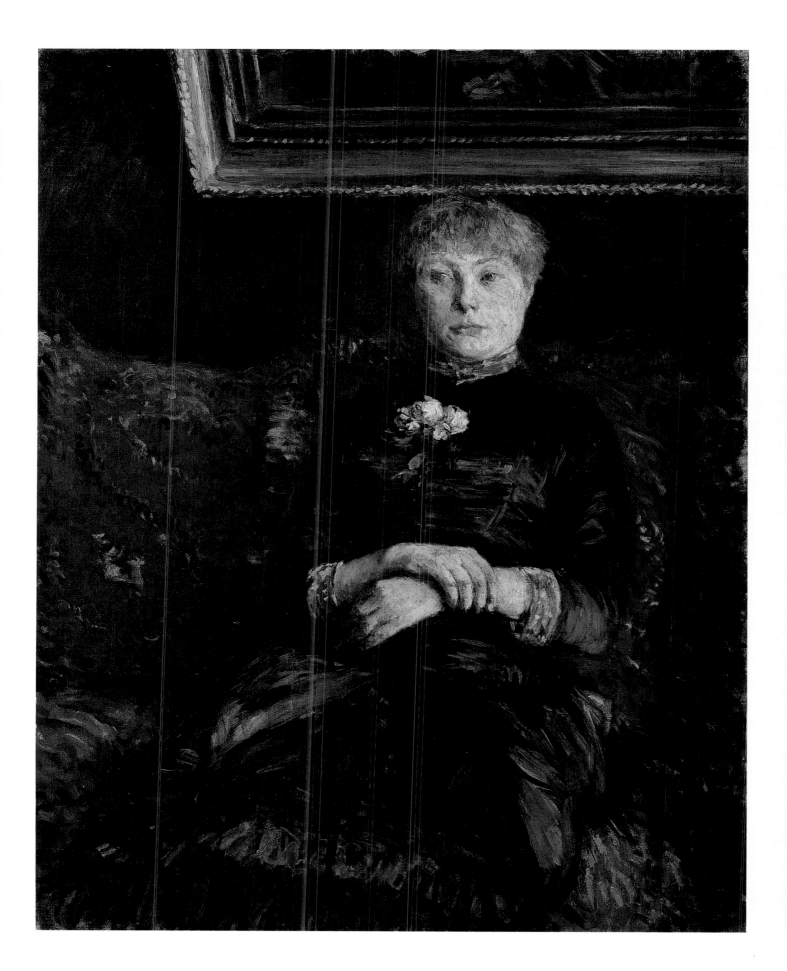

CAT. NO. 6
MARY STEVENSON CASSATT
1844–1926

*Portrait of Mrs. Currey; Sketch of Mr. Cassatt*
(c. 1871)

Oil on canvas
32 ¼ x 27 inches (82 x 68.6 cm)

Collection Mr. and Mrs.
Joseph Zicherman, New York

Mary Stevenson Cassatt, the fourth child of Robert Simpson Cassatt (1806–1891), a prosperous Pittsburgh businessman, and his wife, Katherine Kelso Johnston (1816–1895), enjoyed a nurturing childhood in a close-knit family. She trained initially at the Pennsylvania Academy of the Fine Arts in Philadelphia, but like many of her contemporaries, was drawn to Paris after the Civil War. In December 1865, Cassatt arrived in the French capital, a city with which she was already familiar as a result of a family sojourn there in the early 1850s. The young artist pursued her studies with the academic painters Charles Chaplin and Jean-Léon Gérôme. In 1868 *The Mandolin Player* (private collection), a representation of a rather doleful young girl playing the stringed instrument, was accepted at the Salon. Further study, together with travel in France and Italy, filled the remaining years before Cassatt was forced to return to America at the outbreak of the Franco-Prussian War in 1870.

Cassatt's dismay at leaving Europe is evident in an 1871 letter to a Philadelphia friend and fellow artist, Emily Sartain (1841–1927). Her unhappiness was compounded by the family's move from Philadelphia to Hollidaysburg, a small town in central Pennsylvania near Altoona:

*I cannot tell you what I suffer for want of seeing a good picture, no amount of bodily suffering occassioned [sic] by the want of comforts would seem to be too great a price for the pleasure of living in a country where one could have some art advantages.[1]*

In the same letter, Cassatt tells Sartain:

*I am working by fits & starts at fathers [sic] portrait but it advances slowly [as] he drops asleep while sitting. I commenced a study of our mulatto servant girl but just as I had the mask painted in she gave warning. My luck in this country![2]*

The portrait of her father to which the artist refers is the inverted sketch beneath the image of the family servant in this unfinished canvas, one of the few paintings executed by Cassatt during her sixteen-month hiatus in America. (She would complete a formal portrait of Robert Cassatt similar to this some six years later.) While the image of her father is only roughed out, that of the servant is more fully realized, especially in the area of the face or "mask," as mentioned by the artist. In its bold realism and vigorous brushwork, the portrait recalls the teachings of Thomas Couture (see cat. no. 19) with whom Cassatt had studied in the late 1860s. The artist apparently presented this unfinished portrait to the sitter, identified as Mrs. Currey, at the time of her departure from the family household.[3]

PROVENANCE
Given by the artist to Mrs. Currey, Philadelphia, 1871–72; James E. Lewis, Baltimore, 1943; to Hirschl & Adler, New York, 1966–67; W. Myron Owen, New Bedford, Massachusetts, and Florida, 1967; descendants of W. Myron Owen; Sotheby's Sale, New York, 1997; Gary Hendershott, Little Rock, Arkansas.

NOTES
1. Cassatt to Sartain, 7 June [1871], in Nancy Mowll Mathews, ed., *Cassatt and Her Circle: Selected Letters* (New York: Abbeville Press, 1984), p. 74.
2. Ibid.
3. Adelyn Dohme Breeskin, *Mary Cassatt: A Catalogue Raisonné of the Oils, Pastels, Watercolors, and Drawings* (Washington, D.C.: Smithsonian Institution Press, 1970), p. 32.

CAT. NO. 7
MARY STEVENSON CASSATT
1844–1926

*Portrait of a Woman*
(1872)

Oil on canvas
23 1/4 x 19 3/4 inches (59 x 50.2 cm)

The Dayton Art Institute: Gift of Mr.
Robert Badenhop (1955.67)

Cassatt returned to Europe in December 1871, accompanied by fellow artist Emily Sartain. Rather than settling in Paris, however, the two young women traveled to Parma in northern Italy, where Cassatt immersed herself for several months in a study of the sixteenth-century painter Correggio. Her choice of Parma was apparently determined by a commission she had received from the bishop of Pittsburgh for copies of two paintings by the Italian master for the cathedral of Pittsburgh.[1] According to a March 1872 report in the American press, Cassatt was somewhat of a celebrity during her stay in the Italian city:

> Miss Mary Stevenson Cassatt has just finished an original painting which all Parma is flocking to see at her studio at the Accademia of that city. Professor Raimondi and other Italian painters of reputation are quite enthusiastic in regard to our fair young countrywoman's talent which they pronounce to be nearly akin to genius and they offer her every inducement to make Parma her home and to date her works from that city.[2]

In its softness of execution, rich tonalities, and dramatic use of chiaroscuro, the present image of an unknown peasant woman pays homage to Correggio. It also speaks to Cassatt's conviction, early in her career, to learn by emulating the Old Masters. The engraver Carlo Raimondi (1809–1883), to whom the portrait is inscribed, taught at the academy in Parma and guided Cassatt through the city's artistic and social circles.[3]

Cassatt remained in Italy until October 1872, when she traveled to Spain. In early 1873 she wrote to Emily Sartain from Seville, "Now that I have begun to paint from life again, constantly the thought of Correggio's pictures returns to my mind and I am thankful for my six months' study in Parma."[4]

PROVENANCE
Gift from the artist to Carlo Raimondi, 1872; Raimondi family; R. M. C. Livingston Sale, Parke-Bernet, New York, 1951; J. W. Young; Robert Badenhop.

NOTES
1. Nancy Mowll Mathews, ed., *Cassatt: A Retrospective* (New York: Hugh Lauter Levin Associates, 1996), p. 76.
2. Unidentified newspaper account, quoted in a letter from William Sartain (1843–1924), Emily's younger brother and a painter, to his father, 25 March 1872, in Mathews, *Cassatt: A Retrospective*, p. 76.
3. The portrait is inscribed: "Mary Stevenson Cassatt/à mon ami C. Raimondi." Adelyn Dohme Breeskin, *Mary Cassatt: A Catalogue Raisonné of the Oils, Pastels, Watercolors, and Drawings* (Washington, D.C.: Smithsonian Institution Press, 1970), p. 33.
4. Cassatt to Sartain, 1 January 1873, in Nancy Mowll Mathews, ed., *Cassatt and Her Circle: Selected Letters* (New York: Abbeville Press, 1984), p. 114.

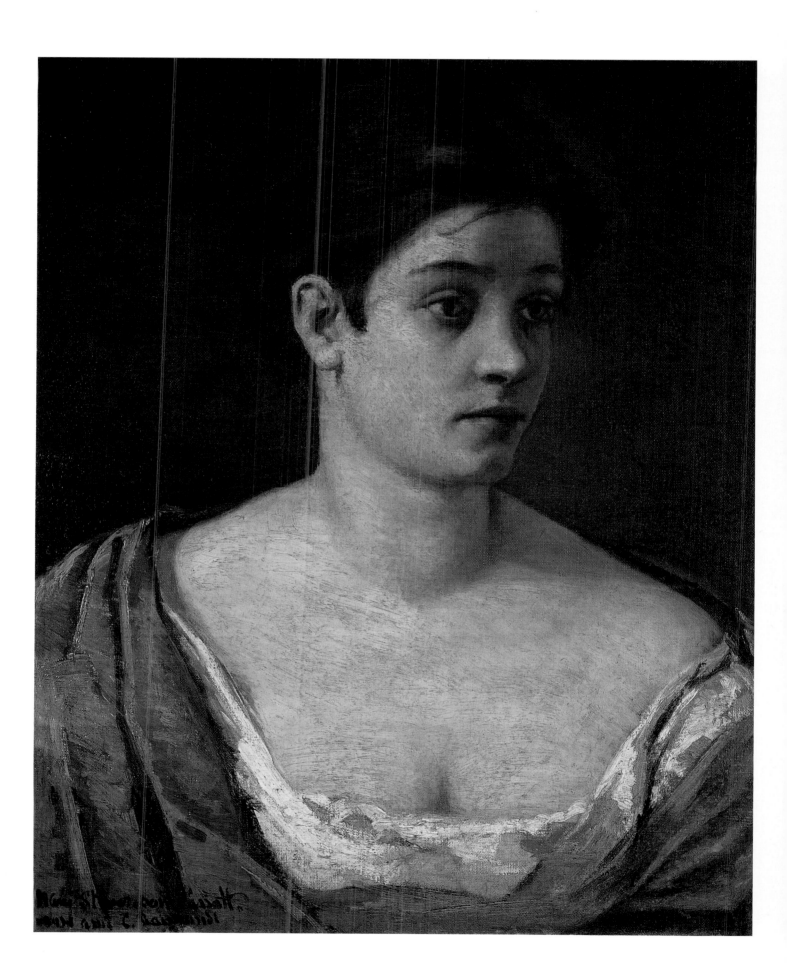

CAT. NO. 8
MARY STEVENSON CASSATT
1844–1926

***Woman Reading***
(1878–79)

Oil on canvas
32 x 23 ½ inches (81.3 x 59.7 cm)

Joslyn Art Museum, Omaha, Nebraska;
Museum purchase (JAM.1943.38)

*Fig. 8a. Mary Stevenson Cassatt.* Lydia at
a Tapestry Frame. *(c. 1881). Flint Institute
of Arts: Gift of the Whiting Foundation*

After extended visits to Italy and Spain in
the early 1870s, Cassatt settled in Paris,
taking a studio at 19, rue Laval, in the
autumn of 1875. Her painting was gradu-
ally evolving from the somber, rather pon-
derous realism apparent in her early work
toward a freer, vibrant style more aligned
with the avant-garde. These years also
marked the beginning of her long associa-
tion with Edgar Degas, who first noticed
her work at the Salon of 1874 and three
years later invited her to exhibit with the
Impressionists. She would participate in
four Impressionist Exhibitions: 1879, 1880,
1881, and 1886.

In October 1877 Cassatt's parents and
her older sister, Lydia (1837–1882), moved
to France to live permanently with her.
Louisine Elder Havemeyer (1855–1929)
whom Cassatt assisted in the formation of
her great collection, had met the artist in
1874 and would later recall:

> I often visited the family during our
> early friendship, and I remember Mr.
> Cassatt as a very courteous, tall,
> white-haired man with military bear-
> ing. Her sister, Lydia, was exactly as
> represented in Miss Cassatt's portraits
> of her where she is sitting in an easy
> chair in the garden beautifully dressed,
> elegant and indolent[, one] who gra-
> ciously allows her sister . . . to do a
> double share in making them all com-
> fortable and happy.[1]

In fairness to Lydia Simpson Cassatt, she
suffered from Bright's disease, a debilitat-
ing illness of the kidneys, which rendered
her a semi-invalid for much of her life.
She would succumb to the affliction in
November 1882 at the age of forty-five.
The sisters were close, and Mary Cassatt
included her sibling in several composi-
tions, among them *Lydia Crocheting in the
Garden at Marley* (1880; The Metropolitan
Museum of Art, New York) and *Lydia at a
Tapestry Frame* (c. 1881; fig. 8a).

In *Woman Reading,* Cassatt portrays
her sister in profile, journal in hand,
absorbed in her reading. The loosely
brushed pigments and light palette convey
an impression of both delicacy and femi-
ninity, the latter emphasized by Lydia's
attire and the pink-toned background.
A similar image, probably painted at

about the same time, shows her in an inte-
rior setting defined by a window with
ornate iron grillwork and a landscape
beyond (*Lydia Reading the Morning
Paper*; present location unknown).

*Woman Reading* was one of eleven
works by Cassatt included in the Fourth
Impressionist Exhibition in 1879, her debut
with the group. Reviews were complimen-
tary, and several noted her association with
Degas. One critic singled out this portrait
for particular praise:

> There is not a canvas nor a pastel by
> Mary Cassatt that is not an exquisite
> symphony of color. She is fond of the
> palette's sharp tones and has the secret
> of combining them into a whole that is
> filled with pride, mystery, and fresh-
> ness. La femme lisant *seen in elegant
> profile, is a miracle of elegance and
> simplicity.*[2]

This painting is apparently the work
mentioned by Édouard Manet in a letter
to the dealer Alphonse Portier from 17
April 1879: "Monsieur, when the [Fourth
Impressionist] exhibition ends, would
you please send Mlle. Cassatt's *Woman
Reading* to M. Antonin Proust, Deputy, at
32 Boulevard Haussmann, where the sum
of 300 francs will be paid as agreed."[3]
Thus, Manet's close friend, the critic and
politician Antonin Proust, became the
first owner of the portrait. Subsequently
it was acquired by the Parisian dealer
Dikran G. Kelekian, an acquaintance of
Cassatt, and it remained in his personal
collection for more than forty years.

PROVENANCE
From the artist to Antonin Proust, Paris, 1879;
D. G. Kelekian, Paris; Kelekian & Co., Paris.

NOTES
1. Louisine W. Havemeyer, *Sixteen to Sixty:
Memoirs of a Collector*, ed. S. A. Stein (New York:
Ursus Press, 1993), p. 272.
2. F.-C. de Syène (Arsène Houssaye), "L'Artiste,"
May 1879, quoted in Charles S. Moffett, ed.
*The New Painting: Impressionism, 1874–1886*,
exh. cat. (San Francisco: Fine Arts Museums of
San Francisco, 1986), p. 277.
3. Manet to Portier, 17 April 1879, in Juliet
Wilson-Bareau, ed., *Manet by Himself* (London:
Macdonald and Company, 1991), p. 186.

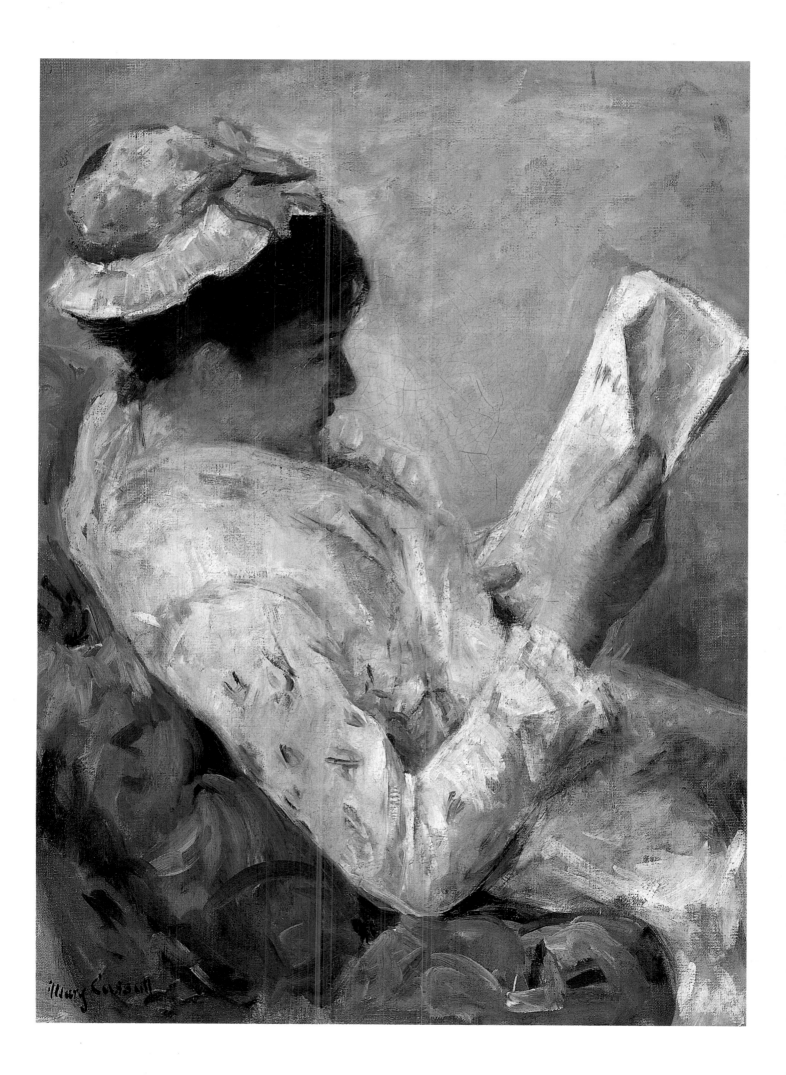

CAT. NO. 9
MARY STEVENSON CASSATT
1844–1926

**Susan Comforting the Baby**
(c. 1881)

Oil on canvas
25 5/8 x 39 3/8 inches (65.1 x 100 cm)

The Museum of Fine Arts, Houston:
The John A. and Audrey Jones Beck
Collection (74.136)

Houston only

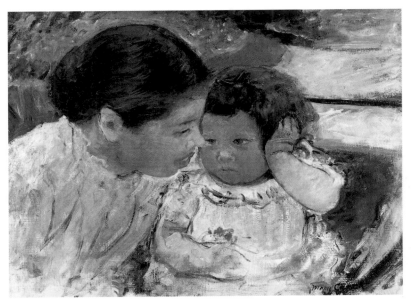

Fig. 9a. *Mary Stevenson Cassatt.* Susan Comforting the Baby (no. 1). *(c. 1881).*
*Columbus Museum of Art, Ohio: Bequest of Frederick W. Schumacher*

Although Cassatt had painted individual portraits of women and children, she only began to explore in her art the relationships among such subjects around 1880. She may possibly have been prompted by the arrival in France of her brother and his young family for an extended visit in the summer of that year. While Alexander Cassatt and his wife traveled, the four children remained at Marly-le-Roi near Paris with their grandparents and two aunts. Mary and her sister, Lydia.[1]

At this time, Cassatt painted a number of images of her nieces and nephews, who ranged in age from five to eleven years. However, she would come to prefer to record the more intimate associations between younger children, or infants, and women, often showing her subjects in private, unguarded moments engaged in ordinary activities such as bathing, eating, or simply caressing or embracing one another.

In the early 1880s the artist employed a model identified only as Susan, possibly a relation of her housekeeper, Mathilde Valet, whom she would portray in a number of informal representations.[2] Here, Cassatt shows the young woman leaning forward as she attempts to console a blue-eyed baby who holds a small hand to his or her head in obvious dismay. Although most of the composition is loosely rendered in sketchy, broad brushstrokes, Susan's features are more carefully defined. The can-

dor with which Cassatt captures this minor event calls to mind a critic's observations made several years later.

*What graceful supple movements Miss Cassatt has realized! Her babies' gestures are exquisitely fidgety and awkward. Their eyes, astonished and naïve, stare solemnly. The folds of fat in their pink, milky flesh and their plump softnesses show them to be in fine health. The babies' attitudes are spiritual and remain true to life. . . . Her art maintains its distinction as well as its truth.[3]*

There is a smaller, more intimate variant of this composition that may have been a preliminary study (fig. 9a).

PROVENANCE
Ambroise Vollard, Paris; Mrs. and Mrs. John
A. Beck, Houston.

NOTES
1. Frederick A. Sweet, *Miss Mary Cassatt: Impressionist from Pennsylvania* (Norman: University of Oklahoma Press, 1966), pp. 54–55.
2. Other works in which the same model appears include *Susan Seated Outdoors Wearing a Purple Hat,* (c. 1881), (B108; private collection, New York) and *Susan on a Balcony Holding a Dog,* 1883 (B125; Corcoran Gallery of Art, Washington, D.C.).
3. Georges Lecomte, "L'Art Impressioniste d'après la collection privée de M. Durand-Ruel" (1892), in Nancy Mowll Mathews, ed., *Cassatt: A Retrospective* (New York: Hugh Lauter Levin Associates, 1996), p. 156.

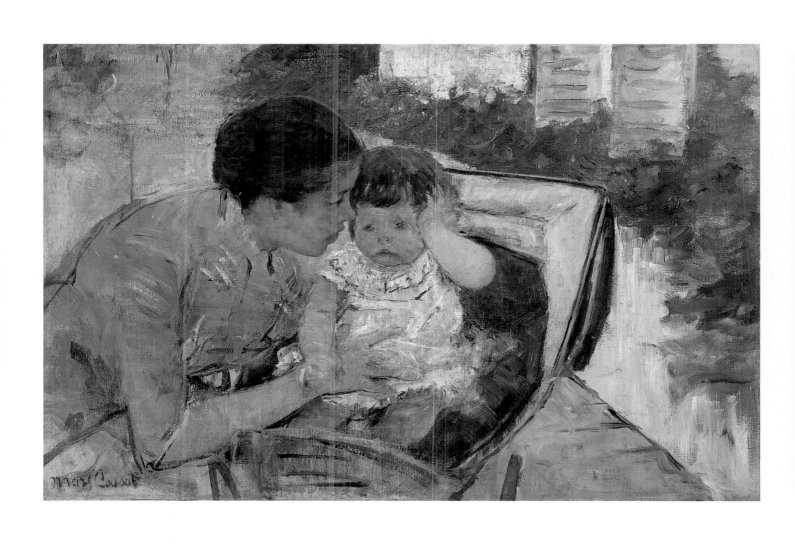

CAT. NO. 10

MARY STEVENSON CASSATT
1844–1926

**Young Woman in Black**
*[possibly Jennie Cassatt]*
(1883)

Oil on canvas
31 ³/₄ x 25 ¹/₂ inches (80.7 x 64.8 cm)

The Peabody Art Collection. Courtesy of
the Maryland Commission on Artistic
Property of the Maryland State Archives,
on loan to The Baltimore Museum of Art
(MSA SC 4680-10-0010)

*Fig. 10b. Mary Stevenson Cassatt.
Gardner Cassatt Held by His Mother.
(c. 1887). Drypoint. The Baltimore
Museum of Art: George A. Lucas
Collection (BMA 1996.48.511)*

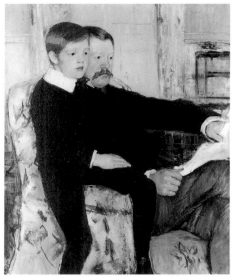

*Fig. 10a. Mary Stevenson Cassatt.
Alexander Cassatt and His Son Robert
Kelso Cassatt. 1884–85. Philadelphia
Museum of Art: Purchased with the W. P.
Wilstach Fund and funds contributed by
Mrs. William Coxe Wright*

In 1893 the critic André Mellério com-
mented, "Miss Cassatt knows and under-
stands the ladies of society—because she
herself is one. She conveys them and ren-
ders them with rare felicity and perfect
accuracy, because her nature is that of an
artist as well."[1] This portrait of a refined
young woman in an interior would
appear to embody Mellério's observations.
Elegantly dressed in black, she sits in a large
armchair upholstered in a flowered fabric.
A thin veil delicately covers a portion of her
face, and she gazes to one side, absorbed in
private thoughts. Mounted on the wall
behind the figure is a decorative fan design.

The chair fabric as well as the fan sug-
gest that the canvas was painted in
Cassatt's Paris studio. A similar chair cov-
ering is found in Cassatt's portrait of her
brother, Alexander, with his young son,
Robert, painted circa 1884–85 during a visit
by the Alexander Cassatt family to Paris
(fig. 10a). Behind them is the window that,
in the present portrait, delicately illumi-
nates the young woman's face.

The fan on the wall, recognizable from
the configuration of its broadly painted
passages, was acquired by Cassatt from her
friend Edgar Degas. Never intended for
actual use, these decorative designs were
matted and framed. In the late 1870s and
early 1880s in particular, Degas was among
a number of artists who explored the com-
positional possibilities presented by the fan
format. This fan was eventually deposited
by Cassatt with the dealer Paul Durand-
Ruel, who subsequently sold it to the col-
lector Louisine Havemeyer. It is now in
the collection of The Metropolitan Museum
of Art, New York.

Identifying the sitter remains problem-
atic. It has been suggested that she is
Eugenia Carter, called Jennie (1855–1929),
the wife of Cassatt's youngest brother,
Joseph Gardner Cassatt.[2] The couple were
married in Philadelphia in October 1882,
and, as neither the artist nor her parents
had been present at the wedding, the new-
lyweds traveled to Paris the following
summer, where they were graciously
received by the family.[3] It is possible that
Cassatt painted this portrait of her new
sister-in-law during their visit.

A letter written in September 1885 by
the artist to her brother Alexander may
refer to the work: "I will send the portrait
to Gard [a large, recently completed pas-
tel of their father on his horse] as I have
never given him a portrait of Father and
he is disgusted because I won't send him
Jennie's portrait."[4] A drypoint by Cassatt
from 1888, *Gardner Cassatt Held by His
Mother* (fig. 10b), representing Jennie with
her young son, makes a convincing argu-
ment for this identification.

This painting has also been identified
as *Portrait of Mme J.*, which was exhibited
in the Fifth Impressionist Exhibition in
1880; however, if the sitter is, indeed,
Jennie Cassatt, such an assumption would
not be possible.[5]

PROVENANCE

Mary Cassatt; Durand-Ruel, Paris, 1924; Durand-
Ruel, New York, 1924; Peabody Institute of The City
of Baltimore, 1942; The Peabody Institute of The
Johns Hopkins University, Baltimore.

NOTES

1. André Mellério, *Exposition Mary Cassatt*
(Paris: Galeries Durand-Ruel, November–December
1893), as quoted in Nancy Mowll Mathews, ed.,
*Cassatt: A Retrospective* (New York: Hugh Lauter
Levin Associates, 1996), p. 202.

2. See Nancy Mowll Mathews, *Mary Cassatt*
(New York: Harry N. Abrams, in association with
the National Museum of American Art, Smithsonian
Institution, Washington, D.C., 1987), p. 59.

3. Frederick A. Sweet, *Miss Mary Cassatt:
Impressionist from Pennsylvania* (Norman:
University of Oklahoma Press, 1966), p. 80.

4. Mary Cassatt to Alexander Cassatt, September
1885, as quoted in Sweet, *Miss Mary Cassatt*, p. 107.

5. See Charles S. Moffett, ed., *The New Painting:
Impressionism, 1874–1886*, exh. cat. (San Francisco:
Fine Arts Museums of San Francisco, 1986), p. 321.

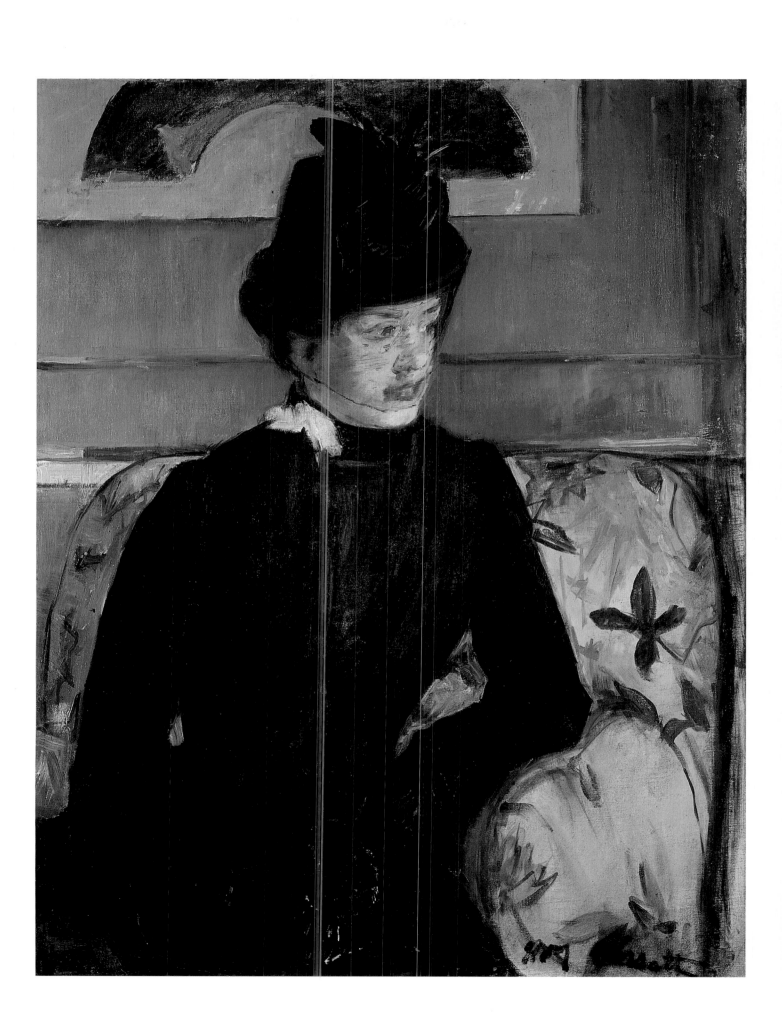

CAT. NO. II

MARY STEVENSON CASSATT
1844–1926

**Reine Lefebvre Holding a Nude Baby**
(1902–3)

Oil on canvas
26 ¹³/₁₆ x 22 ⁹/₁₆ inches (68.1 x 57.3 cm)

Worcester Art Museum, Worcester,
Massachusetts, Museum Purchase
(1909.15)

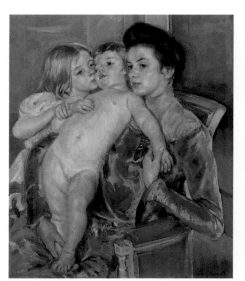

Fig. 11a. Mary Stevenson Cassatt. The
Caress. 1902. National Museum of
American Art, Smithsonian Institution,
Washington, D.C.: Gift of William T.
Evans, 1911

Fig. 11b. Mary Stevenson Cassatt. Little
Eve (L'Enfant). (c. 1902). Pastel on tan
paper. Frye Art Museum, Seattle,
Washington

In 1894, three years after her father's death, Cassatt and her mother moved into the seventeenth-century Château Beaufresne at Mesnil-Théribus, northwest of Paris. It would remain Mary Cassatt's country home for the rest of her life. In the autumn of the following year Katherine Kelso Cassatt died, leaving the artist bereft of family for the first time in almost twenty years.

After the turn of the century Cassatt continued to explore the theme of women and children, often relying on local models for subjects. During the period 1901–3, a young woman identified as Reine Lefebvre sat for a number of compositions that show her with children of various ages. She later recalled the experience of posing for these portraits: "Notre Mademoiselle [as Cassatt was called] always wore a white blouse while painting. She was serious but not severe, though I must say at times she was difficult. It was hard to pose at first but became easier when I got used to it."[1]

In this portrait Reine Lefebvre sits in an armchair similar to the one in *The Caress*, painted about the same time (fig. 11a). She wears a long-sleeved robe decorated with a brown border, its configuration adding a distinctive element of design to the composition. In her arms she holds a plump baby whose fair hair is in contrast to her own darker coloring. The child may be the same baby seen standing somewhat awkwardly on Reine's lap in *The Caress* as well as in other works of the period. A pastel titled *Little Eve (L'Enfant)* provides the only clue to her identity (fig. 11b).

In a letter to her good friend Louisine Havemeyer, written a number of years later, the artist expressed some frustration in dealing with her young models:

*It is not worthwhile to waste one's time over little children under three who are spoiled and absolutely refuse to allow themselves to be amused and are very cross, like most spoiled children. It is not a good age, too young and too old, for babies held in the arms pose very well.*[2]

PROVENANCE
From the artist to Durand-Ruel, Paris, c. 1902;
Durand-Ruel, New York.

NOTES
1. Frederick A. Sweet, *Miss Mary Cassatt:
Impressionist from Pennsylvania* (Norman:
University of Oklahoma Press, 1966), p. 148.
2. Cassatt to Havemeyer, 8 March 1909, as
quoted in Adelyn Dohme Breeskin, *Mary Cassatt:
A Catalogue Raisonné of the Oils, Pastels,
Watercolors, and Drawings* (Washington, D.C.:
Smithsonian Institution Press, 1970), p. 17.

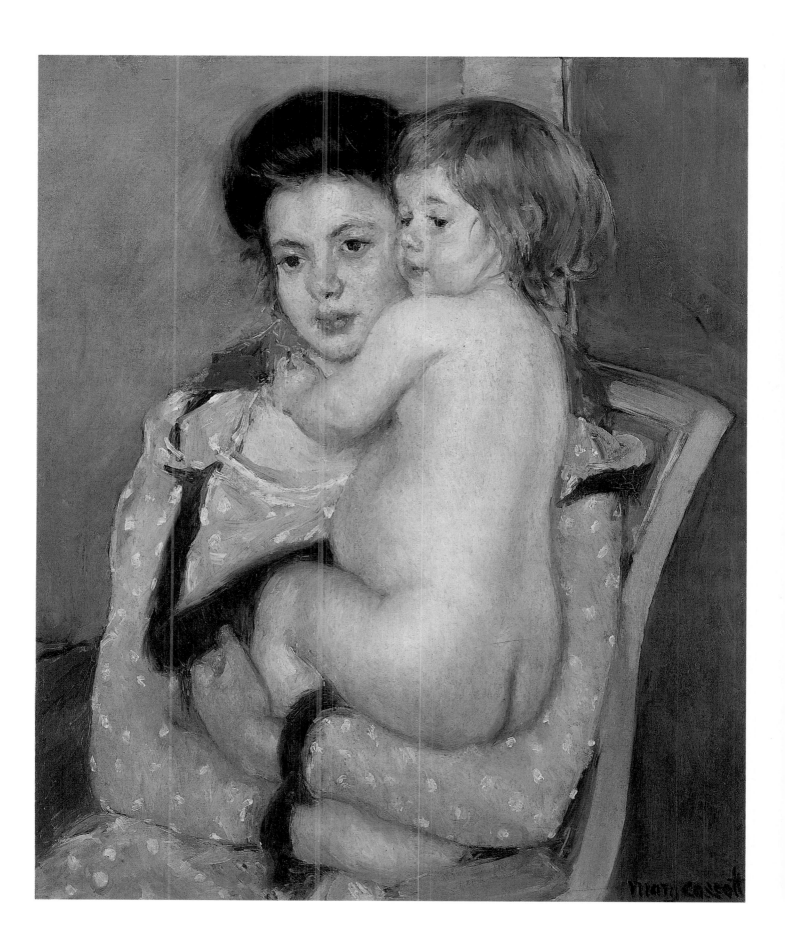

MARY STEVENSON CASSATT
1844–1926

*Ellen Mary Cassatt in a Big Blue Hat*
(c. 1905)

Oil on canvas
32 ⅛ x 23 ⅜ inches (81.6 x 59.4 cm)

Dr. Herchel Smith, Courtesy of the
Williams College Museum of Art
(EL.77.1.1)

Ellen Mary (1894–1966) was the second child of Cassatt's youngest brother, Joseph Gardner, and his wife, Jennie (see cat. no. 10). She would be the subject of numerous portraits by her aunt, which record her passage from infancy through childhood.

In the autumn of 1895, at the time of Katherine Kelso Cassatt's death, Gardner traveled to Europe with his family for a two-year visit.[1] During this period the artist painted her first portrait of young Ellen Mary, seated in an armchair and wearing a white fur-trimmed bonnet and coat (fig. 12a).

This representation depicts Ellen Mary several years later. Posed somewhat formally, her expression appropriately solemn, she wears an enormous broad-brimmed hat decorated with an elaborate blue ribbon. Although her features are carefully articulated, the rest of the composition is only suggested. In this regard the likeness is reminiscent of Cassatt's earlier portrait of Mrs. Currey, painted in Philadelphia around 1871 (see cat. no. 6).

Mary Cassatt was apparently especially fond of her niece. A letter from the artist to Ellen Mary written in 1913 in response to inquiries about "cubists and others" implies that they exchanged thoughts on various artistic matters.[2] When she married in 1924 Ellen Mary, together with her new husband, Horace Binney Hare, visited her elderly aunt in France, and upon Cassatt's death in 1926 she inherited the artist's country retreat, Château Beaufresne, and its contents.[3]

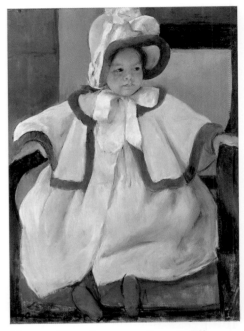

*Fig. 12a. Mary Stevenson Cassatt.* Ellen Mary Cassatt in a White Coat. *(c. 1896). Anonymous fractional gift in honor of Ellen Mary Cassatt, courtesy Museum of Fine Arts, Boston*

PROVENANCE
Robert Kelso Cassatt, the artist's nephew;
Mr. and Mrs. Richman Proskauer, New York;
Hirschl & Adler Gallery, New York, c. 1977.

NOTES
1. Frederick A. Sweet, *Miss Mary Cassatt: Impressionist from Pennsylvania* (Norman: University of Oklahoma Press, 1966), p. 149.
2. Cassatt to Ellen Mary Cassatt, 26 March 1913[?], in Nancy Mowll Mathews, ed., *Cassatt and Her Circle: Selected Letters* (New York: Abbeville Press, 1984), p. 310.
3. Sweet, *Miss Mary Cassatt*, pp. 206 and 212.

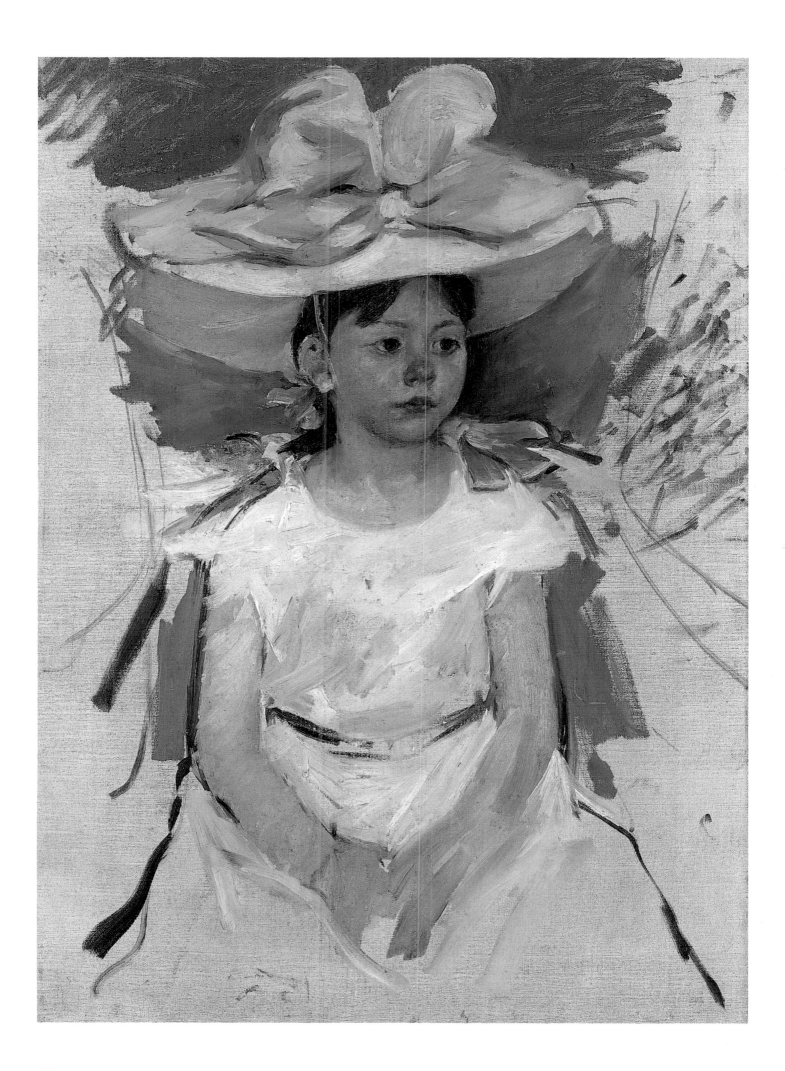

CAT. NO. 13
PAUL CÉZANNE
1839–1906

*Antony Valabrègue*
(1866)

Oil on canvas
45 ¾ x 38 ¾ inches (116.3 x 98.5 cm)

National Gallery of Art, Washington:
Collection of Mr. and Mrs. Paul Mellon
(1970.35.1)

*Fig. 13b. Photograph of Antony Valabrègue. (n.d.). Rewald/Cézanne Archive, Courtesy of the Photographic Archives of the National Gallery of Art, Washington, D.C.*

A native of Aix-en-Provence in southern France, Cézanne received his earliest education in local schools, among them the Collège Bourbon, where, about 1852, he met the novelist and critic Émile Zola (1840–1902), who would become a devoted friend. Five years later he enrolled in the École Municipale de Dessin and continued to attend classes while also studying law in deference to his father's wishes. In 1861, however, Cézanne left Aix for Paris to pursue a career as a painter. Throughout the 1860s he journeyed regularly back and forth between the two cities. Summers were generally spent at Aix, and the artist maintained close ties with a number of the city's aspiring young painters and men of letters.

Among these acquaintances was Antony Valabrègue (1844–1900), a poet, who, like Zola, had been a boyhood friend. In the spring of 1866 Valabrègue sat for this portrait, which, in its dark tonality and thick, vigorous application of paint, typifies much of the artist's early production. The sitter's severe expression and clenched fists barely resting on his legs bring a certain tension to the characterization.

Cézanne submitted the painting to the Salon of 1866, fully expecting it to be rejected. Valabrègue reported the jury's decision to a friend:

*A Philistine in the jury exclaimed on seeing my portrait that it was not only painted with a knife but even with a pistol. Many discussions have already arisen. Daubigny* [the painter Charles François Daubigny] *said some words in defense* [of the portrait]. *He declared that he preferred pictures brimming over with daring to the nullities which appear at every Salon. He didn't succeed in convincing them.[1]*

In the mid-1860s the artist would produce a number of images employing a similar technique, most notably a series of some ten bust portraits of his maternal uncle, Dominique Aubert, a bailiff, who is depicted in a variety of guises (see House, fig. 11).[2] Valabrègue commented to Zola about these works as they progressed:

*Luckily I had to pose for only one day, but the uncle serves as a model more often. Every afternoon another portrait of him appears, while Guillemet*

[Antoine Guillemet, a painter friend] *overwhelms him with atrocious jokes.[3]*

Antony Valabrègue appears again with Antoine Fortuné Marion, a scientist and amateur painter, in an 1866 composition, *Marion and Valabrègue Setting Out for the Motif* (private collection, Mexico), which represents the pair about to venture into the countryside to paint. Two other portraits painted in subsequent years record a somewhat more mature, contemplative Valabrègue.

In a number of letters from the 1870s and early 1880s, Cézanne speaks of Valabrègue; however, the two men eventually drifted apart. Writing to Zola in 1884, the artist would refer, with nostalgia, to one of their last encounters:

*Finding myself in L'Estaque, I received a handwritten letter from good Valabrègue, Antony, telling me he was in Aix, whence I hied myself at once, yesterday, and where I had the pleasure of seeing him this morning, Saturday. We took a stroll through town together—recalling some of those we had known—but how different our feelings are now![4]*

PROVENANCE
Ambroise Vollard, Paris; Breysse; Ambroise Vollard, Paris; Bernheim-Jeune, Paris; Auguste Pellerin, Paris; Jean-Victor Pellerin, Paris; Wildenstein Galleries, Paris, London, and New York; private collection, Switzerland; Mr. and Mrs. Paul Mellon, Upperville, Virginia.

NOTES
1. Valabrègue to Antoine Fortuné Marion, boyhood friend of Cézanne, 1 April 1866, from M. Scolari and A. Barr, Jr., "Cézanne in the Letters of Marion to Morsatt 1865–1868," *Magazine of Art* (February–April–May 1968), as quoted in John Rewald, *The History of Impressionism,* 4th rev. ed. (New York: Museum of Modern Art, 1973), p. 139.

2. See for instance *L'Avocat,* c. 1866, Musée d'Orsay, Paris; *Portrait d'un moine (L'Oncle Dominique),* c. 1866, The Metropolitan Museum of Art, New York; and *L'homme au bonnet de coton (L'Oncle Dominique),* c. 1866, The Metropolitan Museum of Art, New York.

3. Valabrègue to Zola, November 1866, in Lawrence Gowing et al., *Cézanne: The Early Years, 1859–1872,* exh. cat. (Washington, D.C.: National Gallery of Art, in association with Harry N. Abrams, 1988), p. 100.

4. Cézanne to Zola, 23 February 1884, in John Rewald, ed., *Paul Cézanne: Letters,* trans. Seymour Hacker (New York: Hacker Art Books, 1984), p. 213.

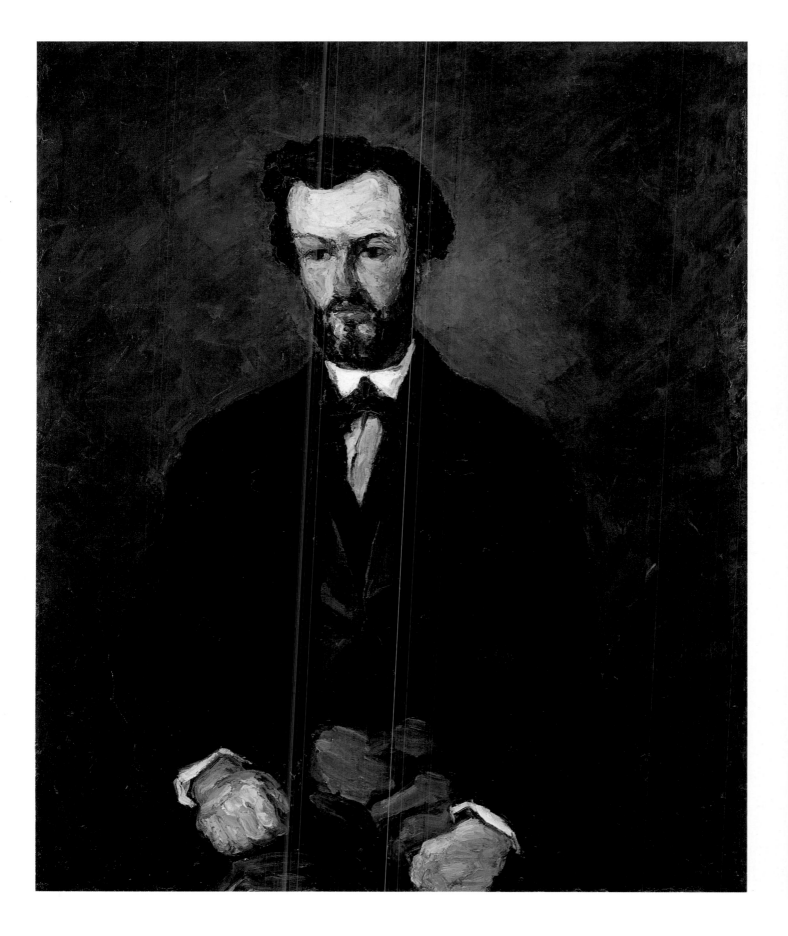

*Fig. 14b. Pierre-Auguste Renoir (1841–1919). Victor Chocquet. (c. 1875). Fogg Art Museum, Harvard University Art Museums, Cambridge: Bequest of Grenville L. Winthrop*

CAT. NO. 14
PAUL CÉZANNE
1839–1906

***Victor Chocquet in an Armchair***
(1877)

Oil on canvas
18 x 15 inches (45.7 x 38.1 cm)

Columbus Museum of Art, Ohio: Museum Purchase, Howald Fund (50.024)

*Fig. 14a. Photograph of Victor Chocquet. (n.d.). Document found among Cézanne's papers. Rewald/Cézanne Archive, Courtesy of the Photographic Archives of the National Gallery of Art, Washington, D.C.*

The collector Victor Chocquet (1821–1891) is reported to have met Cézanne through Renoir in 1875, shortly after he had purchased Cézanne's *Three Bathers* (c. 1874–75; Musée d'Orsay, Paris). Ultimately, Chocquet would own more than thirty paintings by Cézanne. A minor government official from Lille, Chocquet became an impassioned supporter of the Impressionists, not only acquiring their works but also defending them in public, notably at the Impressionist exhibition in 1877. According to critic Georges Rivière:

> He [Chocquet] *was something to see, standing up to hostile crowds at the exhibition . . . . He accosted those who laughed, making them ashamed of their unkind comments, lashing them with ironic remarks . . . . Hardly had he left one group before he would be found, farther along, leading a reluctant connoisseur, almost by force, up to canvases by Renoir, Monet, or Cézanne, doing his utmost to make the man share his admiration for these reviled artists. . . . He exerted himself tirelessly without ever departing from that refined courtesy that made him the most charming, and the most dangerous adversary.*[1]

It is likely that Cézanne produced his first portrait of the collector in late 1876 or early 1877 (*Portrait of Victor Chocquet*, private collection). Shown at the Impressionist Exhibition that spring, it provoked a storm of criticism, one journalist warning a pregnant woman to refrain from viewing it lest it should "give yellow fever to her fruit before it came into the world."[2]

The setting for the small full-length image considered here was the dining room of the Chocquet residence on the Rue de Rivoli overlooking the Tuileries Gardens.[3] Seated comfortably in an elegant armchair, the collector is depicted among his possessions, most conspicuously, the canvases in elaborate gilt frames mounted close together on the wall behind him. Chocquet's pose, with his fingers intertwined, repeats that seen in an earlier likeness by Renoir (fig. 14b).

In all, Cézanne painted six portraits and made a number of drawings of the collector, who became a trusted friend. In April 1886, he would write to Chocquet:

> *How I would have liked to possess the intellectual balance so notable in you and that enables you to attain the goals you set. . . . Fate did not provide me with similar fare, it's my only regret where earthly matters are concerned. As for the rest, I can't complain. The sky and the infinite elements of nature still attract me and provide me with opportunity to take pleasure in looking.*[4]

At the Paris sale of the Chocquet collection in July 1899, Edgar Degas bid unsuccessfully on *Victor Chocquet in an Armchair* for his personal collection, calling it "the portrait of one madman by another."[5]

PROVENANCE

Victor Chocquet; his widow, Caroline Buisson Chocquet; Chocquet Sale, Galerie Georges Petit, Paris, July 1899; Durand-Ruel Gallery, New York, by 1929; Lillie P. Bliss, New York, until 1931; The Museum of Modern Art, New York, by bequest; deaccessioned June 1941; Paul Rosenberg Gallery, New York; Marius de Zayas, Greenwich, Connecticut; Paul Rosenberg Gallery, New York, 1947.

NOTES

1. Georges Rivière, as quoted in Anne Distel, *Impressionism: The First Collectors*, trans. Barbara Perroud-Benson (New York: Harry N. Abrams, 1990), p. 137.

2. Louis Leroy, "Exposition des impressionistes," *Le Charivari* (11 April 1877), as quoted in Françoise Cachin et al., *Cézanne*, exh. cat. (Philadelphia: Philadelphia Museum of Art, 1996), p. 167.

3. John Rewald, "Chocquet and Cézanne," *Gazette des Beaux-Arts*, 6th ser., 74 (July–August 1969), p. 52. Rewald's article is the most comprehensive study of the relationship between the two men.

4. Cézanne to Chocquet, 11 May 1886, in John Rewald, ed., *Paul Cézanne: Letters*, trans. Seymour Hacker (New York: Hacker Art Books, 1984), p. 224.

5. Degas's comment was recorded by Julie Manet in her journal on 1 July 1899. See Julie Manet, *Journal, Extraits, (1893–1899)*, 2nd ed. (Paris, 1988), p. 174, as quoted in Françoise Cachin, *Cézanne*, p. 167.

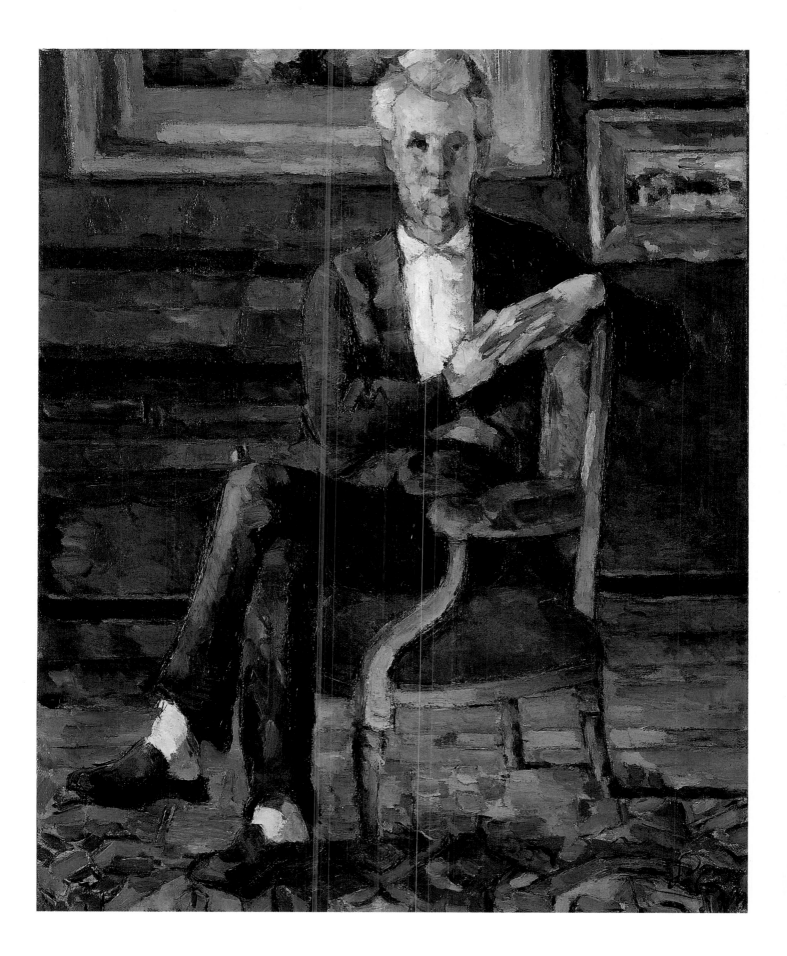

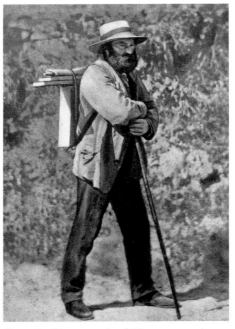

*Fig. 15b. Photograph of Cézanne on the way to paint. (c. 1874). Rewald/Cézanne Archive, Courtesy of the Photographic Archives of the National Gallery of Art, Washington, D.C.*

CAT. NO. 15
PAUL CÉZANNE
1839–1906

*Self-Portrait*
(1878–80)

Oil on canvas
23 ¾ x 18 ½ inches (60.3 x 47 cm)

The Phillips Collection, Washington, D.C.
(0288)

Cleveland and Houston only

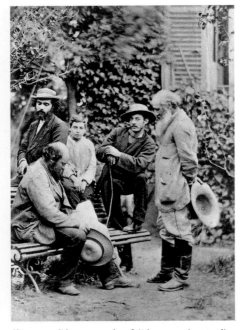

*Fig. 15a. Photograph of Cézanne (seated) and Pissarro (far right) in Pissarro's garden at Pontoise. (c. 1874). Rewald/Cézanne Archive, Courtesy of the Photographic Archives of the National Gallery of Art, Washington, D.C.*

In the course of his career Cézanne created many self-portraits in a variety of mediums. His earliest, dated c. 1861–62, is a brooding, almost sinister image, based on a photograph, in which he engages the viewer with dark, expressive eyes (*Self-Portrait*, private collection). By the late 1860s he had acquired a distinctive full beard, and his hair had thinned considerably. Georges Rivière described his appearance:

*At age thirty: [he was] a tall, solid man perched on rather slender legs. . . . His noble face, surrounded by a black curly beard, recalled the figures of the Assyrian gods. His large eyes, sparkling brilliantly and extremely mobile, presiding over a fine but slightly bent nose, tended to give his physiognomy an oriental character. He generally had a serious air, but when he spoke, his features grew animated, and he accompanied his words with expressive gestures.[1]*

In contrast to earlier self-portraits, the present likeness, painted toward the end of the 1870s, shows a calm man, seemingly confident and at peace with himself.

The 1870s had been marked by major events in Cézanne's personal and public life. Early in 1872 his mistress, Hortense Fiquet, gave birth to a son, Paul, and the small family left Paris to live at Pontoise, a village on the Oise River, northwest of Paris. There the artist worked out-of-doors with Camille Pissarro, for whom he had a profound admiration. Cézanne exhibited with the Impressionists during this period, in 1874 and again in 1877, but

he vowed not to take part in subsequent shows because of the harsh criticisms his works had engendered. Indeed, disdain and a certain arrogance may also be read into this evocative image.

In the autumn of 1894 the artist visited his friend Claude Monet at Giverny, remaining for several weeks. In an effort to entertain Cézanne, Monet invited a group of acquaintances to Giverny, confirming the arrangement with journalist Gustave Geffroy, one of the guests. Mindful of Cézanne's temperamental personality, he fretted:

*We are on for Wednesday. I hope that Cézanne will still be here and that he will join us, but he is so peculiar, so timid about seeing new faces, that I am afraid that he might not be of the company, despite his desire to meet you. What a tragedy that this man has not had more support in his life. He is a true artist, who has come to lose too much faith in himself.[2]*

Shortly after purchasing this self-portrait in 1928, the collector Duncan Phillips wrote:

*For ultimate consummation, for working within self-imposed bounds to the end that there shall be no touch of color which is not functional and structural, for restrained, self-contained mastery of material, nothing in the museums can surpass the subtle, solid modeling of that head of an old lion of a man, the pride and the loneliness of him so directly conveyed by purely plastic means.[3]*

PROVENANCE
Ambroise Vollard, Paris; Paul Cassirer, Berlin; Theodor Behrens (1857–1921), Hamburg, in 1912; Baron Leo von Koenig, Berlin-Schlachtensee, c. 1920; Paul Rosenberg, Paris, by 1928; Duncan Phillips, Washington, D.C.

NOTES
1. Georges Rivière, *Le Maître Paul Cézanne* (Paris, 1923), p. 76, as quoted in Françoise Cachin et al., *Cézanne*, exh. cat. (Philadelphia: Philadelphia Museum of Art, 1996), p. 20.
2. Monet to Geffroy, 23 November 1894, in Gustave Geffroy, *Monet: Sa vie, son oeuvre* (Paris, 1924), as quoted in Charles F. Stuckey, ed., *Monet: A Retrospective* (New York: Hugh Lauter Levin Associates, 1985), p. 174.
3. John Rewald, in collaboration with Walter Feilchenfeldt and Jayne Warman, *The Paintings of Paul Cézanne: A Catalogue Raisonné*, vol. 1 (New York: Harry N. Abrams, 1996), p. 251.

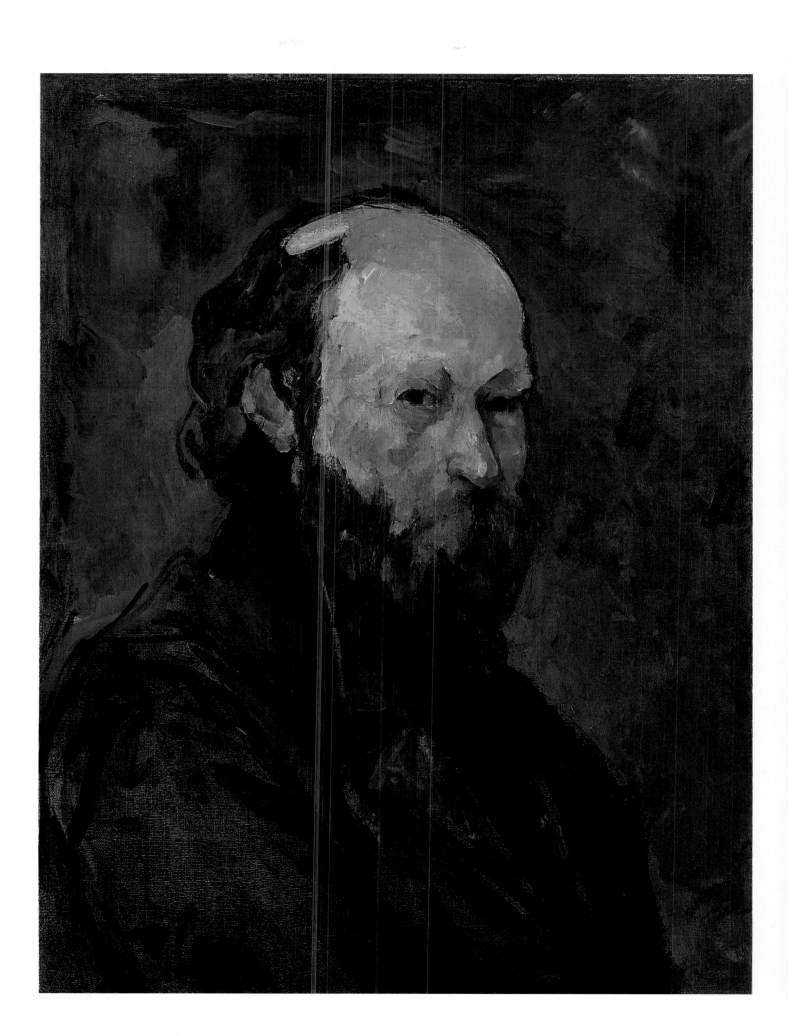

CAT. NO. 16
PAUL CÉZANNE
1839–1906

*Madame Cézanne in Blue*
(1888–90)

Oil on canvas
29 3/16 x 24 inches (74.2 x 61 cm)

The Museum of Fine Arts, Houston: The
Robert Lee Blaffer Memorial Collection,
Gift of Sarah Campbell Blaffer (1947.29)

Cézanne met Hortense Fiquet (1850–1922),
a young model, in Paris at the beginning of
1869. Born in the Jura in eastern France
into a family of modest means, she had
moved to Paris as a child. With the out-
break of the Franco-Prussian War in July
1870, Cézanne and Fiquet, now a couple,
fled south to L'Estaque, not far from Aix.
Following the birth of their only child,
Paul, in January 1872, they lived at
Pontoise and later at nearby Auvers-sur-
Oise, where the artist painted with Camille
Pissarro. For many years, Cézanne con-
cealed the existence of his small family
from his father; however, when he and
Hortense finally married on 28 April 1886,
his elderly parents were in attendance.

Although Cézanne and his wife appar-
ently spent extended periods living apart,
he painted more than forty portraits of
her and also executed a number of draw-
ings. For the most part, Hortense is por-
trayed seated frontally with her hands
resting in her lap. Her severe hairstyle is
only occasionally softened by a mound of
curls. Variations occur in settings and in
her clothing, the latter an indication of
her interest in fashion.[1] However,
although the format of these likenesses
may appear somewhat repetitious, the
individual characterizations are subtly
varied and probing. Patience, a certain
resignation, and perhaps boredom mark
some images, while others hint of more
contrary, negative emotions.

This portrait, from the end of the 1880s,
shows Hortense seated in the couple's Paris
apartment on the Île-Saint-Louis, where
they resided from 1888 to 1890, years dur-
ing which the artist painted several notable
images of his wife.[2] Typically, her expres-
sion betrays little of her psychological
state, reflecting only a certain passivity as
she complies with the task of posing, which
she has performed often in the past.
Although Hortense occupies the center of
this composition, her position, leaning
slightly to one side, together with barely
perceptible irregularities in her features
and the somewhat ambiguous forms in the
background, gives an unsettling aspect to
the likeness.

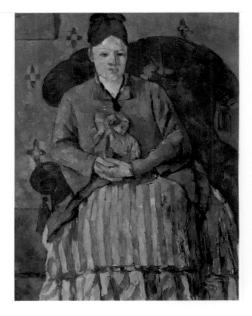

*Fig. 16a. Paul Cézanne.* Madame Cézanne
in a Red Armchair. *(c. 1877). Museum
of Fine Arts, Boston: Bequest of Robert
Treat Paine, 2nd (44.776)*

PROVENANCE
Ambroise Vollard, Paris; Walther Halvorsen, Oslo;
Galerie Thannhauser, Lucerne; Étienne Bignou,
Paris; Knoedler Galleries, New York, in 1930;
Mrs. Robert Lee Blaffer, Houston, in 1948.

NOTES
  1. For a discussion of Hortense Fiquet's interest
in fashion, see Anne H. van Buren, "Madame
Cézanne's Fashions and the Dates of Her Portraits,"
*The Art Quarterly* 29, no. 2 (1966), pp. 111–27.
  2. See Joseph J. Rishel in Françoise Cachin et al.,
*Cézanne*, exh. cat. (Philadelphia: Philadelphia
Museum of Art, 1996), p. 308.

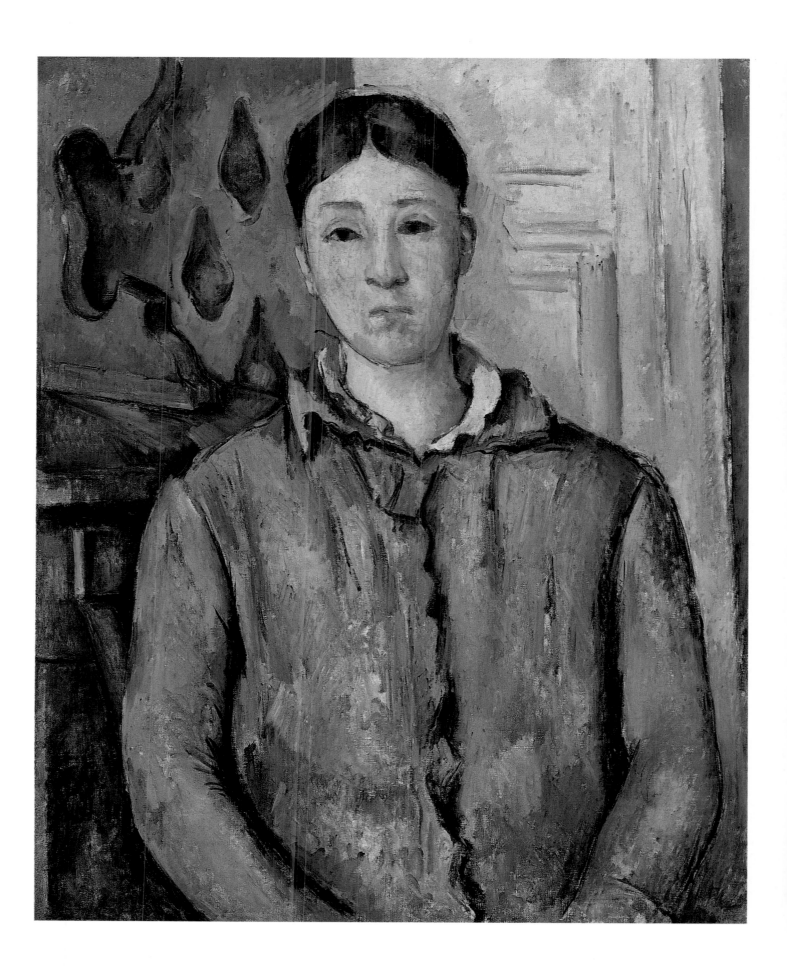

CAT. NO. 17
PAUL CÉZANNE
1839–1906

*Portrait of Madame Cézanne with Loosened Hair*
(1890–92)

Oil on canvas
24 3/8 x 20 1/8 inches (61.9 x 51.1 cm)

Philadelphia Museum of Art: The Henry P. McIlhenny Collection in Memory of Frances P. McIlhenny (1986.26.1)

Correspondence among Cézanne's friends who clearly cared deeply for him reveals his deteriorating relationship with Hortense in the early 1890s. In response to an inquiry from Émile Zola for news of the artist, a mutual acquaintance, the novelist Paul Alexis (1847–1901), replied from Aix:

> *He* [Cézanne] *is furious with Globe* [Hortense] *who, after a year's stay in Paris, punished him with five months' in Switzerland and hotel food last summer . . . . After Switzerland, the Globe, escorted by her bourgeois son, made her way back to Paris. However, by cutting off her allowance, he forced her to retreat back to Aix.[1]*

The letter continues with further criticisms of Madame Cézanne and references to the couple's general unhappiness.

Such comments, however, seem in marked contradiction to the artist's portrayal of his wife in this painting, probably dating from the early 1890s. Rather than pulled back tightly off her face, Hortense's hair flows loosely down her back, the stripes of her dress echoing the vertical movement. Her head bows slightly to the left as she gazes into the distance, seemingly absorbed in private reflection. In contrast to the many representations of his wife in which she appears somewhat dispassionate, Cézanne here has captured a profound sense of sadness, and in doing so may, briefly, have shared the emotion. Just as Édouard Manet revealed Victorine Meurent (see cat. no. 34) devoid of her various guises, so too perhaps Cézanne presents Hortense free of the imperfections he so often perceived in her character.

PROVENANCE
Ambroise Vollard, Paris; Walther Halvorsen, Oslo; Ambroise Vollard, Paris, by 1914; Gottlieb Friedrich Reber, Lausanne; Paul Rosenberg Gallery, Paris, by 1929; Samuel Courtauld, London; Paul Rosenberg Gallery, New York, 1950s; Henry P. McIlhenny, Philadelphia.

NOTE
1. Alexis to Zola, February 1891, in John Rewald, ed., *Paul Cézanne: Letters*, trans. Seymour Hacker (New York: Hacker Art Books, 1984), p. 231.

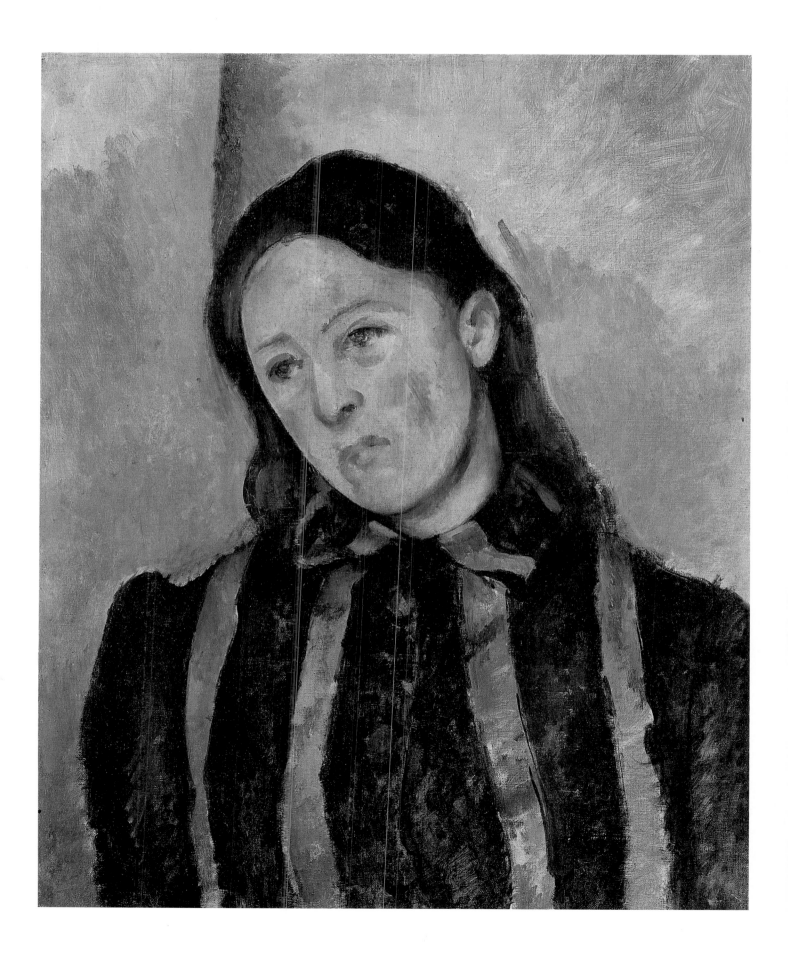

CAT. NO. 18
GUSTAVE COURBET
1819–1877

*Portrait of Clément Laurier*
1855

Oil on canvas
39 3/8 x 31 3/4 inches (100.1 x 80.7 cm)

Milwaukee Art Museum: Gift of Friends
of Art (M 1968.31)

In his passionate commitment to record contemporary life, Gustave Courbet anticipated the Impressionist movement. Born in Ornans in eastern France, he was the son of a well-to-do farmer who had hoped that his son would study law. Young Courbet, however, dismissed his father's desires and in 1839 went to Paris to pursue a career as a painter. Although he had received some artistic instruction prior to his arrival in the capital, he was mainly self-taught and chose instead to study the work of the Old Masters in the Louvre. Encountering the Flemish and Dutch masters on a visit to Belgium and Holland in 1846–47 reinforced his belief that the ordinary aspects of life furnished sufficient and indeed desirable subject matter for painting.

In 1855, the year of the Universal Exposition in Paris, Courbet mounted his own exhibition nearby in the "Pavilion of Realism," displaying forty works, among them two enormous compositions, *A Burial at Ornans* (1850; Musée d'Orsay, Paris) and *The Painter's Studio* (1855; Musée d'Orsay, Paris), that had been refused at the Exposition. In a catalogue accompanying his exhibition, the artist stated his aim "to be in a position to translate the customs, the ideas, the appearance of my epoch, according to my own estimation."[1] This declaration, as well as the concept of holding an exhibition independent of official circles, had a profound influence on the younger painters who would lead the Impressionist crusade.

During the late 1850s and 1860s Courbet turned increasingly to landscape and portraiture. In the latter, sitters are occasionally depicted against scenic backgrounds that do not define specific locales but rather suggest outdoor settings. The artist apparently knew Clément Laurier (1831–1878), a young barrister, as early as 1851, when he was a guest at Laurier's country estate, the Château Epineau, near Le Blanc in western France.[2] Here, the jurist poses in front of a loosely brushed dark landscape that evokes a rocky terrain beneath a dramatic sky, the bleak setting heightening his decidedly somber

attitude. His broad forehead, brooding eyes, and firm jaw convey a certain intransigence, which is reinforced by the gesture of his gloved hand thrust into his pocket. A year after Courbet executed this portrait, which he inscribed "*A mon ami Laurier*," he would paint a likeness of Laurier's mother-in-law, *Mme. Maquet* (1856; Staatsgalerie, Stuttgart).[3]

Initially, Laurier embraced a variety of liberal causes, and, by virtue of his expertise in financial matters, was instrumental in arranging government loans to help stabilize the economy after the Franco-Prussian War. As his career progressed, however, his reputation was clouded by a decidedly more reactionary stance on issues.[4] Two years after his death Laurier was described in a withering characterization as:

> *Skepticism personified, a fencer who draws his weapon for sheer pleasure, and to render red with his sword and white with his convictions. This little man without a chin, without lips, the head of a weasel, a harebrained fellow and one of the strongest "nobs" of his time, the Machiavelli of his era . . . A mean looking Machiavelli, a wag, a rummager, a rake.[5]*

PROVENANCE
Clément Laurier from the artist; Rodolphe d'Adler, Paris; Galliera, Paris, Sale 23 June 1963; Knoedler Gallery, New York.

NOTES
1. Pierre Courthion, ed., *Courbet raconté par lui-même et par ses amis*, vol. 2 (Geneva, 1950), p. 61.
2. Gerstle Mack, *Gustave Courbet* (New York: Alfred A. Knopf, 1951), p. 81.
3. See Alan Bowness et al., *Gustave Courbet*, exh. cat. (Paris: Editions des musées nationaux, 1977), p. 138.
4. Sarah Faunce and Linda Nochlin, *Courbet Reconsidered* (New York: Brooklyn Museum, 1988), p. 131.
5. Jules Vallès, writing in *L'Insurgé* (1880), as quoted in Bowness et al., *Gustave Courbet*, pp. 137–38.

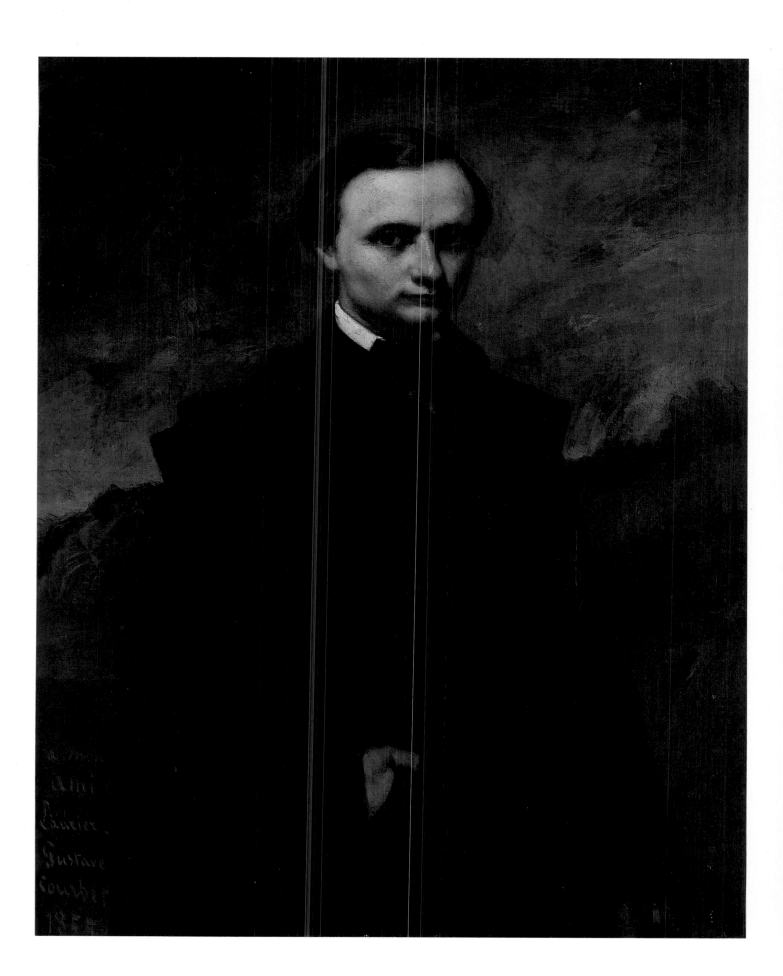

CAT. NO. 19
THOMAS COUTURE
1815–1879

*A Cuirassier*
(1856–58)

Oil on canvas
36 ¼ x 26 ⅝ inches (92.1 x 67.7 cm)

Joslyn Art Museum, Omaha, Nebraska:
Gift of C. N. Dietz (JAM.1948.39)

A student of the Romantic painter Antoine-Jean Gros (1771–1835) and, briefly, of Paul Delaroche (1797–1856), Couture began exhibiting at the Salon in 1840, where his somewhat moralizing, anecdotal compositions were favorably received by critics. In addition to portraits, he painted history, allegory, and genre pictures, and his most celebrated work, *The Romans of the Decadence* (1847; Musée d'Orsay, Paris), which he exhibited at the Salon, firmly established his reputation as a fresh and progressive presence.

From the late 1840s to 1860 Couture maintained a large and popular atelier, imparting to his students a method that emphasized robust, painterly brushwork and, in particular, adherence to the spontaneity of the sketch. In the late 1860s he published two treatises, *Méthodes et entretiens d'atelier* (1867) and *Paysage— entretiens d'atelier* (1869), in which he describes his innovative techniques and his attitudes about art. Among his better known pupils were Édouard Manet and Pierre-Cécile Puvis de Chavannes (1824–1898).

Although remembered chiefly as a history painter, Couture excelled in portraiture. Unencumbered by theatrical narrative, he produced images marked by penetrating revelations of the human condition. Here, a figure identified only as a cuirassier (an armor-clad soldier) is all but enveloped by his splendid military regalia. Shadows darken his face as he gazes with hooded eyes toward some remote vision.

For much of his career Couture enjoyed the patronage of the various governments that ruled France during the tumultuous years of the mid-nineteenth century. In 1856 he was commissioned by Napoleon III to paint a series of large decorations, none of which were completed, including a representation of the return of the French troops from the Crimea. This melancholy image, executed at the time of the unfilled commission, is both a portrait of an unknown officer and, more broadly, a reflection of the complex emotions associated with battle.

PROVENANCE
M. Perret, Paris; M. Barbedienne, Paris Sale, 2–3 June 1892, lot 54; Charles Sedelmeyer, Paris; John Wanamaker, Philadelphia; Schneider-Gabriel Galleries, New York.

CAT. NO. 20
## HILAIRE-GERMAIN-EDGAR DEGAS
1834–1917

*René De Gas*
(c. 1855)

Oil on canvas
36 ¼ x 29 ½ inches (92.1 x 75 cm)

Smith College Museum of Art,
Northampton, Massachusetts: Purchased
Drayton Hillyer Fund, 1935 (1935.12)

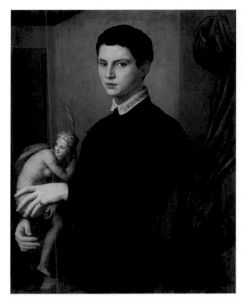

*Fig. 20a. Angelo di Cosimo Bronzino
(1503–1572). Portrait of a Sculptor.
(c. 1545). Musée du Louvre, Paris*

Portraiture preoccupied Degas throughout much of his career. Whether carefully delineating the familiar features of a family member or recording the likeness of an artist or musician friend in an intimate setting, he produced penetrating studies of human character.

A Parisian by birth, Edgar Degas was the oldest child in his family. His banker father had been born in Naples, and his mother was a native of New Orleans. After receiving his baccalaureate from the Lycée Louis-le-Grand in 1853, he registered to copy in the Louvre and at the Cabinet des Estampes of the Bibliothèque Nationale. Shortly before enrolling at the École des Beaux-Arts in the spring of 1855, Degas met Jean-Auguste-Dominique Ingres (1780–1867), whose emphasis on draftsmanship would have a profound influence on the young artist's evolving style.[1]

Degas's earliest likenesses are self-portraits and images of his immediate family. A series of drawings preceded this painting, which shows his youngest brother, René (1845–1926), at the age of eleven. Many years later, René would recall that during his childhood, "when he came home from school, he would barely have put away his books when Edgar would get hold of him and make him pose."[2]

Both René's general demeanor and his pose are reminiscent of sixteenth-century Italian portraiture, most notably the paintings of the Florentine Mannerist Bronzino (1503–1572), whose *Portrait of a Sculptor* (fig. 20a), Degas had copied in the Louvre.[3] The inkwell, notebooks, and the large volume on the table behind René, as well as the cap he holds in his right hand and his smock, all identify him as a student. His softly modeled features, smooth, full face, and somewhat apprehensive expression speak to the vulnerability and innocence of youth.

Later in life René De Gas spent several years in New Orleans managing a wine-importing business with his brother Achille (1838–1893). In 1869 he married a first cousin, Estelle Musson Balfour, who was blind (see cat. no. 22), but he deserted her nine years later for his mistress, Léonce Olivier. Following his return to France with Léonce, now his second wife, he became manager of the newspaper *Le Petit Parisien*. René was estranged for a time from his brother Edgar, who disapproved of his remarriage; however, they had reconciled by the late 1890s.[4]

This portrait remained in the artist's Paris studio until his death in 1917, when it passed to René.

PROVENANCE
Studio of the artist, Paris, until 1917; René De Gas, the artist's brother, Paris, 1918–21; Drouot, Paris, René De Gas Estate Sale, 10 November 1927, no. 72; Ambroise Vollard, Paris; Knoedler and Co., New York, 7 October 1933; Bignou, Paris, 1934.

NOTES
1. See Chronology in Jean Sutherland Boggs et al., *Degas*, exh. cat. (New York: Metropolitan Museum of Art; Ottawa: National Gallery of Canada, 1988), pp. 47–48.
2. René De Gas as told to Paul-André Lemoisne, as quoted in Marcel Guérin, *Dix-neuf Portraits de Degas par lui-même* (Paris: privately printed, 1931), in Boggs et al., *Degas*, p. 62.
3. Jean Sutherland Boggs, *Portraits by Degas* (Berkeley and Los Angeles: University of California Press, 1962), p. 6.
4. Boggs, *Portraits by Degas*, p. 115.

CAT. NO. 21

# HILAIRE-GERMAIN-EDGAR DEGAS
1834–1917

*Giovanna and Giuliana [Giulia?]*
*Bellelli*
(1862–64)

Oil on canvas
36 5/16 x 28 1/2 inches (92.3 x 72.4 cm)

Los Angeles County Museum of Art:
Mr. and Mrs. George Gard De Sylva
Collection (M46.3.3)

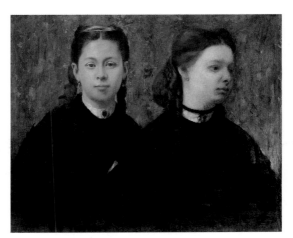

*Fig. 21a. Hilaire-Germain-Edgar Degas.* Double
Portrait, the Cousins of the Painter (Elena and
Camilla Montejasi-Cicerale). *1865. Wadsworth*
*Atheneum, Hartford, CT: The Ella Gallup Sumner*
*and Mary Catlin Sumner Collection Fund*

Double portraiture provided Degas with
the opportunity to examine relationships
between sitters. While some of these
paintings reflect uncomplicated associa-
tions, others convey complex psychologi-
cal interactions. The Bellelli sisters,
Giovanna (b. 1848) on the left, and Giulia
(1851–1922), were daughters of Degas's
aunt, Laura, and her husband, Baron
Gennaro Bellelli of Naples. They first
appeared in the artist's large group por-
trait *The Bellelli Family* (see House, fig.
14), begun in Florence in 1858 but not
completed until nearly a decade later.[1] In
that celebrated painting he shows the two
girls as children, nine and seven years of
age, posing with their mother and father
in a richly appointed salon.

Here, in a composition he first explored
in an unfinished painting from about 1858
(*Giovanna and Giulia Bellelli*, private
collection),[2] the artist has focused his
attention on the two girls. Although their
attire and accessories suggest a certain
maturity, the slight fullness apparent in
both faces betrays their still tender ages.

In *The Bellelli Family* the sisters are
posed somewhat formally on either side of
their mother. Although Degas has brought
them together in this composition, their
physical proximity is negated by lack of
engagement with each other. Turned away
from her sister, each figure occupies a sep-
arate space. Fair-haired Giovanna in the
foreground on the left looks in the direc-

tion of the viewer, her hands clasped
primly in front of her. The white collar
and coral pendant at her throat are in con-
trast to her black dress and emphasize her
warm complexion. Giulia, on the other
hand, seems strangely remote. Degas has
carefully drawn her profile, but her fea-
tures, although delicately rendered, seem
almost out of focus. Standing behind her
sister, she wears a brown dress that blends
with the muted tones of her surroundings.

At about the time this work was
created, Degas painted another double
portrait of two Neapolitan cousins,
the Montejasi-Cicerale sisters (fig. 21a).
Although Elena on the left looks toward
the viewer while Camilla turns away from
her sister, both subjects seem less psy-
chologically detached than the Bellellis.

As with the portraits of René De Gas and
of Edmondo and Thérèse Morbilli (see cat.
nos. 20 and 23), Degas retained *Giovanna*
*and Giulia Bellelli* until his death.

PROVENANCE
Artist's studio, Paris, until 1918; Paul Rosenberg,
Paris; Henri-Jean Laroche, Paris, 1928; Jacques
Laroches, Paris, 1937; Paul Rosenberg, New York;
Mrs. and Mrs. George Gard De Sylva, Holmby Hills,
California.

NOTES
   1. Jean Sutherland Boggs et al., *Degas*, exh. cat.
(New York: Metropolitan Museum of Art; Ottawa:
National Gallery of Canada, 1988), pp. 79–80.
   2. For a reproduction, see Boggs, *Degas*, p. 80.

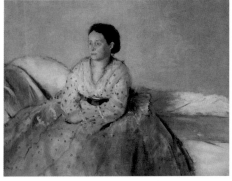

Fig. 22b. Hilaire-Germain-Edgar Degas. Madame René De Gas. (1872–73). National Gallery of Art, Washington: Chester Dale Collection (1963.10.124)

CAT. NO. 22
# HILAIRE-GERMAIN-EDGAR DEGAS
1834–1917

**Portrait of Estelle Musson Balfour**
(1863–65)

Oil on canvas mounted on panel
10 9/16 x 8 5/8 inches (26.8 x 21.9 cm)

The Walters Art Gallery, Baltimore,
Maryland (37.179)

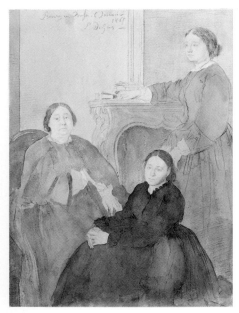

Fig. 22a. Hilaire-Germain-Edgar Degas.
Mme. Michel Musson and Her Two
Daughters, Estelle and Désirée. 1865.
Watercolor with touches of charcoal and
red chalk wash over graphite, heightened
with touches of white gouache on cream
wove paper. The Art Institute of Chicago:
Gift of Margaret Day Blake (1949.20)

Throughout the 1860s and 1870s Degas maintained strong ties with the American branch of his family. His mother, Marie-Céléstine Musson (1815–1847), had been born in New Orleans, where his uncle, Michel Musson (1812–1885), conducted a successful business in the cotton trade.[1]

In January 1862 Michel Musson's daughter Estelle (1843–1909), married Lazare David Balfour, an officer in the Confederate army. Tragically, he was killed nine months later at the battle of Corinth, only weeks before she gave birth to a child, Estelle Joséphine. The following spring the young widow, accompanied by her infant daughter; her mother, Odile; and an unmarried sister, Désirée, left Louisiana for France, where they would remain until the end of the Civil War in America.

Shortly after the family arrived in Paris, Degas wrote to his Uncle Michel, noting especially Estelle's plight:

> Your family arrived here last Thursday, June 18. . . . It would be impossible for them to be better or more unassuming. . . . As for Estelle, poor little woman, one cannot look at her without thinking that before that face are the eyes of a dying man.[2]

The four refugees settled in Bourg-en-Bresse in eastern France, not far from Mâcon, and Degas is known to have visited them at least twice in the course of their eighteen-month sojourn. This intimate portrait of Estelle, still in mourning, is thought to have been painted during this period. Placed in the immediate foreground, she is depicted against a stand of barren trees in the distance. With her eyes cast down and mouth small and tight, her image reflects the recent adversity in her life.

In 1865 the Mussons returned to New Orleans, accompanied by René De Gas (see cat. no. 20), who, together with another brother, Achille, would establish a wine-importing business in the city. Four years later Estelle and René were married;

however, by that time, she had become completely blind, the deterioration of her eyesight apparently having begun several years earlier. Her condition was noted by her brother-in-law Edgar in a letter from New Orleans written during his journey to America in 1872–73. Ironically, Degas himself was already feeling the effects of eye problems that would render him virtually blind in his last years:

> My poor Estelle, René's wife, is blind as you know. She bears it in an incomparable manner; she needs scarcely any help about the house. She remembers the rooms and the position of the furniture and hardly ever bumps into anything. And there is no hope![3]

Misfortune would enter Estelle's life once again in 1878, when René abandoned her in order to marry his mistress. As a consequence, the artist severed his ties with his brother until the late 1890s.

Degas executed a number of images of his cousin Estelle in the 1860s and 1870s including a drawing, Mme. Michel Musson and Her Two Daughters, Estelle and Désirée (1865; fig. 22a) and Mme. René De Gas (1872–73; fig. 22b).

At some point the small portrait considered here was acquired by the artist's close friend Mary Cassatt. In May 1903 it was purchased from her, together with Claude Monet's Springtime (c. 1872; cat. no. 43), by Henry Walters of Baltimore.[4]

PROVENANCE
Purchased together with Monet's Springtime (cat. no. 43), from Mary Cassatt, 1903, by Henry Walters.

NOTES
1. A comprehensive account of Degas's New Orleans family is found in John Rewald, "Degas and His Family in New Orleans, Gazette des Beaux-Arts 6th ser., 30 (August 1946), pp. 105–26.
2. Degas to Musson, 25 June 1863, as quoted in Jean Sutherland Boggs, "'Mme. Musson and Her Two Daughters' by Edgar Degas," The Art Quarterly 19, no. 1 (spring 1956), p. 60.
3. Degas to his friend the musician Désiré Dihau, 11 November 1872, in Marcel Guérin, ed., Degas Letters, trans. Marguerite Kay (Oxford: Bruno Cassirer, 1947), p. 15.
4. William R. Johnston, The Nineteenth Century Paintings in the Walters Art Gallery (Baltimore: Trustees of the Walters Art Gallery, 1982), p. 134.

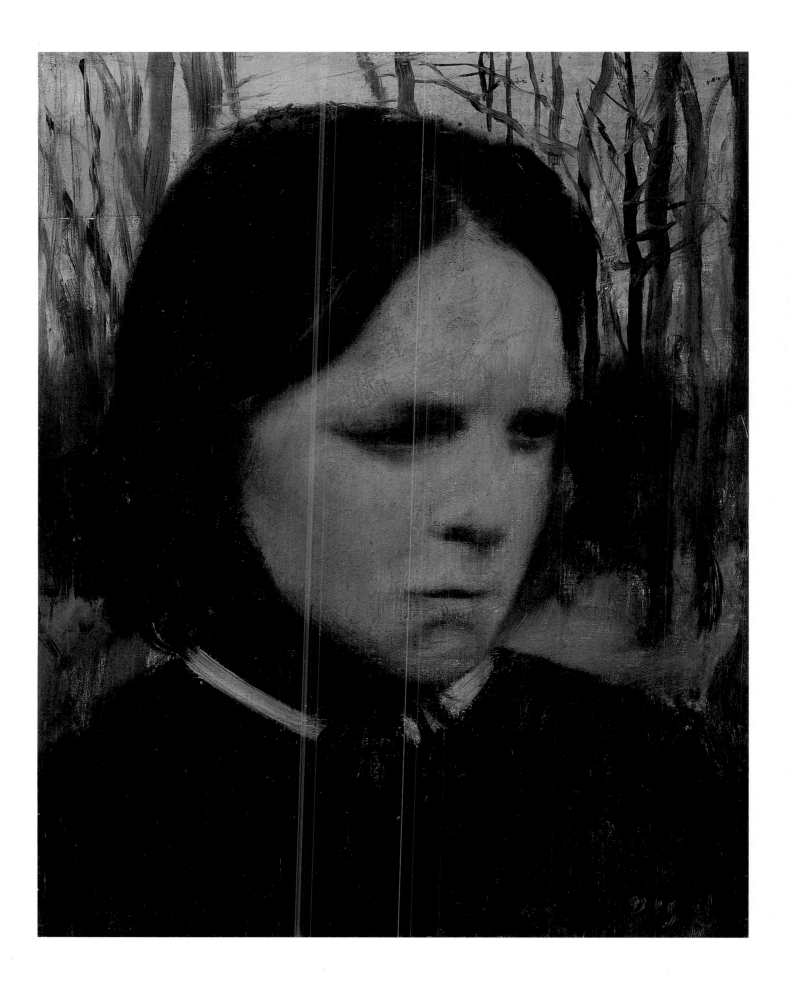

CAT. NO. 23
HILAIRE-GERMAIN-EDGAR DEGAS
1834–1917

**Edmondo and Thérèse Morbilli**
(c. 1865/67)

Oil on canvas
45 ⅞ x 34 ¾ inches (116.5 x 88.3 cm)

Museum of Fine Arts, Boston: Gift of
Robert Treat Paine, 2nd (31.33)

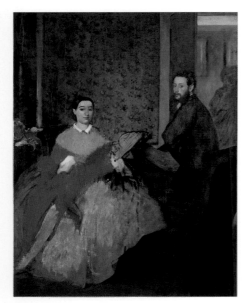

*Fig. 23a. Hilaire-Germain-Edgar Degas.*
Edmondo and Thérèse Morbilli. *(c. 1863).*
*National Gallery of Art: Chester Dale*
*Collection (1963.10.125)*

In the summer of 1856 Degas departed for a three-year sojourn in Italy, where he visited family in Naples and Florence and made excursions to Rome and surrounding hill towns. Much of his time was spent copying works in museums, but he also attended classes in the French Academy at the Villa Medici in Rome and continued to paint portraits of various family members.

While in Florence in the autumn of 1858, the artist received a letter of encouragement from his father in response to an expression of frustration and boredom with portraiture:

> *Calm your mind and follow . . . that path which lies open before you, which you yourself have laid open. It is yours and yours alone. Work peacefully in this fashion, I tell you, and you can be sure you will achieve great things. You have a splendid career ahead of you. Do not be discouraged, and do not torment yourself. . . . You speak of the boredom you suffer in doing portraits: you must overcome this later on, for portraiture will be one of the finest jewels in your crown.[1]*

Edmondo Morbilli (1836–1894), a Neapolitan cousin, seems to have taken an early interest in Degas's painting career. Two years younger than the artist, he nonetheless wrote somewhat paternalistically from Naples following Edgar's return to Paris in the spring of 1859. "Now you have your own studio; that will make you feel more like working, though I do not think the desire is lacking; what you need is the courage to reach your goal."[2]

Thérèse De Gas (1840–1897), the artist's younger sister, met Edmondo Morbilli in the course of her own visits to Naples. The relationship flourished and led to their marriage at the church of La Madeleine in Paris on 16 April 1863.[3] In the months following their wedding Degas painted a double portrait (fig. 23a) in which Thérèse, who was expecting a child, is shown with her husband seated nearby, their demeanors reflecting a certain contentment as they contemplate their impending parenthood. Tragically, she would lose the baby in the course of the pregnancy.

The present portrait, painted a few years later, reveals a profound change in the couple's aspects. Husband and wife sit close to each other with Edmondo occupying a dominant foreground position, overshadowing his wife. His posture as well as his expression exude confidence, if not a certain arrogance. In contrast, Thérèse seems both anxious and vulnerable. As she holds one hand to her face, she gently places the other on her husband's shoulder as if to draw strength from his presence. Both figures are silhouetted against a somewhat abstract background suggesting drapery; however, the details of their attire and jewelry, and of the Turkish table covering with its intricate calligraphy, including a *tuğra* or royal cipher, are carefully drawn.

The Morbillis apparently led quiet, uneventful lives. At one point Thérèse hoped that her husband could bring about a reconciliation between her estranged brothers Edgar and René; however, he refused to intercede.[4] In the early 1890s Degas noted with sadness his brother-in-law's failing health in a letter to his old friend Ludovic Halévy (1834–1908): "I have scarcely left the side of the poor invalid and my heroic sister. Women have goodness when we are no longer worth anything."[5]

Edmondo Morbilli died in December 1894, and his wife three years later. This double portrait remained in Degas's studio until his death in 1917.

PROVENANCE
Atelier Degas; René De Gas, the artist's brother, Paris, 1918–21; René De Gas Estate Sale, Drouot, Paris, 1927; Wildenstein and Co., New York; Robert Treat Paine, 2nd, Brookline, Massachusetts.

NOTES
    1. Auguste De Gas to his son Edgar, 11 November 1858, as quoted in Robert Gordon and Andrew Forge, *Degas* (New York: Harry N. Abrams, 1988), p. 87.
    2. Morbilli to Degas, 30 July 1859, in Jean Sutherland Boggs et al., *Degas*, exh. cat. (New York: Metropolitan Museum of Art; Ottawa: National Gallery of Canada, 1988), p. 53.
    3. Boggs, *Degas*, p. 55.
    4. See letter, Edmondo Morbilli to his wife Thérèse, 27 June 1882, as quoted in Boggs, *Degas*, p. 376.
    5. Degas to Halévy, 31 August 1893, in Marcel Guérin, ed., *Degas Letters*, trans. Marguerite Kay (Oxford: Bruno Cassirer, 1947), p. 186.

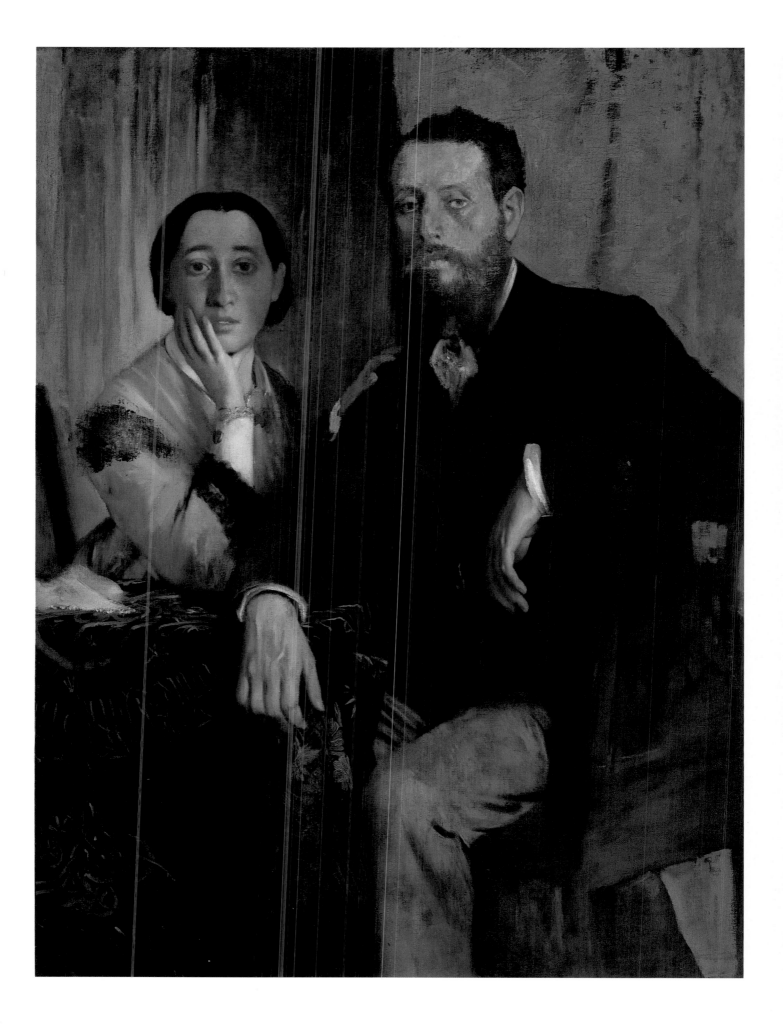

CAT. NO. 24
HILAIRE-GERMAIN-EDGAR DEGAS
1834–1917

**Portrait of a Man**
(c. 1866)

Oil on canvas
33 ½ x 25 ⅜ inches (85.1 x 64.5 cm)

Brooklyn Museum of Art: Museum
Collection Fund (21.112)

*Fig. 24a. Hilaire-Germain-Edgar Degas.* Manet
Seated, Turned to the Right. *(1864–65).* Etching and
drypoint, fourth state. The Baltimore Museum of Art:
Blanche Adler Memorial Fund (BMA 1952.76)

Although the identity of this sitter is open to conjecture, it has been suggested that he is the British still-life painter Robert Grahame.[1] An informality as well as a certain intimacy in the characterization imply that the man is a friend. On the floor to the left and on the table beside the figure are large platters of what appear to be assorted cuts of meat, subjects for which Grahame's paintings were noted. Various tones of brown and red predominate throughout the composition, including in the images in the large frame on the wall.

The pose of the sitter is similar to that of Édouard Manet in Degas's series of prints, also from the mid-1860s, showing Manet seated informally in a studio with his hands clasped between his legs in comparable fashion (fig. 24a). Unlike Manet, however, the subject in this portrait appears somewhat apprehensive and curiously ill at ease. Although his attitude is relaxed, his expression betrays a certain disquietude, which is reinforced by unfocused eyes and furrowed brow. Much of the rendering is sketchy, and a *pentimento* indicating repositioning of the sitter's leg is visible near the table; however, the man's face and especially his hands, which are large and somewhat coarse, are more fully resolved.

The portrait, which may be unfinished, remained in the artist's studio until his death.

PROVENANCE
Atelier Degas, until 1918 sale; Vollard, Bernheim-Jeune, Durand-Ruel, Seligmann; Seligmann Sale, American Art Association, New York, 1921; purchased by the Brooklyn Museum of Art, New York.

NOTE
1. See John House, "Impressionism and the Modern Portrait," herein.

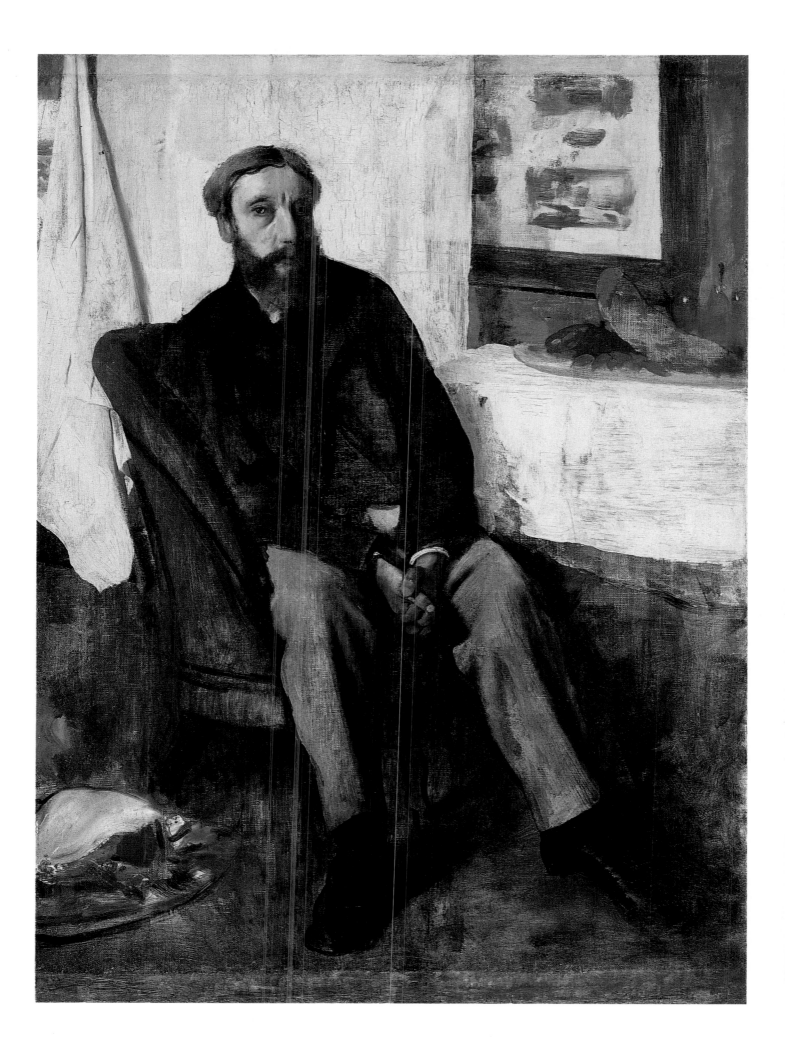

CAT. NO. 25

HILAIRE-GERMAIN-EDGAR DEGAS
1834–1917

*James-Jacques-Joseph Tissot*
(c. 1866–68)

Oil on canvas
59 5/8 x 44 inches (151.5 x 111.8 cm)

Lent by The Metropolitan Museum of
Art: Rogers Fund, 1939 (1939.161)

*Fig. 25a. James-Jacques-Joseph Tissot
(1836–1902). Self-Portrait. (mid-1860s).
Oil on panel. Fine Arts Museums of
San Francisco: Mildred Anna Williams
Collection (1961.16)*

At the age of nineteen James Tissot
(1836–1902) left his birthplace, the port
city of Nantes in western France, to study
in Paris. He enrolled in the École des
Beaux-Arts and became a pupil of Louis
Lamothe (1822–1864), who had taught
Degas, and of Hippolyte Flandrin
(1809–1864). Tissot made his debut at the
Salon in 1859 and continued to exhibit
through the 1860s. A painter mainly of lit-
erary and religious subjects early in his
career, he would go on to record the more
fashionable aspects of contemporary soci-
ety in a highly polished style.

The precise circumstances under which
Degas and Tissot met remain unknown.
However, the two artists were certainly on
familiar terms by September 1862, when
Tissot, writing to his friend from Venice,
described his impressions of the art he had
seen and also inquired about Degas's liai-
son with a woman named Pauline who
remains unidentified.[1]

This portrait is thought to have been
painted about 1866–68. Tissot is shown
seated in a studio, walking stick in hand,
leaning back against a table; his hat and
coat are close by. Of the paintings in his
midst, the most prominent are the large
picture high on the wall depicting sever-
al women in Japanese costume, and a
copy of Lucas Cranach's portrait of
Frederick the Wise.[2] The latter holds the
center of the composition, juxtaposed
with Tissot's head, which tilts slightly
away so as not to block the small paint-
ing. Both works have significance: Degas
was known to have admired Cranach, and
Tissot, like many artists in the 1860s, had
developed a fascination with Japanese art
and culture, exhibiting a painting, *Jeunes
femmes regardant des objets japonais*, at
the Salon of 1869.

During the Franco-Prussian War Tissot
fought gallantly in the defense of Paris,
but he fled to London in 1871, possibly to
avoid retribution for his association with
the Commune. It must have been shortly
after his arrival in England that he was
described as "a charming man, very hand-
some . . . always well-groomed, and [he]
had nothing of artistic carelessness either
in his dress or his demeanour."[3]

Tissot remained in London for ten
years and enjoyed considerable success,

exhibiting regularly at the Royal Academy.
In 1874 Degas, very much involved in the
organization of the First Impressionist
Exhibition, wrote to his friend in England:

*Look here, my dear Tissot, no hesita-
tions, no escape. You positively must
exhibit at the Boulevard [35, boule-
vard des Capucines, the location of the
First Impressionist Exhibition]. It will
do you good, you (for it is a means of
showing yourself in Paris, from which
people said you were running away)
and us too. Manet seems determined to
keep aloof, he may well regret it . . . . I
am getting really worked up and am
running the thing with energy and, I
think, a certain success. . . . The realist
movement no longer needs to fight with
others, it already is, it exists, it must
show itself as something distinct, there
must be a salon of realists.*[4]

Tissot, however, would not participate in
any of the Impressionist Exhibitions.

Following the death of his English
mistress, Kathleen Newton, in 1882,
Tissot returned to France. In the early
1880s he painted a series of rather large
compositions that record Parisian women
pursuing different activities and amuse-
ments. In the mid-1880s, convinced that
he had experienced a religious revelation,
Tissot journeyed to the Holy Land; he
devoted the remainder of his life to illus-
trating scenes from the Bible.

PROVENANCE

Atelier Degas, until 1918 sale; Jos. Hessel, Paris;
Durand-Ruel, New York, 1921; Adolph Lewisohn,
New York, 1922; Jacques Seligmann, New York, 1939.

NOTES

1. See Tissot to Degas, 18 September 1862,
as quoted in Jean Sutherland Boggs et al., *Degas*,
exh. cat. (New York: Metropolitan Museum of Art;
Ottawa: National Gallery of Canada, 1988), p. 54.

2. For a discussion of the various canvases that
appear in the portrait, see Theodore Reff, *Degas:
The Artist's Mind* (New York: Metropolitan Museum
of Art, 1976; distributed by Harper and Row),
pp. 101–10.

3. Louise Jopling, *Twenty Years of My Life,
1867–1888* (London, 1925), as quoted in *From
Realism to Symbolism: Whistler and His World*,
exh. cat. (New York: Wildenstein; Philadelphia:
Philadelphia Museum of Art, 1971), p. 132.

4. Degas to Tissot, 1874, in Marcel Guérin, ed.,
*Degas Letters*, trans. Marguerite Kay (Oxford: Bruno
Cassirer, 1947) pp. 38–39.

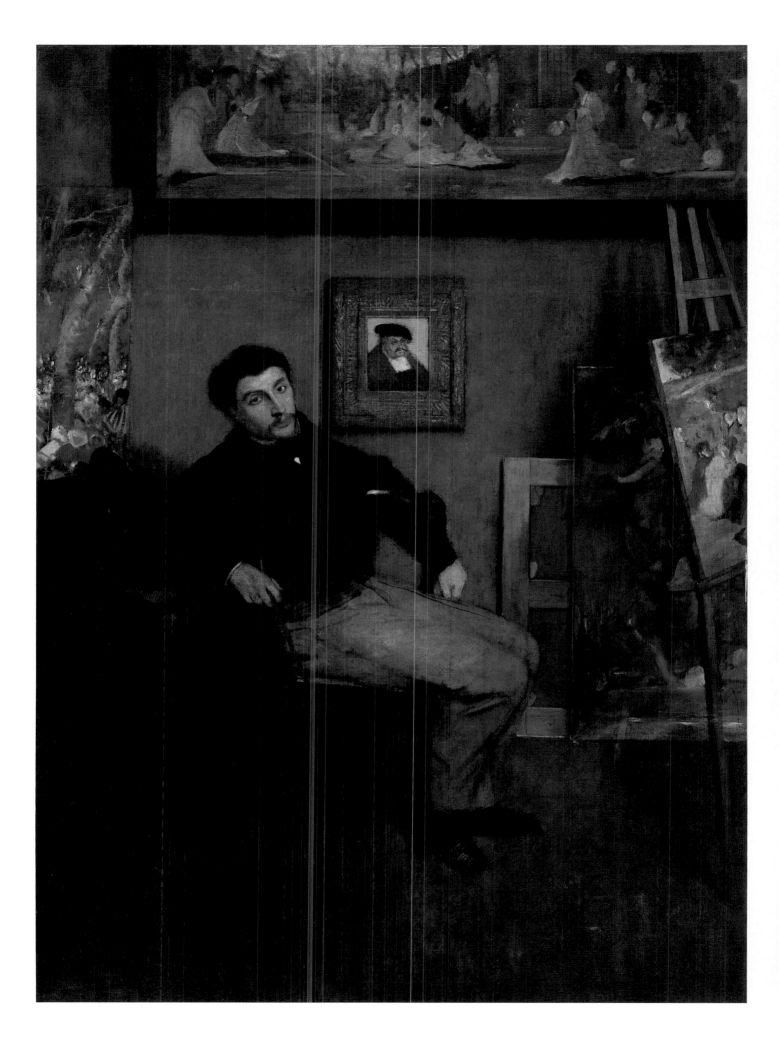

CAT. NO. 26

HILAIRE-GERMAIN-EDGAR DEGAS
1834–1917

*Melancholy*
(Late 1860s)

Oil on canvas
7 ½ x 9 ¾ inches (19.1 x 24.8 cm)

The Phillips Collection, Washington, D.C.
(0480)

Cleveland and Houston only

In this small painting a young woman dressed in red sits bent over in a red upholstered chair similar to the one in Degas's *Portrait of a Man* (see cat. no. 24). The pose of the figure, with her body leaning forward, arms folded tightly in front, and chin resting on the back of the chair, conveys a sense of great weariness. Her face, however, with its knitted brow above downcast eyes and mouth slightly open, personifies melancholy if not anguish.

Although the identity of the subject is not known, her delicately illuminated features are carefully drawn, and the artist has subordinated elements in the rest of the composition in order to focus on her face. Assigned a date in the late 1860s, the painting, with the model despairing in both pose and countenance, recalls Degas's remark made in a notebook at about the same time: "Make portraits of people in typical familiar poses being sure above all to give to their faces the same kind of expression as their bodies."[1]

The first recorded owner of this small canvas, Dr. Georges Viau, was a discerning collector of Impressionist paintings at the end of the nineteenth century and owned a large number of Degas's works.

PROVENANCE
Dr. Georges Viau, Paris; Wilhelm Hansen, Copenhagen; A. M. Cargill, Glasgow, 1931; D. W. T. Cargill, Lanark, Scotland; Reid and Lebevre, London; Bignou Gallery, New York.

NOTE
1. Edgar Degas, from Notebooks 22 and 23, n.d., as quoted in Richard Kendall, ed., *Degas by Himself: Drawings, Prints, Paintings, Writings* (Boston: Little, Brown and Company, 1987), p. 32.

## CAT. NO. 27

### HILAIRE-GERMAIN-EDGAR DEGAS
1834–1917

***Portrait of Mary Cassatt***
(c. 1884)

Oil on canvas
28 1/8 x 23 1/8 inches (71.5 x 58.8 cm)

National Portrait Gallery, Smithsonian Institution: gift of the Morris and Gwendolyn Cafritz Foundation and the Regents' Major Acquisitions Fund, Smithsonian Institution (NPG.84.34)

Baltimore only

*Fig. 27a. Baroni and Gardelli, photographers. Carte-de-visite photograph of Mary Cassatt in Parma. (c. 1872). Albumen print. The Pennsylvania Academy of the Fine Arts, Philadelphia, Archives*

*Fig. 27b. Hilaire-Germain-Edgar Degas. Mary Cassatt at the Louvre: The Etruscan Gallery. 1885. Softground etching, drypoint, aquatint, and etching on ivory Japanese tissue. The Art Institute of Chicago: Albert Rouillier Memorial Collection (1921.368)*

From all accounts, the relationship between Degas and Mary Cassatt (1844–1926) was one of extremes. Their association is said to have begun in 1877, when Degas asked her to exhibit with the Impressionists. As a woman and an American, she most certainly must have welcomed the invitation. Cassatt would participate in four of the eight Impressionist shows.

Degas's regard for her is evident in an undated letter to Count Ludovic Napoleon Lepic (1839–1889), an artist and breeder of dogs, requesting a pet for his friend:

> *I think it in good taste to warn you that the person who desires this dog is Mlle Cassatt. . . . I also think that it is useless to give you any information about the asker whom you know to be a good painter, at this moment engrossed in the study of reflection and shadow. . . . This distinguished person whose friendship I honour, as you would in my place, asked me to recommend to you the youth of the subject. It is a young dog that she needs, so that he may love her.*[1]

Cassatt served as a model for a number of Degas's compositions from the late 1870s and early 1880s, which record her elegant figure touring the galleries of the Louvre or modeling hats in a milliner's shop.[2] Of all Degas's representations, however, it is the present work that may be regarded as a true portrait.

Cassatt is shown seated informally, leaning forward with her arms resting on her knees. A woman of approximately forty years, she seems lost in reverie, a slightly bemused expression on her face. The cards she holds have been variously identified as prints, photographs, or tarot cards, the last

symbolic of fortune-tellers or, more darkly, prostitutes. This aspect of the portrait may have accounted for Cassatt's aversion to it and could have contributed to the breach that developed between the two artists.

That Cassatt continued to value Degas's artistic opinions is clear from a letter of 1892 to Bertha Palmer of Chicago, but she also had her reservations:

> *I have been half a dozen times on the point of asking Degas to come and see my work, but if he happens to be in the mood he would demolish me so completely that I could never pick myself up.*[3]

In 1912 Cassatt was prepared to sell the portrait that Degas had presented to her and wrote to the art dealer Paul Durand-Ruel:

> *I especially desire not to leave it to my family as being me. It has artistic qualities, but is so painful and represents me as a person so repugnant that I would not wish it to be known that I posed for it. . . . I should like it to be sold abroad but without my name being attached to it.*[4]

Her dislike of the painting aside, Cassatt expressed sorrow upon Degas's death in 1917. She wrote to an acquaintance, "Degas died at midnight not knowing his state—His death is a deliverance but I am sad [as] he was my only friend here, and the last great artist of the 19th Century—I see no one to replace him."[5]

PROVENANCE

Mary Cassatt, Paris, until 1913; Ambroise Vollard, until at least 1917; Wilhelm Hansen, Copenhagen, 1918–23; Kojiro Matsukata (possibly through Galerie Barbazanges, Paris), 1923; Matsukata Collection, Paris, Kobe, and Tokyo, 1923–51; Wildenstein and Co., New York, 1951; André Meyer, 1952; Meyer Collection, New York, 1952–80; Galerie Beyeler, Basel.

NOTES

1. Degas to Lepic, n.d., in Marcel Guérin, ed., *Degas Letters*, trans. Marguerite Kay (Oxford: Bruno Cassirer, 1947), pp. 144–45.

2. See, for instance, *At the Louvre*, c. 1879, pastel (Lemoisne 581, private collection), and related works, and *At the Milliner's*, c. 1882, pastel (Lemoisne 693, The Museum of Modern Art, New York).

3. Cassatt to Palmer, 1 December 1892, in Nancy Mowll Mathews, ed., *Cassatt and Her Circle: Selected Letters* (New York: Abbeville Press, 1984), p. 241.

4. Cassatt to Durand-Ruel, 1912, in Nancy Mowll Mathews, ed., *Cassatt: A Retrospective* (New York: Hugh Lauter Levin Associates, 1996), p. 121.

5. Cassatt to George Biddle, 29 September 1917, in Mathews, *Cassatt and Her Circle*, p. 328.

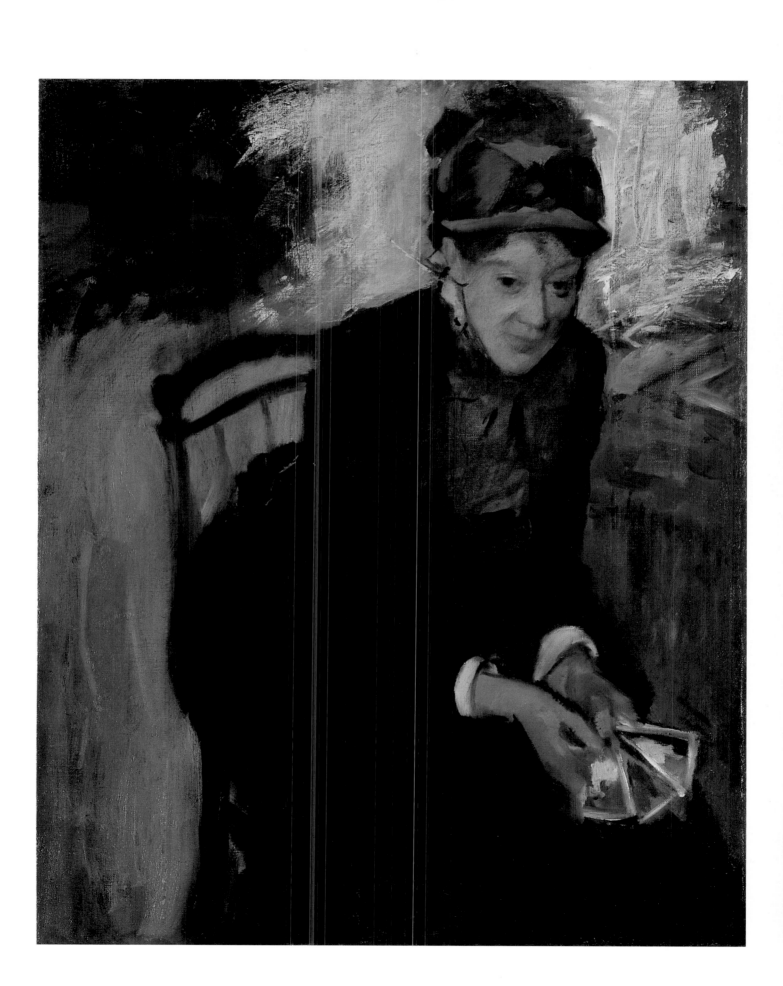

HILAIRE-GERMAIN-EDGAR DEGAS
1834–1917

**Portrait of Rose Caron**
(c. 1885–90)

Oil on canvas
30 x 32 ½ inches (76.2 x 82.6 cm)

Albright-Knox Art Gallery, Buffalo, New York: Charles Clifton, Charles W. Goodyear and Elisabeth H. Gates Funds, 1943 (43.1)

BENQUE & Cº 33.RUE BOISSY D'ANGLAS PARIS.

*Fig. 28a. Benque & Co., Paris. Photograph of Rose Caron. (c. 1890). Harvard Theatre Collection, Nathan Marsh Pusey Library, Harvard University Library, Cambridge, Mass.*

That Degas was captivated by the charms of Rose Caron (1857–1930) is demonstrated not only by this portrait but also through correspondence, as well as a sonnet that he composed in her honor in the late 1880s.[1] Caron, a soprano, had studied at the Paris Conservatory before making her debut at the Théâtre de la Monnaie in Brussels in 1884. The following year she premiered at the Paris Opera as Brunehild in Ernest Reyer's *Sigurd*; she subsequently appeared in leading roles in a number of operas including Charles Gounod's *Faust* and Richard Wagner's *Tannhäuser* and *Lohengrin*.

Degas is known to have indulged his fascination with Caron by hearing her perform in *Sigurd* more that two dozen times.[2] He would also follow her to Brussels in the spring of 1890, when she performed in Reyer's *Salammbô*. In September 1885, probably after attending one of her performances, the artist wrote to his old friend, the novelist and librettist Ludovic Halévy (1834–1908), "The

arms of Mme Caron are still there. How well she is able to raise her thin and divine arms, holding them aloft for a long time, without affectation, for a long time and then lowering them gently!"[3]

In this portrait the singer is shown against a richly colored abstract background, her face eclipsed by shadow. Central to the composition are her graceful arms so admired by Degas. By depicting her in the act of drawing on a long glove, he exploits this feature to its maximum.

In the aforementioned sonnet, which Degas dedicated to Caron in her role as Brunehild in *Sigurd*, the painter wrote touchingly of her voice, referring to his own diminished vision: "This beauty will remain with me to the end of my days . . . / Though my eyes fail me, may my hearing continue strong,/ for in that voice shall I forever see what my eyes cannot."[4]

In the 1880s, Rose Caron enjoyed the attentions of another prominent Parisian, Georges Clemenceau (see cat. no. 40), and was described as his "most dazzling conquest in the world of theatre."[5] In the summer of 1929, a few months before his death, the statesman and the singer met again. Caron, in her seventies, was amazed to see him and quite overcome when he told her that she was one of his fondest memories.[6]

PROVENANCE
Atelier Degas, until 1919 sale; Dr. Georges Viau, Paris; Viau Collection, until 1930; André Weil and Matignon Art Galleries, New York, 1939.

NOTES
1. See Edgar Degas, *Huit Sonnets d'Edgar Degas*, preface by Jean Nepveu-Degas (Paris: Le Jeune Parque, 1946), no. 7, pp. 37–38.
2. Jean Sutherland Boggs et al., *Degas*, exh. cat. (New York: Metropolitan Museum of Art; Ottawa: National Gallery of Canada, 1988), p. 481.
3. Degas to Halévy, September 1885, in Marcel Guérin, ed., *Degas Letters*, trans. Marguerite Kay (Oxford: Bruno Cassirer, 1947), p. 109.
4. Edgar Degas, late 1880s, "Madame Caron, Brunehilde de Sigurd," as quoted, roughly translated into the English, in Boggs, *Degas*, p. 533.
5. Edgar Holt, *The Tiger: The Life of Georges Clemenceau, 1841–1929* (London: Hamish Hamilton, 1976), p. 45.
6. Holt, *The Tiger*, p. 266.

IGNACE-HENRI-JEAN-THÉODORE
FANTIN-LATOUR
1836–1904

**The Two Sisters**
1859

Oil on canvas
37 ½ x 50 ¼ inches (95.3 x 127.7 cm)

The Saint Louis Art Museum Purchase
(8:1937)

Fig. 29a. *James Abbott McNeill Whistler
(1834–1903).* At the Piano. *(1858–59). The
Taft Museum, Cincinnati, Ohio: Bequest
of Mrs. Louise Taft Semple (1962.7)*

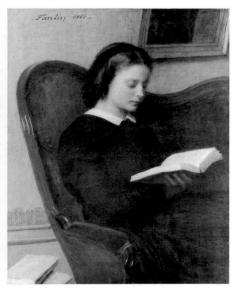

Fig. 29b. *Ignace-Henri-Jean-Théodore
Fantin-Latour.* Woman Reading. *1861.
Musée d'Orsay, Paris (RF 3702)*

Born in Grenoble in southeastern France, Henri Fantin-Latour was the son of a portraitist who had studied with Benjamin de Rolland (1777–1855), a pupil of Jacques-Louis David. At the age of five Fantin moved to Paris with his parents and two sisters, Marie and Nathalie. Throughout his youth he pursued his artistic studies under the watchful eye of his father, and by 1854 he had abandoned a formal education in order to devote his efforts to copying paintings in the Louvre, an activity he would continue for a number of years. He was drawn especially to the works of Titian, Giorgione, Rembrandt, Frans Hals, and Jean-Baptiste-Siméon Chardin. The benefits of this pursuit were twofold: not only did he become familiar with methods and styles of past masters but he also established ties with a number of his contemporaries who were refining their skills in a similar manner. Among the young painters Fantin met at the Louvre were Édouard Manet in 1857, and, in 1858, the sisters Edma and Berthe Morisot, as well as the Anglo-American James Abbott McNeill Whistler. Fantin, who was copying Paolo Veronese's *Marriage at Cana* when he encountered Whistler, described him as a "personnage étrange, le Whistler en châpeau bizarre."[1] First impressions notwithstanding, the two artists developed a close friendship.

Fantin-Latour's paintings fall into three groups: exquisite floral still lifes, which brought him considerable success in England; imaginative compositions inspired by the Romantic music of his era, especially that of Hector Berlioz and Richard Wagner, and evocative portraits, which focused mainly on family, close friends, and colleagues. The large number of self-portraits also attests to what some have perceived as his shy, introspective temperament. Fantin once described portraiture in terms of both flowers and music: "One paints people like flowers in a vase, happy just to depict the exterior as it is—but what of the interior, the inner life? The soul is like music playing behind the veil of flesh; one cannot paint it, but one can make it heard . . . or at least try, to show that you have thought of it."[2]

Parallels have been drawn between Whistler's *At the Piano*, begun in 1858, (fig. 29a) and this double portrait completed in March 1859. In it, Fantin presents his two sisters, Nathalie (1838–1903) on the left at her embroidery, and blond Marie (1837–1901), reading a book, an activity common to several of the artist's representations of women.[3] As in Whistler's canvas, which shows his half-sister, Deborah Haden, and her ten-year-old daughter Annie, absorbed in their music, *The Two Sisters* offers a glimpse into the intimate, sheltered world of middle-class young women at mid-nineteenth century. The subdued interior is enlivened only by touches of white in the girls' apparel and by the colorful yarns on the embroidery frame. An unsettling note is introduced by Nathalie's face, partly in shadow as she turns toward the viewer. Her decidedly grave expression suggests the depressive illness that would shortly confine her to an institution, where she would remain for the rest of her life.[4] Marie subsequently posed alone for her brother on several occasions. In portraits from 1861 and 1863 she is similarly shown, book in hand, immersed in her reading (see fig. 29b; and *Reading*, 1863, Musée des Beaux-Arts, Tournai, Belgium).

PROVENANCE
Mme. Victor Klotz, Paris, by 1903; Tooth & Sons, London; Mme. Gillou, Paris; Jacques Seligmann, New York.

NOTES
1. Fantin-Latour, as quoted in E. R. and J. Pennell, *The Life of James McNeill Whistler*, vol. 1 (Philadelphia: J. B. Lippincott Company, 1909), p. 68.
2. Fantin-Latour, as quoted in Camille Mauclair, *Servitude et grandeur littéraire*, 2d ed. (Paris, 1922), p. 158, as quoted in Douglas Druick and Michael Hoog, *Fantin-Latour*, exh. cat. (Paris: Réunion des musées nationaux, 1982), p. 86.
3. See Douglas Druick and Michael Hoog, *Fantin-Latour*, exh. cat. (Ottawa: National Gallery of Canada, National Museums of Canada, 1983), p. 95.
4. Druick and Hoog, *Fantin-Latour* (Ottawa, 1983), p. 94.

CAT. NO. 30
IGNACE-HENRI-JEAN-THÉODORE
FANTIN-LATOUR
1836–1904

**Édouard Manet**
1867

Oil on canvas
46 ¼ x 35 ½ inches (117.5 x 90 cm)

The Art Institute of Chicago: Stickney
Fund (1905.207)

*Fig. 30a. Gaspar Félix Tournachon,
called Nadar (1820–1910). Édouard Manet.
(c. 1867). Woodburytype. The Baltimore
Museum of Art: George A. Lucas Collection
(BMA 1996.48.5093)*

The friendship that evolved between
Fantin-Latour and Édouard Manet
(1832–1883) following their initial en-
counter in the Louvre galleries in 1857 is
documented in both paintings and corre-
spondence. In 1864 Fantin included Manet
in his large group portrait *Hommage à
Delacroix* (Musée d'Orsay, Paris), and he
made him the focus of his equally impres-
sive composition from 1870, *Un Atelier aux
Batignolles* (see House, fig. 6), which
shows Manet at his easel in the company
of young, avant-garde artists and writers
of the day, including Renoir, Émile Zola,
Bazille, Monet, and the critic Edmond
Maître. In Manet's portrayal of a festive
gathering of Parisians, *Music in the
Tuileries* (1862; National Gallery, London),
he includes in the throng a portrait of
Fantin, who appears strangely detached
from the revelry surrounding him.

Manet's letters to Fantin from the 1860s
further reveal shared enthusiasms. Writing
from Madrid on 3 September 1865, he
comments with verve:

> *How I miss you here and how happy it
> would have made you to see Velasquez
> who all by himself makes the journey
> worthwhile; the artists of all the other
> schools around him in the museum at
> Madrid, who are extremely well repre-
> sented, all look like shams. He is the
> supreme artist; he didn't surprise me,
> he enchanted me.[1]*

In February 1867 Manet wrote to Fantin,
"Bracquemond [Félix Bracquemond,
1833–1914, printmaker and friend of Manet
and the Impressionists] told me yesterday
that you're counting on doing my portrait
[for the Salon] this week, so let's set a date
for Thursday (the day after tomorrow)
because otherwise I won't be able to make
it until 7 or 8 March." He adds: "Tell my
maid if that's all right. And let me know
what time you want me to come."[2]

Fantin's portrait of Manet was finished
in time for the opening of the Salon in the
spring of 1867. It shows the painter in his
mid-thirties, having withstood the contro-
versy brought about by his revolutionary
compositions *Le Déjeuner sur l'herbe* and
*Olympia* (both 1863; see figs. 34a and 34b).

Isolated against a neutral background bro-
ken only by Fantin's inscription at the
lower left corner, "A mon ami Manet," the
artist stands erect and confident.

Writing in 1893, George Moore
(1852–1933), the Irish novelist and habitué
of Paris cafés, recalled meeting Manet. He
provides a description remarkably close to
Fantin's portrayal:

> *It was a great event in my life when
> Manet spoke to me in the café of the
> Nouvelle Athènes. I knew it was Manet;
> he had been pointed out to me, and I
> had admired the finely-cut face from
> whose prominent chin a closely-cut
> blond beard came forward; and the
> aquiline nose, the clear grey eyes, the
> decisive voice, the remarkable comeli-
> ness of the well-knit figure, scrupu-
> lously but simply dressed, represented
> a personality curiously sympathetic.[3]*

Indeed, Fantin's likeness, while both dig-
nified and reserved, also betrays softness
and a certain vulnerability.

Fantin-Latour and Manet remained
close until the latter's death in 1883.
In November 1876, when Fantin married
the still-life painter Victoria Dubourg
(1840–1926), Manet witnessed the cere-
mony. A pallbearer at Manet's funeral
seven years later, Fantin assisted in the
organization of the 1884 exhibition of his
friend's work at the École des Beaux-Arts
and also contributed monies toward
the purchase of *Olympia* through public
subscription for the French nation.

PROVENANCE
Édouard Manet, Paris; Mme. Édouard Manet,
Paris; Coll. Canrenton (or Camentron); Gustave
Tempelaere with Allard and Noël, Paris by 1900;
Durand-Ruel, Paris, 1900.

NOTES
    1. Manet to Fantin-Latour, 3 September 1865,
in Juliet Wilson-Bareau, ed., *Manet by Himself*
(London: Macdonald and Company, 1991), p. 34.
    2. Manet to Fantin-Latour, 19[?] February 1867,
in Wilson-Bareau, *Manet by Himself*, p. 42.
    3. George Moore, *Modern Painting* (London,
1893), pp. 30–31, as quoted in *Henri Fantin-Latour,
1836–1904*, exh. cat. (Northampton, Mass.: Smith
College Museum of Art, 1966), n.p.

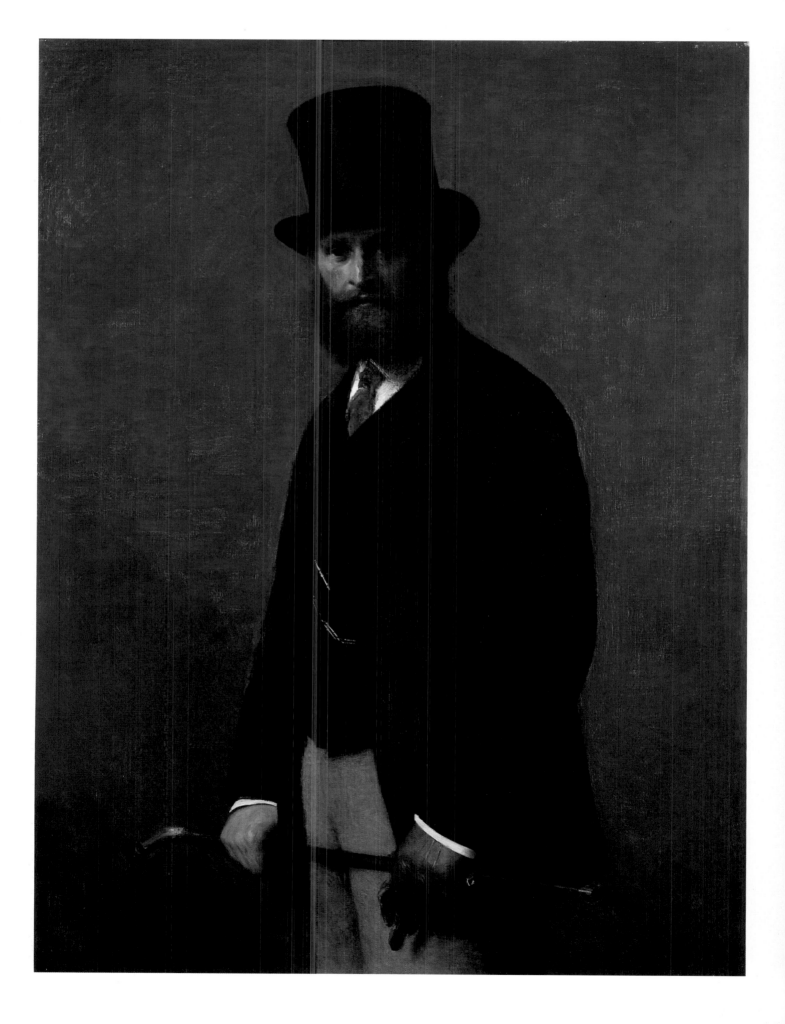

CAT. NO. 31
IGNACE-HENRI-JEAN-THÉODORE
FANTIN-LATOUR
1836–1904

**Portrait of Léon Maître**
1886

Oil on canvas
51 ½ x 38 ½ inches (130.9 x 97.8 cm)

The Chrysler Museum of Art, Norfolk,
Virginia: Gift of Walter P. Chrysler, Jr.
(71.509)

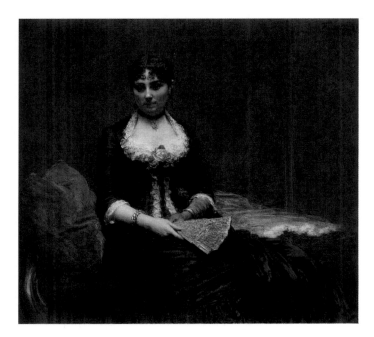

*Fig. 31a. Ignace-Henri-Jean-Théodore Fantin-Latour. Portrait of Madame Léon Maître. 1882. Brooklyn Museum of Art: Gift of A. Augustus Healy and George A. Hearn (06.69)*

Toward the end of the 1880s portraiture became less prevalent in Fantin's art, and in 1890 he would paint his last likeness, an image of his niece, Sonia Yankowski (National Gallery of Art, Washington, D.C.). In the present canvas Léon Maître (1847–1929), brother of Edmond Maître, critic and close friend of the artist, appears to have paused momentarily as he turns toward the viewer. The similarities between this work and Fantin's portrait of Édouard Manet (see cat. no. 30) painted almost twenty years earlier are striking; however, while Manet stands squarely on both legs, Maître appears to be walking, the sense of movement suggested by the position of his legs below his frock coat.[1]

Exhibited at the Salon of 1886, the portrait was praised by the critic Amédée Pigeon among others:

> [It is] *a serious and charming work, unforgettable as are all those signed by this master who, throughout his life, has preferred the solemn beauty of more severe art to the brilliant improvisations and ephemeral fantasies that surprise and fascinate the public. A portrait by Fantin-Latour always portrays the very soul of the sitter and all that is essential to the likeness. . . . There is not a single accessory to catch the eye and distract it to no good effect.*

> *Portrait painters might do well to study this serious and strong work; in it they will recognize all the masterful qualities that they admire in the finest portraits in the old museums.*[2]

That his portraiture would be admired for its associations with the art of the past clearly sets Fantin apart from his Impressionist friends. However, his keen perception and his adherence to the reality of the image before him decidedly connect him to his more progressive contemporaries.

Fantin also painted two portraits of Madame Léon Maître, one in 1882 (fig. 31a), and the other two years later (*Mme. Léon Maître [Reverie]*, City Art Gallery, Leeds). Neither can be considered a pendant to this portrait of her husband.

PROVENANCE
Léon Maître, Paris; Henri Lerolle, Paris, in 1906; David-Weil, Paris; Alfred Deber, Paris, by 1954; Galerie Charpentier, Paris, in 1954; Walter P. Chrysler, Jr., Norfolk, Virginia.

NOTES
1. Douglas Druick and Michael Hoog, *Fantin-Latour*, exh. cat. (Ottawa: National Gallery of Canada, National Museums of Canada, 1983), pp. 333–34.
2. Amédée Pigeon, *Le Passant*, 1886, as quoted in Druick and Hoog, *Fantin-Latour*, p. 333.

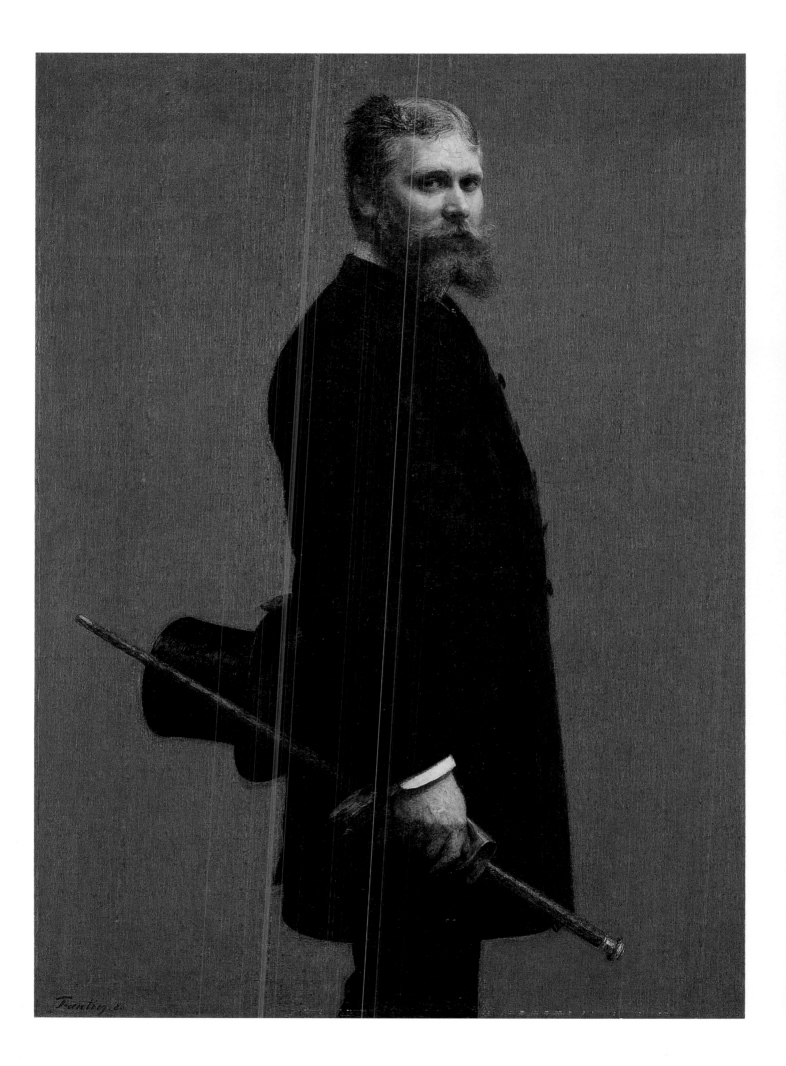

CAT. NO. 32
PAUL GAUGUIN
1848–1903

*Clovis*
(1886)

Oil on canvas
22 1/4 x 16 inches (56.5 x 40.7 cm)

Collection of The Newark Museum: Gift
of Mrs. Lloyd Wescott, 1960 (1960.570)

*Fig. 32a. Photograph of Aline and Clovis
Gauguin. 1884. Location unknown*

*Fig. 32b. Paul Gauguin. Bust of Clovis.
(c. 1882). Painted wax and carved walnut.
Private collection, Paris*

Paul Gauguin's early life was marked by
both tragedy and adventure. Following the
Revolution of 1848 and Louis-Napoleon's
rise to power, the family decided to leave
Paris and reside with relatives in Lima,
Peru. In the course of their journey the
artist's father, Clovis, a journalist, died
suddenly, leaving his widow with two small
children. Returning to France in 1855,
young Gauguin pursued his academic
studies first in Orléans and eventually in
Paris. Not an especially promising student,
he left school while still in his teens and
joined the merchant marine, later enlisting
in the military. A series of voyages to Rio
de Janeiro and other foreign ports intro-
duced him to a variety of exotic locales.

Upon completion of his military service
in 1871, Gauguin obtained a position with
the Paris brokerage firm of Paul Bertin,
where he met Émile Schuffenecker
(1851–1934). Like Gauguin, Schuffenecker
aspired to become a painter; the two men
would remain lifelong acquaintances.
Gauguin's marriage to a young Danish
woman, Mette-Sophie Gad (1850–1920)
also took place in the early 1870s.

In 1879, although still employed in the
brokerage business, Gauguin was invited
to participate in the Fourth Impressionist
Exhibition. That year also marked the
birth of Clovis-Henri Gauguin (1879–
1900), the artist's third child. The good
fortune the family had enjoyed was soon
reversed with the stock market collapse in
1882. Now fully committed to an artistic
career, Gauguin struggled to support his
expanding family, finally leaving Paris late
in 1884 for Copenhagen, his wife's home.

Clovis must have been a favorite child,
for by June 1885 the artist had returned to
Paris with the boy, declaring that he hated
the Danes.[1] In the course of the following
year, he corresponded regularly with Mette,
often imploring her to supply such necessi-
ties as blankets and clothing for Clovis and
himself. Writing to her in February 1886,
he described their predicament:

*I have been turned out of my house and
am living in one room with a bed, a
table, no firing and seeing nobody.
Clovis is a hero: when we sit down
together at the table in the evening
with a crust of bread and a relish, he
forgets how greedy he used to be: he*

*says nothing, asks for nothing, not even
to play and goes quietly to bed. Such is
his daily life; he is quite adult, he
grows every day, but is not very well,
always has headaches and a certain
pallor which worries me.*[2]

It seems likely that Gauguin painted this
portrait of his son during their sojourn
in Paris. Dressed in a wool sweater, the
young boy of six or seven years glances up
from his open book as he poses for his
father. Other representations of Clovis by
Gauguin include an unusual bust portrait
made of wax and wood (fig. 32b), and a
pastel double portrait where he appears
with his younger brother, Pola (*Portrait of
Clovis and Pola Gauguin*, 1885, collection
Mr. and Mrs. David Lloyd Kreeger).[3]

In March 1887 Gauguin wrote to his
wife informing her that he had tired of
"this tedious and enervating life" and had
decided to embark on an extended journey
with a new painter-friend, Charles Laval
(1861–1894).[4] They would travel to Panama
and Martinique. The artist instructed Mette
to retrieve Clovis from Paris, and in April
she returned to Copenhagen with her son.
Never robust, Clovis died of blood-poison-
ing in June 1900 at the age of twenty-one.
In a letter to Schuffenecker informing him
of the tragic event, Mette asked with obvi-
ous bitterness, "Dear friend, give me Paul's
address if you have it. It seems to me that
he must be written to although it goes
much against the grain, for his ferocious
egoism revolts me every time I think of it."[5]

PROVENANCE
Ambroise Vollard, Paris; Galéa; Fine Arts Associates,
New York (Otto Gerson); Morton D. May, Jr.,
St. Louis; Justin Thannhauser, New York; Mr. and
Mrs. Lloyd B. Wescott, Rosemont, New Jersey.

NOTES
1. Maurice Malingue, ed., *Paul Gauguin: Letters to
His Wife and Friends*, trans. Henry J. Stenning
(Cleveland and New York: World Publishing
Company, 1949), p. 252.
2. Paul Gauguin to Mette Gauguin, 27 February
1886, in Malingue, *Paul Gauguin*, p.60.
3. Richard Brettell et al., *The Art of Paul Gauguin*,
exh. cat. (Washington, D.C.: National Gallery of Art;
Chicago: Art Institute of Chicago, 1988), p. 38.
4. Paul Gauguin to Mette Gauguin, March 1887,
in Malingue, *Paul Gauguin*, p. 74.
5. Mette Gauguin to Schuffenecker, 11 June 1900,
ibid., p. 249.

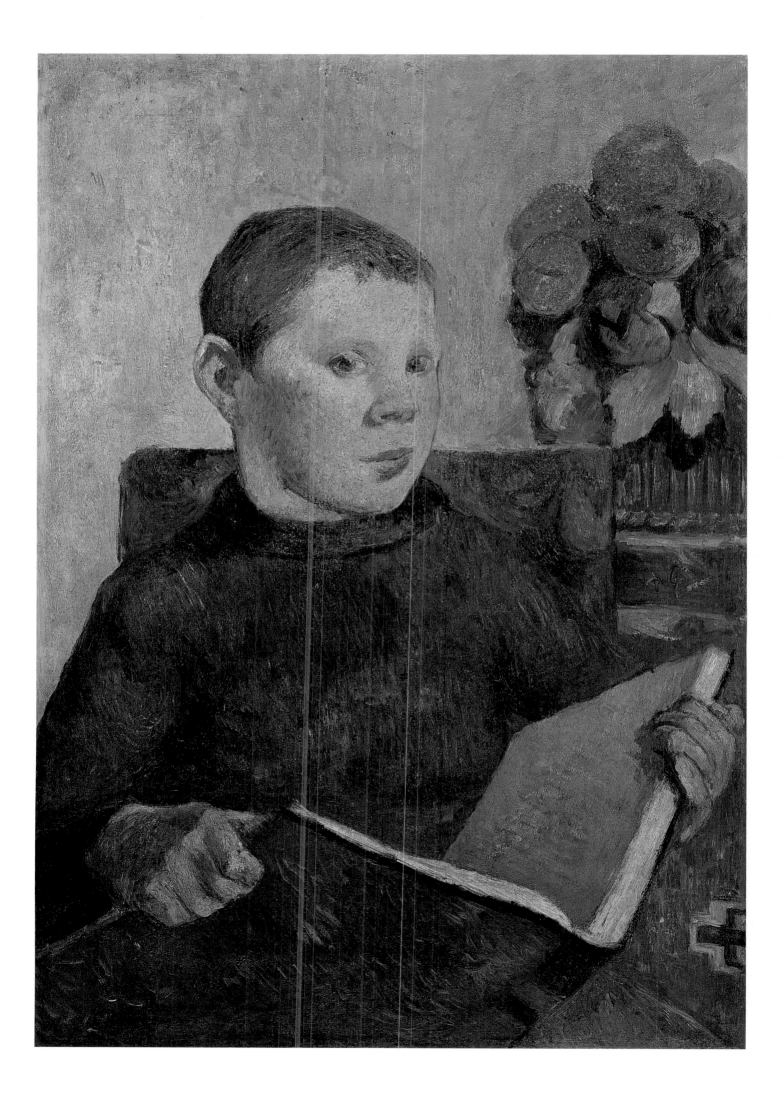

CAT. NO. 33
PAUL GAUGUIN
1848–1903

**Upaupa Schneklud (The Player Schneklud)**
1894

Oil on canvas
36 ½ x 28 ⅞ inches (92.7 x 73.5 cm)

The Baltimore Museum of Art: Given by Hilda K. Blaustein, in Memory of her late Husband, Jacob Blaustein (BMA 1979.163)

*Fig. 33a. Photograph of Frédéric-Guillaume Schneklud (formerly known as Fritz). (n.d.) Location unknown*

*Fig. 33b. Boutet de Monvel. Photograph of Gauguin. 1891. Musée Départemental du Prieuré, Maurice Malingue Donation, Saint-Germain-en-Laye*

In August 1893 Gauguin returned to Paris after his first visit to Tahiti. He stayed in France for only two years, returning in 1895 to the South Seas, where he would spend the remainder of his life. During the late 1880s he had moved away from Impressionism as his unique style evolved. Indeed, he would condemn the movement with which he had allied himself in previous years:

> The Impressionists searched with their eye and not in the mysterious centre of their imagination; and from there fell into scientific reasons. They are the official [painters] of to-morrow, terrible in a different way from the official ones of yesterday....The art of these latter has been thorough, has produced and will still produce masterpieces, while the official ones of tomorrow are in a vacillating craft badly steered and incomplete. When they speak of their art, what is it? An art, purely superficial, nothing but coquetting, purely material; imagination does not inhabit it.[1]

Derived from a wide range of sources and distinguished by simplified form, decorative line, and flat passages of expressive color, Gauguin's mature work is highly personal. As he explained:

> By arrangements of lines and colors, using as pretext some subject borrowed from human life or nature, I obtain symphonies, harmonies that represent nothing absolutely real in the vulgar sense of the word; they express no idea directly but they should make one think, as music does, without the aid of ideas or ages, simply by the mysterious relationships existing between our brains and such arrangements of colors and lines.[2]

The analogy to music seems especially appropriate in regard to this portrait of the cellist Frédéric-Guillaume Schneklud (1859–1930), painted in 1894 at the artist's Paris apartment on Rue Vercingétorix, where he entertained painters, musicians, and writers at Thursday evening gatherings.[3] Schneklud, who graduated from the Paris Conservatory in 1880 and performed regularly in chamber music concerts, is mentioned with frequency in the Paris press through 1914.[4] A highly decorative composition, the portrait is dominated by the figure of the musician playing his cello against an abstracted background with the suggestion of tropical flowers. His eyes are cast down and he appears to listen intently to the sound of the bow drawn across the strings. While certain aspects of Schneklud's body, most notably his legs, which steady the cello, have been reduced to their essential elements, his face and, in particular, his elegant hands, are finely drawn.

It has been observed that the sitter bears a striking resemblance to Gauguin himself, suggesting that the portrait, whether intentional or not, may represent a synthesis of the features of artist and model. Adding to the ambiguity of the image is the inscription in the upper left corner: "Upaupa Schneklud," *upaupa* alluding to an erotic Tahitian dance.[5]

PROVENANCE
*La Peau de l'Ours* Sale, Paris, 2 March 1914; Galerie Druet, Paris; Marcel Noréro Sale, Paris, 14 February 1927; M. Stonborough; unknown sale, New York, 17 October 1940; Mr. and Mrs. Jacob Blaustein, Baltimore.

NOTES
1. Gauguin, from "Diverses choses," 1896–97; Département des Arts Graphiques, Musée du Louvre, Paris, as quoted in Robert Burnett, *The Life of Paul Gauguin* (New York: Oxford University Press, 1937), p. 59.
2. Gauguin, as quoted by E. Tardieu, "La Peinture et les peintres, M. Paul Gauguin," *Echo de Paris* (13 May 1895), in John Rewald, *History of Impressionism*, 4th rev. ed. (New York: Museum of Modern Art, 1973), p. 574.
3. Richard Brettell et al., *The Art of Paul Gauguin*, exh. cat. (Washington, D.C.: National Gallery of Art; Chicago: Art Institute of Chicago, 1988), p. 292.
4. See correspondence from Stephen Sensbach to Brenda Richardson, 19 August 1997, Object File, The Baltimore Museum of Art. The subject has also previously been identified as Fritz Schneklud, a Swedish cellist. See also Brettell et al., *Gauguin*, pp. 313–15.
5. Brettell et al., *Gauguin*, pp. 313–15.

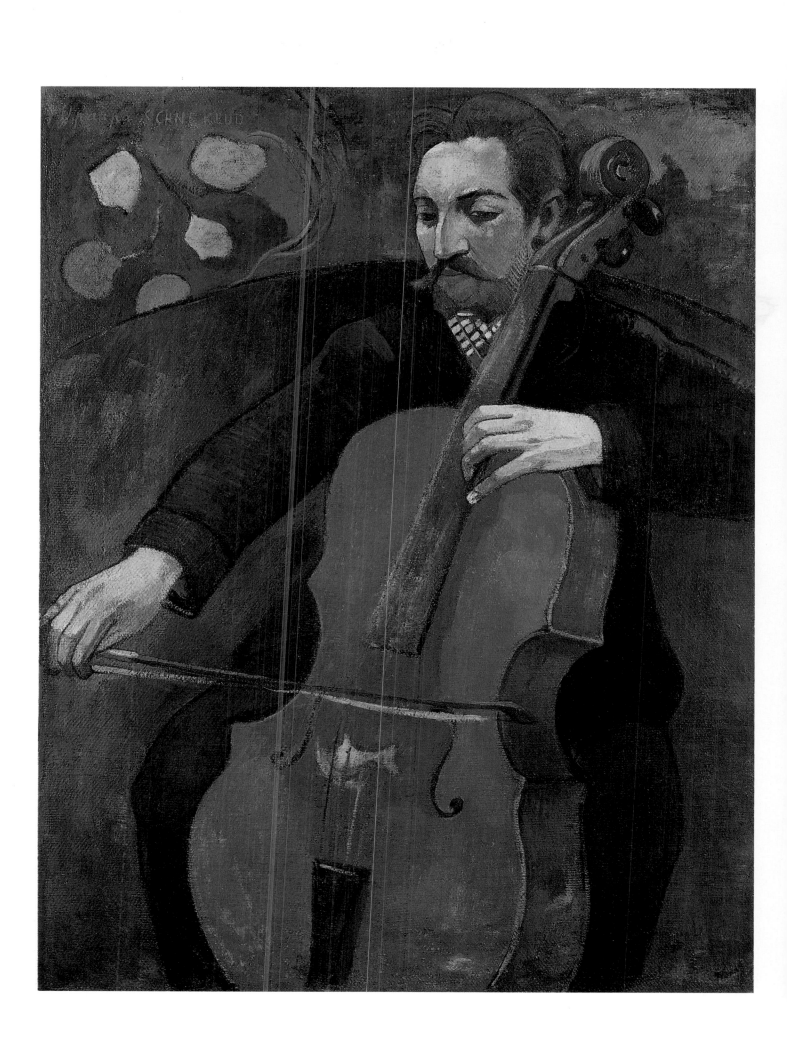

CAT. NO. 34
ÉDOUARD MANET
1832–1883

**Portrait of Victorine Meurent**
(1862)

Oil on canvas
16 7/8 x 17 1/4 inches (42.9 x 43.8 cm)

Museum of Fine Arts, Boston: Gift of
Richard C. Paine in Memory of his
father, Robert Treat Paine, 2nd (46.846)

Fig. 34a. *Édouard Manet.* Le Déjeuner
sur l'herbe. *1863. Musée d'Orsay, Paris*

Fig. 34b. *Édouard Manet.* Olympia. *1863.
Musée d'Orsay, Paris*

Various accounts suggest that Manet met
Victorine Meurent by chance and was
immediately "struck by her original
appearance and her sculptural look."[1]
A notation in the artist's sketchbook from
1861–62 records a "Louise Meuran" at 17,
rue Maître-Albert, a Left Bank location
near the Latin Quarter. At about the same
time, Victorine's name appears in studio
accounts for the atelier of Thomas
Couture (1815–1879), where Manet had
studied for nearly six years in the 1850s.
Payments to her for modeling are noted
through 1863.[2]

Records indicate that Victorine-Louise
Meurent was born in a tenement district of
Paris on 18 February 1844, and it is likely
that she grew up in impoverished circum-
stances. The date of 1862, generally
assigned to this portrait, places its execu-
tion close to the beginning of Manet's asso-
ciation with her. She would continue to
pose for him through 1873, most signifi-
cantly for his notorious compositions from
1863, *Le Déjeuner sur l'herbe* and *Olympia*
(figs. 34a and 34b). Although Manet
assigned to the model a seemingly different
persona in these and other works, the
remarkable candor with which she engages
the viewer is apparent in all of the images.

In this bust portrait, Victorine turns
her head slightly to one side toward strong
light, leaving a portion of her face in
shadow. Her thick red hair, set off by a
somewhat primly tied blue ribbon, is
bound in a net, and she gazes out from
beneath eye lids edged with pale lashes.
The narrow black ribbon at her neck and
the small gold earrings are accessories also
worn by her in *Olympia*. Both the proxim-
ity of the image to the picture plane and a
slight air of defiance bring a marked inten-
sity to the characterization. In contrast,
she seems almost bemused in *Le Déjeuner
sur l'herbe* and assumes an attitude of con-
fidence in her portrayal as *Olympia*.

Victorine was barely thirty when she
posed for Manet for the last time. As her
youth faded and she was no longer desir-
able as a model, Victorine turned to other
pursuits, including painting; however,
none offered financial security. Two vivid
accounts of her life in later years docu-
ment the meagerness of her existence.
Paul Leclercq, a young poet and founder
of *La Revue Blanche*, recalled a visit

made with Henri de Toulouse-Lautrec to
her lodging in the 1890s:

> *I followed Lautrec through a maze of
> Montmartre streets. . . . At the end of a
> fifteen minute walk . . . he was swal-
> lowed up in the porch of an old house
> in the rue de Douai. He went slowly up
> the five flights of an obscure staircase,
> hanging on the greasy banister and
> propping himself on his little cane.
> And, arriving at the roof timbers, he
> stopped . . . [and] knocked, finally at a
> little door. An old lady came to open it
> to us and Lautrec presented me to—
> the* Olympia *of Manet.*[3]

Maurice Joyant (1864–1930), Toulouse-
Lautrec's childhood friend and biogra-
pher, similarly remembered "[a] melan-
choly pilgrimage to see a shapeless old
lady on the fifth floor of a building oppo-
site. She'd posed for Manet and for Puvis
de Chavannes' *Hope*. She'd kept a draw-
ing of her head with a purity and sim-
plicity like that of Ingres."[4] The reference
to Victorine Meurent having a portrait of
herself is intriguing in light of the absence
of documentation regarding the early his-
tory of this painting, and the suggestion
that has been put forth that Manet may
have presented it to her as a gift.[5]

PROVENANCE
Sir William Burrell, Glasgow; Bernheim-Jeune, Paris,
1905; Alphonse Kann, Saint-Germain-en-Laye; Paul
Rosenberg; Robert Treat Paine, 2nd, Boston; Richard
C. Paine, Boston.

NOTES
1. See Théodore Duret, quoted in Adolphe
Tabarant, *Manet: Histoire catalographique* (Paris:
Éditions Montaigne, 1931), in Pierre Courthion and
Pierre Cailler, eds., *Portrait of Manet*, trans. Michael
Ross (London: Cassell & Co., 1960), p. 53.

2. Margaret Mary Armbrust Seibert, "A Biography
of Victorine-Louise Meurent and Her Role in the Art
of Édouard Manet," vol. 1 (Ph.D. diss., Ohio State
University, 1986), pp. 51–52.

3. Paul Leclercq, *Autour de Toulouse-Lautrec*
(Paris, 1920; reprint Geneva, 1954), pp. 54–56,
and 124–25, as quoted in Seibert, "A Biography of
Victorine-Louise Meurent," vol. 1, p. 311.

4. Maurice Joyant, *Henri de Toulouse-Lautrec*,
2 vols. (Paris, 1926–27), in Seibert, "A Biography of
Victorine-Louise Meurent," vol. 1, p. 310.

5. Françoise Cachin, in Cachin and Charles
S. Moffett, in collaboration with Michel Melot,
*Manet, 1832–1883*, exh. cat. (New York:
Metropolitan Museum of Art, 1983; distributed by
Harry N. Abrams), p. 105.

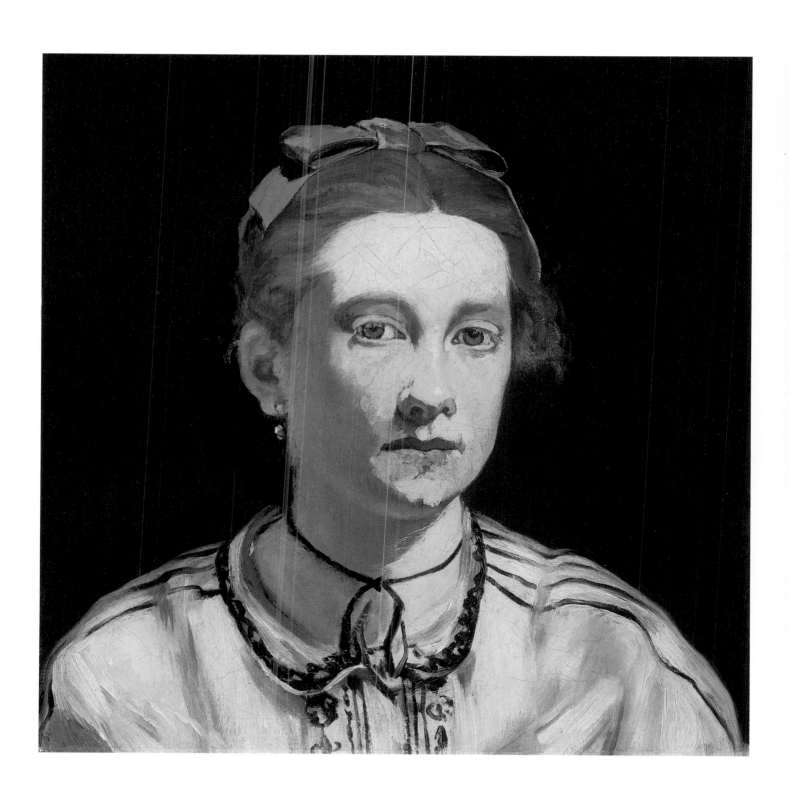

CAT. NO. 35
ÉDOUARD MANET
1832–1883

**Berthe Morisot**
(c. 1869)

Oil on canvas
28 ¹⁵/₁₆ x 23 ⅝ inches (73.5 x 60 cm)

The Cleveland Museum of Art: Bequest
of Leonard C. Hanna, Jr. (1958.34)

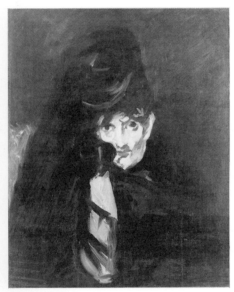

Fig. 35b. Édouard Manet. Berthe Morisot
in a Mourning Hat. 1874. Private collec-
tion, Zurich

Fig. 35a. Photograph of Berthe Morisot
(one knee on chair). (c. 1868–69). Private
collection. Courtesy Galerie Hopkins-
Thomas-Custot, Paris

In 1868 Henri Fantin-Latour introduced
Manet to Berthe and Edma Morisot, whom
he had met while copying paintings at the
Louvre. Encouraged by their father to
pursue their artistic interests, both sisters
studied with Camille Corot (1796–1875)
and by 1864 were exhibiting at the Salon.
Manet's early admiration for the young
women is expressed in a somewhat mis-
chievous comment made to Fantin in a
letter from August 1868:

*I agree with you, the young Morisot girls
are charming, it's a pity they're not
men; but being women, they could still
do something in the cause of painting by
each marrying an academician and
bringing discord into the camp of those
old dodderers, though that would be
asking for considerable self-sacrifice.[1]*

From their initial meeting, Manet was
clearly drawn to Berthe's striking appear-
ance; he would paint more than ten por-
traits of her, five of which remained in his
possession until his death.[2] As a group,
these works are remarkable for they not
only convey the nuances of Berthe's psyche
and varying emotional states but also reveal
Manet's personal response to their complex
association. Nine years younger than
Manet, she served as his model, confidant,
and critic. In December 1874, the year of her
father's death, Berthe married Eugène
Manet, the artist's younger brother, thus
adding the bond of family to their relation-
ship. Édouard Manet's remarkable portrait
of her painted at this time is a moving tes-
tament to the depth of her grief (fig. 35b).

The present portrait, thought to have
been painted in 1869, shows Berthe in her
late twenties, about a year after meeting
Édouard Manet. Her winter attire, espe-
cially the muff in which she thrusts her
hands, is loosely brushed, but her elabo-
rate hat, dark hair, and expressive features
are more carefully delineated. The artist
has captured a feeling of seriousness if not
slight apprehension in her demeanor.
Some ten years later, Morisot herself would
paint a half-length image of a young
woman with a muff, which was titled
*Winter* (see cat. no. 47) when shown at the
Fifth Impressionist Exhibition in 1880.

Édouard Manet's death in the spring
of 1883 deeply affected Berthe. Writing to
Edma she noted with sorrow:

*If you add to these almost physical emo-
tions my old bonds of friendship with
Édouard, an entire past of youth and
work suddenly ending, you will under-
stand that I am crushed. The expres-
sions of sympathy have been intense
and universal; his richly endowed
nature compelled everyone's friendship;
he also had an intellectual charm, a
warmth, something indefinable. . . . I
shall never forget the days of my friend-
ship and intimacy with him. When I sat
for him and when the charm of his mind
kept me alert during those long hours.[3]*

The early history of this portrait remained
associated with Édouard Manet's family.
At the sale of the contents of his Paris stu-
dio in 1884, it was purchased by his
widow, Suzanne, later passing to her son,
Léon Leenhoff.

PROVENANCE
Manet Estate Sale, Drouot, Paris, 1884; Suzanne
Manet, his widow; Léon Leenhoff, her son; Auguste
Pellerin, Paris; Jules Strauss, Paris; Georges Petit,
Paris, 1932; Turner, London; Mr. and Mrs. Jacques
Balsan, New York; Knoedler and Co., New York;
Leonard C. Hanna, Jr., Cleveland.

NOTES
1. Manet to Fantin-Latour, 26 August 1868, as
quoted in Juliet Wilson-Bareau, ed., *Manet by Himself*
(London: Macdonald and Company, 1991), p. 49.
2. Anne Higonnet, *Berthe Morisot* (Berkeley,
Los Angeles, and London: University of California
Press, 1995), pp. 225–26.
3. Berthe Morisot to Edma Morisot, May 1883, in
Denis Rouart, ed., *Berthe Morisot: Correspondence*,
trans. Betty W. Hubbard (Mount Kisco, New York:
Moyer Bell Limited, 1987), p. 131.

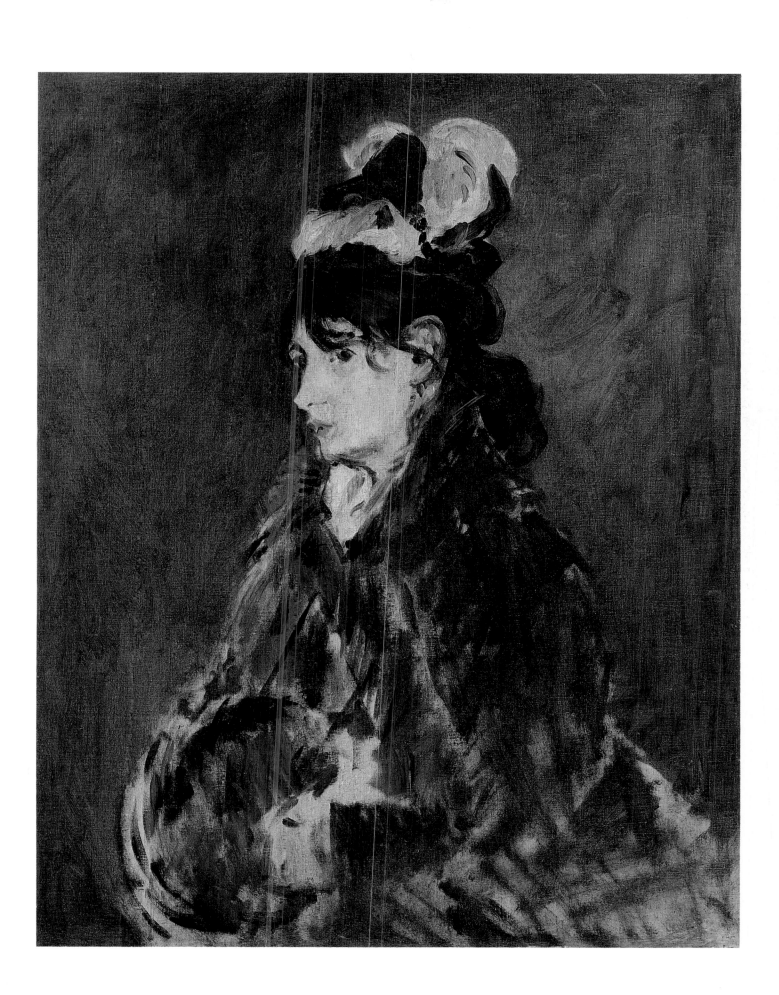

CAT. NO. 36
ÉDOUARD MANET
1832–1883

**The Monet Family in their Garden
at Argenteuil**
(1874)

Oil on canvas
24 x 39 ¼ inches (61 x 99.7 cm)

Lent by The Metropolitan Museum of
Art: Bequest of Joan Whitney Payson,
1975 (1976.201.14)

*Fig. 36a. Pierre-Auguste Renoir (1841–1919).
Madame Monet and Her Son. (1874).
National Gallery of Art, Washington: Ailsa
Mellon Bruce Collection (1970.17.60)*

During the summer of 1874, while visiting
family at Gennevilliers on the Seine river,
Manet joined Claude Monet at nearby
Argenteuil. His admiration for his younger
colleague's innovations is revealed in
remarks made about the same time to the
painter Jean Béraud (1849–1936), and
recorded by his close friend Antonin Proust:

> *There's not one of the school of 1830
> who can set down a landscape like
> him. And when it comes to water, he's
> the Raphael of water. He knows all its
> movements, whether deep or shallow,
> at every time of day. I emphasize that
> last phrase because of Courbet's mag-
> nificent remark to Daubigny who had
> complemented him on a seascape: "It's
> not a seascape, it's the time of day."
> That's what people don't fully under-
> stand yet, that one doesn't paint a
> landscape, a seascape, a figure; one
> paints the effect of a time of day on a
> landscape, a seascape, or a figure.[1]*

On the same occasion Auguste Renoir
arrived at Argenteuil, and the three artists
proceeded to paint a group of works that
would collectively evoke the essence of the
Impressionist movement. Among them is a
pair of paintings by Manet and Renoir that
depict an idyllic scene with Camille Monet
and her young son, Jean, posed beneath a
tree in the garden of the Maison Aubry, the
family's first house at Argenteuil. The two
visitors worked side by side, and Monet
later described the episode:

> *One day, Manet, enthralled by the
> color and the light, undertook an out-
> door painting of figures under trees.
> During the sitting, Renoir arrived. He,*

too, was caught up in the spirit of the
moment. He asked me for palette,
brush and canvas, and there he was,
painting away alongside Manet. The
latter was watching him out of the cor-
ner of his eye, and from time to time
came over for a closer look at the can-
vas. Then he made a face, passed dis-
creetly near me, and whispered in my
ear about Renoir: "He has no talent,
that boy! Since you're his friend, tell
him to give up painting! . . ." Wasn't
that amusing of Manet?[2]

At the same time, Monet was working on
his own canvas, in which he recorded
Manet seated at an easel in the garden,
painting his wife and child.[3]

Unlike Renoir's version (fig. 36a),
Manet's shows Camille looking directly at
the viewer. Although she appears to smile
slightly, her features convey an impres-
sion of wistfulness, recalling portraits of
her by her husband. More expansive than
Renoir's composition, this work includes
a view of the garden beyond and, to the
left, the figure of Claude Monet, watering
can at his side. Tending his beloved flow-
ers, he serves to reaffirm the identities of
Camille and Jean. Upon completion of
their respective canvases, both Manet and
Renoir gave them to Monet as souvenirs
of the occasion.

PROVENANCE
Claude Monet, from the artist; returned to Manet by
1878; Toul; Auguste Pellerin; Bernheim-Jeune, Paul
Cassirer, and Durand-Ruel, in 1910; Eduard Arnhold,
Berlin; M. Knoedler and Co., New York, in 1964;
Mrs. Charles S. Payson.

NOTES
1. Manet to Jean Béraud, as recorded by Antonin
Proust, in Juliet Wilson-Bareau, ed., *Manet by Himself*
(London: Macdonald and Company, 1991), p. 169.
2. Monet, as quoted in M. Elder (Marc Tendron),
*À Giverny, chez Claude Monet* (Paris, 1924), in
Françoise Cachin and Charles S. Moffett, in
collaboration with Michel Melot, *Manet, 1832–1883*,
exh. cat. (New York: Metropolitan Museum of Art,
1983; distributed by Harry N. Abrams), p. 362.
3. Claude Monet, *Manet Painting in Monet's
Garden*, 1874. The present location of this painting
is unknown.

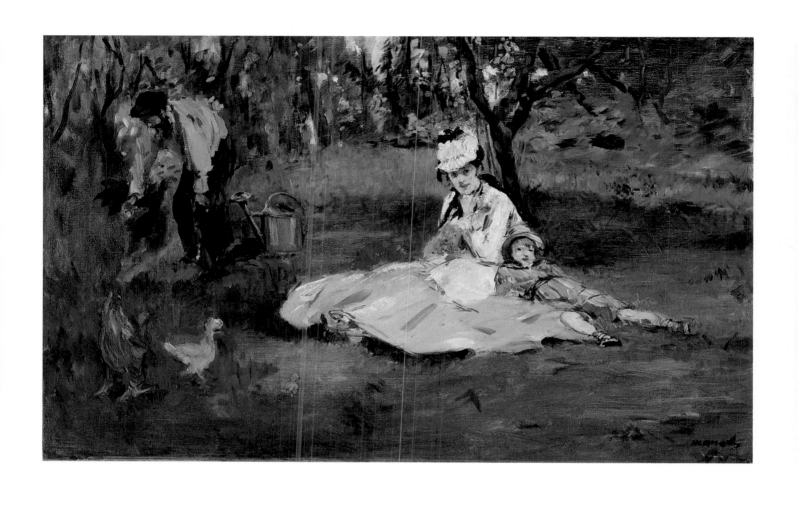

CAT. NO. 37
ÉDOUARD MANET
1832–1883

**Portrait of Lise Campinéanu**
1878

Oil on canvas
21 7/8 x 18 5/16 inches (55.7 x 46.5 cm)

The Nelson-Atkins Museum of Art,
Kansas City, Missouri (Purchase:
Nelson Trust) (36-5)

*Fig. 37a. Photograph of Lise Campinéanu.
(c. 1878). Rewald/Cézanne Archive,
Courtesy of the Photographic Archive of the
National Gallery of Art, Washington, D.C.*

*Fig. 37b. Édouard Manet. Lise
Campinéanu (Little Girl in Armchair).
(c. 1878). Spencer Museum of Art, The
University of Kansas: Gift of Charles
E. Curry (58.121)*

On 31 August 1878 the Romanian physician
Dr. Georges de Bellio (1828–1894), who
tended to a number of the Impressionists
and was an astute collector of their works,
wrote to Claude Monet:

> [Manet] *made a portrait of my great-
> niece, a ravishing, eight-year-old child
> with blond hair and astonishing, large
> blue eyes. You see from this what he
> could do with the elements and the tal-
> ent with which you are familiar.[1]*

Lise was the daughter of de Bellio's
nephew, Jean Campinéanu, governor of the
National Bank of Romania, who, at the
suggestion of his uncle, commissioned this
portrait from Manet in 1878.[2] Portraits of
children such as this and a related, less fin-
ished variant, possibly a preliminary study
(fig. 37b), are relatively rare in the artist's
production. Of particular appeal in the
characterization is the young girl's open,
animated expression, due in large part, as
de Bellio noted, to her extraordinary blue
eyes. Also enhancing the image is a rich-
ness of color and animated brushwork.

PROVENANCE
M. and Mme. Campinéanu, Bucharest; Mme. Grégoire
Gréceano, Bucharest, c. 1930; Wildenstein, New York;
purchased by the William Rockhill Nelson Gallery.

NOTES
1. De Bellio to Monet, 31 August 1878, in Denis
Rouart and Daniel Wildenstein, *Édouard Manet:
Catalogue raisonné*, vol. 1. (Lausanne and Paris:
Bibliothèque des Arts, 1975), p. 226.
2. Anne Distel, *Impressionism: The First
Collectors*, trans. Barbara Perroud-Benson
(New York: Harry N. Abrams, 1990), p. 115.

CAT. NO. 38
ÉDOUARD MANET
1832–1883

**Young Woman in a Round Hat
(The Amazon)**
(1879)

Oil on canvas
21 ½ x 17 ¾ inches (54.6 x 45.1 cm)

The Henry and Rose Pearlman
Foundation, Inc.

Fig. 38a. Édouard Manet. Two Hats. 1880.
Watercolor. Musée des Beaux-Arts, Dijon,
France

Fig. 38b. Édouard Manet. The Amazon
(The Horsewoman). (1882–83). Villa Flora,
Winterthur, Hahnloser Collection

Whether carefully delineating the details of a fashionable ensemble or theatrical costume, or merely suggesting a particular style or fabric, Manet was keenly aware of his sitter's apparel. A study of his images of women shows a particular fascination with hats, and he is known to have made watercolor studies of various types of millinery (fig. 38a).[1] Such an interest is also reflected in this portrait of an elegantly attired young woman poised as if preparing to venture out-of-doors for an excursion. Sometimes titled *Amazone*, the French term for a horsewoman, she may indeed be wearing a type of riding hat that provided an alternative to the taller, more masculine "top hat" also seen in the artist's paintings of such sportswomen.

The identity of the subject remains unknown; however, her dark hair and features are not unlike those of the young woman who appears in a group of portraits of *amazones* that are generally dated in the early 1880s (fig. 38b). It has been proposed that the sitter in two of these works was the daughter of a bookseller on the Rue de Moscou, located not far from Manet's last Paris studio, at 77, rue d'Amsterdam. It is tempting to suggest that the young woman shown here is the same model.[2]

The portrait remained in the artist's studio until his death and was subsequently sold at the Manet sale in February 1884. A later owner, although only for a brief period, was the legendary New York collector John Quinn (1870–1924), one of the organizers of the 1913 Armory Show.

PROVENANCE
Manet Estate Sale, 1884; Samson; Auguste Pellerin, by 1902; Bernheim-Jeune, Paul Cassirer, and Durand-Ruel, 1910; John Quinn, New York, 1911; Durand-Ruel, 1911; Martin A. Ryerson, Chicago, 1912; Mrs. Martin Ryerson, Chicago, until 1937; The Art Institute of Chicago, by bequest; deaccessioned, 1947, and sold to E. & A. Silberman Galleries, New York, until 1955; Mr. and Mrs. Henry Pearlman, New York.

NOTES
1. Françoise Cachin and Charles S. Moffett, in collaboration with Michel Melot, *Manet, 1832–1883*, exh. cat. (New York: Metropolitan Museum of Art, 1983; distributed by Harry N. Abrams), pp. 460, 484–85.
2. See Paul Jamot and Georges Wildenstein, *Manet*, vol. 1 (Paris: Les Beaux-Arts Édition d'Études et de Documents, 1921), p. 178.

CAT. NO. 39
ÉDOUARD MANET
1832–1883

**Portrait of Émilie Ambre as Carmen**
(c. 1879)

Oil on canvas
36 ³/₈ x 28 ¹⁵/₁₆ inches (92.4 x 73.5 cm)

Philadelphia Museum of Art: Gift of
Edgar Scott (1964.114.1)

*Fig. 39a. Mora, New York. Photograph of Émilie Ambre. (c. 1880). Harvard Theatre Collection, Nathan Marsh Pusey Library, Harvard University, Cambridge, Mass.*

In the autumn of 1879 Manet, suffering the debilitating effects of the illness that would take his life four years later, rented a villa at Bellevue in the southern environs of Paris. There he underwent therapeutic treatment for his condition. In September he wrote to his former pupil and friend Eva Gonzalès, "I'm working again. At the moment I'm doing a portrait of Mlle. Émilie Ambre, a landowning *prima donna* neighbor. I go and work on it every day because she's leaving for America on October 8."[1]

Émilie Ambre (1854–1898), a singer of modest talent, had perfected the role of Carmen in Georges Bizet's opera and was about to embark on an American tour. As to her origins, a contemporary newspaper account revealed:

> *Mlle. Ambre is by birth an African, having first seen the light of day at Oran, in Algiers. Her parents belonged to a distinguished Moorish family, and were highly regarded in the Court of the late Emperor of Morocco. Both were accomplished in the musical art, and at an early age their child began to give proofs of sympathy in the same direction.*[2]

Intending, perhaps, to enhance her own reputation, she took with her Manet's controversial painting *The Execution of Maximilian* (1868–69; Städtische Kunsthalle, Mannheim), planning to display it in the course of her journey.[3] Banned from public exhibition in Paris because of its political content, the composition graphically depicts the death of the Emperor Maximilian of Mexico before a firing squad on 19 June 1867, thus ending France's political aspirations in that country. Despite her efforts, the American tour met with only limited success and both the painting and Mlle. Ambre returned to Paris.

In this likeness, Manet portrays the vivacious diva in Spanish dress, prepared for her signature role as Carmen. Such attire was certainly familiar to the artist, who is known to have kept a collection of Spanish costumes in his studio, which he drew upon from a number of portraits painted in the 1860s.[4] Depicting a sitter in such garb many years later must have rekindled memories of earlier enthusiasms.

Typically, he has lavished attention on the details of the clothing. Although broadly painted, the trim of the short jacket, the transparent lace mantilla draped around Ambre's head and shoulders, and the fan she grasps at her side all serve to define her characterization as Bizet's heroine.

In the course of her travels, Mlle. Ambre wrote to Manet from Boston in January 1880, reporting on her efforts to promote *The Execution of Maximilian* to the American press, "I even persuaded some of them that I have copied the cynicism of the woman on top of the wall for the role of Carmen."[5]

Confidence rather than cynicism, however, radiates from this image of the singer prior to her departure, and she appears to anticipate the accolades she hopes to receive in the course of her journey.

Mlle. Ambre did not acquire her portrait upon its completion. Rather, in 1883 it was purchased from Manet's widow by Mrs. Thomas A. Scott of Philadelphia, at the suggestion of her cousin, Mary Cassatt.

PROVENANCE
Sold by Manet's widow, Suzanne, to Mrs. Th. A. Scott, Philadelphia, in 1883; Mr. and Mrs. Edgar Scott, Philadelphia.

NOTES
1. Manet to Gonzalès, 27 September 1880 (postmark), in Juliet Wilson-Bareau, ed., *Manet by Himself* (London: Macdonald and Company, 1991), p. 256.
2. Unidentified newspaper clipping, Harvard Theatre Collection, Nathan Marsh Pusey Library, Harvard University, Cambridge, Mass.
3. For a discussion of Ambre's American tour, see Hans Huth, "Impressionism Comes to America," *Gazette des Beaux-Arts*, 6th ser., 29 (April 1946) pp. 226–28.
4. See Charles S. Moffett, in Françoise Cachin and Charles Moffett, in collaboration with Michel Melot, *Manet, 1832–1883*, exh. cat. (New York: Metropolitan Museum of Art, 1983; distributed by Harry N. Abrams), p. 110.
5. Ambre to Manet, January 1880, as quoted in Anne Coffin Hanson, *Édouard Manet, 1832–1883*, exh. cat. (Philadelphia: Philadelphia Museum of Art, 1966), p. 177. The figure to which she refers gazes down with alarm from a high wall above the firing squad.

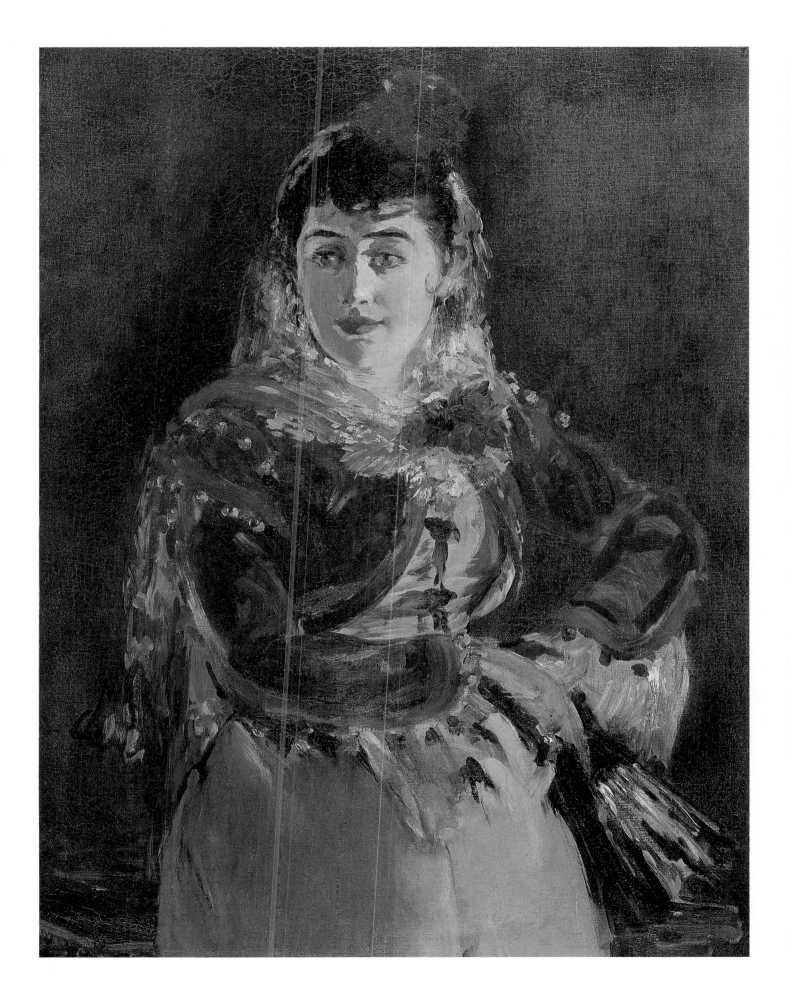

CAT. NO. 40
ÉDOUARD MANET
1832–1883

**Portrait of Clemenceau at the Tribune**
(1879–80)

Oil on canvas
45 ⅝ x 34 ¾ inches (115.9 x 88.3 cm)

Kimbell Art Museum, Fort Worth,
Texas (AP.81.1)

Fig. 40a. Benque & Co., Paris. Photograph of Georges Clemenceau. (n.d.). Musée Clemenceau, Paris

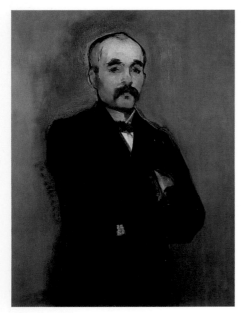

Fig. 40b. Édouard Manet. Portrait of Georges Clemenceau. (1879–80). Musée d'Orsay, Paris

A native of the Vendée in western France, Georges Clemenceau (1841–1929) pursued a career in medicine as a young man. In 1865 he traveled to America, settling in New York, where he wrote commentaries on life in the United States for the Paris newspaper *Le Temps*. In July 1869 he returned to France and joined the effort to overthrow the Second Empire of Napoleon III; subsequently he became a dominant figure in the Third Republic. Early in his political life Clemenceau served as Mayor of the eighteenth arrondissement of Paris, which included the district of Montmartre. He then became a member of the Chamber of Deputies, and his public career culminated in his designation as premier of France on two occasions, 1906–9 and 1917–20. Throughout his life he counted among his acquaintances many of the progressive artists and writers of his era.

Correspondence from Clemenceau to Manet concerning the scheduling of sittings establishes as 1879–80 the date of this portrait and a second, similar version (fig. 40b).[1] At about this time Antonin Proust (1832–1905), a lifelong friend of the artist, recorded Manet's concerns in respect to the availability of subjects to provide an adequate number of sittings:

> That's always been my principal concern, to make sure of getting regular sittings. Whenever I start something, I am always afraid that the model will let me down....They come, they pose, then away they go, telling themselves that he can finish it off on his own. Well, no, one can't finish anything on one's own.[2]

Indeed, both portraits remained unfinished in Manet's studio, possibly due to Clemenceau's inability, given his busy public life, to provide sufficient opportunity for the artist to complete the likenesses.

Clearly apparent in these paintings is Manet's debt to his teacher, Thomas Couture, who stressed the use of strong outline and expressive brushwork. Manet shows the statesman standing at a rail with a stack of documents close by, as if preparing to address an assembly. Although his arms are folded across his chest, giving him an air of authority, he appears somewhat dwarfed by the balustrade and the spacious void surrounding him. Clemenceau was in fact a small man, and Manet has conveyed that reality in this portrait.

Some twenty-seven years after he sat for Manet, Georges Clemenceau, as premier of France, would enhance the artist's posthumous reputation. At the urging of his close friend Claude Monet, he ordered the transfer of *Olympia* from the Musée du Luxembourg to the Louvre, the ultimate destination for France's artistic treasures. (In 1890 Monet had also organized the purchase of the controversial masterpiece for the nation through public subscription.)

Shortly after Manet's death in 1883, his widow presented Clemenceau with both this portrait and its variant. In 1905 the latter work was acquired by the American collector Louisine Havemeyer, who donated it to the Louvre in 1927.[3]

PROVENANCE
Presented to Georges Clemenceau by Manet's widow, Suzanne, after the artist's death in 1883; Vollard; Marczell von Nemes, until 1913; Rothenstein Sale, 1922; Georges Bernheim; Walter Halvorsen, Oslo; Justin K. Thannhauser, Berlin and New York, until 1960s.

NOTES
1. These letters are dated 9 December 1879 and 8 January 1880. See Françoise Cachin and Charles S. Moffett, in collaboration with Michel Melot, *Manet, 1832–1883*. exh. cat. (New York: Metropolitan Museum of Art, 1983; distributed by Harry N. Abrams), p. 443.
2. Manet, recorded by Antonin Proust, 1878, in Juliet Wilson-Bareau, ed., *Manet by Himself* (London: Macdonald and Company, 1991), p. 184.
3. Cachin and Moffet, *Manet*, p. 447.

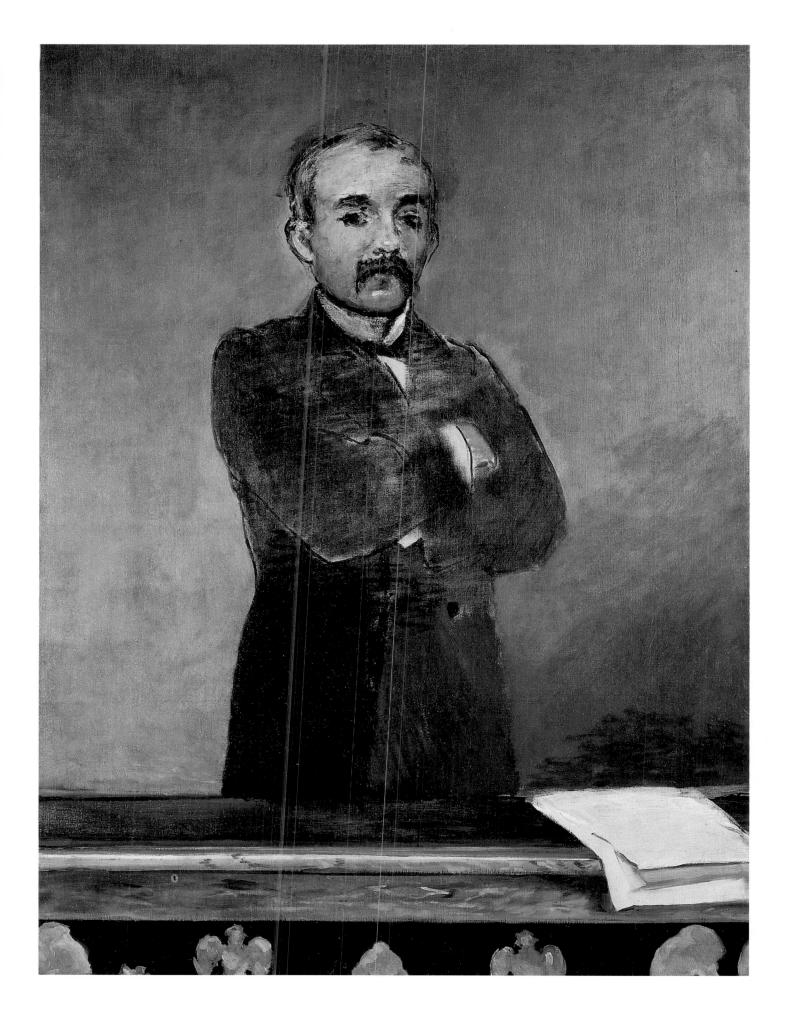

CAT. NO. 41
ÉDOUARD MANET
1832–1883

*Lady with a Bonnet*
(1881)

Pastel on canvas
23 5/8 x 19 1/4 inches (600 x 489 mm)

The Baltimore Museum of Art: The Cone Collection, formed by Dr. Claribel Cone and Miss Etta Cone of Baltimore, Maryland (BMA 1950.217)

Baltimore only

Late in life, as his health deteriorated, Manet "bethought himself of pastel as demanding less exertion, and he may also have been led to it by the hope of obtaining orders from society ladies whom he would have liked to please."[1] Between 1879 and 1883 the artist produced a series of approximately forty pastel portraits of fashionably attired women, which, in their freshness and delicacy, reveal his brilliant mastery of the technique. Adolphe Tabarant (1863–1950), writer and Manet biographer, described a typical sitting: "Manet would put paper or canvas on his easel, and without having his visitor actually pose, and perhaps without her noticing, he would 'catch' her even while carrying on a conversation with her."[2]

The immediacy inherent in the medium is apparent in this portrait of an unidentified woman of indeterminate age who is depicted against a neutral background. Broadly applied passages of gray enhance her profile. Although Manet treats the costume, bonnet, and hairstyle in summary fashion, he has rendered the subject's features and skin tones with exquisite subtlety.

Referring to this group of late pastel portraits, it has been observed:

> [They] *show no attempt at psychological analysis, no curiosity about the sitter's personality or the imprint of character on her features. In pastel, Manet painted his visitors like flowers, with attention to their elegance and refinement; they were above all, Parisiennes.*[3]

PROVENANCE
Manet Sale, 4–5 February 1884, no. 100; M. Robin; Auguste Pellerin, Paris; Durand-Ruel, Paris; Alfred Cassirer, Berlin; Galerie Thannhauser, Lucerne–Berlin; Jamot/Wildenstein, 1921, no. 472 [titled here *Femme au Chapeau à Brides*]; Etta Cone, Baltimore, 3 December 1930.

NOTES
1. J.-E. Blanche, *Masters of Modern Art: Manet*, trans. F. C. De Sumichrast (New York: Dodd, Mead and Company, 1925), p. 52.
2. Adolphe Tabarant, *Manet et ses oeuvres* (Paris, 1947), as quoted in Françoise Cachin and Charles S. Moffet in collaboration with Michel Melot, *Manet, 1832–1883*, exh. cat. (New York: Metropolitan Museum of Art, 1983; distributed by Harry N. Abrams), p. 493.
3. Françoise Cachin in Cachin and Moffett, *Manet, 1832–1883*, p. 493.

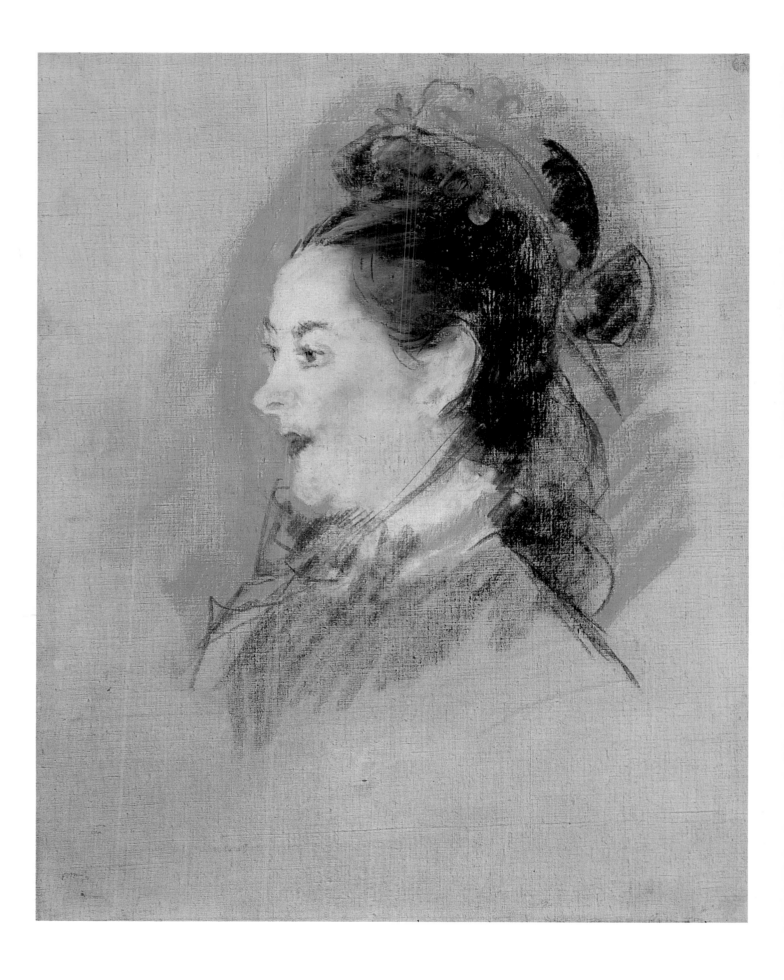

## CAT. NO. 42
### OSCAR-CLAUDE MONET
1840–1926

*Portrait of Claude-Adolphe Monet, the Artist's Father (formerly Portrait of a Man)*
(1865)

Oil on canvas
21 ¼ x 17 ⅝ inches (54 x 44.8 cm)

Jane Voorhees Zimmerli Art Museum, Rutgers, The State University of New Jersey: Gift of Dr. Ralph André Kling (0210)

*Fig. 42a. Oscar-Claude Monet. Garden at Sainte-Adresse. 1867. The Metropolitan Museum of Art, New York: Purchased with special contributions and purchase funds given or bequeathed by friends of the Museum, 1967 (67.241)*

The subject of this somewhat formal likeness is now thought to be the artist's father, Claude-Adolphe Monet (1800–1871).[1] The exact nature of the elder Monet's business activities in Paris remains obscure; however, his relocation to Le Havre in the mid-1840s apparently improved the family's financial prospects. Joining his brother-in-law's wholesale grocery firm, he took an increasingly large role in the management of the enterprise, retiring in 1860 as its sole proprietor.[2]

Claude Monet's relationship with his father was complex. Contrary to some accounts, Adolphe Monet was initially supportive of his son's desire to pursue artistic studies, petitioning the Municipal Council of Le Havre on two occasions for funds to send Claude to Paris.[3] Young Monet managed to make an extended visit to the capital in 1859–60. With sporadic financial assistance from his family, he continued his studies, first at the somewhat loosely structured Académie Suisse and later, following military service in Algeria, with the Swiss painter Charles Gleyre (1806–1874), in whose studio he met Auguste Renoir, Frédéric Bazille, and Alfred Sisley.

In this portrait the elder Monet appears as a man in his mid-sixties, serious in demeanor, with spectacles and graying hair. Having lost his wife in 1857, the widower had formed a liaison with a young servant, who gave birth to a daughter in 1860. They would not marry until ten years later. In April 1867, however, when Claude Monet informed his father of Camille Doncieux's pregnancy,

Adolphe, seemingly heedless of his own affair, urged his son to abandon his mistress.[4] The artist settled Camille in Paris in the care of a young doctor friend and returned for the summer to his aunt's home at Sainte-Adresse on the Normandy coast. Monet's early masterpiece *Garden at Sainte-Adresse* (fig. 42a), painted at this time, includes a full-length image of his father, seated comfortably in the right foreground, enjoying the panorama of oceangoing vessels on a brilliant day.

Claude Monet saw his father for the last time in the autumn of 1870, as he prepared to go into exile in London with Camille and their young son, Jean, at the outbreak of the Franco-Prussian War. While in England, he would learn of Adolphe Monet's death at Sainte-Adresse on 17 January 1871.

### PROVENANCE
Michel Monet, Giverny; Wildenstein; Dr. Ralph André Kling, New York, 1957.

### NOTES
1. See Daniel Wildenstein, *Monet: Catalogue Raisonné* (Cologne: Taschen/Wildenstein Institute, 1996), vol. 2, W53, in which the subject is identified as the artist's father. In Wildenstein's first edition of the catalogue (1974), the painting appears only as *Portrait of a Man* (W53). Another, similar portrait, also from 1865, has traditionally been called *Portrait of Adolphe Monet* (see W53a [1996]).

2. Wildenstein, *Monet* (1996), vol. 1, p. 16.

3. Ibid., vol. 1, pp. 20–21.

4. For discussions of Adolphe Monet and his relationship with his son, see Paul Hayes Tucker, *Claude Monet: Life and Art* (New Haven: Yale University Press, 1995), pp. 5–34 passim, and Wildenstein, *Monet* (1996), vol. 1, pp. 9–87 passim.

CAT. NO. 43
OSCAR-CLAUDE MONET
1840–1926

*Springtime*
(c. 1872)

Oil on canvas
19 ⅝ x 25 ¾ inches (49.9 x 65.4 cm)

The Walters Art Gallery, Baltimore,
Maryland (37.11)

*Fig. 43a. Oscar-Claude Monet.* Les Lilas, temp gris
(Beneath the Lilacs). *(c. 1872). Musée d'Orsay, Paris*

A native of Lyons, Camille-Léonie Doncieux (1847–1879) was living with her family in Paris in the mid-1860s when she met Claude Monet. She subsequently posed for several of the female figures in his idyllic summer scene from 1866, *Women in the Garden* (Musée d'Orsay, Paris). In her late teens she became Monet's mistress, and she appears repeatedly in both figure paintings and portraits throughout the 1860s and 1870s. With dark hair and eyes and features often marked by a certain sadness, she is clearly recognizable.

By early 1867 Camille was pregnant, and on 8 August she gave birth to a son, Jean-Armand-Claude Monet. When the infant was baptized the following spring, his father's close friend and fellow artist Frédéric Bazille served as godfather, and Camille Pissarro's companion, Julie Vellay, was named godmother. Camille Doncieux and Claude Monet eventually married in Paris on 28 June 1870, only months before they sought refuge in London at the outbreak of the Franco-Prussian War.

Argenteuil, a small Seine river community located in the suburbs northwest of Paris, had become a popular leisure retreat for city dwellers when Monet took up residence there with his small family in December 1871, following their return to France. The gardens and orchards surrounding their first house, the Maison Aubry, rented from an acquaintance of Édouard Manet, became the setting for a number of landscape and figure paintings that are manifestations of the artist's purest, most classic Impressionist style.

Here, Camille sits comfortably on the grass, shaded by foliage. Her pale pink dress is arranged luxuriously around her, and she appears about to turn the page of the book that absorbs her attention. Unlike many of Monet's representations of his wife, Camille radiates an air of serenity, seemingly free, for the moment, from the financial worry and illness that plagued much of her life.

Around 1872 Monet painted several canvases depicting figures in a garden locale distinguished by the presence of tall flowering lilac bushes. The present work is most closely related to a similar image of Camille reading in the company of another woman, who reclines at her side.[1]

PROVENANCE
*Either* Monet Sale, Drouot, Paris, 1873; Durand-Ruel, Paris; *or* purchased from the artist by Durand-Ruel, Paris, 1872. Hoschedé, Paris, by 1877. *Either* Hoschedé Sale, Drouot, Paris, 1878; to Lussac?; *or* purchased by Durand-Ruel at Hoschedé, Paris, in 1881; Mary Cassatt, c. 1889; Henry Walters, Baltimore, 1903.

NOTE
1. This painting, *Madame Monet in a Garden*, does not appear in either edition of the Wildenstein catalogue raisonné [Daniel Wildenstein, *Monet: Catalogue Raisonné* (Cologne: Taschen/Wildenstein Institute, 1996), 4 vols., first edition published 1974]. It was last recorded as being in a private collection in the United States. For a discussion of the work, see John House, "The New Monet Catalogue," *Burlington Magazine* 120, no. 907 (October 1978), pp. 680–81.

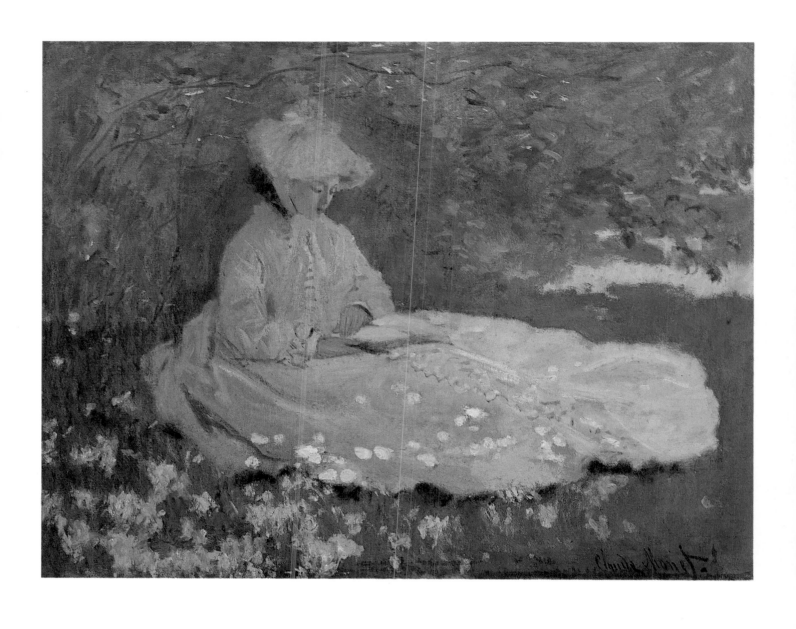

CAT. NO. 44
OSCAR-CLAUDE MONET
1840–1926

**La Capeline rouge (The Red Cape, Camille Monet in the Snow)**
(1870–75)

Oil on canvas
39 x 31 7/16 inches (99 x 79.8 cm)

The Cleveland Museum of Art: Bequest of Leonard C. Hanna, Jr. (1958.39)

Fig. 44b. Oscar-Claude Monet. Camille at the Window, Argenteuil. 1873. Virginia Museum of Fine Arts: Collection of Mr. and Mrs. Paul Mellon (83.38)

Fig. 44c. Oscar-Claude Monet. Camille sur son lit de mort (Camille on Her Deathbed). 1879. Musée d'Orsay, Paris

Fig. 44a. A. Greiner, Amsterdam. Photograph of Camille Monet. 1871. Private collection

In this image, possibly painted at the beginning of 1873,[1] Camille, bundled against the cold, appears in a wintry landscape beyond closed doors, which serve to bar her from the warmth of the interior. Her red shawl brightens the otherwise subdued coloring of the composition. As she pauses to look into the room, her expression conveys a sense of profound melancholy. The work is very different in feeling from another canvas probably painted the same year titled *Camille at the Window, Argenteuil* (fig. 44b), in which she stands in sunlight at an open window, looking out, a glorious array of brightly colored flowers on the terrace in front of her.

Various financial reversals through the mid-1870s and Camille's declining health put the Monet family in desperate straits. After the birth of their second son, Michel, in March 1878, Camille's condition deteriorated rapidly, and she died at Vetheuil, a small village on the Seine, on 5 September 1879 at the age of 32.[2] In a letter to Georges de Bellio, a Romania-born physician and early supporter of the Impressionists, written on the same day, the distraught painter described the ordeal and made a request:

*My poor wife gave up the struggle this morning at half past ten after the most ghastly suffering. I am in a state of distress, finding myself alone with my poor children. . . . I am writing to ask another favor of you; could you retrieve from the Mont de Piété [a pawn shop] the locket for which I am sending you the ticket. It is the only keepsake my wife had managed to hold on to and I would like to be able to place it around her neck before she goes.[3]*

In her last hours, Monet would paint a final, extraordinary portrait of his wife on her deathbed. He described the experience to his close friend Georges Clemenceau (1841–1929) many years later:

*When I was at the deathbed of a lady who had been and still was, very dear to me, I found myself staring at the tragic countenance, automatically trying to identify the sequence, the proportions of light and shade in the colors that death had imposed on the immobile face. Shades of blue, yellow, gray, and I don't know what. . . . In spite of myself, my reflexes drew me into the unconscious operation that is but the daily order of my life. Pity me, my friend.[4]*

PROVENANCE
Michel Monet, Giverny; Edward Molyneux, Paris, c. 1939; Carroll Carstairs, New York; Leonard C. Hanna, Jr., Cleveland, 1948.

NOTES
1. The dating of this painting is controversial. While Wildenstein (*Monet*, 1974 and 1996 editions) maintains a date of early 1873, other scholars have assigned it to the late 1860s or earlier in the 1870s.
2. Camille was nursed in her final illness by Alice Hoschedé, wife of collector Ernest Hoschedé, who was sharing the Monet household with her children. Following Ernest Hoschedé's death in 1891, Alice and Monet would marry at Giverny.
3. Monet to de Bellio, 5 September 1879, as quoted in Richard Kendall, ed., *Monet by Himself*, trans. Bridget Strevens Romer (London: Macdonald Orbis, 1989), p. 32.
4. Monet to Clemenceau in Georges Clemenceau, *Claude Monet* (Paris: Gallimard, 1929) in Charles F. Stuckey, ed., *Monet: A Retrospective* (New York: Hugh Lauter Levin Associates, 1985), pp. 350–51.

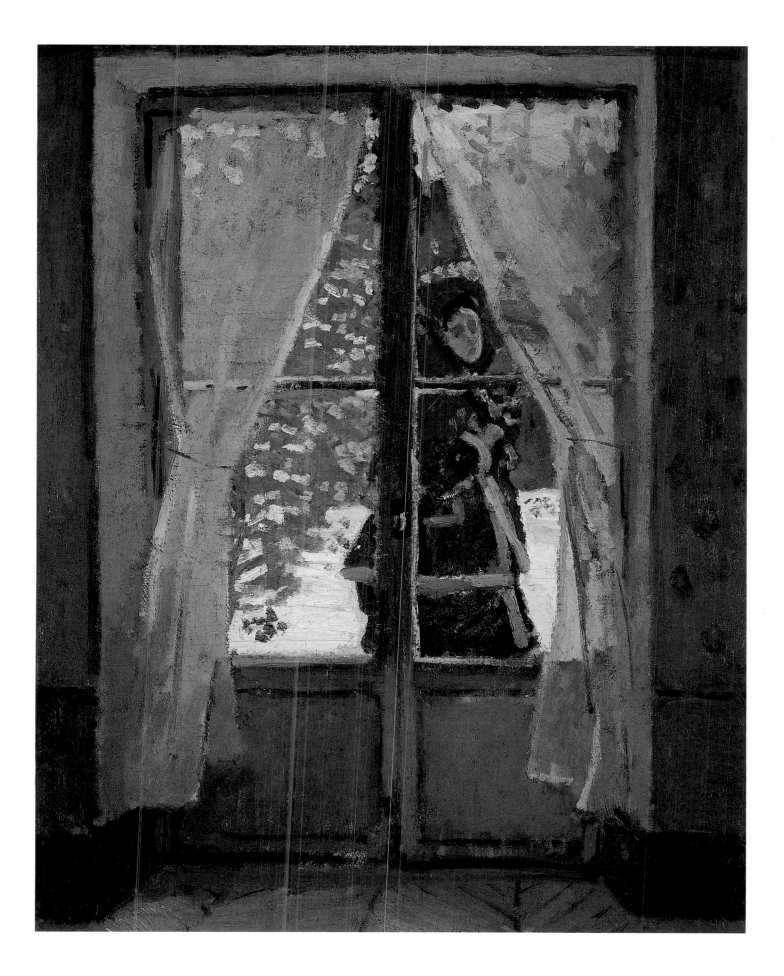

CAT. NO. 45
BERTHE-MARIE-PAULINE
MORISOT
1841–1895

**Reading (La Lecture)**
1873

Oil on canvas
18 x 28 ⅛ inches (45.8 x 71.5 cm)

The Cleveland Museum of Art:
Gift of the Hanna Fund (1950.89)

*Fig. 45a. Pierre Petit, photographer.*
*Edma Pontillon. (n.d.). Courtesy Galerie*
*Hopkins-Thomas-Custot, Paris*

A native of Bourges, a small city in central France, Berthe Morisot was the third daughter of Edme-Tiburce Morisot, a civil servant, and his wife, Marie-Joséphine-Cornélie Thomas. In the 1850s the family settled in Passy, west of Paris. At an early age the three girls displayed both talent and a keen interest in art. Encouraged by their mother, they enrolled in drawing classes. Yves (1838–1893), the eldest, soon lost interest, but Berthe and Edma (1839–1921) continued their studies with Joseph Guichard (1806–1880), an admirer of Eugène Delacroix. Although impressed with their abilities, Guichard nevertheless issued a stern warning to their mother:

> *Given your daughters' natural gifts, it will not be petty drawing-room talents that my instruction will achieve; they will become painters. Are you aware of what that means? It will be revolutionary—I would almost say catastrophic—in your high bourgeois milieu.[1]*

Undaunted, the sisters continued their instruction under Guichard and later Camille Corot. They also registered to copy at the Louvre, where in 1858, they met Henri Fantin-Latour. Ten years later Fantin would introduce them to Édouard Manet, to whom Berthe Morisot became especially close (see cat. no. 35).

In 1869 Edma Morisot abandoned her artistic pursuits following her marriage to Adolphe Pontillon (1832–1894), a naval officer. The close union the sisters had forged was broken, and the difficult adjustment to life independent of each other is revealed in a letter from Edma to Berthe written shortly after her marriage:

> *I have never once in my life written to you, my dear Berthe. It is therefore not too surprising that I was very sad when we were separated for the first time. I am beginning to recover a little, and I hope that my husband is not aware of the void that I feel without you.[2]*

Berthe continued to share her thoughts with her sister, writing in May 1869 to express her opinions about various works she had seen at the Salon:

> *The tall Bazille [Frédéric Bazille] has painted something that I find very good. It is a little girl in a light dress seated in the shade of a tree, with a glimpse of a village in the background*

[*View of the Village*, 1869; Musée Fabre, Montpellier, France]. *There is much light and sun in it. He has tried to do what we have so often attempted—a figure in the outdoor light—and this time he seems to have been successful.[3]*

In this portrait of her sister seated in a meadow, Berthe has created her own plein air painting, marked by soft color and a subdued, even light. A fan lies open at Edma's side, and an umbrella has been upended nearby. Neither element concerns the sitter, who appears deeply engrossed in her reading.

This canvas has been identified as one of four oil paintings shown by Morisot at the First Impressionist Exhibition in 1874.[4] A critic described her work:

> *In her watercolors as in her oils, [Morisot] likes grassy fields where some young woman holds a book [or sits] near a child. She juxtaposes the charming artifice of a young woman from Paris with the charm of nature. It is one of the tendencies of this emerging school [of artists], to mix Worth [the fashion designer] with the Good Lord.[5]*

Edma is the subject of several portraits and figural compositions by her sister, including *Mme. Morisot and Her Daughter, Mme. Pontillon* (1869–70; see House, fig. 12). She is easily recognizable by her medium brown hair, somewhat longish face, and high, arched eyebrows.

PROVENANCE
Gabriel Thomas, Paris; Edward H. Molyneux, Paris; César de Hauke; Leonard C. Hanna, Jr., Cleveland.

NOTES
1. Guichard, as quoted in Armand Fourreau, *Berthe Morisot* (Paris, 1925), pp. 11–12, in Charles F. Stuckey and William P. Scott, with the assistance of Suzanne G. Lindsay, *Berthe Morisot: Impressionist* (South Hadley, Mass.: Mount Holyoke College Art Museum, in association with National Gallery of Art, Washington, D.C.; New York: Hudson Hills Press, 1987), p. 18.
2. Pontillon to Morisot, in Denis Rouart, ed., *Berthe Morisot: Correspondence*, trans. Betty W. Hubbard (Mount Kisco, New York: Moyer Bell Limited, 1987), p. 32.
3. Morisot to Pontillon, 5 May 1869, in Rouart, *Berthe Morisot*, p. 37.
4. Stuckey and Scott, *Berthe Morisot*, pp. 55–57.
5. Jean Prouvaire, "L'Exposition du boulevard des Capucines," *Le Rappel* (20 April 1874), in Stuckey and Scott, *Berthe Morisot*, pp. 55–57.

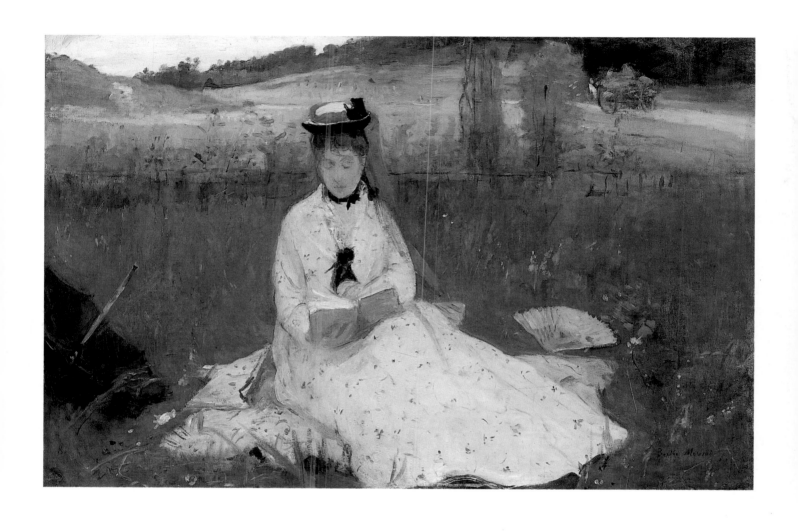

CAT. NO. 46
BERTHE-MARIE-PAULINE
MORISOT
1841–1895

**Mme. Boursier and Her Daughter**
(1873)

Oil on canvas
28 ¾ x 22 inches (73 x 55.9 cm)

Brooklyn Museum of Art:
Museum Collection Fund (29.30)

Fig. 46a. Galimard Fils, photographers.
Mme. Boursier. (n.d.). Courtesy Galerie
Hopkins-Thomas-Custot, Paris

Fig. 46b. Berthe-Marie-Pauline Morisot.
On the Terrace. 1874. Fuji Art Museum,
Tokyo

Many of the subjects in Morisot's portraits were members of her family, especially women and children. Following her marriage to Eugène Manet (1834–1892), a younger brother of Édouard Manet, in December 1874, she included her husband in a small number of works where he is generally shown with their daughter, Julie, born in 1878.

Here, she has portrayed her paternal cousin's wife, Mme. Lucien Boursier, with her small daughter, in a somewhat formal pose unusual in her production. Although the figures appear in an interior setting, which includes such decorative elements as a mirror and vase on a wood cabinet and a colorful shawl on the chair in which Mme. Boursier is seated, they are dressed for an outing. Of special appeal is the affection shared by mother and child, demonstrated most obviously by the manner in which the little girl holds her mother's thumb with both of her hands.

A description of Morisot by Théodore Duret (1838–1927), art critic and admirer of the artist, seems particularly germane to this painting:

> She was graceful, very distinguished, and perfectly natural. The slender nervous body betrayed the sensitive impressionable temperament. . . . Whatever she did came straight from the heart and was full of charm and sensitivity of spirit. There was a perfect accord between her and her work.[1]

Morisot had painted an earlier, more traditional portrait of Maria Boursier in 1867 (private collection, Paris), and she also appears in a less formal composition titled *On the Terrace* (fig. 46b) executed at Fécamp on the Normandy coast during the summer of 1874.

On 25 June 1873, this double portrait was purchased from Morisot by the dealer Paul Durand-Ruel, who, on the same day, sold it to Alfred Stevens, the Belgian painter and friend of the artist. At some point subsequent to Stevens's ownership, it reverted to Mme. Hitier (née Boursier), the child shown in the painting.[2]

PROVENANCE
Durand-Ruel, Paris; Alfred Stevens, Paris, 1873; Mme. Hitier, Paris; M. Knoedler & Co., New York, until 1929.

NOTES
1. Théodore Duret, as quoted in Regina Shoolman, in Ira Moskowitz, ed., *Berthe Morisot: Drawings, Pastels, Watercolors, Paintings* (New York: Tudor Publishing Company and Shorewood Publishing Co., 1960), p. 38.
2. See Curatorial file, Brooklyn Museum of Art.

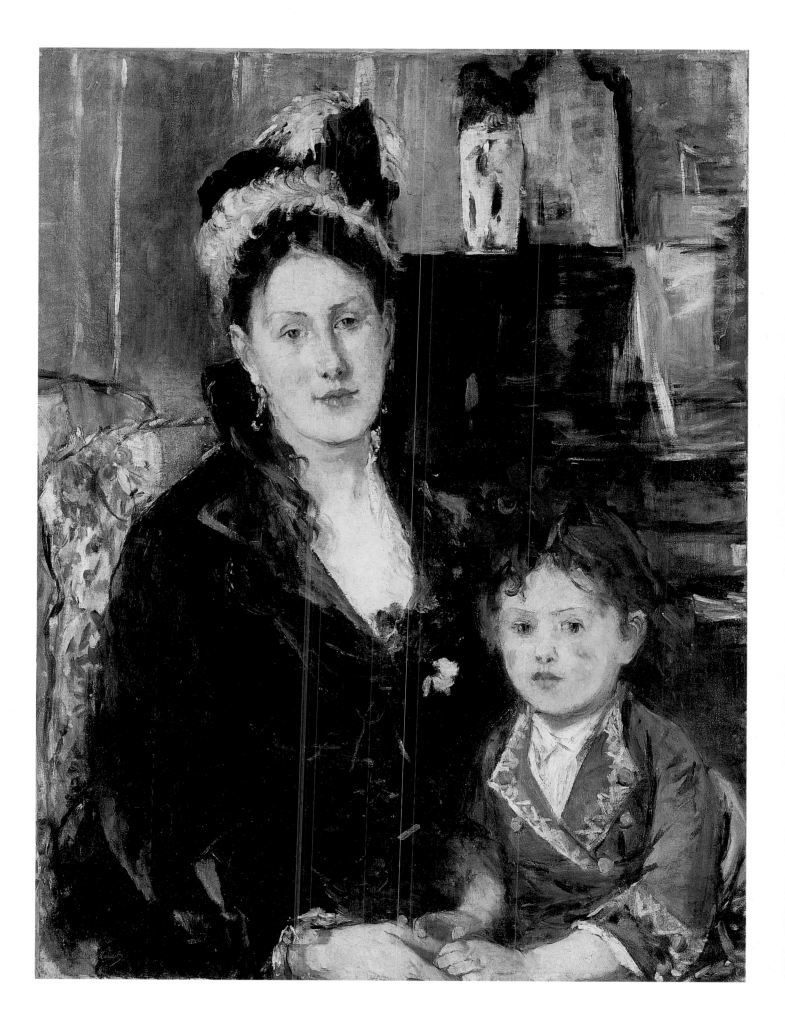

CAT. NO. 47
BERTHE-MARIE-PAULINE
MORISOT
1841–1895

**Woman with a Muff (Winter)**
(1880)

Oil on canvas
29 x 23 inches (73.7 x 58.4 cm)

Dallas Museum of Art, gift of the Meadows
Foundation Incorporated (1981.129)

This painting, together with its pendant *Summer* (*L'Été*, c. 1878; see House, fig. 17), was included in the Fifth Impressionist Exhibition in 1880, where it was exhibited with the title *Winter*. The coloring and features of the sitter in the pair of canvases suggest that the same model may have posed for both compositions. Although *Summer* has been identified as a self-portrait, the subject's somewhat pale complexion and fair hair would appear to argue against such an assumption.[1]

For the most part, Morisot's works were well received in the 1880 exhibition, several reviewers commenting on the refinement of color and delicacy of touch manifested in her style. The critic and collector of Impressionist paintings Charles Ephrussi (1849–1905) was especially complimentary:

> Berthe Morisot is French in her distinction, elegance, gaiety and nonchalance. She loves painting that is joyous and lively. She grinds flower petals onto her palette, in order to spread them later on her canvas with airy, witty touches, thrown down a little haphazardly. These harmonize, blend and finish by producing something vital, fine, and charming that you do not see so much as intuit. . . . Here are some young women rocking in a boat on choppy water; there are some picking flowers; this one walks through a winter landscape; that one is at her dressing table. All are seen through fine gray tones, matte white, and light pink, with no shadows, set off with little multi-colored daubs, the whole giving the impression of vague and opaline tints.[2]

The mention of a young woman walking through a winter landscape would appear to be a reference to this portrait, in which the model, elegantly dressed in seasonal attire, pauses momentarily in the course of her outing. A stylish hat sits low on her forehead, and a white scarf and red flower accessorize the costume. Ephrussi's admiration for Morisot and for this painting, in particular, was clearly genuine, as he later acquired the canvas for his personal collection.

In 1881 Édouard Manet painted two portraits as personifications of spring and autumn, possibly in response to a commission from his friend the journalist and politician Antonin Proust (1832–1905).[3] As in Morisot's *Summer* and *Winter*, the sitters are shown in half-length against decorative backgrounds suggesting the respective seasons. Unlike Morisot's portraits, however, in which the subject (or subjects) remain unknown, Manet posed a favorite model, Méry Laurent, for the personification of autumn, and Jeanne Demarsy, an actress, for his youthful spring.

PROVENANCE
Charles Ephrussi, Paris; Emil Staub-Terlinden, Switzerland; Pedro Valenilla-Echeverria, Caracas; Lester Avnet, King's Point, New York; Wildenstein, New York; Mr. and Mrs. Algur H. Meadows, Dallas.

NOTES
1. Xavier Dejean, *Le Portrait à travers les collections du Musée Fabre, XVII, XVIII, XIX siècles*, exh. cat. (Montpellier, France: Musée Fabre, 1979), no. 58, as quoted in Charles S. Moffett et al., *The New Painting: Impressionism, 1874–1886*, exh. cat. (San Francisco: Fine Arts Museums of San Francisco, 1986), p. 326.
2. Charles Ephrussi, "Exposition des artistes indépendants," *Gazette des Beaux Arts* (1 May 1880), pp. 485–88, as quoted in Moffett, *The New Painting*, p. 327.
3. Françoise Cachin and Charles S. Moffett, in collaboration with Michel Melot, *Manet: 1832–1883*, exh. cat. (New York: Metropolitan Museum of Art, 1983; distributed by Harry N. Abrams), pp. 486–91. Manet never executed the compositions representing summer and winter.

CAT. NO. 48
BERTHE-MARIE-PAULINE
MORISOT
1841–1895

***In the Garden at Maurecourt***
(c. 1884)

Oil on canvas
21 ¼ x 25 ⅝ inches (54 x 65.1 cm)

The Toledo Museum of Art: Purchased
with funds from the Libbey Endowment,
Gift of Edward Drummond Libbey
(1930.9)

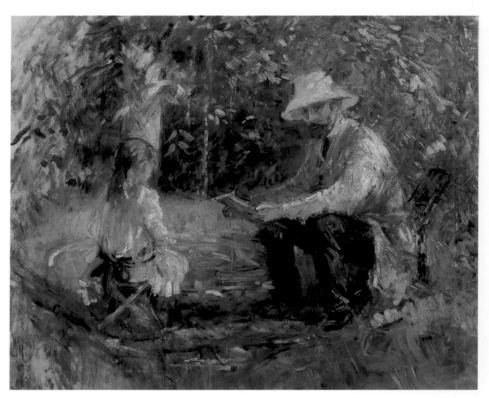

*Fig. 48a. Berthe-Marie-Pauline Morisot. Eugène Manet and his Daughter in the Garden.
1883. Private collection, Paris. Courtesy Galerie Hopkins-Thomas-Custot, Paris*

Following the death of her brother-in-law
and confidante, Édouard Manet, in April
1883, Morisot and her family spent the
summer at Bougival on the Seine west of
Paris. There she painted several works *en
plein air* in the garden of her house,
among them a canvas showing her hus-
band, Eugène, and their young daughter,
Julie (1878–1966), near a small pond in
the lush green surroundings (fig. 48a).

Similar in style, this composition, pos-
sibly from the following year, repeats the
artist's frequent theme of family members
in garden settings. Although figures are
often engaged in ordinary activity, such
as reading or sewing, the models here
simply enjoy the quiet pleasures of a sum-
mer day. While the woman on the left
turns toward the viewer, the child faces
away and looks out across the luxuriant
expanse of green grass. The location is
probably Maurecourt, the country home
not far from Paris, of the artist's sister
and brother-in-law, Edma and Adolphe
Pontillon. Maurecourt was the setting for
a number of Morisot's compositions. The
sitters have been identified as Morisot's
nieces, Jeanne and Edma Pontillon.[1]

For Berthe Morisot the year 1884 would
be dominated by family concerns. The
Édouard Manet Sale in February at the
Hôtel Drouot in Paris proved disappoint-
ing, and the declining health of both
her mother-in-law, Eugénie Manet, and
her husband's younger brother, Gustave,
would end with their deaths within weeks
of each other in late 1884 and early 1885.

PROVENANCE
Etienne Bignou, Paris; Lady Cunard, London; Louis
Churchill, London; Lefevre Gallery, London; Chester
J. Johnson, Chicago; Edward Drummond Libbey,
Toledo.

NOTE
1. Alain Clairet, et al., *Berthe Morisot, 1841–1895:
Catalogue raisonné de l'oeuvre peint* (Montolivet,
France: CÉRA-nrs éditions, 1997), p. 190.

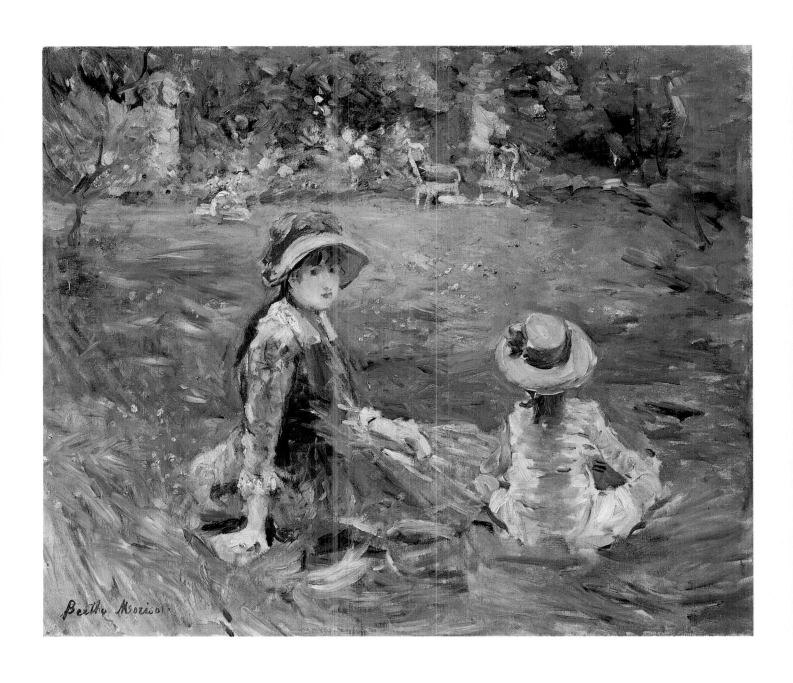

CAT. NO. 49
BERTHE-MARIE-PAULINE
MORISOT
1841–1895

*Reading (La Lecture)*
(1888)

Oil on canvas
29 ¼ x 36 ½ inches (74.3 x 92.7)

Museum of Fine Arts, St. Petersburg,
Florida: Gift of Friends of Art in memory
of Margaret Acheson Stuart (81.2)

Morisot spent the first part of 1888 in Paris at her home on the Rue de Villejust near the Bois de Boulogne. Having shown in all of the Impressionist Exhibitions but one, she would continue to participate in various group shows following the last Exhibition in 1886. Encouraged by her colleagues, she sent several works to the dealer Paul Durand-Ruel in the spring of 1888, joining fellow Impressionists Alfred Sisley, Camille Pissarro, and Pierre-Auguste Renoir, among others. Included in this number was this portrait of a little girl reading, exhibited with the title *La Lecture*.[1]

Probably painted on a balcony adjacent to the garden of her Rue de Villejust residence, this vibrant canvas shows a seated young model, identified as Jeanne Bonnet, with book in hand, a pose reminiscent of a number of Morisot's compositions. Close to Julie Manet in age as well as demeanor, the sitter appears in two other paintings from the same period and may have served as a surrogate for the artist's daughter.[2]

Throughout the early 1890s, Morisot continued to portray children and young women in pleasurable settings, often posing Julie and other family members as models. The period was also marked by immense sorrow, with the death of her husband, Eugène Manet, in April 1892; however, her ties with her Impressionist colleagues helped sustain her. In February 1895, while caring for Julie, who had contracted the flu, Morisot herself became ill. She succumbed to pneumonia on March 2. Her last letter to her sixteen-year-old daughter reveals both a profound love for her only child and the closeness she felt for her fellow Impressionists:

*My little Julie, I love you as I die; I shall love you even when I am dead; I beg you not to cry, this parting was inevitable. I hoped to live until you married. . . . Work and be good as you have always been; you have not caused me one sorrow in your little life. . . . Please give a remembrance of me to your aunt Edma and to your cousins; and to your cousin Gabriel give Monet's* Bateaux en réparation. *Tell M. Degas that if he founds a museum he should select a Manet. A souvenir to Monet, to Renoir, and one of my drawings to Bartholomé* [Albert Bartholomé, 1848–1928, painter, sculptor and close friend of Degas]. . . . *Do not cry; I love you more than I can tell you.*[3]

Berthe Morisot was fifty-five years old when she died; on her death certificate, she was listed as "without occupation."[4]

PROVENANCE
Collection Fayet; Gabriel Thomas, Paris;
M. Rosenberg, Paris; Brady Collection, U.S.A.;
Hirschl and Adler Galleries, New York.

NOTES
1. Charles F. Stuckey and William P. Scott, with the assistance of Suzanna G. Lindsay, *Berthe Morisot: Impressionist* (South Hadley, Mass.: Mount Holyoke College Art Museum, in association with National Gallery of Art, Washington, D.C.; New York: Hudson Hills Press, 1987), pp. 130, 136.
2. See *Fillette à la perruche*, 1888 (no. 224), and *Le Volant*, 1888 (no. 225), in Alain Clairet et al., *Berthe Morisot, 1841–1895: Catalogue raisonné de l'oeuvre peint* (Montolivet, France: CÉRA-nrs éditions, 1997), pp. 224–25.
3. Berthe Morisot to her daughter, 1 March 1895, in Denis Rouart, ed., *Berthe Morisot: Correspondence*, trans. Betty W. Hubbard (Mount Kisco, New York: Moyer Bell Limited, 1987), p. 212.
4. Stuckey and Scott, *Berthe Morisot*, p. 175.

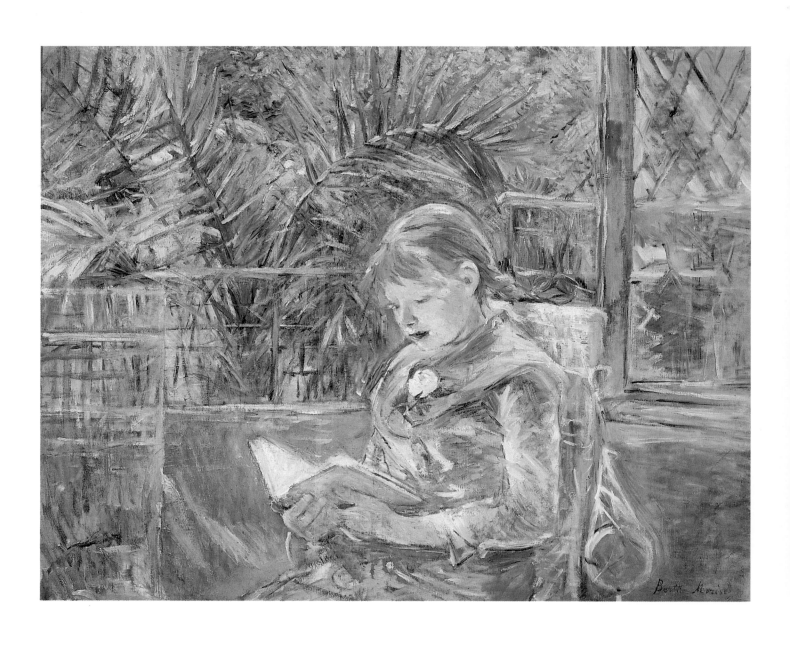

CAT. NO. 50
CAMILLE PISSARRO
1830–1903

*The Artist's Daughter*
1872

Oil on canvas
28 5/8 x 23 7/16 inches (72.7 x 59.6 cm)

Yale University Art Gallery: John Hay
Whitney, B.A. 1926, Hon. M.A. 1956,
Collection (1982.III.4)

*Fig. 50a. Camille Pissarro. Louveciennes,
the Road to Versailles. 1870. Emil G.
Bührle Collection, Zurich*

In 1865, the year his second child, Jeanne-
Rachel (1865–1874), was born, Camille
Pissarro and his small family were living
at La Varenne-Saint-Maur in the suburbs
of Paris. In the ten years since his arrival
in France from his birthplace, St. Thomas,
in the Danish West Indies, the artist had
studied briefly at the École des Beaux-
Arts and at the Académie Suisse, where he
met Claude Monet and Paul Cézanne. An
admirer of Corot, Pissarro would list him-
self as a pupil of the older artist when he
exhibited landscapes of the environs of
Paris at the 1864 and 1865 Salons.[1]

In 1860 Pissarro began an affair with his
mother's maid, Julie Vellay, who bore their
first child, Lucien, in 1863. Two years later,
on May 18, she gave birth to Jeanne-
Rachel, also known as Minette. Pissarro
and Julie would not marry until June 1871,
while in exile in England during the
Franco-Prussian War. The artist's devotion
to his young children is demonstrated in
correspondence with Julie through the late
1860s in which he repeatedly urges them to
be good and expresses his love for them.

Pissarro includes a representation of his
daughter in the painting *Louveciennes, the
Road to Versailles* (fig. 50a) from 1870. She
is shown, a little girl of five, partially hid-
den by her mother's skirt as they stand
together in the small garden of their house
at Louveciennes. Although more a figure
painting than a portrait, the work nonethe-
less records Jeanne-Rachel's features with
some detail.

Primarily a painter of landscapes and
figural compositions, Pissarro also exe-
cuted a small number of portraits, most of
which depict members of his family. In 1872,
the year in which he settled in the village of
Pontoise, in the environs of Paris near
Auvers, he painted this likeness of Jeanne-
Rachel posed somewhat formally, her small
hand, which rests in her lap, grasping a
bouquet of brightly colored flowers. A dec-
orative border on the left enhances the oth-
erwise unadorned space surrounding her as
she looks sweetly toward the viewer from
beneath her straw hat. The artist's obvious
affection for his daughter, clearly expressed
in the portrait, is also apparent in an
earlier letter to Julie, in which he writes,
"Embrace my little Minette, tell her to be
as wise as my good fellow Lucien [and] I
will bring her a cake."[2]

PROVENANCE
Estate of the artist; Ludovic-Rodo Pissarro, the
artist's son, Paris; Wildenstein & Co., New York;
Mr. and Mrs. Otto L. Spaeth, New York; New York art
market; The Honorable and Mrs. John Hay Whitney,
New York; John Hay Whitney Charitable Trust.

NOTES
1. John Rewald, *Camille Pissarro* (New York:
Harry N. Abrams, 1963), p. 46.
2. Pissarro to Julie Vellay, undated letter,
probably 1868–69, in Janine Bailly-Herzberg, ed.,
*Correspondance de Camille Pissarro, Tome 1,
1865–1885* (Paris: Presses Universitaires de France,
1980), p. 62.

CAT. NO. 51
CAMILLE PISSARRO
1830–1903

*Portrait of Minette*
(c. 1872)

Oil on canvas
18 ¹/₁₆ x 14 inches, framed (45.9 x 35 cm)

Wadsworth Atheneum, Hartford,
Connecticut: The Ella Gallup Sumner
and Mary Catlin Sumner Collection
Fund (1958.144)

Fig. 51a. Camille Pissarro (1830–1903). Enfant mort. (1874). Lithograph.
Location unknown

Although undated, this likeness of Pissarro's young daughter, Jeanne-Rachel, also called Minette, shows her at about the same age as, or perhaps slightly older than, in *The Artist's Daughter* from 1872 (see cat. no. 50). A look of slight apprehension is evident in her expression as she poses with her hands carefully clasped in front of her. Planes of subdued color define the space, and a richly painted arrangement of objects on the table at her side forms a still life. The diamond-pattern design on the wall is also apparent in a gouache depicting a young girl seated in an interior with her doll, suggesting that the setting is a room in the artist's house.[1]

Death would claim Jeanne-Rachel at an early age. From mid-October 1873 through late winter of the following year, a series of moving letters from Pissarro to Dr. Paul Gachet (1828–1909), a physician, engraver (under the name of Paul Van Ryssel), and avid collector, records the course of her final illness. Noting on 11 October 1873 that "Jeane" is sick, Pissarro continues on 28 October, "She seems the same however her appetite is poor, she eats but with pain."[2] Two days later, the distraught father informs Gachet, who had been prescribing a series of potions, that "the medicine was finished yesterday on Wednesday evening. My wife is tormented, she prays that you will continue the treatment."[3]

Jeanne-Rachel Pissarro died at Pontoise on 6 April 1874. It has been suggested that a lithograph dated 3 February 1874, in which she is shown lying on her deathbed, is her father's final poignant image of her (fig. 51a).

Pissarro and his wife had eight children, among them a girl born in August 1881, whom they named Jeanne, in memory of her sister.

PROVENANCE
Camille Pissarro; Mme. Pissarro, his widow; Galerie Georges Petit, Paris, 3 December 1928, no. 48; Paul Rosenberg, Paris; Bruno Stahl, Berlin; Wildenstein and Co., New York; Mrs. Anna Sorine, New York.

NOTES
1. See Ludovic Rodo Pissarro and Lionello Venturi, *Camille Pissarro: Son art—son oeuvre*, vol. 1 (Paris: Paul Rosenberg, 1939), p. 264 [no. 1322, *Fillette assise avec une poupée*].
2. Pissarro to Gachet, letters dated 11 and 18 October 1873, in Janine Bailly-Herzberg, ed. *Correspondance de Camille Pissarro, Tome 1, 1865–1885* (Paris: Presses Universitaires de France, 1980), pp. 81, 83.
3. Pissarro to Gachet, 30 October 1873, in Bailly-Herzberg, *Correspondance de Camille Pissarro*, p 83.

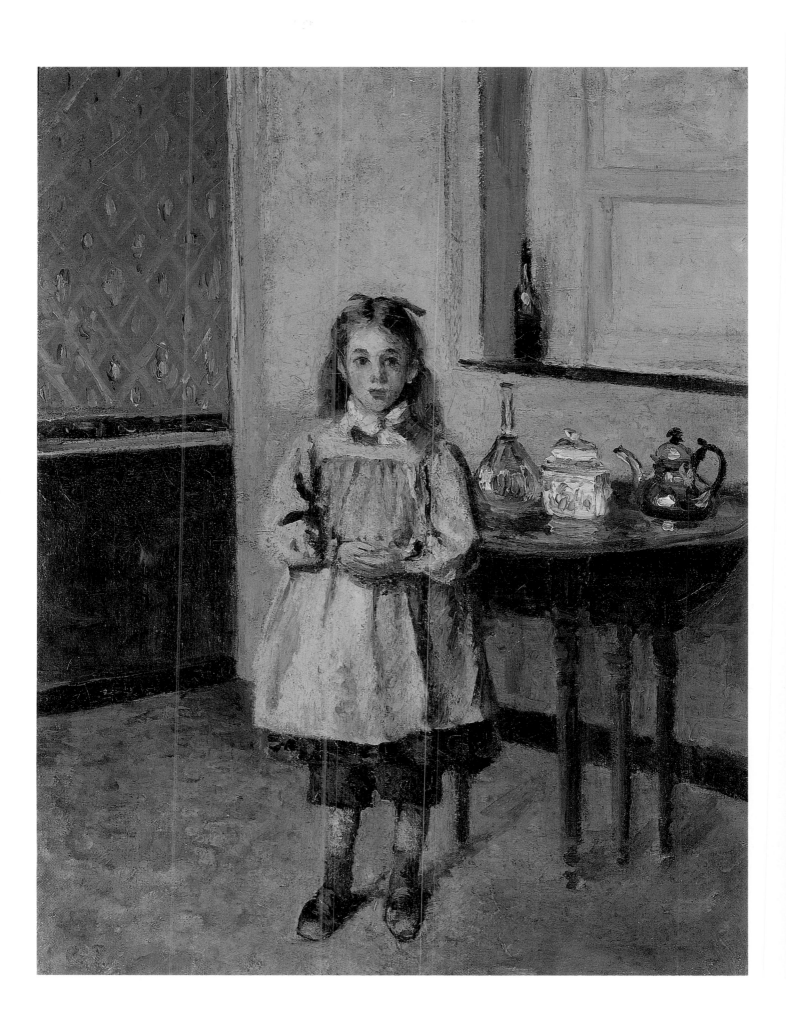

CAT. NO. 52
CAMILLE PISSARRO
1830–1903

**Portrait of Eugène Murer**
1878

Oil on canvas
25 5/8 x 21 3/8 inches, oval (65.1 x 54.3 cm)

Museum of Fine Arts, Springfield,
Massachusetts: James Philip Gray
Collection

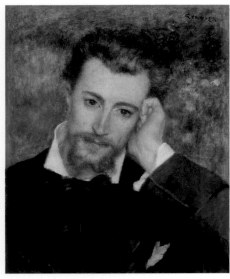

*Fig. 52a. Pierre-Auguste Renoir
(1841–1919). Eugène Murer. 1877. The
Metropolitan Museum of Art, New York:
From the Collection of Walter H. and
Leonore Annenberg*

For several of the Impressionists, the
1870s and 1880s were years marked by
poverty and a constant struggle to sell
their innovative paintings to a skeptical
public. One of their chief supporters,
Eugène Murer (1841–1906), was a school-
friend of Armand Guillaumin (1841–1927),
a somewhat lesser known member of the
group. During the 1870s Murer, a former
pastry chef, writer, and amateur painter,
owned a restaurant in Paris on the
Boulevard Voltaire, not far from the
Place de la Nation and the cemetery of
Père Lachaise. He described the estab-
lishment in one of his notebooks:

> *I was living on the Boulevard Voltaire in
> a shop decorated by the Impressionists.
> Renoir had adorned the frieze with bril-
> liant garlands of flowers. Pissarro with
> a few strokes of the brush had covered
> the walls with landscapes of Pontoise.
> Monet, who was always in pursuit of a
> louis, had contented himself with com-
> ing in to see how it was all getting on.
> Every Wednesday for two years we had
> met together, my friends and I, to par-
> take of a little fraternal dinner presided
> over by my sister.[1]*

At this time both Pissarro and Renoir pro-
duced portraits of Murer (fig. 52a) and
his half-sister, Marie-Thérèse Meunier
(*Mademoiselle Marie Murer*, 1877; National
Gallery of Art, Washington, D.C.). In
preparation for this painting, Pissarro
urged Murer to allow his beard to grow,
advising him, "We will see about working
it in on the portrait. It will be an addi-
tional attraction, for I fancy there will be
some rich colouring to add."[2]

Pissarro, desperate for funds to sup-
port his growing family, asked for pay-
ment of one hundred and fifty francs
for the likeness. When Murer complained
about the amount, noting that Renoir had
charged him less for his half-sister's por-
trait, Pissarro responded:

> *You were surprised at my asking a
> hundred and fifty francs for your por-
> trait seeing that Renoir had only
> charged one hundred for Mademoiselle
> Marie's. I must tell you, therefore, that
> before fixing on the price, I consulted
> our friend Renoir, and we both consid-
> ered a hundred and fifty a reasonable
> figure. I know perfectly well that
> Renoir could command a higher price*

> *than I, seeing that he is well-known as
> a portrait painter, but I still don't see
> how I could ask less.[3]*

Like the Renoir portrait of Marie-Thérèse
cited in the above letter, Pissarro's canvas
is oval in shape. Murer is shown with pre-
dominately red multicolored scarves tied
both at his collar and around his head, his
reddish beard and mustache indeed
enlivening his contemplative demeanor.

In the autumn of 1883 the artist made
an extended visit to Rouen, where Murer
and his sister had opened the Hôtel du
Dauphin et d'Espagne, advertising a
"magnificent collection of impressionist
paintings, which can be seen any day
without charge between ten and six."[4]
Pissarro, in a letter to his son Lucien
dated 19 October 1883 confided:

> *They [Murer and his sister] were very
> kind to me. Since they are part owners
> of the hotel, they arranged to let me
> have a room on the street and all my
> meals for one hundred and fifty a
> month. I work at my window on rainy
> days, I think the paintings I do then
> are my best work.[5]*

In an 1887 article on the Murer collection
in *Le Cri du peuple*, the critic Paul Alexis
noted that there were among his holdings
twenty-five Pissarros, twenty-eight Sisleys,
sixteen Renoirs, ten Monets, and eight
Cézannes.[6]

PROVENANCE

Eugène Murer, Paris; Dr. Georges Viau, Paris;
Léon Pedron, Paris; Jean Pedron; Paris; Galerie
d'Art Moderne, Paris; Knoedler & Company, New
York, 1951.

NOTES

1. Murer, notebook entry, quoted in A. Tabarant,
*Pissarro*, trans. J. Lewis May (New York: Dodd,
Mead and Company, 1925), p. 39. Tabarant writes
that he received a quantity of notebooks and other
writings by Murer upon his death in 1906.

2. Pissarro, as quoted by Murer, in Tabarant,
*Pissarro*, p. 43.

3. Pissarro, as quoted by Murer, in Tabarant,
*Pissarro*, p. 44.

4. John Rewald, ed., with assistance of Lucien
Pissarro, *Camille Pissarro: Letters to His Son Lucien*
(New York: Pantheon Books, 1943), p. 42n.

5. Camille Pissarro to Lucien Pissarro, 19 October
1883, in Rewald, *Camille Pissarro*, pp. 42–43.

6. Alexis, *Le Cri du peuple*, 21 October 1887,
as quoted in Rewald, *Camille Pissarro*, p. 121.

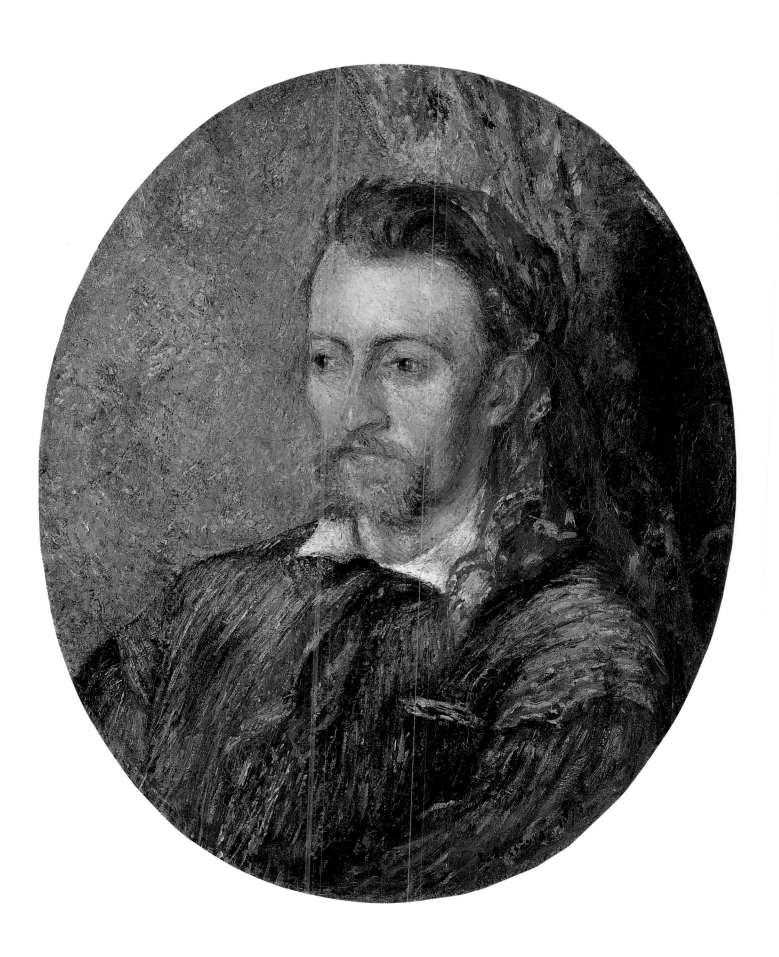

CAT. NO. 53
PIERRE-AUGUSTE RENOIR
1841–1919

*Romaine Lacaux*
1864

Oil on canvas
31 7/8 x 25 1/4 inches (81 x 64.2 cm)

The Cleveland Museum of Art:
Gift of the Hanna Fund (1942.1065)

Although Renoir's family moved to Paris shortly after his birth at Limoges, the artist's native city, renowned for its production of earthenware, determined his earliest artistic activities. He told the dealer Ambroise Vollard, many years later, "In as much as my father came from a city famous for its porcelain, it was natural that the profession of china-painting should seem the finest in his eyes."[1]

At the age of thirteen Renoir was apprenticed to a porcelain decorator in Paris; he also studied drawing in the evenings. With the introduction of a process that allowed the printing of designs directly onto ceramic, he was forced to abandon this pursuit and turned to the decoration of fans and window blinds. In 1861 Renoir joined the atelier of the Swiss history painter Charles Gleyre (1806–1874); shortly thereafter he was admitted to the École des Beaux-Arts. At this time he made the acquaintance of Claude Monet, Frédéric Bazille, and Alfred Sisley, followed by Paul Cézanne and Camille Pissarro.

Although the nature of the association between Renoir and Paul Lacaux (1816–1876), a Parisian manufacturer of ceramics, remains unclear, it seems reasonable to assume that they could have known each other through their common involvement in the industry. Romaine-Louise (1855–1918) was the second child and only daughter born to Lacaux and his wife, Denise-Léonie Guénault, whose family also manufactured earthenware.[2]

In 1864, the year the artist debuted at the Salon, Romaine-Louise sat for this formal portrait either at Barbizon during a family holiday, or possibly in her parents' apartment above their shop at 27, rue de la Roquette in the Popincourt quarter of Paris.[3] One of the artist's earliest commissioned portraits, it represents a girl of nine seated in a simple wood chair against a translucent curtain with a profusion of softly colored flowers behind her to the right. Dressed in crisp white and gray, Romaine rests her loosely clasped hands on a small bouquet of red flowers in her lap. The muted tones throughout the composition, together with the delicacy of her immediate surroundings, serve to draw attention to Romaine's youthful face, which expresses both innocence and candor.

While Renoir painted a number of figural works through the 1860s, portraits of family and friends predominated in his production at this time. He would later somewhat ruefully acknowledge his sister's suggestion that he pursue this potentially lucrative activity: "And that is just what I did. Except that my models were my friends and I did their portraits for nothing."[4]

In 1883 Romaine Lacaux married, and she and her husband, François Martial Lestrade (1850–1918), opened a general store in the ninth arrondissement. Two children were born to the couple in the late 1880s. Many years later, tragedy would ravage the family, first with the death of a son, Francis-Eugène, in battle in September 1915, and subsequently with the demise of the remaining family members, including sixty-three-year-old Romaine Lacaux Lestrade, in March 1918 during a bombardment of Paris only months before the armistice that ended World War I.[5]

PROVENANCE
Lacaux family, Paris; Edmond Decap, Paris; by descent to Mme. Maurice Barret-Decap, Biarritz; Barret-Decap Sale, Hôtel Drouot, 12 December 1929, Paris; Roger Bernheim, Paris; Jacques Seligmann and Co., New York, by 1941.

NOTES
1. Renoir, as quoted in Ambroise Vollard, *Renoir: An Intimate Record*, trans. Harold L. Van Doren and Randolph T. Weaver (New York: Alfred A. Knopf, 1925), pp. 22–23.
2. Colin B. Bailey, with the assistance of John B. Collins, *Renoir's Portraits: Impressions of an Age*, exh. cat. (New Haven and London: Yale University Press in association with the National Gallery of Canada, Ottawa, 1997), p. 94.
3. Bailey, *Renoir's Portraits*, p. 94.
4. Ibid, p. 92.
5. Ibid, p. 94.

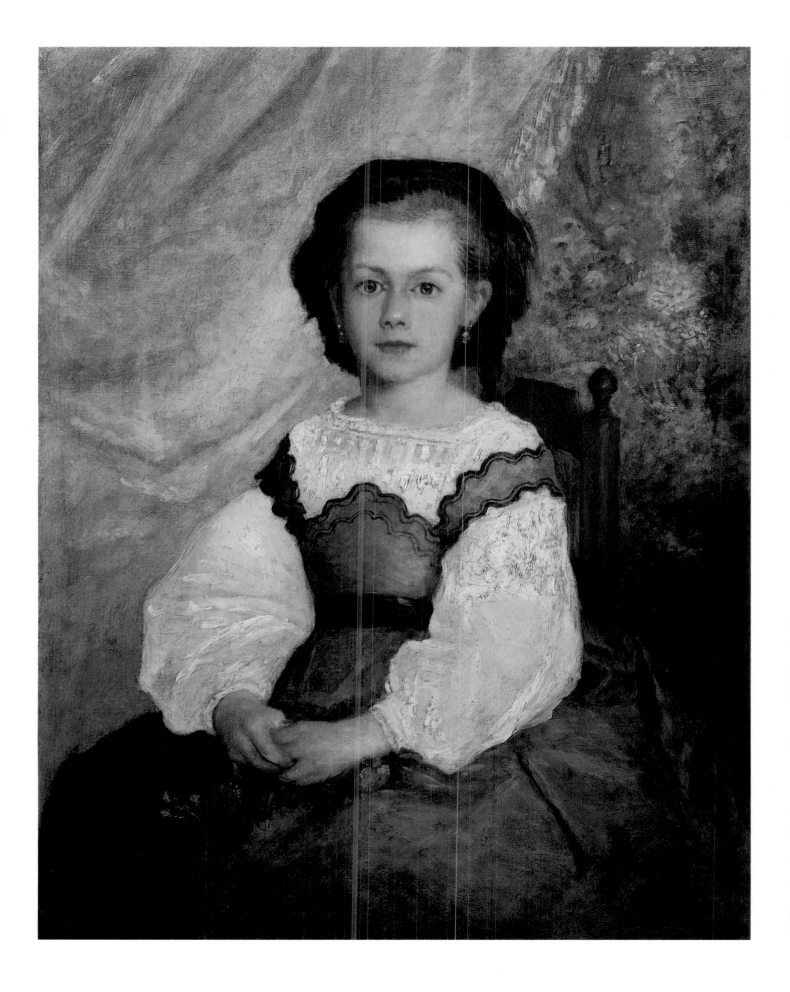

CAT. NO. 54
PIERRE-AUGUSTE RENOIR
1841–1919

*Léonard Renoir, The Artist's Father*
1869

Oil on canvas
24 x 18 inches (61 x 45.7 cm)

The Saint Louis Art Museum Purchase
(37.1933)

Fig. 54a. Pierre-Auguste Renoir. The
Artist's Brother, Pierre-Henri Renoir.
1870. Private collection, Japan

Although he never knew his grandfather,
the artist's second son, Jean Renoir
(1894–1979), once noted that he was:

> ... a grave and silent man [who] con-
> sidered that the only important thing in
> life was to give his children an educa-
> tion and to bring them up in a manner
> worthy of their legendary forebears.
> He worked all day long, but as he was
> a simple man and his prices were rea-
> sonable, he made only a modest income.
> Yet if Renoir's [the artist's] childhood
> impressions are correct, his father was
> happy in his work.[1]

An air of seriousness, if not displeasure,
prevails in this likeness of Léonard Renoir
(1799–1874), painted in 1869. A tailor by
profession, he was born in Limoges,
where he lived with his wife, Marguerite
Merlot, a dressmaker, prior to moving his
family to Paris in 1844. Although he may
not have been able to provide tangible
financial assistance to his son in the
course of his artistic training, Léonard
Renoir apparently did not oppose such
aspirations. Indeed, by the summer of
1869 Renoir had already exhibited at the
Salon on four occasions.

It is likely that this portrait was
painted sometime during the months of
July through September, 1869, when the
artist was living with his parents at
Voisins-Louveciennes, a Paris suburb
where they had settled in the previous
year. From this locale, he would journey
regularly to Bougival to paint with Monet
at nearby La Grenouillère, a pleasure park
on the Seine river.[2]

Léonard Renoir's stern countenance
seems reinforced by the effects of age. His
fixed mouth, heavy-lidded, somewhat
watery eyes, creased face, and formless
chin all speak to his advancing years.
Placed against a plain background, his
arms folded in an authoritative manner,
he appears to challenge the viewer as he
undoubtedly did his son.

In the following year Renoir painted
companion portraits of his older brother,
Pierre-Henri Renoir (1832–1909), and his
wife Blanche-Marie Renoir (fig. 54a; and
Fogg Art Museum, Harvard University,
Cambridge, Mass.). A successful engraver
of gems and ornamental designs, Pierre-
Henri appears prosperous and, unlike his
father, content with life.[3]

PROVENANCE
Renoir Family; Ambroise Vollard, Paris, in 1917;
Étienne Bignou, Paris, and Knoedler and Co., New
York, in 1933; City Art Museum, Saint Louis, in 1933.

NOTES
1. Jean Renoir, *Renoir: My Father*, trans.
Randolph and Dorothy Weaver (Boston and Toronto:
Little, Brown and Company, 1962), pp. 23–24.
2. John House and Anne Distel, *Renoir*,
exh. cat. (London: Hayward Gallery, 1985), p. 191.
3. Colin B. Bailey, with the assistance of John
B. Collins, *Renoir's Portraits: Impressions of an Age*,
exh. cat. (New Haven and London: Yale University
Press in association with the National Gallery of
Canada, Ottawa, 1997), p. 104.

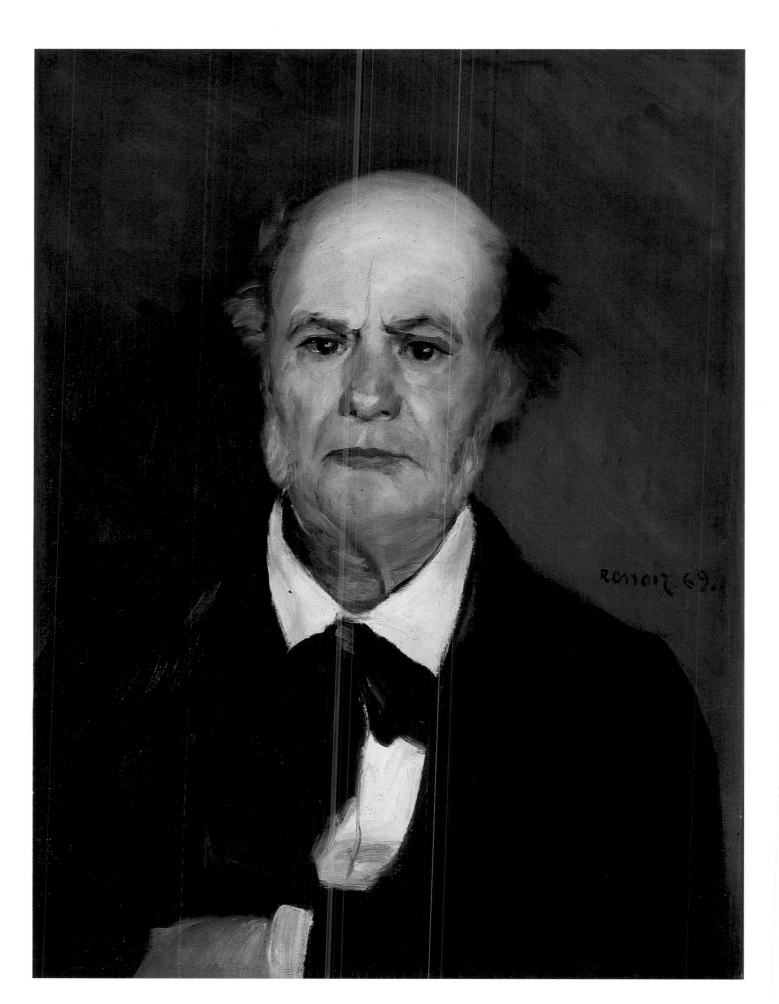

CAT. NO. 55

# PIERRE-AUGUSTE RENOIR
1841–1919

**Monet Working in His Garden at Argenteuil**
(1873)

Oil on canvas
19 3/4 x 23 1/2 inches (50.2 x 59.7 cm)

Wadsworth Atheneum, Hartford, Connecticut: Bequest of Anne Parrish Titzell (1957.614)

Baltimore only

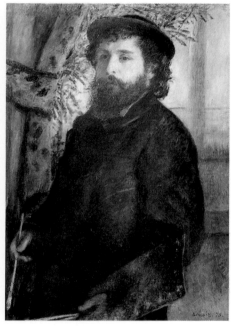

Fig. 55a. Pierre-Auguste Renoir. Portrait of Claude Monet Painting. 1875. Musée d'Orsay, Paris: Bequest of Monsieur and Madame Raymond Koechlin, 1931

In his reminiscences of Renoir, the dealer Ambroise Vollard noted the artist's recollection of this painting: "In 1873, feeling that I had really 'arrived,' I rented a studio in the Rue Saint-Georges.... The same year I went to Argenteuil, where I worked with Monet. I did quite a few studies there, among them, *Monet Painting Dahlias.*"[1]

The association between the two young painters had begun in Charles Gleyre's Paris studio in the early 1860s. It flourished through the following decade, with Renoir visiting his friend during Monet's interlude at Argenteuil, a popular boating center on the Seine near Paris.

Here Renoir portrays Monet standing before an easel, brush in hand, painting a glorious profusion of dahlias in the garden of his rented house, the Maison Aubry. A fence in the foreground serves to contain the flourishing blooms, and beyond the garden a cluster of buildings suggests a suburban community setting. Monet wears a round-brimmed hat seen in other images by Renoir (fig. 55a), and his deep blue jacket is typical of garments worn by farmers and gardeners in the French countryside until recent times. As he confidently works at his canvas out-of-doors, Monet seems to be the very embodiment of the Impressionist ideology.

The precise circumstances that prompted Renoir to record his friend in this manner are not known; x-rays reveal that he reused a canvas, painting over an earlier image of Monet's wife, Camille, shown in a bust portrait facing left, wearing an elaborate bonnet. There is some question as to whether Renoir or perhaps even Monet himself was responsible for the initial composition.[2]

Although each artist ultimately developed a unique style, this painting, together with Monet's own *The Artist's Garden in Argenteuil (A Corner of the Garden with Dahlias)* from 1873 (fig. 55b), illustrates the moment when their respective visions

seemed most closely linked. Indeed, in the autumn of 1873, Monet and Renoir helped form the group that would subsequently become known as the Impressionists.

Shortly before his death in December 1919, Renoir spoke of his association with Monet and of his life in general:

*I have always put myself at the mercy of fate. I have never had a fighter's temperament and would have given up on many occasions if my old friend Monet—one who does have a fighter's temperament—had not been there to put me on my feet again. Today when I look back at my life, I compare it to one of those corks thrown into a river. It bobs along, then gets caught in a whirlpool, spins back, goes down again, surfaces, gets tangled into a weed, makes desperate efforts to free itself and then vanishes from sight altogether.[3]*

Learning of Renoir's death, Monet reminisced with comparable sentiment:

*You can imagine how painful the loss of Renoir has been to me: with him goes a part of my own life. All I've been able to do these last three days has been to go back over our early years of struggle and hope. . . . It's hard to be alone, though no doubt it won't be for long as I'm feeling my age increasingly as each day goes by, despite what people say.[4]*

PROVENANCE
Hôtel Drouot, Paris, 17 April 1896; Durand-Ruel, Paris; Edmond Decap, Paris, the same day; the dramatist Georges Feydeau, Paris; Feydeau Sale, Hôtel Drouot, Paris, 14 June 1902; Durand-Ruel, Paris; Charles Albert Corliss, New York; Mr. Josiah Titzell, Georgetown, Connecticut; Anne Parrish Titzell.

NOTES
1. Renoir, quoted in Ambroise Vollard, *Renoir: An Intimate Record*, trans. Harold L. Van Doren and Randolph T. Weaver (New York: Alfred A. Knopf, 1925), p. 62.
2. John House et al., *Renoir: Master Impressionist*, exh. cat. (Sydney, New South Wales: Queensland Art Gallery, Art Exhibitions Australia Limited, 1994), p. 64.
3. Renoir, quoted in Albert André, "Renoir (1919)," 1928, in Nicholas Wadley, ed., *Renoir: A Retrospective* (New York: Hugh Lauter Levin Associates, 1987; distributed by Macmillan Publishing Company), p. 275.
4. Monet, letter to Félix Fénéon, December 1919, in Richard Kendall, ed., *Monet by Himself*, trans. Bridget Strevens Romer (London: Macdonald Orbis, 1989), p. 253.

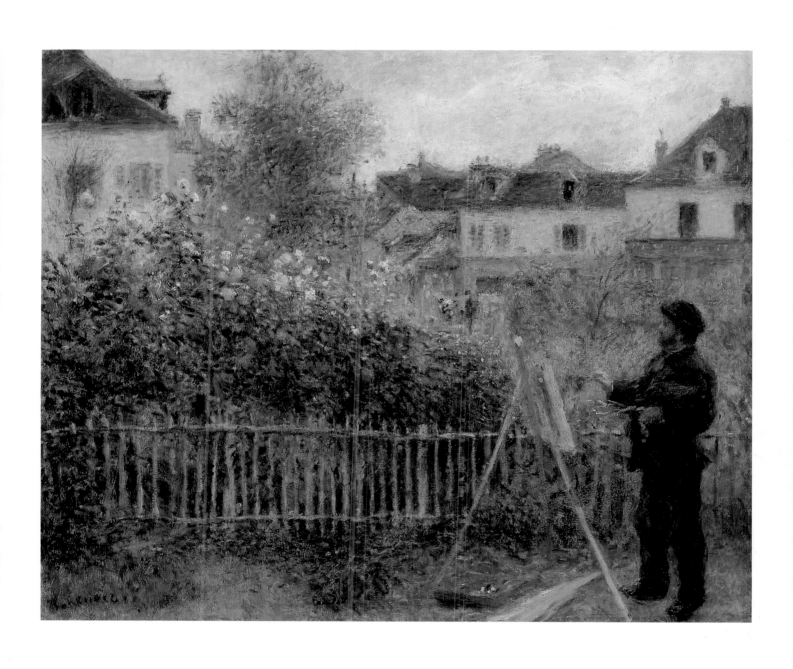

CAT. NO. 56
PIERRE-AUGUSTE RENOIR
1841–1919

**Child with Hoop**
(c. 1875)

Oil on canvas
24 ½ x 19 ¼ inches (62.3 x 48.9 cm)

The Baltimore Museum of Art:
The Helen and Abram Eisenberg
Collection (BMA 1976.55.8)

*Fig. 56a. Pierre-Auguste Renoir.* Portrait de Jean Renoir,
L'Enfant au cerceau. *1898. Courtesy Sotheby's, London*

Throughout his long career Renoir record-ed likenesses of children, both in formal commissioned portraits and, following the birth of his first son, Pierre, in 1885, in more intimate studies. The latter often depicted Pierre and his younger brothers, Jean (b. 1894) and Claude, called Coco (b. 1901).

Here, a dark-eyed, fair-haired child of two or three stands grasping a hoop, an attribute given by the artist to a number of his younger subjects.[1] A red upholstered chair and the suggestion of a richly col-ored carpet behind the figure provide the setting. Although variously titled *Child with Hoop* and *Portrait of Jean Renoir*, the latter identification cannot be possible, given a date in the mid-1870s generally assigned to the work. Moreover, the can-vas demonstrates stylistic similarities to the likenesses of the small children in Renoir's *Portrait of Madame Georges Charpentier and Her Children, Georgette and Paul*, painted in 1878 (see House, fig. 2), suggesting a comparable date for this composition.[2]

In 1898 Renoir would paint a portrait of his second son, Jean, at the age of four (fig. 56a). Holding a hoop, the young boy is dressed in black velvet embellished with an elaborate lace collar. Apparently yet to receive his first haircut, Jean has long blond tresses tied on one side with a ribbon.

PROVENANCE
Mrs. Abram Eisenberg, Baltimore, by 1935.

NOTES
1. See, for instance, the small child in *Les Parapluies* (1881–85; National Gallery, London) and *La Fille au cerceau (Marie Goujon)* (1885; National Gallery of Art, Washington, D.C.).
2. These stylistic similarities are discussed in a letter from François Daulte to Gertrude Rosenthal, 17 May 1968, Archives, The Baltimore Museum of Art.

CAT. NO. 57
PIERRE-AUGUSTE RENOIR
1841–1919

*Studies of the Berard Children*
1881

Oil on canvas
24 5/8 x 32 1/4 inches (62.6 x 82 cm)

Sterling and Francine Clark Art Institute,
Williamstown, Massachusetts (590)

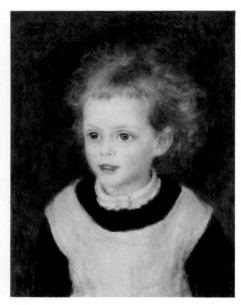

*Fig. 57a. Pierre-Auguste Renoir.*
Marguerite-Thérèse (called Margot)
Berard. 1879. *The Metropolitan Museum
of Art: Bequest of Stephen C. Clark, 1960
(61.101.15)*

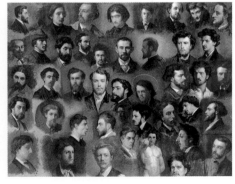

*Fig. 57b. Collective work with contribu-
tions by Pierre-Auguste Renoir and Émile-
Henri Laporte (1841–1919).* Forty-three
Portraits of Painters in Gleyre's Atelier.
*(c. 1856–68). Musée du Petit Palais, Paris*

Renoir is said to have met Paul Berard
(1833–1905) through the collector Charles
Deudon (1832–1914).[1] All three frequented
the Paris salon of Madame Marguerite
Charpentier during the 1870s. Also at these
gatherings on a regular basis were the
painters Manet, Monet, Degas, and Sisley,
as well as the journalist Théodore Duret
and the collectors Charles Ephrussi and
Ernest Hoschedé.[2] A diplomat, business-
man, and banker, Berard would remain a
devoted patron and close friend to Renoir
until his death in 1905.

In the spring of 1879, Berard commis-
sioned portraits of a number of his chil-
dren including his eldest daughter, Marthe-
Marie (Museu de Arte de São Paulo
Assis Chateaubriand), and little Margot
(fig. 57a). Through the early 1880s the
artist painted numerous portraits of fam-
ily members, visiting the Berard country
estate, Wargemont, on the Normandy
coast near Dieppe on several occasions.
Jean Renoir, the artist's son, described
these outings:

> *My father used to spend long visits
> with the Berards in their château in
> the Caux country. He found an ample
> supply of models there and scarcely
> stopped painting a moment. When
> canvas and paper gave out, he paint-
> ed on the doors and walls, much to the
> annoyance of the kindly Mme. Berard
> who did not share her husband's blind
> admiration for their visitor's painting.[3]*

After painting individual portraits of the
Berard children, Renoir depicted them in
a format generally associated with prelim-
inary studies or sketches. Artists often
juxtaposed multiple images on a single
sheet as they worked through composi-
tions. However, precedents for more for-
mal portraits in the manner are numerous.
A canvas with images of students in the
atelier of Charles Gleyre painted by vari-
ous artists over a period of years depicts
the young Renoir among the forty-three
heads (fig. 57b).[4] In the realm of prints,
examples include a lithograph by Pierre-
Roch Vigneron (1789–1872), *The Vigneron
Family* (1817; The Metropolitan Museum of
Art, New York). In 1876, working from
photographs, Renoir himself incorporated
into a single composition several images of
young Marie-Sophie Chocquet (*Marie-

Sophie Chocquet*, 1876, private collec-
tion), the deceased only child of another
patron, the collector Victor Chocquet.[5]

Here, the artist presents a composite
study of the four Berard children. The fig-
ures are arranged somewhat haphazardly
across the picture plane, each likeness
contained in its own space. Marthe-Marie,
the oldest daughter, shown holding an
open book, dominates the center of the
canvas, and she appears again in profile in
the lower right corner. Her brother,
André-Victor, at the lower left, concen-
trates intently on his reading. Seven-year-
old Marguerite-Thérèse, called Margot, is
portrayed in profile in the upper center of
the composition, and again in the upper
right, her hands folded in her lap as she
gazes to one side. The baby, Lucie, is
shown both asleep and awake. The lively
expressions of the Berard daughters, with
their disarmingly vivid blue eyes, recalls a
description given by society portraitist
and writer Jacques-Émile Blanche, who
lived near Wargemont: "The Berard girls,
unruly savages who refuse to learn to read
or spell, their hair wind-tossed, slipped
away into the fields to milk the cows."[6]

PROVENANCE
Paul Berard, Wargemont and Paris; Galeries Georges
Petit, Paris, Berard Sale, 8 May 1905; Albert Pra;
Galerie Charpentier, Paris, Pra "Succession" Sale. 17
June 1938; Knoedler and Co., London, New York,
and Paris; Robert Sterling Clark, Paris, 1938.

NOTES
1. Anne Distel, *Impressionism: The First Collectors*,
trans. Barbara Perroud-Benson (New York: Harry
N. Abrams, 1990), p. 165.
2. Distel, *Impressionism*, pp. 142–3.
3. Jean Renoir, *Renoir: My Father*, trans.
Randolph and Dorothy Weaver (Boston and Toronto:
Little, Brown and Company, 1962), p. 141.
4. For a comprehensive discussion of this paint-
ing, see Colin B. Bailey, with the assistance of John
B. Collins, *Renoir's Portraits: Impressions of an Age*,
exh. cat. (New Haven and London: Yale University
Press in association with the National Gallery of
Canada), pp. 88–91.
5. Bailey, *Renoir's Portraits*, pp. 25 and 184.
6. Jacques-Émile Blanche, *Portraits of a Lifetime*
(London, 1937), pp. 37–38, as quoted in John
House and Anne Distel, *Renoir*, exh. cat. (London:
Hayward Gallery, 1985), p. 230.

CAT. NO. 58
PIERRE-AUGUSTE RENOIR
1841–1919

*Albert Cahen d'Anvers*
1881

Oil on canvas
31 7/16 x 25 1/8 inches (79.9 x 63.8 cm)

The J. Paul Getty Museum,
Los Angeles (88.PA.133)

*Fig. 58a. Gaspard Félix Tournachon (called Nadar) (1820–1910). Photograph of Albert Cahen d'Anvers. (c. 1896). Bibliothèque Nationale de France, Paris*

In September 1881, while at Wargemont, the Berard country estate near Dieppe, Renoir painted this portrait of the elegantly attired composer Albert Cahen d'Anvers (1846–1903), a guest at the château. During the late 1870s and 1880s such commissions came with regularity following the artist's introduction into the wealthy and prominent circle of acquaintances of the publisher Georges Charpentier and his wife, Marguerite.[1]

Born in Antwerp into a banking family, Albert was the younger brother of Louis Cahen d'Anvers, who, in 1881, commissioned from Renoir a double portrait of two of his daughters, Alice and Elisabeth Cahen d'Anvers (Museu de Arte de São Paulo Assis Chateaubriand); the artist had painted a likeness of their older sister, Irène, in the previous year (Foundation E. G. Bührle Collection, Zurich).

A pupil of the pianist Madame Szarvady in the mid-1860s, Albert Cahen d'Anvers went on to study composition and harmony with the Romantic composer César Franck (1822–1890). When his initial musical works met with only moderate success, he turned to orchestrating for the stage, and made his debut at the Opéra-

Comique on 11 October 1880 with *Le Bois*. Cahen d'Anvers is best remembered for *Marines*, a collection of seven melodies set to the poems of Paul Bourget and Maurice Boucher that, like many of his musical compositions, reflect the influence of his teacher, Franck.[2]

In a letter written at Wargemont to the collector Charles Deudon, dated 7 September 1881, Paul Berard noted that this portrait was progressing well; indeed, it was finished two days later.[3] Cahen d'Anvers, his features dominated by a generous mustache and thick eyebrows, poses comfortably in an armchair as he gazes past the viewer. While one hand rests in his lap, the other holds a cigarette in a holder between two fingers. Warm browns and a variety of blues predominate throughout the painting, most notably in the elaborate floral wallcovering in the background.

A member of the lively intellectual milieu of Paris in the 1880s, Cahen d'Anvers counted among his closest friends the novelist and short story writer Guy de Maupassant. Although he could not be considered a major collector, he did own works by Jean-François Millet, Claude Monet, and Gustave Moreau.[4] Cahen d'Anvers's marriage to a prominent Polish socialite, Rosalie Louise Warshawska, was not especially happy, and he died alone at Cap d'Ail, near Monte Carlo, in February 1903.[5]

PROVENANCE
Albert Cahen d'Anvers, Paris; by inheritance to Hubert Cahen d'Anvers, his nephew; Dr. Joseph Steegman, Zurich; Galerie Beyeler, Basel, by 1971; private collection, Geneva; Galerie Beyeler, Basel.

NOTES
1. Kathleen Adler, "Renoir's Portrait of Albert Cahen d'Anvers," *The J. Paul Getty Museum Journal* 23 (1995), p. 31.
2. Stanley Sadie, ed., *The New Grove Dictionary of Music and Musicians*, vol. 3 (London: Macmillan, 1980), pp. 604–5.
3. Berard to Deudon, 7 September 1881, in Anne Distel, "Charles Deudon (1832-1914), Collectionneur," *Revue de l'Art*, vol. 86 (1989), pp. 58–65, as quoted in Colin B. Bailey, with the assistance of John B. Collins, *Renoir's Portraits: Impressions of an Age*, exh. cat. (New Haven and London: Yale University Press, in association with the National Gallery of Canada, Ottawa, 1997), p. 178.
4. Bailey, *Renoir's Portraits*, p. 178.
5. Ibid.

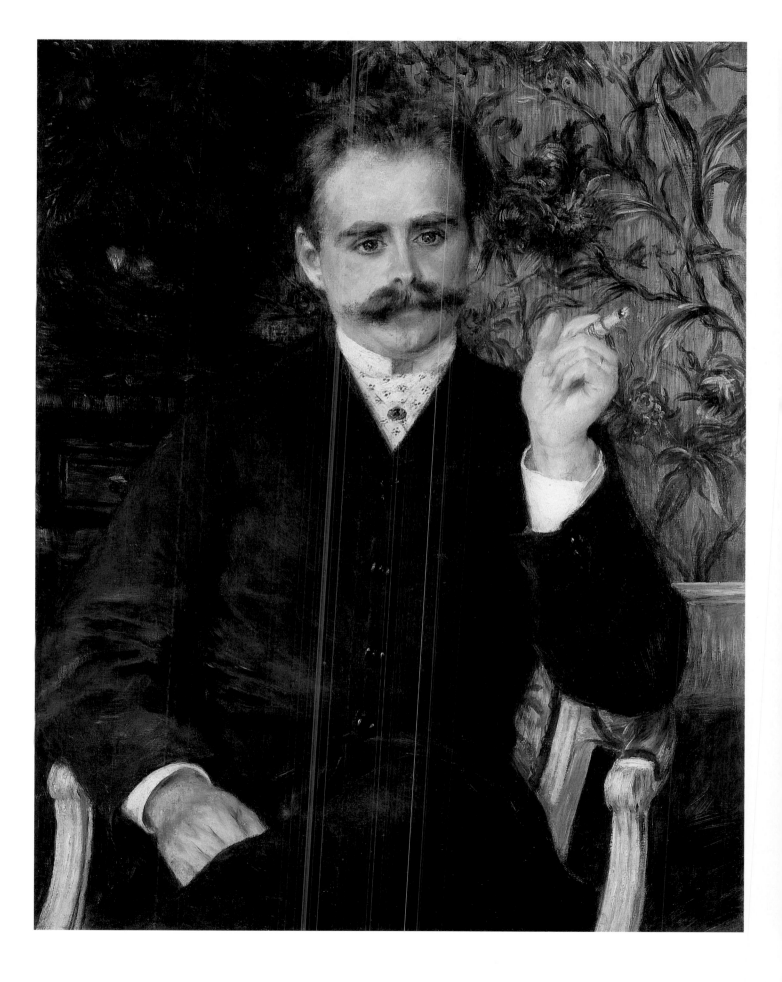

CAT. NO. 59
PIERRE-AUGUSTE RENOIR
1841–1919

**Marie-Thérèse Durand-Ruel Sewing**
1882

Oil on canvas
25 ½ x 21 ³/₁₆ inches (64.8 x 53.8 cm)

Sterling and Francine Clark Art Institute,
Williamstown, Massachusetts (613)

Fig. 59a. Photograph of Marie-Thérèse
Durand-Ruel. 1890. Archives Durand-
Ruel, Paris

Fig. 59b. Pierre-Auguste Renoir. The
Daughters of Durand-Ruel. 1882.
The Chrysler Museum of Art, Norfolk,
Virginia: Gift of Walter P. Chrysler, Jr. in
Memory of Thelma Chrysler Foy (71.518)

In his reminiscences as told to Ambroise
Vollard, Renoir recalled: "It was in 1873
that one of the most important events of
my life took place: I made the acquain-
tance of Durand-Ruel, the first dealer—
the only one, in fact, for many a long
year—who believed in me."[1]

Indeed, Paul Durand-Ruel (1831–1922),
the Paris art dealer, had been among the
first to recognize the Impressionists' inno-
vations and would zealously promote their
works both in France and abroad. Late in
life, Renoir spoke with enduring apprecia-
tion of his support:

> Durand-Ruel was a missionary. It is
> lucky for us that his religion was paint-
> ing. He had his moments of doubt too.
> Every time I tried out something new,
> he was sorry I hadn't kept to my old
> style, which was safer and had already
> been accepted by the art fanciers. But
> put yourself in his place. In 1885, he
> almost went under, and the rest of us
> with him.[2]

In 1910 the artist commemorated his long
association with Durand-Ruel in a portrait
that presents the latter as an urbane,
clearly sympathetic individual (Paul
Durand-Ruel, Durand-Ruel, Paris).

The early 1880s were exceptional years
in the artist's relations with Durand-Ruel.
Despite his own refusal to exhibit in the
Seventh Impressionist Exhibition in 1882,
Renoir could not prohibit his dealer, who
played a dominant role in organizing the
show, from including twenty-five Renoir
paintings from his own holdings. In April
1883 Durand-Ruel would mount the first
one-man exhibition of Renoir's work at his
Paris gallery.[3]

During the summer of 1882 Renoir
painted a series of four compositions that
depict the Durand-Ruel children. As a
group, these portraits are conspicuously
varied, each capturing the particular
characteristics of the individual sitter
with unusual acumen. Commissioned by
Durand-Ruel père while the family was
on holiday at Dieppe, they include two
double portraits: one showing brothers
Charles (1865–1892) and Georges
(1866–1931), and the other depicting their
sisters Marie-Thérèse (1868–1937) and
Jeanne (1870–1914) (fig. 59b). The oldest
son, Joseph (1862–1928), is represented in

a separate portrait, and Renoir painted
Marie-Thérèse a second time in the like-
ness discussed here.[4]

Shown seated out-of-doors in a color-
ful garden setting, the fourteen-year-old
girl concentrates intently on her hand-
work. Her long brown hair, tied at the
nape of her neck, cascades down her
shoulder, all but enveloping her left arm.
Marie-Thérèse's features are carefully
drawn, and the crispness of her profile
beneath the red-rimmed hat is in contrast
to the lush, verdant background. Six years
later Renoir would portray her again as a
young woman in a somewhat formal,
rather conventional characterization.[5]

In 1893 Marie-Thérèse married Félix-
André Aude, a diplomat, with Pierre-
Cécile Puvis de Chavannes and Edgar
Degas serving as witnesses for the bride.[6]
A pastel by Mary Cassatt from 1899 shows
Mme. Aude as a matronly young woman
with her two dark-haired daughters,
Madeleine and Thérèse (Portrait of Mme.
A.F. Aude and Her Two Daughters,
Durand-Ruel, Paris).[7]

PROVENANCE
Paul Durand-Ruel, Paris; Madame Félix-André Aude
(Marie-Thérèse Durand-Ruel), Paris; Knoedler and
Co., New York, London, and Paris; acquired from
Knoedler, Paris, by Robert Sterling Clark, New York,
July 1935.

NOTES
1. Renoir, quoted in Ambroise Vollard, Renoir:
An Intimate Record, trans. Harold L. Van Doren and
Randolph T. Weaver (New York: Alfred A. Knopf,
1925), pp. 61–62.
2. Pierre-Auguste Renoir, quoted in Jean Renoir,
Renoir: My Father, trans. Randolph and Dorothy
Weaver (Boston and Toronto: Little, Brown and
Company, 1962), p. 251.
3. John House and Anne Distel, Renoir,
exh. cat. (London: Hayward Gallery, 1985), p. 221.
4. See Colin B. Bailey, with the assistance of John
B. Collins, Renoir's Portraits: Impressions of an Age,
exh. cat. (New Haven and London: Yale University
Press in association with the National Gallery of
Canada, Ottawa, 1997), pp. 190–97.
5. Bailey, Renoir's Portraits, p. 194. See reproduc-
tion in François Daulte, Auguste Renoir: Catalogue
raisonné de l'oeuvre peint, I: Figures, 1860–1890
(Lausanne: Éditions Durand-Ruel, 1971), no. 549.
6. Bailey, Renoir's Portraits, p. 194.
7. Adelyn Dohme Breeskin, Mary Cassatt:
A Catalogue Raisonné of the Oils, Pastels,
Watercolors, and Drawings (Washington, D.C.:
Smithsonian Institution Press, 1970), p. 136, no. 307.

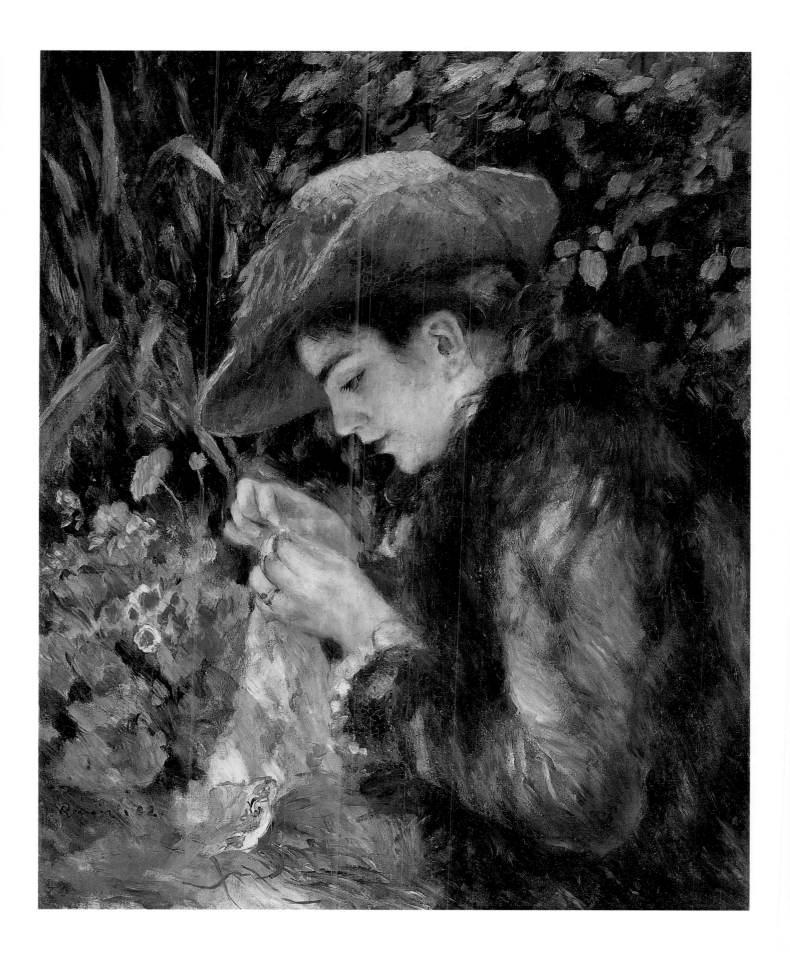

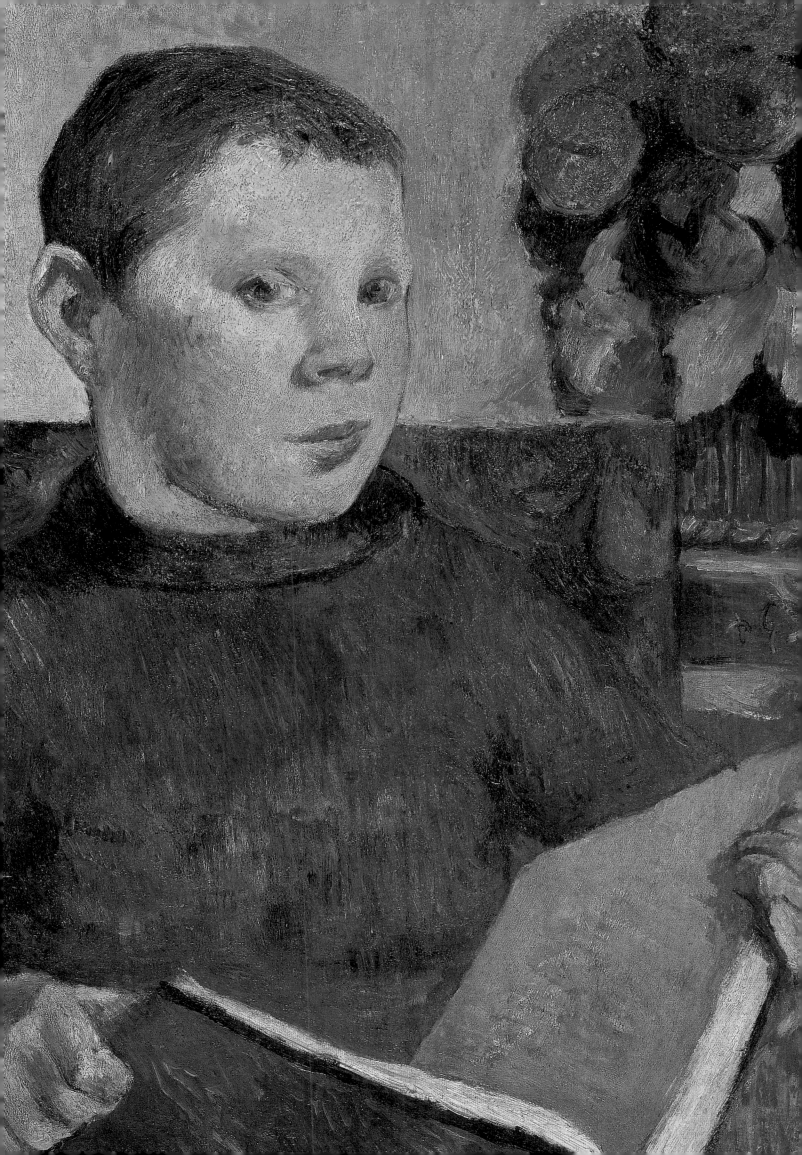

# Selected Bibliography

Ackerman, Gerald M. "Thomas Eakins and his Parisian Masters Gérôme and Bonnat." *Gazette des Beaux-Arts* 73 (April 1969): 233–56.

Adler, Kathleen. "Renoir's Portrait of Albert Cahen d'Anvers." *The J. Paul Getty Museum Journal* 23 (1995): 31–40.

Alphant, Marianne. *Claude Monet: Une vie dans le paysage.* Paris: Hazan Collection 35/37, 1993.

Amaya, Mario. "Contrasts and Comparisons in French Nineteenth-Century Painting." *Apollo* 107 (April 1978): 254–63.

Athanassoglou-Kallmyer, Nina. "An Artistic and Political Manifesto for Cézanne." *Art Bulletin* 72, no. 3 (September 1990): 482–92.

Bailey, Colin B. "Renoir's Portrait of His Sister-in-Law." *Burlington Magazine* 137 (October 1995): 684–87.

Bailey, Colin B., with the assistance of John B. Collins. *Renoir's Portraits: Impressions of an Age* (exh. cat.). New Haven and London: Yale University Press in association with National Gallery of Canada, Ottawa, 1997.

Bailey, Colin B., Joseph J. Rishel, and Mark Rosenthal. *Masterpieces of Impressionism and Post-Impressionism: The Annenberg Collection.* Philadelphia: Philadelphia Museum of Art, 1989.

Bailly-Herzberg, Janine, ed. *Correspondance de Camille Pissarro, Tome 1, 1865–1885.* Preface by Bernard Dorival. Paris: Presses Universitaires de France, 1980.

Baltimore Museum of Art. *Paintings, Drawings, and Graphic Works by Manet, Degas, Berthe Morisot, and Mary Cassatt.* Catalogue by Lincoln Johnson. Baltimore: Baltimore Museum of Art, 1962.

Barrows, Susanna. *Distorting Mirrors: Visions of the Crowd in Late Nineteenth-Century France.* New Haven and London: Yale University Press, 1981.

Bataille, Marie-Louise, and Georges Wildenstein. *Berthe Morisot: Catalogue des Peintures, Pastels, et Aquarelles.* Paris: Les Beaux-Arts Éditions d'Études et des Documents, 1961.

Baudelaire, Charles. "Le Peintre de la vie moderne." *Écrits sur l'art.* Vol 2. Paris: Le Livre de poche, 1971.

Baumann, Felix, and Marianne Karabelnik, eds. *Degas Portraits* (exh. cat.). London: Merrell Holberton, 1994.

Berhaut, Marie. *Caillebotte: Catalogue raisonné des peintures et pastels.* Rev. and exp. Paris: Wildenstein Institute, 1994.

Berson, Ruth, ed. *The New Painting: Impressionism, 1874–1886, Documentation.* San Francisco: Fine Arts Museums of San Francisco; Seattle: University of Washington Press, 1996.

Blanche, J.-E. *Masters of Modern Art: Manet.* Translated by F. C. De Sumichrast. New York: Dodd, Mead and Company, 1925.

Blanche, Jacques-Émile. "Renoir, Portraitiste." *L'Art vivant* 174 (July 1933).

Boggs, Jean Sutherland. "Edgar Degas and the Bellellis." *The Art Bulletin* 37 (June 1955): 127–36.

———. "Mme. Musson and Her Two Daughters' by Edgar Degas." *The Art Quarterly* 19, no. 1 (spring 1956): 60–64.

———. *Portraits by Degas.* Berkeley and Los Angeles: University of California Press, 1962.

———. "Edgar Degas and Naples." *Burlington Magazine* 105, no. 723 (June 1963): 273–76.

Boggs, Jean Sutherland, Douglas W. Druick, Henri Loyrette, Michael Pantazzi, and Gary Tinterow. *Degas* (exh. cat.). New York: Metropolitan Museum of Art; Ottawa: National Gallery of Canada, 1988.

Boime, Albert. "Thomas Couture and the Evolution of Painting in Nineteenth-Century France." *The Art Bulletin* 51 (March 1969): 48–56.

———. *The Academy and French Painting in the Nineteenth Century.* New Haven and London: Yale University Press, 1971.

———. *Thomas Couture and the Eclectic Vision.* New Haven and London: Yale University Press, 1980.

Bowness, Alan, Marie-Thérèse de Forges, Michel Laclotte, and Hélène Toussaint. *Gustave Courbet* (exh. cat.). Paris: Éditions des musées nationaux, 1977.

Breeskin, Adelyn D. *The Graphic Work of Mary Cassatt: A Catalogue Raisonné.* New York: H. Bittner, 1948.

Breeskin, Adelyn Dohme. *Mary Cassatt: A Catalogue Raisonné of the Oils, Pastels, Watercolors, and Drawings.* Washington, D.C.: Smithsonian Institution Press, 1970.

Brettell, Richard, Françoise Cachin, Claire Frèches-Thory, and Charles F. Stuckey, with assistance from Peter Zegers. *The Art of Paul Gauguin* (exh. cat.). Washington, D.C.: National Gallery of Art; Chicago: Art Institute of Chicago, 1988.

van Buren, Anne H. "Madame Cezanne's Fashions and the Dates of Her Portraits." *The Art Quarterly* 29, no. 2 (1966): 111–27.

Burnett, Robert. *The Life of Paul Gauguin.* New York: Oxford University Press, 1937.

Cachin, Françoise. *Gauguin.* Translated by Bambi Ballard. Paris: Flammarion, 1988.

Cachin, Françoise, and Charles S. Moffett, in collaboration with Michel Melot. *Manet, 1832–1883* (exh. cat.). New York: Metropolitan Museum of Art, 1983; distributed by Harry N. Abrams.

Cachin, Françoise, Isabelle Cahn, Walter Feilchenfeldt, Henri Loyrette, and Joseph J. Rishel. *Cézanne* (exh. cat.). Philadelphia: Philadelphia Museum of Art, 1996.

*Gustave Caillebotte: A Retrospective Exhibition* (exh. cat.). Houston: Museum of Fine Arts, Houston, 1976.

Champa, Kermit S. *Studies in Early Impressionism.* New Haven and London: Yale University Press, 1973.

Chu, Petra ten-Doesschate, ed. *Correspondance de Courbet.* Paris: Flammarion, 1996.

Clairet, Alain, Delphine Montalant, and Yves Rouart, in collaboration with Waring Hopkins and Alain Thomas. *Berthe Morisot, 1841–1895: Catalogue raisonné de l'oeuvre peint.* Montolivet, France: CÉRA-nrs éditions, 1997.

Clark, T. J. *The Painting of Modern Life: Paris in the Art of Manet and His Followers.* New York: Alfred A. Knopf, 1985.

Comstock, Helen. "The Connoisseur in America: A Child Portrait by Manet." *Connoisseur* 97 (May 1936): 282–83.

Courthion, Pierre, and Pierre Cailler, eds. *Portrait of Manet.* Translated by Michael Ross. London: Cassell & Co., 1960.

Cowling, Mary. *The Artist as Anthropologist: The Representation of Type and Character in Victorian Art.* Cambridge: Cambridge University Press, 1989.

Daulte, François. *Auguste Renoir: Catalogue raisonné de l'oeuvre peint, I: Figures, 1860–1890.* Lausanne: Éditions Durand-Ruel, 1971.

Day, Holliday T., and Hollister Sturges, eds. *Joslyn Art Museum: Paintings and Sculpture from European and American Collections.* Omaha: Joslyn Art Museum, 1987; distributed by the University of Nebraska.

Denker, Eric. *In Pursuit of the Butterfly: Portraits of James McNeill Whistler.* Washington, D.C.: National Portrait Gallery, Smithsonian Institution, 1995.

Denvir, Bernard. *The Chronicle of Impressionism: A Timeline History of Impressionist Art.* London: Thames and Hudson; Boston: Little, Brown and Company, 1993.

Distel, Anne. *Impressionism: The First Collectors.* Translated by Barbara Perroud-Benson. New York: Harry N. Abrams, 1990.

Distel, Anne, Douglas W. Druick, Gloria Groom, Rodolphe Rapetti, with Julia Sagraves and essay by Kirk Varnedoe. *Gustave Caillebotte: Urban Impressionist* (exh. cat.). Paris: Réunion des Musées Nationaux; Chicago: Art Institute of Chicago; with Abbeville Press, 1995.

Druick, Douglas, and Michel Hoog. *Fantin-Latour* (exh. cat.). Paris: Réunion des musées nationaux, 1982.

Druick, Douglas, and Michel Hoog. *Fantin-Latour* (exh. cat.). Ottawa: National Gallery of Canada, National Museums of Canada, 1983.

Dumas, Ann. *Degas's 'Mlle. Fiocre' in Context.* New York: Brooklyn Museum, 1988.

Duranty, Louis-Edmond. "Sur la physiognomie." *Revue libérale* (25 July 1867): 499–523.

———. "La Nouvelle Peinture." 1876. Reprint in *The New Painting: Impressionism, 1874–1886* (exh. cat.). San Francisco: Fine Arts Museums of San Francisco, 1986.

Duret, Théodore. *Manet and the French Impressionists.* Translated by J. E. Crawford Flitch. London: Grant Richards, 1912.

———. *Renoir.* Translated by Madeleine Boyd. New York: Crown Publishers, 1937.

———. "Salon de 1870." Reprint in *Critique d'avant-garde.* Paris: École Nationale Supérieure des Beaux-Arts, 1998.

*Henri Fantin-Latour, 1836–1904* (exh. cat.). Northampton, Mass.: Smith College Museum of Art, 1966.

*Opposite:* Detail, Cat. no. 32.

Faunce, Sarah, and Linda Nochlin. *Courbet Reconsidered*. New York: Brooklyn Museum, 1998.

Fisher, Jay McKean. *The Prints of Édouard Manet*. Washington, D.C.: International Exhibitions Foundation, 1985.

Francis, Henry S. "'Mlle. Romaine Lacaux' by Renoir." *The Bulletin of The Cleveland Museum of Art*, no. 6 (June 1943): 92–98.

Fried, Michael. *Manet's Modernism, or, The Face of Painting in the 1860s*. Chicago and London: University of Chicago Press, 1996.

*From Realism to Symbolism: Whistler and His World*. New York: Wildenstein; Philadelphia: Philadelphia Museum of Art, 1971.

Gaunt, William. "Fantin-Latour in the Maturity of His Art." *Connoisseur* 152, no. 614 (April 1963): 220–22.

de Goncourt, Edmond and Jules. *Idées et sensations*. Paris: E. Fasquelle, 1866.

Gordon, Robert, and Andrew Forge. *Monet*. New York: Harry N. Abrams, 1983.

———. *Degas*. New York: Harry N. Abrams, 1988.

Gowing, Lawrence, with contributions by Götz Adriani, Mary Louise Krumrine, Mary Tompkins Lewis, Sylvie Patin, and John Rewald. *Cézanne: The Early Years, 1859–1872* (exh. cat.). Washington, D.C.: National Gallery of Art, in association with Harry N. Abrams, 1988.

Gray, Christopher. *Sculpture and Ceramics of Paul Gauguin*. Baltimore: Johns Hopkins Press, 1963.

Grunchec, Philippe. *Les Concours des Prix de Rome, 1797–1863*. Paris: École Nationale Supérieure des Beaux-Arts, 1986.

Guérin, Marcel. *Dix-neuf Portraits de Degas par lui-même*. Paris: Privately printed, 1931.

———, ed. *Degas Letters*. Translated by Marguerite Kay. Oxford: Bruno Cassirer, 1947.

Halévy, Daniel. *My Friend Degas*. Translated, edited, and annotated by Mina Curtiss. Middletown, Conn.: Wesleyan University Press, 1964.

Hanson, Anne Coffin. *Édouard Manet, 1832–1883* (exh. cat.). Philadelphia: Philadelphia Museum of Art, 1966.

Havemeyer, Louisine W. *Sixteen to Sixty: Memoirs of a Collector*. Edited by S. A. Stein. New York: Ursus Press, 1993.

Herbert, Robert L. *Impressionism: Art, Leisure, and Parisian Society*. New Haven and London: Yale University Press, 1988.

Higonnet, Anne. *Berthe Morisot*. Berkeley, Los Angeles, and London: University of California Press, 1995.

Hobbs, Richard, ed. *Impressions of French Modernity*. Manchester and New York: Manchester University Press, 1998.

Holt, Edgar. *The Tiger: The Life of Georges Clemenceau, 1841–1929*. London: Hamish Hamilton, 1976.

Honour, Hugh. *The Image of the Black in Western Art IV from the American Revolution to World War I*. Cambridge, Mass., and London: Menil Foundation, 1989.

House, John. "The New Monet Catalogue." *Burlington Magazine* 120, no. 907 (October 1978): 636–42.

———. "Impressionism and History: The Rewald Legacy." *Art History* 9, no. 3 (September 1986): 369–76.

———. *Pierre-Auguste Renoir: La Promenade*. Los Angeles: J. Paul Getty Museum, 1997.

House, John, and Anne Distel. *Renoir* (exh. cat.). London: Hayward Gallery, 1985.

House, John, with essays by Kathleen Adler and Anthea Callen. *Renoir: Master Impressionist* (exh. cat.). Sydney, New South Wales: Queensland Art Gallery, Art Exhibitions Australia Limited, 1994.

Huth, Hans. "Impressionism Comes to America." *Gazette des Beaux-Arts* 29 (April 1946): 225–52.

Isaacson, Joel, with the collaboration of Jean-Paul Bouillon, Dennis Costanzo, Phylis Floyd, Laurence Lyon, Matthew Rohn, Jacquelynn Baas Slee, and Inga Christine Swenson. *The Crisis of Impressionism: 1878–1882* (exh. cat.). Ann Arbor: University of Michigan Museum of Art, 1980.

Jamot, Paul, and Georges Wildenstein. *Manet*. 2 vols. Paris: Les Beaux-Arts Édition d'Études et de Documents, 1921.

Johnston, William R. *The Nineteenth Century Paintings in the Walters Art Gallery*. Baltimore: Trustees of the Walters Art Gallery, 1982.

Jourdan, Aleth, Didier Vatuone, Elizabeth W. Easton, Guy Barral, Pascal Bonafoux, Dianne W. Pitman, François Daulte, and Jean-Patrice Marandel. *Frédéric Bazille: Prophet of Impressionism* (exh. cat.). Montpellier, France: Museé Fabre; New York: Brooklyn Museum, 1992.

Kendall, Richard, ed. *Degas by Himself: Drawings, Prints, Paintings, Writings*. Boston: Little, Brown and Company, 1987.

———. *Monet by Himself*. Translated by Bridget Strevens Romer. London: Macdonald Orbis, 1989.

Kendall, Richard, and Griselda Pollock. *Dealing with Degas: Representations of Women and the Politics of Vision*. London: Pandora Press, 1992.

Kern, Steven, Karyn Esielonis, Patricia R. Ivinski, Rebecca Molholt, and Kate Burke. *A Passion for Renoir: Sterling and Francine Clark Collect, 1916–1951* (exh. cat.). New York: Harry N. Abrams, in association with Sterling and Francine Clark Art Institute, 1996.

Lee, Thomas P. *The Collection of John A. and Audrey Jones Beck*. Houston: Museum of Fine Arts, Houston, 1974.

Lemoisne, Paul-André. *Degas et son oeuvre*. 4 vols. Paris: Paul Brame and C. M. de Hauke, Arts et Metiers Graphiques, 1946–49.

Lindsay, Suzanne G. *Mary Cassatt and Philadelphia* (exh. cat.). Philadelphia: Philadelphia Museum of Art, 1985.

Lloyd, Christopher. *Camille Pissarro*. New York: Rizzoli International Publications; Geneva: Editions d'Art Albert Skira, 1981.

Mack, Gerstle. *Gustave Courbet*. New York: Alfred A. Knopf, 1951.

Malingue, Maurice, ed. *Paul Gauguin: Letters to His Wife and Friends*. Translated by Henry J. Stenning. Cleveland and New York: World Publishing Company, 1949.

Manet, Julie. *Journal, Extraits, (1893–1899)*. 2nd ed. Paris, 1988.

Mantz, Paul. "Les Portraits historiques au Trocadéro." *Gazettes des Beaux-Arts* 18 (1 December 1878).

Marandel, J. Patrice, and François Daulte. *Frédéric Bazille and Early Impressionism* (exh. cat.). Chicago: Art Institute of Chicago, 1978.

Mathews, Nancy Mowll, ed. *Cassatt and Her Circle: Selected Letters*. New York: Abbeville Press, 1984.

———. *Cassatt: A Retrospective*. New York: Hugh Lauter Levin Associates, 1996.

Mauner, George. *Manet: Peintre-philosophe*. University Park: Pennsylvania State University Press, 1975.

McCauley, Elizabeth Anne. *A. A. E. Disdéri and the Carte de Visite Portrait Photograph*. New Haven and London: Yale University Press, 1985.

———. *Industrial Madness: Commercial Photography in Paris, 1848–1871*. New Haven and London: Yale University Press, 1994.

McQuillan, Melissa. *Impressionist Portraits*. London: Thames and Hudson, 1986.

Meier-Graefe, Julius. *Auguste Renoir*. Munich: R. Piper & Co., 1911.

Millard, Charles W. *The Sculpture of Edgar Degas*. Princeton: Princeton University Press, 1976.

Moffett, Charles S. *Degas: Paintings in the Metropolitan Museum of Art*. New York: Metropolitan Museum of Art, 1979.

Moffett, Charles S., with the assistance of Ruth Berson, Barbara Lee Williams, and Fronia E. Wissman. *The New Painting: Impressionism, 1874–1886* (exh. cat.). San Francisco: Fine Arts Museums of San Francisco, 1986.

Moffett, Charles S., Eliza E. Rathbone, Katherine Rothkopf, and Joel Isaacson. *Impressionists in Winter: Effets de Neige*. Washington, D.C.: Phillips Collection, in collaboration with Philip Wilson Publishers, 1998.

Montagu, Jennifer. *The Expression of the Passions*. New Haven and London: Yale University Press, 1994.

Moskowitz, Ira, ed. *Berthe Morisot: Drawings, Pastels, Watercolors, Paintings*. New York: Tudor Publishing Company and Shorewood Publishing Co., 1960.

Mount, Charles Merrill. "A Monet Portrait of Jongkind." *The Art Quarterly* 21, no. 4 (winter 1958): 383–90.

Pennell, E. R. and J. *The Life of James McNeill Whistler*. 2 vols. Philadelphia: J. B. Lippincott Company, 1909.

Philadelphia Museum of Art. *The Second Empire, 1852–1870: Art in France under Napoleon III*. Philadelphia: Philadelphia Museum of Art, 1978; distributed by Wayne State University Press, Detroit.

Pissarro, Ludovic Rodo, and Lionello Venturi. *Camille Pissarro: Son art—son oeuvre*. Paris: Paul Rosenberg, 1939.

Rathbone, Eliza E., Katherine Rothkopf, Richard R. Brettell, and Charles S. Moffett. *Impressionists on the Seine: A Celebration of Renoir's "Luncheon of the Boating Party"* (exh. cat.). Washington, D.C.: Phillips Collection, 1996.

Reed, Sue Welsh, and Barbara Stern Shapiro et al. *Edgar Degas: The Painter as Printmaker* (exh. cat.). Boston: Museum of Fine Arts, Boston, 1984.

Reff, Theodore. "Manet's Portrait of Zola." *Burlington Magazine* 117, no. 862 (January 1975): 34–44.

———. *Degas: The Artist's Mind*. New York: Metropolitan Museum of Art, 1976; distributed by Harper and Row.

———. *The Notebooks of Edgar Degas: A Catalogue of the Thirty-Eight Notebooks in the Bibliothèque Nationale and Other Collections*. 2 vols. Oxford: Clarendon Press, 1976.

Renoir, Jean. *Renoir: My Father*. Translated by Randolph and Dorothy Weaver. Boston and Toronto: Little, Brown and Company, 1962.

Rewald, Alice Bellony. *The Lost World of the Impressionists*. London: Weidenfeld and Nicolson, 1976.

Rewald, John. "Degas and His Family in New Orleans." *Gazette des Beaux-Arts* 6th ser., 30 (August 1946): 105–26.

———. *Camille Pissarro*. New York: Harry N. Abrams, 1963.

———. "Chocquet and Cézanne." *Gazette des Beaux-Arts*, 6th ser., 74 (July–August 1969): 33–96.

———. *The History of Impressionism*. 4th rev. ed. New York: Museum of Modern Art, 1973.

———, ed. *Paul Cézanne: Letters*. Translated by Seymour Hacker. New York: Hacker Art Books, 1984.

———, ed., with the assistance of Lucien Pissarro. *Camille Pissarro: Letters to his Son Lucien*. New York: Pantheon Books, 1943.

Rewald, John, James B. Byrnes, and Jean Sutherland Boggs. *Edgar Degas: His Family and Friends in New Orleans*. New Orleans: Isaac Delgado Museum of Art, 1965.

———, Richard Brettell, Françoise Cachin, Janine Bailly-Herzberg, Christopher Lloyd, Anne Distel, and Barbara Stern Shapiro. *Pissarro*. Paris: Réunion des musées nationaux, 1981.

———, in collaboration with Walter Feilchenfeldt and Jayne Warman. *The Paintings of Paul Cézanne: A Catalogue Raisonné*. 2 vols. New York: Harry N. Abrams, 1996.

Richardson, Joanna. *La Vie parisienne, 1852–1870*. New York: The Viking Press, A Studio Book, 1971.

Rishel, Joseph J. *Cézanne in Philadelphia Collections*. Philadelphia: Philadelphia Museum of Art, 1983.

Rogers, Meyric R. "The Two Sisters by Fantin-Latour (1836–1904)." *Bulletin of the City Art Museum of St. Louis* 22. no. 2 (April 1937): 13–16.

Rosenfeld, Daniel, ed. *European Painting and Sculpture, ca. 1770–1937, in the Museum of Art, Rhode Island School of Design*. Providence: Rhode Island School of Design, 1991.

Rouart, Denis, ed. *Berthe Morisot: Correspondence*. Translated by Betty W. Hubbard, with a new introduction and notes by Kathleen Adler and Tamar Garb. Mount Kisco, N.Y.: Moyer Bell Limited, 1987.

Rouart, Denis, and Daniel Wildenstein. *Édouard Manet: Catalogue Raisonné*. 2 vols. Lausanne and Paris: Bibliothèque des Arts, 1975.

Rust, David E. *Small French Paintings from the Bequest of Ailsa Mellon Bruce* (exh. cat.). Washington, D.C.: National Gallery of Art, 1978.

Schapiro, Meyer. *Paul Cézanne*. New York: Harry N Abrams, 1952.

———. "The Apples of Cézanne." *Art News Annual* 34 (1968). Reprinted in Meyer Schapiro. *Modern Art: 19th and 20th Centuries*. New York: George Braziller, 1978.

Scheyer, Ernst. "Jean Frédéric Bazille—The Beginnings of Impressionism, 1862–1870." *The Art Quarterly* 5, no 2 (spring 1942): 115–32.

Seibert, Margaret Mary Armbrust. "A Biography of Victorine-Louise Meurent and Her Role in the Art of Édouard Manet." 2 vols. Ph.D. diss., Ohio State University, 1986.

Sennett, Richard. *The Fall of Public Man*. 1977. Reprint, London: Faber and Faber. 1986.

Shackelford, George T. M., and Mary Tavener Holmes. *A Magic Mirror: The Portrait in France, 1700–1900* (exh. cat.). Houston: Museum of Fine Arts, Houston, 1986.

Smith College Museum of Art. *Edgar Degas: Paintings, Drawings, Pastels, Sculpture* (exh. cat.). Northampton, Mass.: Smith College Museum of Art, 1933.

Sterling, Charles, and Margaretta M. Salinger. *French Paintings: A Catalogue of the Collection of the Metropolitan Museum of Art III: XIX–XX Centuries*. Greenwich, Conn.: New York Graphic Society, 1967.

Stuckey, Charles F. *Claude Monet, 1840–1926* (exh. cat.). Chicago. Art Institute of Chicago, 1995.

———, ed. *Monet: A Retrospective*. New York: Hugh Lauter Levin Associates, 1985.

Stuckey, Charles F., and William P. Scott, with the assistance of Suzanne G. Lindsay. *Berthe Morisot: Impressionist*. South Hadley, Mass.: Mount Holyoke College Art Museum, in association with the National Gallery of Art, Washington, D.C.; New York: Hudson Hills Press, 1987.

Sutton, Denys. "Degas and America." *Gazette des Beaux-Arts* 116 (July–August 1990): 29–40.

Sweet, Frederick A. *Miss Mary Cassatt: Impressionist from Pennsylvania*. Norman: University of Oklahoma Press, 1966.

Tabarant, A. *Pissarro*. Translated by J. Lewis May. New York: Dodd, Mead and Company, 1925.

Talbot, William S. "Henri Fantin-Latour, Madame Henri Lerolle." *The Bulletin of The Cleveland Museum of Art* 56. no. 9 (November 1969): 309–19.

Tendron, Marcel. *À Giverny: chez Claude Monet*. Paris: Bernheim-Jeune, 1924.

Tinterow, Gary, and Henri Loyrette. *Origins of Impressionism* (exh. cat.). New York: Metropolitan Museum of Art, 1994; distributed by Harry N. Abrams

Tucker, Paul Hayes. *Monet at Argenteuil*. New Haven and London: Yale University Press, 1982.

———. *Claude Monet: Life and Art*. New Haven: Yale University Press, 1995.

Valéry, Paul. *Degas, Manet, Morisot*. Translated by David Paul. Bollingen Series 45, vol. 12. Princeton, New Jersey: Princeton University Press, 1989.

Varnedoe, Kirk. *Gustave Caillebotte*. New Haven and London: Yale University Press, 1987.

Vollard. Ambroise. *Renoir: An Intimate Record*.

Translated by Harold L. Van Doren and Randolph T. Weaver. New York: Alfred A. Knopf, 1925.

———. *Recollections of a Picture Dealer*. Translated by Violet M. MacDonald. Boston: Little, Brown and Company, 1936.

———. *La Vie et l'oeuvre de Pierre-Auguste Renoir*. 1919. Reprinted in Vollard. *En écoutant Cézanne, Degas, Renoir*. Paris: Bernard Grasset, 1938.

Wadley, Nicholas, ed. *Renoir: A Retrospective*. New York: Hugh Lauter Levin Associates, 1987; distributed by Macmillan Publishing Company.

Wagner, Anne M. "Why Monet Gave Up Figure Painting." *Art Bulletin* 76, no. 4 (December 1994): 613–29.

Walter, Rodolphe. "Les Maisons de Claude Monet à Argenteuil." *Gazette des Beaux-Arts* 68 (December 1966): 333–42.

———. "Claude Monet as a Caricaturist: A Clandestine Apprenticeship." *Apollo* 103 (June 1976): 488–93.

Weisberg, Gabriel P. *The Realist Tradition: French Painting and Drawing, 1830–1900*. Cleveland: Cleveland Museum of Art, 1980; distributed by Indiana University Press, Bloomington.

Whistler, James Abbott McNeill. *The Gentle Art of Making Enemies*. London: William Heinemann, 1890.

White, Barbara Ehrlick. *Renoir: His Life, Art, and Letters*. New York: Harry N. Abrams, 1984.

Wildenstein, Daniel. *Monet: Catalogue Raisonné*. 4 vols. Cologne: Taschen/Wildenstein Institute, 1996.

Wildenstein, Georges. *Gauguin*. Vol. 1. Paris: Les Beaux-Arts Éditions d'Études et des Documents, 1964.

Wilson-Bareau, Juliet, ed. *Manet by Himself*. London: Macdonald and Company, 1991.

Wilson-Bareau, Juliet, with essays by John House and Douglas Johnson. *Manet: The Execution of Maximilian, Painting, Politics, and Censorship*. London: National Gallery Publications, 1992.

Wisdom, John Minor. *French Nineteenth Century Oil Sketches: David to Degas* (exh. cat.). Chapel Hill, N.C.: Ackland Memorial Art Center, University of North Carolina, 1978.

Wise, Susan, ed. *European Portraits, 1600–1900, in The Art Institute of Chicago* (exh. cat.). Chicago: Art Institute of Chicago, 1978.

Wivel, Mikael, with Juliet Wilson-Bareau and Hanne Finsen. *Manet*. Copenhagen: Ordrupgaard, 1989.

Woodall, Joanna, ed. *Portraiture: Facing the Subject*. Manchester and New York: Manchester University Press, 1997.

Worcester Art Museum. *A Handbook to The Worcester Art Museum*. Worcester, Mass.: Worcester Art Museum, 1973.

Zerner, Henri, David S. Brooks, and Michael Wentworth. *James Jacques Joseph Tissot, 1836–1902: A Retrospective Exhibition*. Providence: Museum of Art, Rhode Island School of Design, 1968; Toronto: Art Gallery of Ontario.

# INDEX

# PHOTOGRAPHY CREDITS

Jack Abraham, p. 123; ©Albright-Knox Art Gallery, Buffalo, p. 95; ©Archives Durand-Ruel, Paris, p. 156 (top); Armen, pp. 103, 158; Arnaudet, p. 44 (top); ©The Art Institute of Chicago, back cover and pp. 41, 82 (left), 92 (top), 99; ©The Baltimore Museum of Art, pp. 58 (left), 86, 98, 105, 121, 151; Bellot/Coursaget, p. 17; ©Bibliothèque Nationale de France, Paris, p. 154; Gérard Blot, pp. 16, 45 (bottom), 78, 79; ©Board of Trustees, National Gallery of Art, Washington, D.C., pp. 24, 43, 65, 82 (top), 84, 110, 148 (top); ©Brooklyn Museum of Art, pp. 87, 100, 131; ©Emil G. Bührle Collection, Zurich, p. 138; Cathy Carver, p. 31; Christie's, New York, p. 28; ©The Chrysler Museum, Norfolk, VA, pp. 101, 156 (bottom); ©Clark Art Institute, Williamstown, Massachusetts, front cover and pp. 153, 157; ©The Cleveland Museum of Art, pp. 47, 109, 127, 129, 145; ©Columbus Museum of Art, Ohio, pp. 55, 67; ©Dallas Museum of Art, p. 133; ©The Dayton Art Institute, p. 53; Susan Dirk/Under the Light, p. 60 (right); ©Patrice Fevrier, Paris, p. 44 (bottom left); ©Fine Arts Museums of San Francisco, the California Palace of the Legion of Honor, pp. 42 (bottom left), 88; ©Flint Institute of Arts, p. 54; ©Fogg Art Museum, Harvard University Art Museums, Cambridge, p. 66 (top); ©Frye Art Museum, Seattle, Washington, p. 60 (right); ©Fuji Art Museum, Tokyo, p. 130 (top right); ©The J. Paul Getty Museum, Los Angeles, p. 155; Christopher Gray Papers, Ms. 313 Special Collections, Milton S. Eisenhower Library, The Johns Hopkins University, p. 102 (bottom); B. Hatala, p. 23 (left); C. Jean, p. 126 (top right); ©Joslyn Art Museum, Omaha, Nebraska, pp. 38, 55, 77; ©Kimbell Art Museum, p. 119; ©Kunsthalle Bremen, p. 26; Hervé Lewandowski, pp. 12, 18, 19, 20, 21 (left), 40 (left), 106 (bottom), 118 (bottom), 124; Los Angeles County Museum of Art ©Museum Associates, p. 81; Paul Macapia 1994, p. 49; ©The Metropolitan Museum of Art, pp. 2, 14, 23 (right), 89, 111, 122, 142, 152 (top); ©Milwaukee Art Museum, pp. 45, 75; ©Musée Clemenceau, Paris, p. 118 (top); ©Musée d'art et d'histoire, Fribourg/CH, p. 108 (left); ©Musée Départemental du Prieuré, p. 104 (top); ©Musée des Beaux-Arts de Pau, p. 17; ©Musée des Beaux-Arts, Dijon, p. 114 (left); ©Musée d'Orsay, Paris, pp. 12, 18, 19, 20, 21 (left), 23 (left), 27, 40 (left), 96 (bottom), 106, 118 (left), 124, 126 (right), 148 (left); ©Musée du Louvre, Paris, pp. 16, 78; ©Musée du Petit-Palais, Paris, pp. 21 (right), 152 (bottom); ©Musée Fabre, Montpellier, France, pp. 30, 42 (top), 42 (top left); ©Museum of Art, Rhode Island School of Design, pp. 29, 31; ©Museum of Fine Arts, Boston, pp. 62, 70, 85, 107; ©The Museum of Fine Arts, Houston, pp. 57, 71; ©Museum of Fine Arts, Springfield, Massachusetts, p. 143; ©Museum of Fine Arts, St. Petersburg, Florida, p. 137; ©National Museum of American Art, p. 60 (left); ©National Portrait Gallery, Smithsonian Institution, Washington, D.C., p. 93; ©The Nelson Gallery Foundation, p. 113; ©The Newark Museum, pp. 103, 158; Nienhuis/Walls, p. 75; Nihonhasshoku Professional, p. 130 (top right); Edward Owen, p. 91; ©Peabody Art Collection, Maryland Commission on Artistic Property of the Maryland State Archives, p. 59; ©The Henry and Rose Pearlman Foundation, p. 115; ©Pennsylvania Academy of the Fine Arts, Philadelphia, p. 92 (left); Lyle Peterzell, p. 24; ©Philadelphia Museum of Art, pp. 36, 58 (top), 73, 117; ©The Phillips Collection, Washington, D.C., pp. 69, 91; Photo Inc., p. 135; Photostudio Humm, Brüttisellen, p. 114 (right); Photothèque des Musées de la Ville de Paris, pp. 21 (right), 152 (bottom); ©Praun Kunstverlag München, p. 25; ©President and Fellows, Harvard College, Harvard University Art Museums, pp. 94, 116; ©Reunion des Musées Nationaux, Paris, pp. 12, 16, 17, 18, 19, 20, 21 (left), 23 (left), 40 (left), 44 (top), 46 (bottom), 78, 106, 113 (bottom), 124, 126 (top right); Rewald/Cézanne Archive, Photographic Archives, National Gallery of Art, Washington, D.C., pp. 64, 66 (left), 68, 112 (top); ©The Saint Louis Art Museum, pp. 13, 97, 147; José Sanchez, pp. 58 (left), 59, 98; E. G. Schempf, p. 112 (bottom); ©Seattle Art Museum, p. 49; ©Smith College Museum of Art, Northampton, Massachusetts, p. 70; Sotheby's, London, p. 150; Sotheby's, New York, p. 51; ©Spencer Museum of Art, The University of Kansas, p. 112 (bottom); David Stansbury Photography, Springfield, Massachusetts, p. 80; Joseph Szaszfai, pp. 139, 141; ©The Taft Museum, Cincinnati, Ohio, p. 96 (top); ©The Toledo Museum of Art, p. 135; Malcolm Varon, pp. 2, 89; ©Virginia Museum of Fine Arts, p. 126 (top left); ©Wadsworth Atheneum, Hartford, CT, pp. 80, 141, 149; ©The Walters Art Gallery, Baltimore, pp. 33, 83, 125; Katherine Wetzel, p. 126 (top left); ©Williams College Museum of Art, p. 63; ©Worcester Art Museum, Massachusetts, p. 61; ©Yale University Art Gallery, p. 139; and ©Jane Voorhees Zimmerli Art Museum, Rutgers, The State University of New Jersey, p. 123.